'I think it quite a brilliant book, one I must a
of the "local", "domestic" world in which we
defined – like them. A truly radical aesthetic
Thérèse Oulton

'[A] wonderful book. I am impressed and fascina... ... is beautifully written. Each woman artist, in this superb book, addresses the need to transform the confines she inhabits into a space of empowerment. These artists all lived and worked in the first part of the twentieth century yet their legacy continues to be relevant' Celia Paul

'Birrell's blend of art criticism and biography works best when it is tethered to real-world calculation. She is particularly good at teasing out the stubborn material facts that underpin the most serene of still lifes ... Birrell does an excellent job of showing how Gill's creativity was swallowed up in her work as manager of Fry's Omega Workshops ... Birrell is acutely alive to the irony that it was Gill's fate to be overlooked by the very women who made such a big noise about the sacredness of small, intimate items' Kathryn Hughes, *Guardian*

'Here in the dark country, extraordinary developments occur ... Sympathetic to veiled communication and oblique self-revelation, she poses questions, makes playful, provocative suggestions, and invites us into wondering with her. Her attentive, evocative prose renderings of paintings are pleasures in themselves ... In writing of Gill, Waugh, Lloyd and Coombe in brief interludes between chapters, Birrell attempts to restore them to their rightful (if slight) places in the history of modern art, but she is doing something more, too: gesturing at what is missing, at paintings lost or never painted ... In this considered, bracing and elegantly constructed book, such alternative households are properly recognised as the realms of possibility that they were' Sarah Watling, *Times Literary Supplement*

'There are two images made by Vanessa Bell in Rebecca Birrell's unusual and refreshing group biography of artists *This Dark Country* that struck me. One was a shopping list and the other a sum of expenses scribbled beneath a drawing of her husband. Their inclusion, alongside many more unexpected details, illuminates that for this generation of artists – who were forbidden to draw from the nude – a still life is a portrait, an interior is a landscape and a list is a study. I loved Birrell's brilliant re-apprehension of Rodin's The Thinker through the experience of Gwen John. And her explanation of the magnitude of rooms and importance of room, in these women's lives' Leanne Shapton

'Deeply thoughtful and eye-opening ... This book is a brilliant art-history lesson as well as a window into women's lives. It has awoken my craving for their stunning still lifes of apples, jugs, tables laid for tea, views from bedroom windows, eggs, flowers in vases, and liberated women reading books ... This book is a celebration of all things queer ... The strong-mindedness of these women will knock you over' *Daily Mail*

'Birrell's exquisite knack for storytelling and visual analysis draws you deep into the private worlds of ten women artists. You will be left utterly spellbound by their radical lives and the sheer inquisitiveness of their paintings. A lucid insight into a trailblazing art history – too often overlooked – at the very start of the twentieth century' Katy Hessel

'Asks a provocative series of questions about the pioneering lives of artists including Gwen John, Vanessa Bell and Dora Carrington and then finds imaginative ways to answer them … In a striking act of collective empathy, Birrell brings to life not only the interior worlds of the painters and their work, but also the support network – of female friends and lovers and domestic staff – that enabled them' *Guardian*, The best art books of 2021

'Rebecca Birrell urges us to ask new questions about gender and genre, domesticity and work … At its heart is the challenge of understanding the lives and works of women whose desires and ambitions often demanded secrecy, evasion and ambiguity … She writes convincingly of the happiness John found in being alone, remaining unmarried, maintaining friendships with women, filling reams of paper with her thoughts and putting her time and energy into her art. No less convincingly, she links what she sees as a fascination with repetition with the dread of a commonplace woman's life, such as that to which John had seen many of her friends succumb, not least her brother's wife: endless housework and monotonous labour with nothing to show for it' Norma Clarke, *Literary Review*

'This is a bold, unusual book, filled with archival research, exuberant ideas and a determination to counter misogyny' Diana Souhami, *RA Magazine*

'[I was] captivated by this extraordinary book – stayed up way too late scribbling my astonishment on all the pages' Doireann Ní Ghríofa

'Unprecedented and important … A beautifully considered, timely and invigorating treatise on the co-implications of art-making and home-making' Kate Briggs

'Birrell's prose is sumptuous, precise and bewitching – she responds to works of art and the lives of the people who created them with an equivalent imaginative flourish. I can't recommend it enough' Jennifer Higgie, author of *The Mirror and the Palette*

'[I] absolutely loved it! A beautifully written and important art historical work, *This Dark Country* is a magnificent debut by one of Britain's most electrifying new talents. I cannot wait to read what she writes next!' Camilla Grudova, author of *The Doll's Alphabet*

'Blending biography and art criticism with autoethnography and fictional vignettes, *This Dark Country* challenges conventional approaches to art history … It is a book about attention and where it is paid; it is a work of recovery and reimagining … By envisioning and championing these women's experiments in living, Birrell makes space for possibility. In *This Dark Country*, she lets in light' Eloise Hendy, *Frieze*

'Impressive … There is huge skill in [*This Dark Country*'s] omnivorous, discursive reading of the paintings, letters, diaries and short stories of the period … Birrell reaches effortlessly for apt references … Whatever follows from this author I will read' Hermione Eyre, *Apollo Magazine*

'[A] beautiful, bold new book … explores the desires and ambitions of women artists, moving beyond the frame to reflect lives that rarely fit convention' *Elephant*

'Exactly the type of energetic exegesis art history needs right now … Birrell has a way of making these archival finds come alight, living, breathing, dancing and whirling … I adore this book … In post-pandemic times where our interiors have been our entire realms for extended periods, we can hold this book close as an insight into a way of life in domesticity that celebrates the rich beauty, joy and art of it all' *Arts Hub*

'We have not generally thought of the still life as a radical feminist genre – until now … I loved seeing these paintings through Birrell's eyes' Lauren Elkin

REBECCA BIRRELL grew up in Southport and now lives in Cambridge. She studied English Literature at University College London, followed by Women's Studies at the University of Oxford. She has occupied curatorial positions at the Jewish Museum London, the Department of Prints and Drawing at the British Museum and at the Charleston Trust. In 2018 she undertook a fellowship at the Yale Centre for British Art. She completed her PhD at the Edinburgh College of Art. She is a curator in the Department of Paintings, Drawings and Prints at the Fitzwilliam Museum, University of Cambridge.

THIS DARK COUNTRY

COUNTRY

Women Artists, Still Life and
Intimacy in the Early
Twentieth Century

REBECCA BIRRELL

BLOOMSBURY CIRCUS
LONDON · OXFORD · NEW YORK · NEW DELHI · SYDNEY

BLOOMSBURY CIRCUS
Bloomsbury Publishing Plc
50 Bedford Square, London, WC1B 3DP, UK
29 Earlsfort Terrace, Dublin 2, Ireland

BLOOMSBURY, BLOOMSBURY CIRCUS and the Bloomsbury Circus logo are trademarks of
Bloomsbury Publishing Plc

First published in Great Britain 2021
This edition published 2022

For legal purposes the Acknowledgements on p. 359
constitute an extension of this copyright page

'Orientations Toward Objects', in *Queer Phenomenology*, Sara Ahmed, pp. 25–62. Copyright
© Sara Ahmed, 2006, Duke University Press. Republished with permission of the copyright holder.

Carrington's Letters by Dora Carrington (being held at the Harry Ransom Centre). Copyright
© The Estate of Dora Carrington. Reproduced by permission of the author c/o Rogers,
Coleridge & White Ltd., 20 Powis Mews, London W11 1JN

A catalogue record for this book is available from the British Library

ISBN: HB 978-1-5266-0401-9; PB: 978-1-5266-0403-3; EBOOK: 978-1-5266-0402-6;
EPDF: 978-1-5266-4458-9

2 4 6 8 10 9 7 5 3 1

Typeset by Newgen KnowledgeWorks Pvt. Ltd., Chennai, India
Printed and bound in Great Britain by CPI Group (UK) Ltd, Croydon CR0 4YY

MIX
Paper from
responsible sources
FSC® C171272

To find out more about our authors and books visit www.bloomsbury.com
and sign up for our newsletters

for Catherine Faulkner

Contents

'Often nothing tangible remains of a woman's day. The food that has been cooked is eaten; the children that have been nursed have gone out into the world. Where does the accent fall? What is the salient point for the novelist to seize upon? It is difficult to say. Her life has an anonymous character which is baffling and puzzling in the extreme. For the first time, this dark country is beginning to be explored in fiction; and at the same moment a woman has also to record the changes in women's minds and habits which the opening of the professions has introduced. She has to observe how their lives are ceasing to run underground; she has to discover what new colours and shadows are showing in them now that they are exposed to the outer world.'

Virginia Woolf, 'Women and Fiction'

'The study, the parlour, the kitchen: these rooms provide the settings for drama; they are where things happen.'

Sara Ahmed, *Queer Phenomenology*

INTRODUCTION

On the night of 28 March 1918, the economist Maynard Keynes, driven by politician Austen Chamberlain, arrived at the bottom of a muddy country lane in Sussex. Once the government-issue car had withdrawn into the darkness, Keynes retrieved a painting from his suitcase 'about the size of a large slab of chocolate'.[1] Worried by the artwork's weight, keenly aware of its value, Keynes did not want to risk any accidents on the short walk to the Charleston Farmhouse, where his hosts were waiting for him – amongst them Vanessa Bell – and placed it in a hedge for safe-keeping.[2] The previous day, while war raged on the Western Front, Keynes, a passionate art collector, had dashed to Edgar Degas's studio sale in Paris and purchased around twenty paintings with state funds.[3] As a 'personal reward' for his service to the British government, he bought four others using his own money, the star of which was the small, inauspicious parcel he later marshalled his friends to retrieve from the ground.[4]

The painting, *Les Pommes* by Cézanne, entered Vanessa's life as an aspirational symbol of political power: careful economic scheming and a cultural acumen acquired from the nation's most elite educational establishments brought about its acquisition, but the apples themselves, their presence and potential, transcended this narrow context. 'What can six apples *not* be?' her sister, Virginia Woolf, asked on first encountering the painting.[5] Vanessa's

response to a similar sense of the still life's possibility was to paint her own version, placing the apples explicitly in her own home. While Cézanne's fruit float against a backdrop of opaque colour, Vanessa's are arranged on a patterned china plate, sweet and uneven and shining, fragments of the surrounding interior pushing in from all sides of the frame.

The adjustments were subtle, but in making them Vanessa was asking new questions about the relationship between genre, gender, domesticity and work, and outlining how aesthetics might absorb the ephemeral idiom of the everyday. The result was a deceptively simple canvas dedicated to an alternative analysis of still life. Part of her proposal about the genre's intention and worth concerned emotion and connection – how they might be kindled into being. The thrill Vanessa felt on first seeing the Cézanne is transformed into a broader principle of creation and reception: painting as though seeing the apples' colour, shape and texture for the first time, alive to their intricacies and unanticipated awkwardness, she invites the viewer to see their own surroundings anew. In a dense, vibrant canvas rich with intimations of the private experiences that unfolded beyond it, space is wrested open for shared curiosity, surprise and pleasure.

I'd walked down the muddy lane on which the Cézanne had been hurriedly left, and I'd stood in the room where Vanessa had quietly reformulated that painting's terms, the extraordinary locations becoming quite familiar to me. I'd come to Charleston to research and identify previously unexplored papers and artworks, working in a space that had once been Vanessa's attic studio. During the warmer months it filled with wasps, ladybirds and spiders, and in winter it was submerged in an obliterating cold that left me wearing my coat and hat indoors until dark, watching my breath mist before the computer screen.

What I gathered from Vanessa's apples was not unique to her work. I'd been thinking about how women made art for years and had, through a process I didn't quite yet understand, become fixated on still life – never with some abstract sense of artistic merit, but with a belief in its capacity to produce and accommodate intimacy, an affective power other genres simply could not provide.

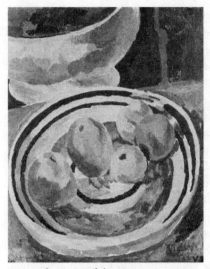

sweet and uneven and shining

Standing before another simple still-life canvas, I'd ask myself again what exactly it was that so held me. In part it was how recognisable these scenes were, how they answered a curiosity about the smallest and most basic components of how some women lived. I'd notice light moving through a window just as it did in a painting; I'd pick up oranges in the supermarket newly attuned to their appearance, trying to see what had so captivated an artist's attention.

In those moments I'd briefly feel my world pressed against that of those women. But identification was rarely the sole aim: the works were descriptive in ways I never could have anticipated. For they were always more than they appeared, these oranges, lemons, sparsely furnished rooms, saucepans, lilies, cups of tea; they were histories of women's lives compiled by way of the objects that bore witness. In still life I began to see a charting of spaces, objects and experiences tantamount to a map of the artists' most tender, troubling moments, and I pored over it, eager to piece together the narratives they held in so distilled a form. Still life took the rough,

raw material of a life and reissued it as compacted, densely coded dramas on the trials of intimacy and of needs hungering at the seams of quotidian concerns.

Through these works I discovered a loosely connected network of women artists who were united by their similarities in ambition, and their shared concerns about gender, creativity and personhood. Dora Carrington, in her often chaotic personal life, struggled to resign herself to the limited roles through which women drew meaning and fulfilment – the roles of daughter, lover and wife all proved problematic. And yet in her creative practice her disinterest in conventional models of success fuelled her playful and uncategorisable art. A high-society hostess dismissed by her contemporaries as shallow and sexless, Ethel Sands painted luminous canvases addressed to the protected life she had built for herself and her partner, each artwork infused with the powerful feelings she so resolutely veiled in her public appearances. For Gluck, gender was an experimental, consuming stylistic and epistemological practice tantamount to a dynamic work of art – subversive thinking which was applied to astonishing experiments in still life. For Gwen John, her art was an intense spiritual undertaking that encouraged explosive connections between painting, writing and desire; if there was a temple for her passionate faith, then it was the spare rented rooms she occupied in Paris and depicted repeatedly throughout her career. Nina Hamnett's paintings were as crucial to her vocation as her flamboyant social performances, each articulating something about the transgressive charge of lone women captivated by pleasure and excess – and indifferent to the promise of the family. Vanessa Bell, meanwhile, abandoned the certainties of a claustrophobic, privileged Victorian upbringing in a body of work that sought to visualise her daring revisions to the basic emotional components of domestic life.

Despite the different paths their lives took, these women were all either queer, or living awry to heteronormativity in some key sense; redefining what it was as a woman to experience love, friendship, coupledom and the family, and dedicating their lives to other women or to queer men. All were immersed within private

cultures resonant with the term 'queer' as Eve Kosofsky Sedgwick seductively defines it: 'the open mesh of possibilities, gaps, overlaps, dissonances and resonances, lapses and excesses of meaning when the constituent elements of anyone's gender, of anyone's sexuality aren't made (or can't be made) to signify monolithically'.[6] Living with queer possibility for each of these women meant dedicating themselves to alternative domestic arrangements, a conviction they sustained even when it meant compromise, or, in its outer extremes, when it risked causing them harm. These women understood with a deepening clarity what they would not accept: the traditional narrative arc of a woman's life; the passage from dutiful adolescence in service to their family to the enthusiastic usefulness of marriage and motherhood. In its place these women defined on their own terms what constituted a liveable life. Drawing on concrete experiences and long-cultivated fantasies, each woman addressed this sudden, electrifying responsibility through experiments in domesticity, attempts at greater financial independence, fulfilling experiences of love that coexisted with professional ambition, bids at self-education – and making art.

What united these experiments was a preoccupation with intimacy: how it felt, what it meant and where it might most passionately flourish. Each of these women wondered what it was to experience enduring love, dwelled over the compromises that might be made in motherhood (only Vanessa chose to raise children) and questioned the relationship between their most intimate bonds and their creative practice. These enquiries could be summarised in a single question: What kind of life, they asked – what kind of selfhood – would best nourish their art?

*

What were the horizons of a middle-class white woman in England in the 1900s? Girls were rarely sent to the same institutions as their male siblings; instead many were schooled in the drawing room by a governess who was unlikely to have been

conventionally educated herself. Young women learnt literature, languages and music, but all in small measure, because the real education was in domesticity itself: how to build an entire existence within a set of rooms, and how to embody the set of sartorial and psychological practices that constituted contemporary femininity; how to remain cheerfully fulfilled in days given over entirely to satisfying others. Without a proper education, there was little chance of pursuing a profession and few other choices besides economic dependence on men: the grinding weekly humiliation of asking for an allowance, and the uncertainty involved, never privy to the state of their own accounts; the subsequent alienation from their most habitual surroundings, knowing nothing in their lives was their own. Tethered in various ways to their father or husband, women remained in the home. What was expected of them was at least in part influenced by the middle-class Victorian feminine ideal, named by the poet Coventry Patmore in his verse novel: *The Angel in the House*. The Angel was sympathetic and charming and unselfish and pure and committed to her household and grateful for the little she had – happy in her absolute submission. Pleasing men was the highest ambition. The Angel never behaved with her own interests or needs in mind.

The respectable archetype of femininity was precisely what Woolf describes renouncing in her bid for artistic autonomy, a juncture that was as much about survival as it was the pursuit of her vocation. 'Had I not killed her,' she wrote, 'she would have killed me.'[7] As the new century progressed, more women were able to do as Woolf did, loosening their ties with an oppressive model of womanhood and seeking out a different kind of self. This was partly a result of their material conditions changing. In February 1918, after years of campaigning, female property owners over the age of thirty – women with a stake in power – were granted the right to vote, initiating a process of change that culminated in the establishment of equal voting rights for men and women a decade later. Through the fight for female suffrage, many women transformed how they saw themselves in relation to the social world, and, through access to political groups and campaign material, suddenly had

the language through which to express their dissatisfaction with patriarchal institutions, as well as their hopes for the future. Losses incurred during the Great War caused a population imbalance that created a surplus of unmarried women: without the deluge of prospective partners that came with coming of age, without proposals to consider and family pressure to endure, the expected course of many women's lives altered irrevocably. Women might now choose to live alone, or to cohabit with other women and, even if marriage beckoned, motherhood was no longer the inevitable outcome of any union. The declining birth rate, the rise of artificial contraception and an increased openness in public on issues of reproductive health meant that family sizes fell by a third between the 1860s and the late 1920s. No longer destined to spend years subjecting their bodies to one pregnancy after another, women had time to engage in forms of leisure and work that had previously been unimaginable. Educational reform meant female literacy increased from around 50 per cent in 1843 to almost 93 per cent in 1891.[8] As a result, women were entering professional life in greater numbers, taking on roles in schools, hospitals, offices and shops. Women were now making their own money, and without dependants, they were free to spend their disposable income on newly available pursuits, such as magazines, cinema, radio and sports. Even changes to women's fashion towards more androgynous styles radically altered public and private perceptions of gender and sexuality.

However, for all the personal, social and professional gains experienced by middle-class women in the new century, many restrictions remained, and the continuing plight of women artists reflected these partial freedoms. Women were painting, modelling for each other in their own studios, networking at parties, commissioning portraits, circulating advice and sharing their experiences, critiquing one another's work, even purchasing one another's paintings. But there were few concrete rewards accompanying these advances. Many still shared the verdict of Charles Tansley in Woolf's 1927 novel *To the Lighthouse*, that: 'women can't write, women can't paint'.[9]

Partly this abiding belief in women's inferiority as artists was because of what they were permitted to paint. Still life, floral subjects in particular, became the remit of artists who, because of their gender, were denied access to essential lessons on anatomy. They excelled in these representations – women in drawing rooms across the country perfected the likeness of a single petal – but for artists who were serious about their craft and eager to professionalise, it was not enough. Accusations of amateurism could never be meaningfully thrown off if women remained unable to draw the human form, without which none of the higher genres (religious or history painting or portraiture) could be attempted. Despite entering art schools in increasing numbers, women found themselves painting more or less the same subjects as their forebears under the same aegis of politeness and religious dogma. Some advantages were enclosed within the practice of painting still life: for women without the time, money or confidence to hire models or occupy a studio, its subjects were readily available, and once domestic duties called, the objects were small enough to be stored (or concealed) with ease. They were convenient and they made artistic work possible in challenging circumstances, but still life largely continued to represent a form of failure, bondage and thwarted ambition. Women's skills flourished only to hit a wall, their impact on broader culture was negligible, and the paintings themselves were often forgotten about, or destroyed. As Woolf has Lily Briscoe remark of her own artistic efforts: 'it would be hung in the servants' bedrooms. It would be rolled up and stuffed under a sofa.'[10]

Women remained under-represented in galleries, and if space was secured, then their work elicited lower prices than that of their male contemporaries and meagre critical coverage in the press. Like Gwen John and Vanessa Bell, they were overlooked in favour of a male sibling or partner; or like Ethel Sands, they were belittled as amateur by their peers; or like Dora Carrington and Nina Hamnett, they colluded in their own invisibility out of disinterest in the established symbols of success; or like Gluck, their gender nonconformity attracted more sustained attention than their art. Confined to footnotes of canonical accounts, remembered only as lovers or muses, women's work was not only denied serious attention in their time, but continues to struggle for status today.

*

In her 1971 essay, 'Why Have There Been No Great Women Artists?', Linda Nochlin argues that 'the white Western male viewpoint' has wholly determined the criteria by which we judge the value of art, casting greatness in its own image. Gender and genre were complexly intertwined in these assumptions. Still life by women had the additional problem of struggling for status within an academic hierarchy that established merit on a sliding scale in which it ranked below landscape and portraiture, and was eclipsed by religious and history painting. For most men the other genres had a clear ethical purpose, but what higher message did still life – the genre of painting dedicated to the representation of ordinary objects – carry? Rather than answer this question directly, women produced scores of paintings, and even without their sharp self-consciousness, their manipulations of the form, their inventiveness with tradition, their bulk was message enough in itself.

From its origins in northern Europe in the 1600s, still life by male painters occupied studios that reproduced elements of domestic space while wholly sanitising it of the ugly, lowly and uninteresting spectre of femininity. A few gleaming objects – no mess, no emotion, nor any trace of function. The planning and organisation of where things were bought, stored and eaten did not matter. Instead, food articulated wealth, or mapped the trade routes taken to the table; in darker moods, possessions spoke to the brevity of life. Painterliness was more of interest than purpose: note the stippled surface of a cucumber, the frills of cabbage leaves like petticoats, or the cut melon's study in contrasts.

For women in the early twentieth century, still life remained a medium through which to explore aesthetics and politics, but to this established repertoire they added an exploration of the uneasy relationship between the public and private spheres, gender and value, lived experience and aesthetic form. The domesticity these women's paintings took as their subject had once been an instrument of oppression, precisely the cause of their careers as

artists being curtailed. Yet on canvas, a kind of reversal occurred. The power to define the values of the home no longer came from without – the patriarchal institutions that wanted to preserve women's subservience – but from within. A new moral universe was founded, constructed by women and circulated by their creative work, with an emphasis on freedom of thought, hope and a suddenly boundless aspiration. At the same time, and through an innovation that their forefathers never conceived of, still life became a repository for daily experiences, a way of summarising the diverse parts that made up their lives.

Women's experiences, their defining passions as well as their more humdrum certainties, had been censored for centuries, and not just on canvas. Unless you were a woman undressed, you were invisible, and if you were a woman undressed, nobody asked: Where did this woman wake up? Where did she leave her cup with dregs of tea from the previous night? What did she hurriedly make for breakfast, conscious of the time? What thoughts possessed her as she pulled on a crumpled skirt, and buttoned her blouse? What talismanic objects did she touch before leaving the house, hoping for luck, a day blessedly different to its precedent? To produce paintings drawn from the rooms in which your entire life unfolded was to address these urgent questions.

*

In one of Vanessa Bell's sketchbooks, there is a shopping list in which each ingredient is stated – stout, oysters, salt, lemon, orange – and struck through with a line indicating their purchase.[11] The items are at once present and absent – the list functions both as a verbal still life and a kind of diagram of the inner workings of the form, celebrating the presence of things that have long since perished. Part of the magic of still life is an awareness of matter's ephemerality, how time has been halted or reversed on canvas, as well as a kind of mediumship in which obsolete objects are brought back to life, made to speak through the scored-through line. As

in Vanessa's list, in still life the food is there, but marked by our
knowledge of its vanishing.

present and absent

What Vanessa's list also brings to mind is what still life conceals,
or what the form always inadequately attempts to strike through.
In Vanessa's household, those with the authority to write the list
differed from those who paid for the shopping, and differed again
from those who actually went to shops, bought the food, carried
it home and were later tasked with cooking it. While their gender
and sexuality may have positioned these women at the margins as
artists, they each to varying extents benefited hugely from wealthy
upbringings, and enjoyed class privileges that connected them
however indirectly or unconsciously to institutions that promoted
imperialist, nationalist and racist agendas.

Vanessa's marriage to Clive Bell, the son of an industrialist who
had made his fortune from coal mining, meant she never wanted
for money and kept servants throughout her life. Ethel Sands, the
daughter of American socialites, and Gluck, the heir to the Lyons tea
shop fortune, were wealthy enough to paint without the pressures
of professionalisation. For these women, their relationship to
possessions and accommodation was straightforward, each entering

their lives without friction, urgency or a sense of the conditional – all of which inevitably had a profound effect on their creative work in general and their still lifes in particular. Dora Carrington, by contrast, came from a suburban lower-middle-class background that provoked the derision of members of the Bloomsbury Group. She was dependent on the financial stability of her closest friends for her own. Gwen John rejected her own middle-class upbringing and spent her entire life in spartan accommodation, frequently unable to dedicate sufficient time to painting due to the necessities of wage labour. Nina Hamnett occupied a similar position, relinquishing the comforts of her childhood for a life that was as freeing as it was punitive, taking modelling and teaching jobs to stay afloat, occupying a string of squalid rented rooms until her death.

These women were all white, and with the exception of Gluck (who was Jewish), were all raised in ambiently Christian households, instilling in them a form of complacency which engendered casual racism – discernible in depressing public statements as well as private reflections – and in the case of the Bloomsbury Group, made space for anti-Semitism. While Vanessa and her circle were beginning to question the violence meted out by the British Empire, the brutal inequities of colonial power, their everyday behaviour often did not sustain these beliefs. In other words, these women's work was complexly intertwined with their experiences of marginalisation and privilege alike. These women were courageous, full of a bold conviction to live otherwise, but they were also conflicted and complicit; what was radical about their work was often undermined by their myopic politics and their enduring attachment to their privilege. Being around them for any length of time involved a keen attunement to this dissonance, to mortifying weaknesses and dazzling apathies, to the troubling, inscrutable and contradictory.

These women's lives did not yield the simple narrative of triumphant heroism that I perhaps unconsciously wanted from them when I began researching this book; they were (as most lives likely are) defined by their disappointments and errors of judgement as much as they were by their more palatable or radical interests and achievements. Yet it was out of this refusal to valorise,

a state of unease and punctured hope and complexity, that their work began to articulate more.

<div align="center">*</div>

Some of the women described here pursued their vocation and ambitions under more trying circumstances. Perhaps they lacked class privileges or cultural capital, meaning they could not access the networks that would have encouraged their practice and could have made their work more commercially viable; or their aesthetic was out of step with modernism, modest in its aims or backward in its style, making it unremarkable to their peers and later invisible to art historians; or they had little interest in exhibition or sale; or they made drastic mistakes choosing a partner; or they suffered more keenly the grip that misogynistic ideology had over everything from the art world to the medical institution. Winifred Gill, Edna Waugh, Mary Constance Lloyd and Helen Coombe were all to varying extents unable to make new and radical lives out of the given norms: committed to their art practice with little external praise or success, they are almost always omitted from accounts of modernism. The fleeting presence of these women, shadowy counterparts to my subjects, could only ever be a partial antidote to their erasure from history. Their experiences should not, however, be forgotten. Their choruses of warnings belong here as much as the stories of success.

<div align="center">*</div>

This is not a standard group biography largely because the writing of queer lives demands a queer form. With its emphasis on familial inheritance and personal coherence, channelled through the standard arc of birth, professional success, marriage, reproduction and death – what is known as the 'cradle to grave' approach – the traditional biography reproduces prescriptive ideas

about the self that have been forged through centuries of patriarchal thought. Such a form is certainly ill-suited to lives 'unscripted by the conventions of family, inheritance, and child rearing' – what Jack Halberstam describes as the 'strange temporalities' and 'imaginative life schedules' of queer time.[12] Instead of a single, decisive, comprehensive narrative, this book offers a series of moments in these women's lives in which the emotional issues and artistic practices that possessed them for decades were condensed.

Besides, so much of what I included was determined by the material at hand: some women left behind more than others. I wanted to somehow preserve the uneven texture of the available archive material, the simultaneous intimacy and evasiveness of the sources, as well as my attempts to write through its obscurities. Archival practices and historical narrative alike have long been shaped by the most powerful, and so the stories of those on the margins have been judged subversive and withheld, or dismissed as unimportant and indifferently erased. And so, for the potential biographer, to borrow José Esteban Muñoz's warning, 'queerness has an especially vexed relationship to evidence.' Some queer women only sought to hasten along their own disappearance, making themselves complicit with these practices, destroying all trace of their existence. With Muñoz's assurance in mind, other forms of interpretation emerged in my analysis of the material, and I learnt to put my trust in the alternative path they charted: speculation, fantasy, hope, empathy – emotional experiences united by possibility.[13]

I did not approach the archive with any a priori assumptions about these women's sexual identities; as Muñoz stresses, those criteria in the context are not only futile, impossible given the underlying motives governing the archive, but insensitive to all the diverse information, identifications, attachments and affects that can be drawn from obliquely queer material. Instead, documenting these women's lives has meant following Sedgwick's model for a form of close reading – or what she terms 'overreading' – which aspires to 'make invisible possibilities and desires visible; to make the tacit things explicit; to smuggle queer representation in where it must be smuggled'.[14]

Which is to say that I was always more interested in possibility than proof, and the practice of compassion and curiosity rather than the imposition of a pre-established narrative. I was not interested in using the artworks and archival material as direct transcriptions of these women's inner lives, texts capable of articulating definitive truths about their experiences, seeing them instead as mediums for thought that invited me to think and feel with them.

This loose and intuitive interpretative method had other motivations. I was reluctant to prescriptively align artworks with archival material, to transform them into explanatory frames for one another, in part because of the obvious dangers of reading women's art through their lives. While men are free to range outside the purely empirical, women remain penned inside the same interpretive cul-de-sac, forced to have their work confess only to their feelings. This is how women artists continue to be excluded from histories of aesthetic movements and dominant configurations of the canon: if read as a chronicle of their lives rather than an investigation into the universal principles or theoretical paradigms that shape artistic endeavour, then their work will always be considered marginal. To me this argument rests on a strict divide between personal experience and theoretical knowledge, a boundary which queer and feminist thought has revealed to be more porous and generative than once assumed, if not collapsed altogether – a tired and irrelevant relic of Cartesian dualist thought. I see no reason not to embrace both.

Throughout the book I read art through a lens that is attuned to affect and everyday narratives, the anecdotal and the privately mythological, making use of the documentation of those experiences in letters and diaries, as well as to more speculative and theoretical avenues, mining texts and objects for ideas that might not necessarily have been in mind during their conception. What interests me now is not the closely watched and carefully cited – the more concrete interpretative connections between life and art – but how emotion circulates, how feeling transcends particular people, places and periods, and makes itself known to others. Different questions began to drive my research: What occurs between people and paintings? What forms of recognition,

sustenance and resistance can a painting – even if only partially – propose to readers and writers, women and queer folk and whoever else finds a part of themselves met in the uncertain promise of a work? I offer the stories and images that make up this book as a coming together of some possible answers.

CARRINGTON

I could begin with Virginia Woolf's description of her, the woman who arrived in a flurry of chatter on the arm of an old friend one fresh spring afternoon, desperate to make a good impression, despite having hardly slept the night before – a party having captivated her attention and confounded her best intentions until well past five that morning. She was talking so much and so quickly her host could remember little of what was said in the days after, but did recall the gloom of the men sitting in the background, a contrast forged through the newcomer's lightness of spirit.

'She was apple red and firm in the cheeks, bright green and yellow in the body, & immensely firm and large all over.'[1]

I had to read Virginia's description of Dora Carrington a few times before I understood it, and saw that it was odd, but not exactly unflattering. The bold colours address Dora's charisma, her heightened presence, and they announce the possibilities Virginia invested in her youth and vocation. Dora is a bowl heaped with ripe fruit, less a woman than the subject of a still life. A way of asserting the primacy of her artistic identity, the remark also displaces her body into the botanical world, and in doing so asserts the irrelevance of femininity in defining Dora. Virginia understood – she was ambivalent about her body too. Dora surely shared her dreams of an androgynous mind.[2] Virginia would be more supportive of Dora's art practice than many in their circle.

Or should I say Carrington, the self she made when starting at the Slade. She dropped 'Dora', pulled breeches over her legs, regarded herself in the mirror (not enough), cut off her long plait of golden hair, enjoyed how it looked with her crooked nose and piercing blue eyes, and endured the stares.

Large, vibrant and solid: there is a muteness to Carrington here, as though she were a modernist sculpture, communicating solely through colour and form – an error belying her most compelling qualities, which Virginia later recognised, correcting herself. Carrington's letters were, she claimed, 'completely unlike anything else in the habitable globe'.[3] Whimsical and rapacious conveyors of everyday life, the letters are at once confiding and reticent, filled with spectacular performance and skilled evasion, as elusive and uncategorisable in tone as they are in style, strange amalgams of text and image, composed of sentences snaking all over the page, punctuated by doodles that corroborate or playfully undercut the written narratives. In them Carrington is herself, and she is absorbed in activity – illustrations follow her walking, reading, cooking, gardening, dancing, sewing – and vibrating with pleasure even when drawn at rest or asleep. In them Carrington is in the midst of transformation: she is a centaur, a purring cat, an elderly woman, a monstrous creature bent over in a rage. When Carrington wrote she rarely remained with the word alone; what she wanted to be and to say were always in excess of the phrases at hand. Words themselves are treated with a lightness, a lack of reverence; words are misspelled, their meaning altered to suit her aims, crossed out and rewritten, opened up and their contents dragged out; words are mined for their visual properties, equally drawn as they are written. Carrington was not bound by the strictures of the form: there is little heed to etiquette, nor to the obligation to accurately record events for posterity. Unsentimental, daring and incisive, the letters are sites of artistic experiment, powerful mediums of fantasy: in them Carrington both affirms the fundamentals of her character – its unbridled curiosity and soaring energy – and summons up a different, more complex self.

What did Vanessa Bell initially make of her?

At first, not much: 'The short haired creature you may have seen at Ottoline's parties.'[4]

She was a frequent guest of Lady Ottoline Morrell. What did she think?

'She is attractive as a wild shaggy Exmoor pony is attractive.'[5] A nod to Carrington's adventurous spirit, her love of the outdoors, and like both Vanessa ('creature') and Virginia, Ottoline's remark is quick to state Carrington's distance from gender norms. Carrington slips out of her body and into nature, shifting from apple to animal and back again.

But it is true that Lady Ottoline was not exactly fond of Carrington. Disagreements about sex, fraught summits in the vegetable patches, gossipy dismissals in her memoirs. Ottoline wants to stress Carrington's inelegance, her crudeness, her wildness – qualities that made her unsuited to the social rituals that defined life at Ottoline's stately home, Garsington Manor.

Think of the often-reproduced photograph of Carrington as a living sculpture in Ottoline's garden. Trees part to declare her presence, and the perspective positions the viewer as though crouched below, observing a minor god revealing herself to her mortal subjects. Hair grazing her cheekbones, a helmet of polished stone; underneath it her body stretched with balletic ease. There is nothing solid about her: she is lithe and moving and soft. You can feel the air prickling her skin, the strain in her muscles, the ache she would experience later.

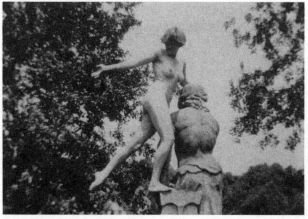

wild, shaggy, short-haired creature

Such confidence, such resilience and poise. And yet, 'She seemed at this time very unsure of herself,' observed Lady Ottoline. And? 'Although she was apparently very frank, I felt that she was really excessively timid and afraid of being sincere,' she went on.[6] The ambivalence Ottoline observed had a clear source. What compromised Carrington's self-confidence and comfort amongst friends and strangers alike was precisely what the photograph so closely identifies her with: her body.

Let's ask Mark Gertler, who loved Carrington for over a decade. 'A beautiful flower encased in a form of gold.'[7]

An image that evokes an earthiness and glamour, a heady blend of nature and artifice, it is lovely – if a little too conventional for the woman Carrington was. But this was not all Mark had to say about her. All the bitter, coercive accusations he directed at her once she tired of his attention. I won't reproduce them.

Remain with the judgement of women. Nina Hamnett was so struck by Carrington that she emulated the key parts of her self-styling: the shingled haircut, the men's trousers, the air of disregard. By her breathless, admiring account, 'she was one of the first women in England to cut off her hair and was very much stared at as she never wore a hat'.[8]

What about Lytton Strachey, who Carrington loved passionately for nearly two decades?

I wanted to find a single sentence that could account for Lytton's relationship with Carrington. Some blazing analysis – smuggled into a letter, a dedication in a book, a remark remembered by a friend – the essence of their passion distilled into a few charged words. I'm still looking. The letters charm, and there is affection there, but there was always a cautiousness in Lytton's tone, a facetiousness whenever real affection arose, what Carrington in a darker mood described as his 'unreality and coldness'.[9]

For Lytton Strachey's biographer, their bond was mostly practical, with Carrington a generous, doting and necessary disciple of his genius.

'His housekeeper, his confidante, his nurse, his messenger, his loving friend.'[10]

Such a dim view of her possible use. This was the same woman who won a coveted scholarship to the Slade, who, as a student, then repeatedly won acclaim for her work: four prizes over the course of three years.

I knew how I liked seeing Carrington. Carrington on a motorbike traversing the Sussex countryside – did she ever take the bike out there? – or speeding around Regent's Park, for she definitely did that, 'tearing quicker and quicker', forging a path through shocked pedestrians.[11]

'But to look at? Was she beautiful?'[12] Bunny Garnett asks the question at the beginning of his introduction to her letters, answering them gleefully in the negative. What else matters?

As a corrective to Bunny's lack of imagination – his inability to see the passions that shaped Carrington's life and self – settle next to her in bed as she read Dorothy Wordsworth's journals, moved by her spiritual intensities, or Marcel Proust's *Swann's Way*, pausing to note down sentences that reminded her of a lover.[13][14] Listen to her sermons on John Donne, who recurs throughout her correspondence as an artistic touchstone, or William Blake, his visionary worlds that chimed so closely with her own, and who she spent years aspiring to imitate.[15] Or stand with her admiring El Greco and Goya. To be beside Carrington then – and at times reading her letters it felt possible – craning my neck towards a scene of drama cloaked in shadow.

Take the motorbike back to its garage, and instead place Carrington on her white pony, Belle. A muddy pair of jodhpurs, late afternoon, trotting along the crest of a hill, watching storms break in the distance.

Best to ignore the conclusions drawn in a recent review of her letters: 'Intensely manipulative and deluded.'[16] Accusations laced with cruelty – to say nothing of the eagerness to pathologise; they recur in accounts of these women's lives. Like so many of her peers, Carrington's talents and their place within a broader cultural movement have been obscured by tired misogynistic tropes. Digs at her character and her appearance, speculations about her mental health: these claims do not even pretend to engage with

Carrington's art, and merely reflect society's deep and pernicious hatred of women, especially those who – unmarried, unproductive, unwilling to compromise – dare live in opposition to social norms.

Carrington remained on the margins as an artist in part because of how her upbringing in suburban Bedford distinguished her from her refined, metropolitan Bloomsbury peers and – no doubt relatedly – because the artists that surrounded her could not see the value of her work, which meant she was reluctant to exhibit. History has all but forgotten her art; Carrington never appears in surveys of the modernist period.

I could begin with a painting.

'Since I last wrote I have been starting some work,' Carrington told Mark Gertler in 1915. 'I am just going to do a still life, in green, yellow, & orange, of apples, & some little orange pumpkins.'[17] The still life, which strikingly echoes Virginia's description of Carrington, endured only as a description, and as such it was typical. The tension between the visionary and the concrete, what existed in her letters and what unfolded in her life, was the engine that at once drove Carrington forward – so much of who she was developed in the boundless possibility of imaginary worlds – but which as a professional prevented her from ever achieving much commercial success. Whether they were only ever hypothetical, or whether they belonged to a canvas that was lost or destroyed, the apples capture the contrary forces that made up Carrington's identity: the woman who was idealistic, robust and fiercely creative, and the artist who found the particulars of her practice – the actual making and selling of work – impossibly dull and restrictive.

Female Figure Lying on Her Back

From her early years as an artist, no still life survives. Carrington's earliest known works are nudes completed in the period after she enrolled at the Slade in 1910. A woman is in the midst of an

awakening: with sheets meticulously rumpled beneath her, she raises her arms as though stirring from sleep, and it is her skin that registers the transformation, moving through rose and yellow and milk, the colours of rising dough. Her cheekbone and shoulder and breast are echoes of each other, soft half-circles highlighted by a shivering white light, effects which lead the eye to her navel, the palette's buttery centre, the warmest spot. Amongst all this beauty, touches of awkwardness: the blunt rendering of the one visible foot, the clumsy foreshortening of the arm held aloft; the thigh fixed at an uncomfortable angle, and her face turned from the viewer. Whatever emotional process we are witness to in this work, the feelings that drove Carrington as she painted it, these upsets in the execution and arrangement of the composition suggest that there is more anxiety to it than is at first revealed.

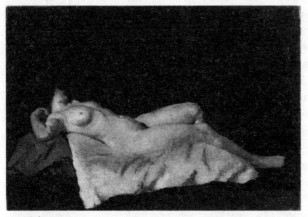

an awakening

Carrington arrived in London the year that Woolf claimed 'human character changed'.[18] What she meant was that the world was transforming around her, across social and cultural forms, and reshaping the selves of her peers in the process. The assertion was a little puckish, self-consciously broad and rhetorical – which humans of what social class were meaningfully affected? – but Carrington's character certainly found itself broken and reborn.

She was free from her parents. Her father she loved with a simple fervour she sustained until his death, but adolescence was spent plotting an escape from her mother, nagging at Carrington for what seemed like years from a tiny sludge-coloured lounge in Bedford. Her mother was a set of lace curtains. Her mother was an indrawn breath. Her mother was a pile of folded cotton dresses on Carrington's bed. Her mother was a cupboard in dark glazed wood. Her mother was anxious, run aground by private disappointments, like many women of her generation – she had been a governess, married late to an older man whose higher social standing wrought subtle agonies from her for decades – meaning her love for her daughter was doomed to be expressed only as harried interference. Her mother would miss her.

Though no such correspondence survives, Carrington probably wrote her parents polite and functional letters from the respectable hostel they had chosen for her on Gordon Square. Less clear was whether she signed these letters with the name she dropped nine months in, writing the D, the O, each letter in turn, with a tentative hand.

In her first weeks in London, Carrington met Barbara Hiles, Ruth Humphries, Alix Sargent-Florence and Dorothy Brett. They would transform one another as women and artists. Their hair was the first bit of femininity they could shed, and they wore it as short as possible, doing the work of shingling themselves, each inch taking them further from their mothers and closer to the future, earning them the nickname 'the cropheads'.[19]

They dined at the Eiffel Tower Restaurant, later immortalised as the meeting place of Vorticists in a 1961 painting by William Roberts. Roberts fills the restaurant with men, crowding the women out of the door and into the margins of the artistic production the painting records, obscuring how, for many women, amongst them the writer Nancy Cunard, the restaurant was, as she put it, 'our carnal-spiritual home'.[20] Carrington and her friends felt as much, and they held the coupes of champagne that Roberts dyes a noxious yellow, an opaque and lurid colour which is nothing like alcohol, as though he had the patrons ingesting paint, insisting

that art itself was the intoxicant. The women talked amongst the potted ferns and the simply laid tables until it grew late, and if they didn't end up dancing in the rooms of the painter Augustus John, there was always somewhere to idle away a few more hours before dragging themselves home.[21] After years deprived of serious conversation, conscious always of tempering their emotions, never asserting their opinion one way or another, forever striving to be judged acceptable by their audience, these women were now free: to be loud, impassioned, impulsive, inquisitive. They accepted invitations to dances at Lady Ottoline's house, and bathed in the old fish pond in borrowed swimsuits the morning after.[22] They stirred on hard carriage seats on a train to Scotland, listened to the shrieking of the horns in the dark, and later ran in their nightgowns amongst the elms by moonlight.[23] They discussed their admiration for Albrecht Dürer at the British Museum, striding through the galleries towards the print room, excited to spend an entire afternoon studying the Old Masters.[24] They drew one another, and critiqued the results. They went home to their interconnecting hostel rooms and dreamed about the future.

Carrington checked her purse to find her allowance dwindling. As for her friends, their anecdotes were optimistic and frictionless, and took place in lavish country estates and European cities, presuming Carrington had some familiarity with the glamorous, nomadic lifestyles of young women of their class. Carrington could talk about her childhood in Bedford, but in her letters she hesitates over the realities of life there, embarrassed at the banality of town hall dances and arguments while shopping in town with her mother. Carrington took commissions and pupils to stay afloat, but it was rarely enough. The holidays meant packing a bag and returning to Bedford. Her lack of freedom could be summarised in a daily ritual implemented by her domineering mother. Intercepting her daughter each time she left or re-entered the house, her mother would ask for every last detail of her afternoon, attempting to expose even the smallest transgression, with Carrington answering with perfunctory monosyllables as she marched grimly up the stairs.

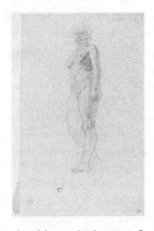

Dour summers were worth it for what Carrington experienced each autumn on returning to the Slade. Observe Carrington on a low stool before her easel, and the notoriously exacting Slade instructor Henry Tonks stalled before one of her drawings. He would have studied her pencil drawing of a woman, her thighs outlined in thicker charcoal, a show of where the woman places her weight, darker where the work of stillness deepens, and light pencil hovering over her shoulders which gives form to their trembling, all of her poised between control and release, a hint at the tension and pleasure of the Life Room.

These drawings show the preliminary investigations into anatomy that underlay the making of *Female Figure Lying on Her Back*. The painting is in fact a composite of drawn and painted matter, ideas and deeds, failures and successes, as it represented a revision to an earlier nude that Carrington had painted over, efforts which succeeded in securing her second prize for Figure Painting in 1912.[25] Another nude, completed the following year, and which won Carrington first prize in the same category: the woman has roused herself, the bed is gone, and she is standing with her hands on her hips, her back to the viewer, light nudging her shoulder – but she will not flinch – her face still unknowable. Together the works disclose a loose narrative of growth and endurance: what the young artist has overcome and cast off, what comforts or assistance she has learnt to live without, how she has reoriented herself in her chosen space, and amongst those developments, what parts of her self will not be ceded.

Decades later Vanessa described these nudes with unusually enthusiastic praise as 'remarkable', 'really very good'.[26] Carrington's time at art school was at once a significant coming into self, and an auspicious start to a possible career.

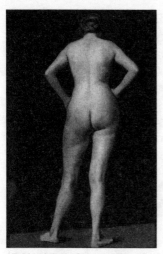

ideas and deeds, failures and successes

Incredible to think when looking at these works of the disgust Carrington felt towards her own body at that time. 'Hanging flesh', was how she saw it, merely 'female encumbrances'.[27] Judging from her letters until the end of her life, those feelings would endure. That rush of horror and alienation – where did it go? One nude has her face obscured entirely, while the other reveals little more than a silhouette. These gestures appear to lend privacy to the nude's staged exposure; they are an extension of sympathy for the women, a collapsing of the distance between subject and object so commonly preserved in the history of the nude. However, over time, I came to suspect these erasures marked the presence of shame: the women turn from our gaze, anticipating its violence, bracing for the inevitable blow.

Less straightforward friendships blossomed with men. Mark Gertler, elfin and confident in their class photo at the Slade, staring seriously into the camera. Carrington is half-smiling with her arms gracelessly at her side: the deliberate inelegance of the pose announces that she is no longer a girl being steadily pressured into the cage of normative femininity, but her own woman, an artist foremost. This distinction would prove a problem for Mark.

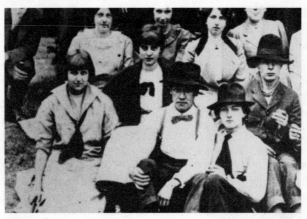

an artist foremost

Mark's portraits are sympathetic, interested, softly probing the selves they represent, and suggest a deference for women profoundly at odds with the relationship that developed between him and Carrington. She was flattered, impressed by Mark's work, but was soon alarmed at the fervour of his desire, the doggedness with which he wanted to possess her, responding to his commands with good-humoured dismissals that are suffused with anxiety. What the letters between the pair perhaps trace most vividly is the naivety with which Carrington accepted Mark's attention, her subsequent failure to protect herself, and her willingness to renew her trust in him no matter how much it was exploited. A disastrous encounter in his studio, or an argument over dinner, the same ugly subject arising again and again: her refusal to sleep with him. Each time the familiar row flared up the letters stopped, but it was never long before they started up again, their tone contrite; met with Mark's silence, they plead. Painted in 1916, one of Gertler's most celebrated works is of a carousel. For all its dark, frightening power, its remark on Europe's descent into chaos during the Great War, it is also an oblique but startlingly accurate vision of the repetitive and fruitless machinations of his emotional life with Carrington. Declarations and accusations; fights and reconciliation; groundlessness and

disorientation; round and round, a stuttering loop for the twelve years of their friendship.

Ambitious and uncomfortable with her gender, for Carrington sex was not about pleasure or connection or even curiosity. So much stood in the way of her own desires, not least the risk of pregnancy and childbirth, and the sudden, finite end that meant for her art. There was no question that she would refuse Mark, and it wasn't personal; she hoped she might avoid sex altogether. If anything, Carrington's disagreements with Mark only confirmed the ideas she had absorbed about the incompatibility of femininity and any kind of desire, proving the irrelevance of her own needs, how sex was solely about men's persistence and women's eventual begrudging acquiescence.

In Carrington's early nudes, the value of the female body as a site of aesthetic contemplation and sexual desire feels at times absolute, the work itself is so assured, and the women so imperious in their substance and heft. Here was a woman looking at herself without the damaging cant of misogyny, an approach that was still so original in art, the thrill of which is palpable in the studied seriousness and force of the nudes. But there remains a shadow of alienation, submission, concession: the remote expression; the eyes trained towards an elsewhere, unknowable. The withholding presence of the woman, her only partial comfort in the scene that so celebrates her, reflects something of the losses that Carrington incurred in her relationship with Mark, the doubt it implanted deep within her about her body – what it was for, who had power over its actions – and what she might gain from sex or love. The damage would prove difficult to recover from; some parts of Carrington did not survive it.

Mark's 1912 portrait of Carrington depicts a fairly standard male artistic fantasy of a woman materialising through the painter's godly genius, reborn into a separate realm of pure, idealised femininity. Carrington wears a deep blue tunic, it billows over and conceals the body she so resented – is that why she's smiling? – and she's floating mid-air, set in the manner of a Raphael Madonna against a backdrop of blue.

And yet Carrington had long felt herself to be composed as Mark
has her here, cleaved in two, split between her feelings and physical
responses. 'You are very fortunate not to have a head separated
from your body,' Carrington wrote, supporting the statement with
a diagram, a hurried and unserious self-portrait, which partly for
its off-handedness is a revealing document on her perception of
the relation between her mind and body. Above a lopsided torso,
and arms of uneven lengths which end in ragged little fins, her
head floats above her neck, the cut so clean it looks done with a
guillotine.[28] Carrington's doodle has her inner conflict as equivalent
to an execution, a kind of public shame and punishment; it marks
her as mutilated, monstrous and unalive. But Mark sees it otherwise.
Carrington transcends the body as any holy object might; she's an
icon, powerful yet prettily feminine. In costuming Carrington as
the Madonna, Mark at once acknowledges the knottiness of how
embodiment felt for her, revealing the mutual understanding that
bound them however destructively while also attesting to the
idealisation of her that made their relationship so difficult.

Mark went on to impose a 'wildly chaotic' atmosphere on
Carrington's life for years, the sprawling details of which reflect
the same banal insecurities and hunger for power, all of which he

how embodiment felt

only desired with such violence because of his own unhappiness, an alienation born out of his own marginal identity as a working-class Jewish artist.[29] Nevertheless, that chaos is not of interest. Mark's story ends here.

<div align="center">*</div>

After a frustrating period at home once she graduated from the Slade, and a brief spell in a small, dank, mice-infested studio in Chelsea, rented out of a desperation to be anywhere but Bedford, in 1916 Carrington negotiated her way into a shared house at 3 Gower Street. Carrington took the attic, her friend Brett the room below, and the writer Katherine Mansfield the bottom floor. It was £9 a year: affordable. Occupied by a mixture of artists and writers who required stable accommodation, and saw – like Carrington – a clean room as a kind of salvation, and who together were drifting towards a better future, it was nicknamed 'The Ark'.

Each day was a succession of ecstatic social encounters. Shrieking at the top of her voice with Brett over tea, bumping into Lady Ottoline deep in conversation with a pearl-stringer – muddling through a few formalities before rushing off, aware she was out of favour – then bursting into the restaurant Isola Bella to borrow half a crown from Aldous Huxley before rushing out again.[30] The evenings were filled with concerts, readings and parties, all material to be plumbed for meaning in the hours after amongst her new friends. 'We talked late into the night together,' Carrington wrote of Katherine before she moved in, 'what fun we will have in Gower Street,' and her prediction proved sound: the women sat on one another's beds in the morning to recount stories from the evening prior.[31]

But what Carrington really loved was the solitude. 'I wish sometimes I could bolt the door and live in here for days and days,' she wrote rather pointedly to Mark, 'and not get disturbed by all the outside world of people.'[32] She longed to be left alone with her ideas. The window open, the sounds of the city drifting through.

A few hours reading Marlowe. Her pencil, drawing book and looking glass until it grew dark.

Securing a decent room and building a social life around other creative women was exactly the sequence of events she had wanted, but Carrington continued to feel unsettled and insecure. Money was short, and her preoccupation with its predictable dwindling was felt as a turning away from life, a condition Carrington summarised to her brother through a cartoon of herself marooned at the top of a tree. Carrington draws herself with her head in her hands, sitting amongst the leaves of a palm, teardrops springing from her eyes, at a remove from the social world, in a sad and desperate position where, even so, the only way is down. Carrington was industrious, going to job interviews day after day and waiting for hours afterwards for the inevitable rejections, determined not to end up eating 'twopenny soup packets, meal after meal in a smelling studio off Brompton Road' as she had in the months before.[33] A detachment, a steeliness, a reserve which Ottoline later mistook for shyness, became Carrington's necessary armour. 'I had acquired such an art of self protection,' she wrote of that time.[34]

Strength of that kind proved urgent, as the Gower Street room did not last much longer. Ever resourceful, Carrington moved to her friend Alix's flat on Frith Street, rooms with a 'vile green paint over everything', but it was another short-lived arrangement.[35] War increasingly made even the most basic aspects of living fraught with terror, wakeful nights during the air raids huddled together in the basement of safer houses. Within this context, the absence of still life was an emphatic statement on Carrington's limited options, her dire conditions. There was her family home and all its inevitable angst, or there was her life in London, which for all its glamour and interest meant trusting everything to chance, accepting rooms that were barely habitable, reliant upon the questionable morals of landlords and the flux of international politics. To place these spaces and objects on canvas was an unnecessary reminder of everything Carrington desperately wanted, but which none of her achievements or schemes brought her closer to: a stable room

of her own. The prominence of the nudes within her early work stresses how in those uncertain years all Carrington really had, her only resource and only comfort, was a self.

Staffordshire Dogs

'Today I started a still life of two china dogs on the mantelpiece,' Carrington wrote to Mark from Cornwall in 1917, and although the landscapes reminded her of Cézanne, she remained more interested in these figurines, describing the 'marvellous creatures' to Gertler as 'white, with salmon pink noses', adding a small illustration, a preview of the finished work.[36]

Carrington's artistic souvenir was as much about remembering Cornwall as it was forgetting – or continuing to distance herself from – a particular domestic atmosphere. Memories of Carrington's childhood migrate across the decor of the late Victorian middle-class lounge, and with them the longings and anxieties that had recently coalesced around the promise of a room. The mood of the work might have been entirely different if it wasn't for the centrepiece, its reverence for kitsch and vulgarity and lowbrow domestic marginalia, and its registering of a new humour and interest in the subject of coupledom.

Towards the end of 1915, Carrington and Barbara Hiles received an invitation to Asheham, a house in Sussex, to spend the weekend among the established core of the Bloomsbury Group: Vanessa and her husband Clive, his lover Mary Hutchinson, the artist Duncan Grant and Lytton Strachey. Carrington was puzzled by her inclusion, not knowing any of them well and aware of their insular tendencies, but it was precisely that breach of an enclosed world which intrigued her, and she accepted. Observing their own brand of privileged domestic inability with amusement, Carrington distinguished herself by correctly cooking a leek when asked.[37] Her skills were surprising to the other guests – laying claim to a

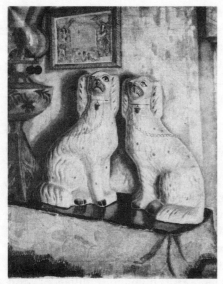

coupledom

self-sufficiency that meant she had lived without a cook – but the exchange ultimately put her at ease, clearly stating her difference to the group rather than having it embarrassingly uncovered, and in a scenario which emphasised her competence rather than any social weakness. Buoyed along by the rum punch and raucous gossip, Carrington enjoyed herself more than she expected. The next morning she woke early and walked over the downs alone, feeling utterly free and full of potential, turning over in her mind the guests that remained asleep in the house below.

To Christine Kühlenthal, a good friend, she was all playful disgust about her first encounter with Lytton, and indifferent to the possible appeals of men: 'his yellow face & beard, ugh!'[38] Yet to Mark, with an ambiguity conscious of its power to enrage him, she wrote: 'Lytton is rather curious.'[39]

Lytton was thirty-five, Carrington twenty-two. The difference was less about age than about era. Lytton was a relic of a Victorian monied intellectual class, while Carrington was a child of the new

century whose social mobility and gender transgressions were part of the dismantling of the value system that his background represented. Her descriptions to friends did not contradict one another: Lytton, or what he represented – wealth, status, elite education – was equally repellent and fascinating to her.

Lytton had been vital in formulating the collective identity of the Bloomsbury Group since its inception. Although they never really eradicated their deep bigotries around class, in Lytton's mocking of high society a more enlightened future was plotted. Humour did something crucial to the shame and unease he and his peers felt about their backgrounds, their whiteness and Britishness and wealth, and it did something similar to their more stubborn attachments to their privilege. No more reverence for the powerful. No more excusing their own prejudices. The snobbery and self-seriousness of that world; it was not aspirational, and it was not natural, it was an artifice worthy only of ridicule. What was exposed by satire could be better understood, and more easily dismantled: through Lytton, the Bloomsbury Group were beginning to look at themselves anew.

The consciousness about class was part of a broader subversive performance that took Lytton's queerness as its centre. The tenets were simple. Reading and writing rather than reproduction were life's higher purpose. Gossip was crucial, not just as a source of pleasure, a space in which to practise and play with language, but as a method for strengthening ties amongst allies, helping to identify which spaces and communities were safe. Wit was weaponised against all the known social and cultural forms, directed at religion, family, the law and the state. Lytton's family was chosen, composed of blood relations, friends and lovers. There was Duncan, the slightly one-sided affair with the besotted Lytton long over but their friendship still a vital form of sustenance for them both. Or Virginia, nearly Lytton's wife during a few confused days some years before, and now one of his dearest friends, his sudden, misjudged proposal and its quick retraction having left no lasting mark on their relationship.

Lytton slept with men, and Carrington was ambivalent about sleeping with men. The pair were getting on well, but given their preferences, desire – or whatever the feeling was that magnetised

them to one another – was unexpected. So when Lytton tried to kiss Carrington as they walked together on the South Downs, she recoiled, and left Lytton blushing as they walked back against the wind. There was more rum punch that night, just enough to embolden them both, meeting each other's gaze for longer as the hours passed at the table, and Carrington's shock softened into interest. The following morning she had formulated a response.

Scissors in hand, Carrington hovered over Lytton as he lay snoring gently beneath her, intending to cut his beard as he slept. Mischievous, it was the kind of prank siblings might play on each other, but there was an eroticism to it too. Lytton under the blankets in luxurious striped silk, a thin light moving through heavy brocade curtains, not even rooks breaking the silence, and Carrington bent over his body in a borrowed nightdress. The act had an archetypical quality to it, as though it were a resolution drawn from a fairy tale or biblical text: like the story of Samson and Delilah, where the cutting of hair figures a submission to pleasure, or the mythical narratives in which only an authentic desire can break an enchanted sleep. Lytton opened his eyes just as the scissors swooped towards him. Both froze, intrigued.

Ever after, their love language would return to beds. For a man of his class a four-poster bed was normally offered as a wedding gift, but some years into knowing Carrington, Lytton bought one for himself. The purchase was partly sentimental, marking the version of marriage he now enjoyed with her, and it was partly a knowing allusion to what he and Carrington did not share. Carrington celebrated the purchase in a drawing of Lytton sleeping alone inside the bed outside of the house: a pastoral fantasy of enchanted birds and foliage, it is tender, childlike and unerotic, and in its location alludes to what remained amicably inaccessible – that is, their separate sleeping arrangements. The bed would always bring them back to how their relationship began, in a transgressive moment of intimacy that felt as close as possible to sex – occupying the emotional and physical spaces in which it occurred – without actually involving sexual acts.

That morning in Lytton's bedroom was the beginning of something, although it wasn't clear what, except that it didn't feel like a conventional romance. Understanding what exactly it was possessed Carrington: *Staffordshire Dogs* was part of a pre-established imaginary in which she used animals to think through what her bond with Lytton meant. In one of their early letters Carrington describes Lady Ottoline's pugs, drawing them all turned towards Lytton, watching him as though waiting for him to join them on a walk. Their expressions are blank and imploring, their tails corkscrew squiggles, their bellies rounded like palms cupped in anticipation of a gift. The pugs proved prescient for the couple in imagining a model of affection that was not explicitly sexual, and was instead centred around love, tenderness, care, pleasure, devotion, humour and attention. Through the pugs as well as the figurines in *Staffordshire Dogs*, Carrington imagines their bond as operating outside the complexities of ordinary human relationships. Above all, sex and gender were not relevant: they could simply be alike animals moving through life as the pugs do the page. In *Staffordshire Dogs* one figurine is slightly but noticeably bigger than the other, an adjustment that subtly places the physical particularities of Lytton and herself within the frame, identifying them without recourse to anything as banal and confining as their given physical forms.

The letters continued: light and affectionate and full of the pleasures of sharing in each other's dailiness. How different Lytton was from Mark, or from any other man Carrington knew. There

would be no demands or threats, no urgency, no frightening sense of the conditional, and her value was not tied to sex. She could love Lytton and remain free. It was a setup that seemed specifically designed as a reparative experience for Carrington.

I struggled to picture Lytton doing anything other than reading. This was how Carrington painted and drew Lytton repeatedly over the course of their relationship. A flash of coppery hair, narrow funnels of fabric, spectacles, a general sense of the body's length, and that body tilting into a book, angular as a bent paperclip. So much of their time was spent like this, reading together, but there is more to the meaning of these works than simply recording a shared activity. These representations of Lytton state how Carrington's relation to him was its own form of reading exercise: it demanded prolonged attention, skill, perseverance and the cultivation of a specialised form of knowledge. Although at times Carrington felt keenly the limits of whatever expertise she had pieced together, and she was back where she began – alongside most other friends of Lytton – merely skimming the mannered, fascinating surface. 'One learns very little of his inside,' Carrington admitted after years of study. A popular, charismatic man, he was also enigmatic. Happy in his own company. Capable of sudden opaqueness. Consider the friends that were surprised, baffled even, by his relationship with Carrington. Few people really knew him as Carrington did; she became the most proficient reader of Lytton's self.

Carrington was aware of what this meticulously compiled expertise amounted to. In the spring of 1917, Carrington could no longer conceal how she felt, recording the conversation that emerged from this new certainty with a masochistic precision in her diary. 'I said that I was in love with you. I hope you don't mind very much,' she told Lytton, cushioning her admission through indirect speech in an account not of any event recently shared with him, but of Mark's most recent outburst.[40] Love was disclosed merely as an extraneous detail in an anecdote, and was quickly dismissed as anything that might be reciprocated in kind. The grammar and tone of resignation was less about disavowal than it was a genuine deflating of the confession's importance, an acceptance of how deep

her love went, how little Lytton's reaction (or possible rejection) could change what now felt like a definitive emotional experience for her.

Carrington also documented Lytton's evasive if affectionate response. Reframing his unsuitability to Carrington as a matter of health rather than sexual orientation, Lytton focused upon the incongruity of their partnership, insisting that he was old and diseased. His ableness, and 'the physical', as he euphemistically put it, posed a problem to them both.[41] The risk of disappointment and bitterness was immense, but the conversation did not signal an end of any kind, and actually served to refine how their bond would function moving forward. Carrington saw that Lytton was obliquely offering her a variation on the role of lover, one which emphasised care over sex, and vulnerability over virility, and although it was not love as she once understood it, she eagerly accepted the position made available by these frank conversations. She would be his dazzled student, his doting ward, his stoical nurse. The performance appealed to Lytton too: both had an opportunity to feel differently about themselves, to acknowledge their attractiveness in new and freeing ways they might otherwise never have experienced. A hypochondriac with the behaviours of a man years older than himself, Lytton was captivated by Carrington's vision of him, her understanding of his age and frailty not as proof of his inadequacies, but as markers of experience and erudition. Carrington wanted to discuss the works that composed his personal canon and adopting the role of teacher allowed Lytton to preserve parts of his former self-image (the weary man of letters) without its element of withdrawal, while also having more fun.

There is an awareness in *Staffordshire Dogs* that Carrington and Lytton's coupledom, and what unfolded in the months that followed, was an unusual iteration of the form. The dogs are replicas, the real scaled down and distorted. Modelled on guard dogs, all the qualities that make the original fit for purpose are lost, and what remains is merely a similarity in appearance. These dogs are heavy and static, fragile enough to shatter if dropped; they are cute and silly and unfrightening. This was much the same way Carrington

and Lytton's relationship functioned, as a self-consciously faulty imitation of a form: a parody of the heterosexual couple. The dogs are lacquered in shimmering pearl, snouts in the air, their pose princely and their expressions comically proud, and it was this element of camp – the artifice, theatrics and irony – that Carrington and Lytton adopted in their partnership: they assumed the couple's conventions only to stress how ill-fitting they were for their uses, or exaggerated them to their logical extreme. Virginia recounted an evening in which they withdrew 'ostensibly to copulate', but were later found to be 'reading aloud from Macaulay'.[42] Abandoning more conventional pet names, Carrington called Lytton 'grandfather' or 'uncle', and signed off as his baby – or rather '*bébé*', using French as a shorthand for excess, femininity, perversity and queerness – caricaturing the distorted power dynamics that had underpinned her prior experiences of heterosexual desire. A woodcut double portrait of them from 1917 – done for Virginia and Leonard's first pamphlet with the Hogarth Press – Carrington titled *The Servant Girl*, stressing the assumed submissiveness and infantilisation of the role she played as Lytton's wife. The role-playing would not be funny if it was a permanent feature of their dynamic, if it was not easily reversed. Elsewhere in their correspondence, Lytton takes indulgent (and arguably erotic) pleasure in accounts of his own weakness, and Carrington scolds him in matronly tones for his reckless behaviour, commands he return home to her, forbids him from leaving his bedroom, and promises to feed him up on warm milk and sweet puddings.

The satire had serious ends, for certain urgencies underlay their new bond. What Carrington offered was an intimacy that also functioned as a form of protection, a disguise. Outside their circle, in certain public places, it was to Lytton's advantage to read as heterosexual, as husband to Carrington's wife. The deception they contrived together was skilled, built through a mutual sense of what was required, the forms of physical affection and formal conversation they could copy from memories of their parents and encounters with their peers. Over time it became a game suffused

with fun, a camp and insouciant performance which was its own art form, as much as it was an essential survival strategy.

Crucial to the humour of these performances was a recognition of how little their dynamic actually resembled the norm. Both had a clear idea of what they did not want to become. Their choice to be together in this playful simulacrum of a marriage implicitly called into question the naturalness and moral superiority of the heterosexual couple, claims that were made across society during Carrington's lifetime, in everything from sexological studies to women's magazines to reluctantly attended family events. 'Two people, with very ordinary minds want each other physically, at least the man does,' was how Carrington explained to Mark Gertler the logic of marriage in 1915, 'the woman only wants to be married and have his possessions and position.'[43] Women gained status, and men acquired a willing body – it was purely transactional, that was Carrington's bleak conclusion. It was not merely the institution itself, the 'ridiculous farce' of a 'real English wedding' as Carrington put it, the rigidly gendered roles it enforced, but also the kind of intimacy marriage promised.[44]

'Do not you hate united pairs,' Carrington wrote to Lytton in 1916, his answer so unnecessary in its obviousness that the question ends on a full stop.[45] Many couples they knew deteriorated inside bad matches, women in Carrington's circle in particular had lost their identities and ambitions through marriage, and the engagements of friends were accordingly met with a species of grief. 'We had formed an alliance against marriage,' Carrington wrote of her best friend Alix after her engagement to James Strachey was announced; 'I am sorry she's had to give in.'[46] Coping with these small tragedies meant making do with the diminished friendships that remained, and one way of doing so was overcoming the gloom Carrington tended towards on the issue, and seeing the funny side. The way that distinct identities within a couple collapse into one another, 'a fundamental unity with its two halves riveted together', in Simone de Beauvoir's description, is given visual correlative in *Staffordshire Dogs*, and mocked with a cool aspersion.[47]

With their preened, haughty demeanours, and their distance from animals as we know them, the dogs are also curiously sexless. Amongst the painting's showily ironic digs at conformity and difference, there is a hint at what made Carrington and Lytton's bond so unique. Carrington realised that with Lytton she could have all the happiness of intimacy without any of the destabilising effects of heterosexual partnership, foremost the risk of bearing children. Carrington knew other women in her circle managed, but it was not enough knowing a privileged few juggled their art and life, and there was as much anger as anxiety about her own limited options in an assertion as absolute as that which she made in 1920. 'One cannot be a female creator of works of art & have children,' she wrote, distancing herself from the statement in her use of the indefinite pronoun, but nevertheless marking where she stood in relation to this choice.[48]

From a few light-hearted references, however, it seems Lytton and Carrington slept together once or twice. Lytton sent a bawdy poem to a friend, full of boyish innuendo, his chosen form framing the event as an experiment unserious enough to be shared, an act that was more about theatrics and sexual adventure than it was emotion, and was certainly not a private romantic gesture. 'I hope you were not wrecked after yesterday's exertions,' Carrington wrote to Lytton, treating the act similarly in resorting to humour, neither of them quite sure what tonal register they were now working with, whether it was romantic or friendly or somewhere in-between, let alone how to sustain or follow on from this surprising foray into a more traditional heterosexual bond.[49] There are no clues as to why that aspect of their relationship was not more sustained, stopping before it had even really started, the reasoning too personal even for their normally frank letters to detail. While Carrington was inevitably hurt, what followed was a revelation about what kind of relationship was possible. Sex would never be the primary engine of meaning for Carrington and Lytton; when those more conventional channels were blocked, their intimacy merely spread, moved elsewhere, and trickled through the runnels that underlay the entire ground of their lives.

Carrington learnt to judge closeness otherwise, to not allow sex much power over naming her connection with Lytton. Besides, what they subsequently shared was much more various, pervasive and definitive than the fumbling of that abortive night together. They read side by side or aloud to one another, and held spirited discussions of literature afterwards. They wrote to one another and waited eagerly each day for the post, the charge of which was advanced by Carrington's only half-serious and self-consciously perverse wish to be Lytton's 'pen-wiper'.[50] They talked late into the night after everyone had left, the detritus of dinner congealing around them, candles burning to their wick, analysing what had been said until it was impossible to remain awake, content in the knowledge that they could continue the same conversation seamlessly the next morning. They ate breakfast, lunch and dinner together, with Carrington planning menus specific to Lytton's tastes. They walked through the countryside in search of a spectacular view, or with packs on their backs under a noon sun in the Spanish mountains, or they hurried through an evening rain shower under a single umbrella on the streets of Soho. They moved through exhibitions at a mutually calibrated pace, wasted afternoons together looking at curios in shops and shared the exquisite, observant silence of concerts. Parties had never been so much fun. Nor had the most basic components of her routine. In truth, for Carrington everything was different now. Sex was exchanged for a life completely saturated with Lytton's presence. There was little compromise in this arrangement.

In their correspondence a fleck of that expansive tenderness is visible in a questionnaire Carrington sent to Lytton while he was staying with friends in the country.[51] Demanding only yes or no answers, Carrington asks a series of questions, some silly, others serious, typical of their relationship's tonal shifts. There are enquiries after his sleep and comfort, and the quality of the care he is receiving; she asks about a hand complaint he has suffered; she offers to send eggs, if he wants them; does he have access to painkillers and a doctor; she asks plainly if he misses her. The enquiries centre around measures of closeness wholly distinct from sex, all of which generate

their own particular, rich intensities. Alongside these questions, in Lytton's hand, there is an *X* for yes, *O* for no. Carrington exposes the depths of their intimacy by framing it through an impersonal form; the joke was that they did not need anything to facilitate a thorough interest in or knowledge of one another. What they had was more effective than any questionnaire: they had love.

*

Lytton relished the role of the pampered genius, and – if we were to be cynical for a moment – it is easy to imagine what he gained from Carrington's devotion to his needs. While there is ample evidence he appreciated her in private, and letters between them prove as much, in public Lytton could be cutting about Carrington, ungrateful. 'That woman will dog me,' he confided to Virginia, or so she claimed, in 1917.[52]

Wasn't Virginia a little jealous, and her diaries at times untrustworthy? And Lytton, perhaps he was eager to preserve his position within Virginia's life, to diminish Carrington so as to reassure his older friends, not to mention that he was unable (as he later told Carrington) to articulate how he truly felt. Insecurities possess an immense capacity to betray our better natures, and Lytton continued to offset his anxieties about co-dependency and social status with these outbursts of contempt, dismissing or distancing himself from Carrington in this way periodically throughout their relationship. Conscious of the fact that Carrington was not born into the same cosy aegis of privilege as the rest of Bloomsbury's immediate circle, the venom he occasionally directed towards her amongst friends was an attempt to acknowledge and overstate that difference, to pre-empt the kind of catty comments he correctly assumed were being made in private. For all her support of Carrington's career as an artist, repeatedly commissioning her woodcuts for Hogarth Press book designs even when Carrington was slow to produce work or reluctant to commit, Virginia could be cruel about her character: the stabs at Carrington's inferior

education, her slowness, how it made her unworthy of Lytton's attention. Typical was Virginia describing Carrington as 'a cook who doesn't go out on Sundays', dismissing her as though she were both servile and an intractable nuisance – that is, essential to the running of the household, but resented for it – while managing too to stress her unbelonging within their circle due to her humble upbringing.[53] Although Virginia had loathed her own childhood in South Kensington, something about the elite status of that life clearly remained meaningful to her, as her remarks were poorly veiled ways of pointing in the direction of Carrington's house in Bedford, its lace curtains and fenced gardens.

Lytton was a snob, and as a man raised to conceal his emotions, he was embarrassed at the suggestion of any fondness for anyone, but he was also struggling to express a relationship that had no stable social model, and which was completely unintelligible to most people in his life, even at times to those with whom he shared a value system. The comment about Carrington's animal neediness ('dog') had the interchangeable, rote quality of a complaint made by precisely the kinds of men Lytton considered himself to be radically different from: it trades in a shared language of romantic fatigue in which women are cast as unpredictable and emotionally demanding – an easy common enemy. Lytton felt it necessary to conjure the trope of the nagging wife to legitimise their bond, to slot it within a standard catalogue of heterosexual thematics, to stress its similarity to forms of deep connection his friends might have felt resistance to, but had known their whole lives, and at least understood.

Kitchen Scene at Tidmarsh

Begin where Carrington did, after weeks of train journeys to the countryside, conversations with estate agents, leads from friends and local farmers, flying down numerous country lanes on her

bicycle, then finally there it was: Tidmarsh Mill. If still life is about an insertion inside domestic space, then *The Mill at Tidmarsh* is an exploration of the genre's charged threshold, allowing us to observe Carrington as she contemplates the promise of that world – set at a slight distance, cautious – the moment before her acceptance by and passionate interest in the home commenced.

a charged threshold

Not long after their closeness deepened, Carrington and Lytton were so committed to one another that they began looking for a house together. New love demanded an architecture, but so too did the parts of themselves that had endured: their work. Lytton needed space to finish his irreverent work of collective biography, *Eminent Victorians*, and Carrington longed to concentrate on her painting. However for Carrington the decision was more complex than this equivalence suggests. Pressing needs that had for years superseded her art were served by the choice, as living with Lytton meant finally accessing stable long-term accommodation; she could finally settle, and relax. More forbidding were the paths the

move foreclosed: through it Carrington fully removed herself from a world in which marriage was expected of her, and if there was a binary choice, and in a way there was – wife and mother, or artist – it definitively laid claim to her aspirations as the latter. The risk was in accepting whatever limits there were to her relationship with Lytton, and the responsibility of rewriting the narrative ahead of her. There would be little assistance and few comforts in forging this path. As an unmarried woman living with a man, Carrington forfeited altogether much of the currency of middle-class womanhood: being respectable, moral, useful, coherent, worthy of compassion and help.

The Mill at Tidmarsh is beautiful, and only strange when studied up close, like Tidmarsh itself: an ordinary country house that once entered revealed a radical reinterpretation of domesticity. Carrington and Lytton were not married, they did not share a sexual identity or any familial bond; none of these assumed connections or prescribed differences amongst couples and kin held true in the family they made there. Secured through a syndicate composed of Oliver Strachey, Maynard Keynes, Harry Norton and Saxon Sydney Turner, Tidmarsh was never intended just for its founding couple alone. Partly it was the group's faith in Lytton, their desire to see him finish *Eminent Victorians*, but Tidmarsh was also an investment, in Carrington's words, in 'a communal nest for breakers of the law'.[54] What appeared to be an insular, normative move – away from a community and into a couple – in fact enabled an additional outpost for their group's subversive elements: conscientious objectors, women, queer friends and their allies.

The irony was that it was Carrington's mother who found Tidmarsh. Carrington loathed her mother's exacting domestic regimes and had long resisted her attempts to intrude upon her life, but her fastidiousness and prying were briefly useful in the search for a house. Nothing about her mother's involvement lingered in the verbal blueprint Carrington sent off to Lytton, which is filled with an uncomplicated hope: 'vast big rooms, 3 in number, 2 Very

big bedrooms and 4 others, Bathroom; water closet; very good garden and a shady grass lawn with river running through it'.[55]

Carrington adds further detail to this preliminary description in *The Mill at Tidmarsh*. The walls are painted a delicious peach, and the glassy surface of the pond doubles the house, wanting more of it to admire, lush greenery hugging the edge of the water. The clouds are the colour of ink blotches, the trees glowing like street lamps, and the rushes on the bank stand perfectly to attention, or lean inquiringly into the pond. With its heightened, whimsical sense of animation, the scene looks enchanted, a fairy-tale house seen from the woods, as though it might come to life at any moment. This was a wish for the kind of solitude Carrington would enjoy there: one that was rich, alive and unpredictable. A touch of surrealism in the swans dipped entirely in ink on the water, and this was Carrington and Lytton, the impure, noble creatures who ruled this idyll.

The moving-in day finally arrived, and Carrington immediately began repainting the entire house, working round the clock and sleeping there alone. It was December, there was a bitter chill in the air, and she unwrapped a parcel of haddock on the counter for her supper, a reward for her labour.[56] Despite the horror of hearing the rats in the walls at night, Carrington persisted, preparing the walls to be whitewashed, unpacking each box on her knees, negotiating the arrival of beds sent by friends, planting bulbs dug up from her mother's garden, and watching the peacocks strut through the grounds. Furniture was picked up in local antique shops or looted from Carrington's family home. This blending of old and new, of Carrington's 'awful' childhood and her carefully planned future, reveals the reparative work that was made possible by Tidmarsh.[57] Through taking and recontextualising her mother's furniture, placing it inside the home she shared with Lytton, and casting over it their investment in a different kind of life, the meaning of the domestic might be recast around ambition, fun, hospitality and freedom. Paint, mud and dust covering her overalls, increasingly worn out, Carrington pressed on, working hard to ensure those old wounds were healed.

*

While the 1918 painting of Tidmarsh's exterior became one of Carrington most well-known works, it was an interior scene from the same year that presents a more vivid snapshot of her life there. Not easily retrieved, nor definitively categorisable, a drawing deep within a collection that is parading as something else.

In the Courtauld Institute's records, *Kitchen Scene at Tidmarsh* is currently attributed to an 'anonymous child'. Another item in the collection, however, bears Carrington's inscription: a double-sided canvas, each with an at least partially realised work. One side is a landscape with a bridge at its centre, a town on a hill just visible, the sky the turquoise of the base of a flame, the valley below composed of oblongs of colour that suggest geological phenomena, and all of it is soft focus, swimming into abstraction in places, as though wrapped in a thin mist. The second is a nude, long and thin with a carefully detailed torso – note the pink of her nipples, the creases of

anonymous child

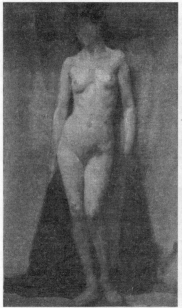

modes of disappearance

her knees – and she holds a sheet behind her, alluding to an act of concealment taken up by the smearing of paint over her face, which has left it entirely featureless. Stylistically both paintings play with presence and absence, and in doing so offer their own interpretation on the attribution mistake of *Kitchen Scene at Tidmarsh*. Each of the three works thinks through the aesthetics and status of the invisible, revealing invisibility as a particular stylistic choice as much as it was a chosen professional strategy for Carrington: at times a blurring of colour and form, at others an effacement of authorship. For Carrington had always sought out modes of disappearance through her art practice. She resisted exhibiting her work, and feared showing it even to friends. 'It was not beastliness which made me not show you my paintings,' she wrote to Vanessa, 'only it was so incomplete, that I thought it was rather absurd to show it you so half-baked.'[58] If she was exhibited, she did not attend the opening. Carrington painted

over or destroyed many of her canvases. Decorative commissions were accepted on the grounds of their anonymity. Through experiencing these specific works together in the archive, their links to one another, or – as with *Kitchen Scene* – their lack of them, we are witness to an unplanned performance of Carrington's artistic principles.

The mistake resonates in unexpected ways with Carrington's practice, but as a symptom of a broader problem, it is not entirely forgivable on these terms. It is true the work is not signed, and it is true that Roger Fry – whose collection this came from – was pioneering in his celebration and exhibition of children's art, and the naive, simplified idiom does resemble that of a child. This attribution mistake is an omission common to a patriarchal art historical culture within which women's work remains difficult to recover, to claim as their own or even simply to see.

In 1919 Carrington praised the 'amazing show of children's work' she saw at the shop and exhibition space run by Roger Fry, Vanessa Bell and Duncan Grant, the Omega Workshop, which frequently held exhibitions either connecting fine and decorative art or, as in this instance, proposing new sites of inspiration for the avant-garde.[59] While Carrington uses the bold colours, playful forms and crude perspective of a child's visual vocabulary, the work is not a sum of those devices alone. Carrington was omnivorous in her tastes. The flattened space and vibrant colour resemble the landscapes of early Italian Renaissance paintings; 'early Sienese primitives, & the very early Florentines' were Carrington's favourites.[60] Carrington had expressed a desire to 'paint like Uccello', and after attending Roger Fry's lectures on Italian Renaissance art vowed to begin 'some big compositions' – what *Kitchen Scene at Tidmarsh*, which looks to be a preparatory drawing, anticipated.[61,62] The kitchen scenes from the seventeenth-century Dutch tradition are also relevant, spaces in which desire, disorder and femininity are aligned so as to articulate blunt, predictable moral messages about women, or – in lighter moods – to pass humorous judgement on their many weaknesses. Carrington removes the men and the leering jokes, and instead presents an ordered visual plane occupied by figures engrossed in their own activities, and in challenging this tradition visualises the true promise of a world governed over by

women. Resonant too are the modernist painters who fetishised the work of artists without professional training, like Henri Rousseau, with whom Carrington was once aligned – a comparison she enjoyed.[63] Matisse, a favourite of Carrington's throughout her career, and his 1911 *Red Studio* in particular, is another possible reference: in echoing the formal language and saturated primary colours of Matisse's scene, Carrington transferred visionary work from the studio to the kitchen. The charged psychological worlds of Surrealism, which in 1918 was just beginning as a movement, share with Carrington's scene a disquieting force: the childlike figures, the animation of the furniture, the errors in perspective, the enigmatic mood. At Tidmarsh Carrington finally had the space, time and motivation to experiment with and develop her aesthetic, to read and educate herself on artistic cultures, building from the narrow focus of her schooling and the beginnings of an education represented by the Slade, and it is this period of study that the mixture of influences in *Kitchen Scene* records. Think of it as a sheet ripped from a notebook, covered in jottings.

Tidmarsh was also a space in which Carrington could attempt works that were never intended to be completed, or compositions that failed altogether. Carrington was uninterested in achievement through the conventional channels, and apathetic about exhibition or sale, in part because her passionate interest in art was deeply intertwined with a suspicion of the forces that made up the traditional canon. One impetus behind the collaging of artistic quotations in *Kitchen Scene* was to strip them of their seriousness, imagining an alternative value system in which nothing was sacred, making use of the most hallowed artistic efforts in a composition that is small, trivial and childlike. How easily the historical and contemporary heroes of art become pretty and silly and feminine and light, interchangeable terms for the critical discourses that surrounded Carrington throughout her career. Carrington was charting an alternative to those dominant voices. For Carrington, a person's talent might necessarily or – simply more captivatingly – involve, as Eve Kosofsky Sedgwick puts it, 'the many characteristic ways in which they might be stupid or resistant', making room for 'blockages, block-headedness and overreaching'.[64] Discussing

her indifference to the Renaissance painter Raphael, championed by Fry in the same lectures that introduced her to Uccello – and already consecrated as a great across art-historical discourses and institutions – Carrington wrote: 'one wishes his hand would have wobbled, just once, & drawn clumsily'.[65] Valuing the wobble was about elevating practices that fell outside the remit of an evaluative criteria established by men: the jumbled references, childlike visual idiom, awkwardness and uncategorisable quality of *Kitchen Scene* mark out a way of interacting with an artistic tradition that does not want – because it does not understand – your contributions.

The same principle of rebellion runs across Carrington's oeuvre. She never obeyed trends in modernist aesthetics, preferring her own mismatch of references, which meant forfeiting any recognition from avant-garde circles: instead, she dwelled inside a world of her own, composed of rich juxtapositions of eighteenth-century British art, Spanish culture and folk practices. Other audiences and modes of display were established, with none of the prestige and with an emphasis on the ephemeral: the hand-painted pub signs available all year round to a wide audience, easily worn and readily painted over; the Victorian glass paintings she gave away or peddled cheaply in department stores, many of which shattered before they could be sold; the letters that were works of art in themselves, costing only as much as a postage stamp, and which were easily destroyed or forgotten.

Failing in this manner was elastic and transgressive and fun, but success had its own allure. Carrington knew patriarchal society resented those women who dared attempt to challenge the primacy of the male painter. 'One reason I often want to paint a very good picture,' she wrote, 'is simply the annoyance it would cause the outside world.'[66] Not motivated by the market, but by making mischief: and it is in this context that there is a certain satisfaction in having her work misplaced, misunderstood. The rightness of the wrong attribution has *Kitchen Scene* as a provocation, an insurrection that continues to defy the narrow metrics of the art historical institution. I believe it is what Carrington would have wanted, a brilliant, if unintentional, joke that long outlived her: the woman artist as anonymous child.

The medium (gouache and pencil) and the work's diminutive size suggest it might have been a cartoon, a plan for a larger work, but it never made it past this sketched-out form. A vast cache of historical references was plundered, but Carrington supplemented them with reality. Another reason to have it concealed, to preserve it in this more private form: it was a slip onto which her relationship with Lytton was printed, a broadcasting of the psychological particulars of the life they built.

Look at these women, flat as paper dolls. A girl in the corner gazes expectantly into the distance, holding up a white object: a piece of china, a moment's rest amongst the scene's colour, an aperture through which a tenderness slips, a gift – but for whom? These figures do not belong to Tidmarsh as we know it, where Carrington and Lytton lived with a couple of servants, but neither are they mere fantasy: the figures dramatise elements of the emotional life Carrington and Lytton shared. Carrington constructs a tableau of care and sweetness, of generosity and gentle discipline, concern and ready aid; a world that is homosocial, safe, innocent, nurturing and warm. Like the bond between children and nursemaids, theirs was loving and preoccupying, playful and pedagogical, physical but unsexual, qualities which were condensed in Carrington's summing-up of their most treasured memories together in 1918. She recalls Lytton scrambling in the garden amongst the weeds, observing him as he reclined in the bath, lying on his bed as he napped, and coming close to him so as to smell his hair.[67] Tender and tactile, Carrington's precious images are closer to the memories of siblings than lovers. Partly this was Carrington hoping for an intimacy that endured, unconditional in the way a blood bond can feel, but it was as much about the mood that was created in their new home. Tidmarsh offered its inhabitants a passage back to their childhood, and Carrington for one was determined to make right its disappointments. For those 'communal breakers of the law', all of whom had experienced some form of oppression or isolation as children, Tidmarsh was an answering kindness. Many preparatory drawings are worked into canvases, and while this one wasn't, its fate was arguably far more significant than that: *Kitchen Scene* is concerned with the invention of a wholly different world.

*

The women in *Kitchen Scene at Tidmarsh* are organised around the production of food, and the array of desserts displayed on the table promises pleasure rather than mere sustenance, an impossible choice at the time of its composition. During the First World War, ingredients like butter and sugar became luxuries, and having previously commanded very little attention in Carrington's circle, they began to attract notice as an acutely felt absence. 'You can't buy chocolates, or toffee; flowers cost so much that I have to pick leaves instead. We have cards for most foods.' Virginia noted with frustration in January 1918, 'Other shops parade tins, or cardboard boxes, doubtless empty.'[68] Carrington, however, had always been preoccupied with food. She believed that 'a kitchen & a larder gives a certain revelation to a female's character,' and her trust in the revelatory power of these spaces explains the recurrence of recipes, menus and references to her appetite across her correspondence.[69] Carrington dwells over biscuits and beef and redcurrant jelly and mutton pies and fish fricassee with poached eggs on top and cold chicken and cream teas and jams and cowslip wine and plum pudding and apricots covered in cold custard – and much else. Each meal Carrington itemised conveyed something about taste and need and satisfaction in the broadest terms, the scale of gratification within reach on that particular day. Occasionally these enraptured descriptions are accompanied by descriptive doodles, but elsewhere in her work the kitchen door shut when the studio opened. Amongst Carrington's still lifes, very few canvases address food as the genre typically does; unlike in the Renaissance tradition, there are no sumptuous spreads, slaughtered animals or radiant fruits. The culinary arts and her art practice were kept separate; what still lifes survive are those Carrington constructed via the written word.

There was a simple architectural explanation for this omission. Carrington looked out onto her garden from the window of her studio, and from this position painted scores of floral scenes. Some combined the thought of the studio with the view of the garden, representations of flowers seen in books or galleries with the realities she saw emerging

from the soil. Like the painting *Cyclamen in a Pot*: soft textures, simplified forms, saturated colour. It is strikingly reminiscent of Van Gogh's flower paintings – like *Irises*, 1890, or *Sunflowers*, 1888 – which Carrington would have seen in Roger Fry's 1910 Post-Impressionist exhibition: they share a lack of sentimentality, a weird luminescence, thick impasto making the flowers look muscled, alive, the threat Van Gogh instilled in his flowers drifting quietly beneath her own.

harsh and unpretty

In many of these paintings Carrington holds back more avant-garde techniques, using plain figurative language and frontal compositions, so it is the flowers that command all the attention, their presence judged interesting enough in themselves. Deceptively simple, each work was the culmination of a long artistic and intellectual process. Carrington researched flowers, selected and planted the seeds, and did most of the maintenance the garden required. Gardening was a private mode of creative production that never demanded a clean, finished product, encouraging digression and experimentation, and enabling a loose, capacious and

sustained form of art practice that corresponded with Carrington's temperament much more than work on canvas. Alongside her work in the garden, Carrington attended flower shows, read Victorian and contemporary botanical studies and later made a regular wage from botanical illustration.[70] Practised in the garden, and accessible without an education, botany at once opened up space for participation by women, broadening their intellectual horizons, and in remaining within the prescribed borders of the home, risked confining them further to the domestic realm. Patriarchal scientific institutions were quick to question the seriousness of any epistemological practice in which women excelled, and primers on botanical drawing aimed at women only corroborated these suspicions, careful to draw attention away from the authority afforded by illustration, aware of how acts of representation might recast received ideas, and instead encouraged its lightly recreational uses, stressing copying and colouring. Carrington's diverse, original engagement with botany subverted these discourses and their assumptions about women's place within the home and the academy, intent upon the grander aims of creation and cultivation. Carrington's flower paintings were therefore a radical work log at the intersection of science and aesthetics, their incendiary power disguised by their surface prettiness.

From this immersion in horticultural discourses, as well as a childhood immured in late Victorian culture and its values, Carrington was exposed to the association flowers carried in relation to female sexuality. Flowers were regarded as domestic, decorative and perfectible; they symbolised an ornamental, idealised femininity in which reproduction was at once foregrounded and sanitised. During the nineteenth century, plants acquired from the distant reaches of colonial territories became popular additions to British gardens, and with this trend came a shift in the white Western cultural imagination: these flowers were fearsome in their sensuality and ripe with possible sickness and decay, associations that reflected anxieties about the indigenous populations of the Empire, and more broadly the fear of the foreign or racial 'other'.[71] In a contradiction that served the authoritarian fantasies of patriarchal institutions, flowers were made to embody the essential passivity

and unruliness of the natural world and the marginalised – both women and those living under colonial rule.

Dissatisfied with this binary, Carrington's paintings create a third term. Her chosen textures, opaque colours and simple environments neither elevate or exoticise the plants under inspection. Nowhere are there the enlarged fuchsia stamen or dainty pastel-coloured petals that constitute either iteration of the floral feminine. Instead, Carrington's flowers are about documenting and theorising how her experiments in the garden intersected with her experiments in aesthetics. Tracking how colour was an action of sunlight and soil as well as paint; observing how movement might be about pruning in the beds and paring back forms on the canvas; paint and soil mixed into a single grot under her fingernails. If these works transmit any meaning about gender, then it is an aligning of femininity with activity and skill, innovation and perseverance. Carrington's flowers are replete with precisely the things that femininity is often deprived of in the realm of the symbolic.

Dissect a flower for its emotional charge and you might arrive at the more morbid sentiments expressed by traditional still life: the sudden coming of death; the meaninglessness of those things valued as beautiful or good. For Carrington, however, flowers connected her to her most productive habits, and so embodied endurance, stability and accomplishment. Little else in her life would ever be so straightforward.

Bonnet

Pink and frilled, the bonnet resembles a rare, delicate cabbage. The sitter wears it like a crown from another world, and these stolid, simple and industrious women – Mrs Box was a Cornish farmer's wife – were a kind of royalty to Carrington, representing a practical revision to femininity she herself would pursue as the matriarch of Tidmarsh. Unusually large, the bonnet swamps the sitter's head;

now age has diminished her, sapped her of strength and substance. Dire questions arise: what trials reduce a woman to this, small and quietly wrecked, until even her ornaments exceed her?

Mrs Box *(1919)*

⌒

Tulips in a Staffordshire Jug

The flowers are marmalade, raspberry and the white of curdled milk, in patterned china on polished wood; the background is the inky black of an unlit room. Carrington was not in the habit of setting her subjects against dark cloth, and would not do so again. There is a mournfulness to this image that was deliberate, distinctive. One tulip sinks to the ground, like an animal dipping its head to drink, while another reaches up towards the upper corner of the canvas; its length makes it look like it is still growing, seeking more light or space. Looking closer, the two tulips appear

to be wriggling free of the jug, attempting to distance themselves from the rest of the bouquet. For all the painting's quiet drama and beauty, what lingers are those intimations of disappointment, need and discord.

animals

Enter Ralph Partridge. Ralph who was first of all Rex, a friend of Carrington's brother, strapping and handsome, conservative, a decorated major returned from war to his literary studies at Oxford University. Later, he would be the assistant at the Hogarth Press, a difficult and embittered assistant who, after months of fighting Virginia and Leonard Woolf, would ultimately be forced to leave.

The question of how Carrington, so resistant to what she described as 'boisterous young men', came to attach herself to Ralph is made all the more mystifying by the absence of their correspondence: no letters survive.[72] What is clear is that the infatuation began with another man.

Carrington's younger brother Teddy was reported missing in action in 1916, and after months of agonising tension, declared dead the following year. Although Carrington had anticipated it, the loss was shocking and consuming. A holiday to Spain with her other brother Noel was arranged after the war, and both siblings were hopeful about its possible therapeutic function. Ralph, whom

Carrington had met before the war on a trip to Scotland – and all but forgotten about – was to accompany them, along with his sister Dorothy. To Carrington's surprise, the trip was a success. The Prado museum in Madrid was an essential part of the cure she received there: in seeing how El Greco 'sweated with agony over each picture', as she later put it, Carrington could understand how suffering might reinvigorate her practice, and reassured that her recent turmoil would soon be transfigured, she felt lighter, happier, capable, social.[73,74] Her sudden buoyancy did not go unnoticed. Ralph looked at Carrington from across a room. He fiddled with his suitcase next to her on a boat. Ralph sat next to her in a restaurant, and began on some lofty topic extracted from a recent tutorial, hardly registering Carrington, who was no more attentive to him, instead describing to Noel the bawdy drawings she had seen that day by Goya: grotesques in red chalk. Ralph excused himself politely from dinner. Ralph arrived at breakfast impeccably dressed. Blandly conventional enough to screen any variety of charged projections, Carrington recognised she might access through Ralph a resurrected part of her brother.

Carrington watched Ralph plant beans, peas and parsnips in her garden weeks after the trip had finished, and was surprised to discover her sudden interest in him – if interest is the right word.[75] From her correspondence, its mixture of humorous dismissal and bawdy objectification, it seems what she felt for Ralph was weirder, more detached and more conflicted than any simple curiosity or any simple desire. She was not quite sure what to make of his eagerness to be around her, his willingness to do whatever it was she required in the house or garden, but she welcomed the help, and found she enjoyed his company. There was a romance to it, no question. A month later the flirtation had escalated, with Ralph spending the afternoon in Carrington's bath, then drying off reading sexology on the lawn. Carrington watched this increasingly erotic performance with amusement.

Carrington and Ralph found themselves together more and more over the months that followed. Ralph continued helping her in the garden, and sat willingly for her as a model. It was a generosity

that was hard to ignore, and soon Carrington was not only happily accepting his attention, but telling others quite earnestly of 'his extreme kindness'.[76] There were moments of flirtatiousness, and stabs of desire that Carrington was eager to share with Lytton. 'I confess I got rather a flux over his thighs & legs,' she wrote to him of drawing Ralph naked in the gardens at Tidmarsh, 'so much so that I didn't do very good drawings.'[77] There was a part of Carrington that was thinking strategically about how she might use Ralph and his sexual power, what thrall it might exert over Lytton. 'His thighs are elegant,' she went on, 'his private parts enorme, his deltoids as white as ivory.'[78] No coincidence that it was a time when Lytton's literary success drew him away from Tidmarsh, and Carrington sensed the stakes had to be raised in order to compete with the illustrious parties and lunches that now dominated his schedule. Using to her advantage all her intimate knowledge of Lytton, what often felt like the source of her deepest vulnerabilities, Carrington found a way of regaining a measure of control. The bait was set: Ralph parking his bicycle by the gate, striding towards the house in a pair of dirty white shorts, a sheen of sweat across his brow.

When tulips began appearing in seventeenth-century Dutch still life, the flowers had established their own lucrative market; their place in these paintings at once displayed wealth and commented upon its creation – and loss. Carrington's choice of tulips was apt as she considered her own value to Lytton, and whether she could introduce a different kind of sexual currency into Tidmarsh. Carrington knew Ralph offered something irresistible to Lytton, admiration and vague sexual possibility, but Ralph also promised to add further nuance to her relationship with Lytton. The arrival of Ralph realised their previously unspoken pact of a mutual non-possessiveness, offering concrete proof that Carrington did not want or need Lytton alone, and that her love was less consuming than he feared.

Carrington later began a portrait of Ralph attired as a boxer.[79] This was the man he was to her, an identity absolutely in opposition to Lytton: combative, hypermasculine, assertive, physically powerful. It was easier to imagine Ralph like this, as additional to Lytton,

never even entertaining the possibility of him as a replacement. No finished version of the painting survives. While she blamed the quality of her paints, the failure of the project suggested something about the difficulties Carrington faced in balancing Ralph's more conventional needs with her desire to be an artist.

His dancing – this Carrington complimented Ralph on, more than once. To understand them together, picture Ralph with the straight back and raised arms of a man beginning a waltz. The possibility invested in this gesture; their whole lives might feel like this, like the opening bars of music at a ball.

Ralph suggested to Carrington a trial cohabiting as a couple in London. The sacrifice that made the proposition at once meaningful and dreadful was leaving Lytton and what Carrington knew was 'the best possible of lives in the best possible of worlds' for her at Tidmarsh.[80] Being governed by the whims of a man was precisely what Carrington had worked hard to avoid, but those efforts now appeared dim and futile, unable to release her from a pressure to be 'domestic and responsible' in a way that felt inimical to her nature.[81] 'The whole reason why I have lived here so peacefully with Lytton is that he never controls me,' she wrote.[82] Nevertheless, Carrington agreed, with conditions, driven by an obstinate faith in her ability to appease Ralph and please herself.[83] Weekdays were spent at 41 Gordon Square with Ralph, functioning as any typically incompatible couple might, tensions and arguments and occasional bouts of happiness, then on Friday afternoons Carrington would pack a bag and return to the life she actually wanted, the life she had chosen and built from scratch.

The division of time did not feel like a winning compromise, and only made Carrington feel more torn. More domineering than ever, Ralph was now so consumed by the idea of marriage that he could not see Carrington at all, only the wife she refused to become for him. The pair sought advice. 'To marry him would not make it any better,' Carrington wrote, 'because one cannot change a spirit inside one.'[84] The statement is firm, but written in thin, faded pencil and surrounded by crossings out, rewritten words and late additions in smaller, almost inscrutable script. Possessed by

doubt, aware that her every move was being watched by their circle of friends, and still strongly believing the institution was archaic, and comically so, Carrington accepted Ralph's proposal in May 1921. 'He is too good a man for a little wretch like me to make unhappy,' she wrote, unable to consider her agreement as beneficial to anyone except Ralph.[85] Even then, in the forced cheerfulness of her announcement, it was becoming clear that this was not destined to be a union of equals. Whether or not she loved Ralph was never even a consideration. To those who knew her, it was a transparently bad decision. 'Poor Carrington is a little uneasy, as indeed I should be in the circumstances,' Virginia wrote to Vanessa.[86]

Struck by the catastrophic change that had been set in motion, there was an urgency to Carrington's confessions in the days after, condensed into a letter full of passion and regret addressed to Lytton. What she felt for Lytton, she insisted, could not be repeated. 'I shall never have another. I couldn't now,' she said of their love, and in a literal sense she was right, entering a partnership that was exactly the opposite of what they enjoyed: a heterosexual marriage, with all its clarity and acceptance as well as its limits.[87] Carrington grieves their inability to approximate this norm, which for all its flaws and inadequate fantasies, ultimately would have allowed them greater freedom and longevity. 'I cried last night to think of a savage cynical fate which had made it impossible for my love ever to be used by you,' she wrote.[88] The injustice resided, as so many had in Carrington's life so far, in her being a woman, but perhaps even more pressing now was how her gender rubbed up against the demands of heterosexuality. The years of determined flight from those norms were effectively over. The dream of a life in which love was useful not for its role in reproduction, and not for its ability to preserve certain social norms, and not for its practice of narrowing an entire emotional world to two, but was used rather as a means of making space, as the ground for art and autonomy – that was over too. 'Of course these years of Tidmarsh when we were quite alone will always be the happiest I ever spent,' she wrote.[89]

The letter took six days to reach Lytton, and his response was unusually open. 'You do know very well that I love you as something

more than a friend, you angelic creature,' he replied, 'whose goodness to me has made me happy for years and whose presence in my life has been, and always will be, one of the most important things in it.'[90] Of course, there was little Lytton's response could do to alter events, but Carrington at least had reason now to set aside those years of speculation and hurt. The relief was profound. There was no delusion in how she had felt; what they had shared had been real.

The day before her wedding day, Carrington had *Tulips in a Staffordshire Jug* exhibited in Roger Fry's 'Nameless Exhibition of Modern British Painting'. As though to counteract her own uncertainty with Ralph, Carrington turned from him and painted with assurance. The adoption of the Old Master idiom obliquely echoed her decision to marry: neither were her ordinary frame of reference, but both offered a legitimacy that was seductive. Even the curation fitted her mood: exhibiting without her name at the moment before she officially changed it on all her documents, as she reported doing ambivalently to friends, reflected the crisis that shift represented to her, however much she joked about the 'thousand mistakes' she had made on her passport.[91] Carrington was the name – and self – she had made entirely on her own terms, and Dora Partridge was the pre-established model of a wife she now was expected to become, the total unsuitability of which her administrative errors foretold. Looking at the grave and heavy mood of the work, it seemed Carrington knew that whatever partial happiness she and Ralph would share would not be for long. 'Somehow I feel rather despondent about the painting!' Carrington said of it.[92]

'Certainly she is not in love,' Virginia observed, quick to forget that it was partly her own urging that had led to Carrington's wary acceptance.[93] She was right, of course, Carrington was not in love and had never claimed to be, and she stated as much to those who pressed her on it, unafraid even to say so to Ralph, and it is no surprise in the circumstances that she did not enjoy being married. Only a couple of years later Carrington was able to be brutally honest about her incompatibility with the institution, the

'horror of its intimacy', as she put it, 'the tediousness of domestic life'.[94] Carrington sent this particular complaint to a close friend of her husband, Gerald Brenan, although she had other reasons for stressing her unhappiness to him.

*

In Carrington's 1921 portrait of Gerald Brenan he looks straight ahead against a sky of star speckled and swirling indigo, a setting that cracks open his impenetrable gaze and reveals an inner turbulence, an adventurous spirit. One of Carrington's nicknames for Gerald was 'Mr Crusoe'. Carrington had begun an affair with Gerald weeks after her doomed marriage to Ralph began. He was a writer living in Yegen, a town in southern Spain: it meant their relationship could be largely verbal, held at a literal distance; it was a commitment to infidelity that came with the reassuringly practical promise – at least at first – not to consume all her time.

Quite unlike anything else Carrington painted, *Spanish Landscape with Mountains* came out of travelling in the twenties while visiting Gerald. The hills are smooth and inviting, surrounded by crevices that move between mountain and wrinkled flesh – it is a hallucinatory feel, the gaze that of the weary hiker – their undulating mimicking the contours of the body. To stress the landscape's vastness, Carrington places matchstick figures for scale. They make their way along a dirt road, easily flicked into the cavernous space that surrounds them. In the foreground a clutch of spiked plants warn against going any further into the environment, let alone pursuing the great heights that call out to the viewer from the luminous peaks. Carrington stalls there, overwhelmed at the immensity of what this bond might mean to her, gazing into a new world of seduction and risk.

Comparisons of Gerald to raspberries note the sensations Carrington felt around him: tart, sweet and brief.[95] Insisting to herself that he was more than simply another difficult man, Carrington draws improbable likenesses between Gerald and

tulips, crown imperials, walking on the Combe Downs in Somerset, the experience of Venice and Padua. Gerald is small and sublime, nouns and verbs, fragments of nature and entire cities. Gerald is the flowers Carrington tends to in the garden, the trails she follows by her house, those simple pleasures, and he is the cities her domestic arrangements keep her from: he is care and responsibility and familiarity – and the undoing of all those terms, their abandonment.

Yet it was never so simple as Carrington's early letters imply. Gerald was soon pursuing Carrington with a frenzied energy she had not experienced since the affair with Mark ended. Carrington was conscious she could ruin any possible happiness she might experience with Ralph like this: stolen moments with Gerald in the barn while Ralph fished nearby, brushing the hay from their clothes conspicuously on his return.

Aware it was reckless, Carrington nevertheless understood her behaviour's deeper logic. 'I dislike merging into a person, which marriage involves,' she wrote to Gerald, and that aversion was partly what their affair was about.[96] Through Gerald she could preserve for herself a space apart from Ralph: he represented an alternative, a possible escape route, and a life Carrington could tell herself she nearly had. With each effusive, provocative letter she wrote to Gerald, Carrington assured herself that she was still free, and her choices were her own.

Carrington was left stranded between a desire for privacy and the relationship's hunger for drama. Risks were taken. Ralph noticed the volume of letters. Already possessive and prone to paranoia about his wife, Ralph was soon demanding he read all of Carrington's mail. Carrington pleaded with Gerald for more subtlety. For Gerald, however, discovery was not necessarily entirely unwanted, as exposure offered a chance to bring things to a dramatic conclusion and secure Carrington's attentions more permanently, and so the long and passionate letters continued. Inevitably the infidelities were uncovered. Ralph was furious. Having strived for even the faintest sign of affection from Carrington, his response was less about the breach of trust the

affair represented than the confirmation of his wife's disinterest in him. Lytton, thrown between the couple, worked hard to salvage the situation, and it was with his guidance that they agreed to open their marriage.

To Carrington's dismay, Gerald was no longer content to conduct their intimacy purely through epistolary channels: he wanted to sleep with her. In their letters the symbol ~ is used to signify sex. When frustrated, the line is longer, undulating crazily across the page. The symbol took at least some of its meaning from the form of a snake, that ancient feminised symbol of sexual shame, a shorthand for Carrington's discomfort. The symbol was partly a redundant attempt at privacy – if anyone did read their letters, it would not be a single explicit word giving them away – but there was also a superstitious quality to its use, as if Carrington convinced herself that sex need not be part of their relationship if she simply demurred from ever articulating it plainly.

Over the years, Gerald increasingly contributed to Carrington's haphazard working practices, and it was unclear now whether she was wholly in control, what were deliberate methods intended to situate her on the margins of culture, and what were basic errors of judgement. So many afternoons wasted on him. Encounters in his rooms, tense walks taken together across London to shake off some argument, an interminable thread of writing binding them during any absences. The letters are full of ideas for compositions, 'a thousand new ideas for pictures' there is no evidence of Carrington ever completing: the 'balloons of delicate pink in blue skies, volcanoes, & lovely bunches of anemones', and much else, remained stranded on the page with Gerald.[97]

Courting failure worked for Carrington as an artist, allowing her to find a distinct voice without the distortions of commercial pressure or critical praise, but she was discovering that the same strategies could not be applied to a marriage. Carrington's abortive performance as a wife only made her life more difficult, and given the authoritarian thrust of Ralph's panicked reactions, more beholden to the very norms she hoped to escape. Worse, the rash impulses that had her forever losing time to some new personal

crisis inevitably impacted her art practice, until she was acting as though wanting to confirm all the worst suspicions she had about herself: to prove she was idle, worthless and talentless.

What would it do to rehearse in detail what went on between them? The endless rotations are easily summarised: spells of secrecy and difficulty, brief exhilarating togetherness, then disappointment, conflict, separation; after a period of silence, new clandestine letters and tentative enquiries. Finally there was a misunderstanding between them they could not come back from, an encounter so dire that it even goes unrecorded in their correspondence. The letters stopped. Gerald continued living in Spain, eventually marrying the writer Gamel Woolsey. Near the bottom of the archive box, the final amongst the stacks that hold their correspondence, is a photograph Gerald sent to Carrington of his new wife – pride about his new, unfamiliar contentment mingling with sentimental thoughts about his turbulent past. Whether it was happiness or fatigue with the drama, the combustible element to their relationship had disappeared. In return, Carrington sent Gerald and Gamel a quilt as a wedding gift.

Two commemorative objects separated by a decade, both addressed to marriage. The promise of warmth and shelter in the quilt, of disparate parts coming together to create a whole; the tulips already wilting in Carrington's painting, their decline set against darkness. What they represent is belief and its opposite.

Accordion

As an instrument, the accordion is as much about spontaneity as it is saturation. Its jarring and jaunty harmonies never leave spaces quite as they were; needling and cacophonous, they are impossible to ignore, filling whatever room they are placed inside. Everything else grinds to a halt, and you turn to look – there is no choice. Afterwards, once the player has gone, a stillness descends like nothing else. Perhaps the peace is appreciated more than before.

Set in a Spanish inn, with Gerald if not close at hand then certainly
on her mind, Carrington observes something of their emotional
tumult in the charged contrasts created by the music.

Spanish Boy, the Accordion Player *(c.1924)*

Eggs on a Table

The scene is structured through patterns of three. On the windowsill
is a potted plant, eggs in a dish and a vibrant bouquet. Outside three
swans move across the pond, one little more than a wisp of white
paint, a few feathers suspended in air, a sneeze of yellow for a beak,
the same yellow that is at the heart of each flower in the jug and
which spills out of the buds to cover the surface beneath. No part
of the painting is wasted; the entire space is filled with colour and
detail and form, like three paintings condensed into a single frame.
Yet, for all this abundance, the crowdedness of the scene, there is no
chaos. Correspondences in colour and form hold the scene tightly
and harmoniously together. All of the threes in this optimistic scene
of difference and balance are in some way images of Tidmarsh's
inhabitants, but it is the eggs nestling in the foreground of the painting

that seem most comparable, most explicitly invested with fantasy. The particulars of their characters that made Ralph and Carrington so ill-suited, and Carrington and Lytton so beloved of each other, are smoothed over, and what is left are three completely identical forms. There is a touching hopefulness to the gesture, the eggs all fitting together perfectly in a simple and frictionless arrangement.

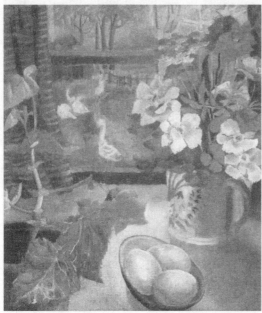

a hopeful gesture

Carrington and Ralph accepted it would be best for everyone to maintain the 'triangular trinity of happiness', as Carrington described it, remaining as a couple at Tidmarsh with Lytton.[98] After the explosive fights, Carrington ceremoniously cleaned up her art materials, readying herself for a new start.[99] As long as Carrington could continue listening to Lytton read *Troilus and Cressida* aloud by the fire, those fundamental pleasures, she could withstand whatever obstacles Ralph mounted, including having all

her letters monitored, and including contemplating motherhood –
given a few years, if her art hadn't picked up – merely to appease
him.[100]

For now such measures were unnecessary. 'I believe if one
wasn't reserved,' Carrington wrote to Gerald in December 1919,
'and hadn't a sense of "what is possible" one could be very fond
of certainly two or three people at a time.'[101] Carrington saw
how expanding the ordinary parameters of love might transform
her circumstances. The couple form had so far been a disaster
for Carrington: Mark, Gerald and Ralph had each forced
her into claustrophobic partnerships that were dramatic and
unpredictable, each demanding self-sacrifice and compromise and
endless emotional maintenance while offering her very little in
return. Even when writing to Gerald of a rare and brief spell of
happiness with Ralph, she qualifies it with a sense of the smallness
of a marriage: 'I want more,' she wrote.[102] Needing more affection,
stimulation and pleasure meant finding a way for the different
feelings Carrington harboured for the three men at the centre of
her life to more productively coexist.

Carrington enacted her new principles in small ways. While
out shopping she bought silk handkerchiefs for herself, Ralph and
Lytton, only hesitating over one for Gerald because she was not
sure what pattern would best match his clothes.[103] The men wore
the tokens of her love, and this uniform united them, made visible
their occupation of a shared space. Indeed, the balance of parts in
Eggs on a Table affirms how the dynamic at Tidmarsh rested on
the intense, loving bond between the men as much as any other,
a reciprocity which Carrington had encouraged from the start.
Although the three apparently shared a bed a handful of times, many
evenings were spent in a milder togetherness which for a while felt
infinitely sustainable: the men engaged in a long discussion about
Einstein's theory while Carrington sat in the corner listening while
darning socks, all three of them wearing their handkerchiefs.[104] At
times Carrington felt sure she had resolved the situation as deftly
as possible in the circumstances, allowing each man their role
and place, no feelings hurt or wishes unmet, while she was poised

precisely between them, forever at work on new methods to bind them all closer.

For all the cheer conveyed by *Eggs on a Table*, there are hints at the tension that continued to define life at Tidmarsh. The happiness the trio had come to was fragile, and each was aware that one wrong move could prove catastrophic in its effects; the eggs swept to the ground, shattered and spoiled in an instant. Ultimately the break between them was more gradual, and it was not anything Carrington's carefulness around the men could prevent. Ralph was engaged in the 'long, high-powered, and concentrated courtship' of Frances Marshall, as Frances later described it, a bookseller at Bunny Garnett's shop.[105] Lytton was going to London to pursue his own romances. Carrington drifted through Tidmarsh alone. At times to be very fond of three people was to accept no longer being at the centre of anyone's life, and while Carrington had imagined enjoying the freedom opened up by the arrangement, she was finding it harder to concentrate on her work, and harder to forge meaningful bonds with others, as deeper anxieties about the future were beginning to take root.

*

Lytton's literary success meant the group had enough money to leave Tidmarsh Mill, and Carrington was thrilled, believing after months of concentrated drama that a different space might be enough to refocus her and rejuvenate her art practice. Besides, she was tired of all the reminders of soured love that Tidmarsh held. Her disillusionment was total. 'My hatred for Tidmarsh, for love, for everyone has reached a crescendo,' she insisted.[106] Ham Spray in Wiltshire promised a fresh start, and while Carrington laboured over the house as she had Tidmarsh, it soon became clear that the idyll of their early life together could not be recreated. Carrington and Lytton would never share in one another's solitude in quite the same way again, and the disappointment of that was hard to ignore. 'Life here is rather monastic,' Carrington wrote to

Gerald, choosing 'monastic' over 'difficult', which she has crossed out, trying to gloss her unhappiness with a spiritual charge. 'It is so very silent – or am I growing old?'[107]

With the men occupied by their other lovers, and 'after so many years with no proper room' in which to paint, Carrington could spend as much time as she liked in her own studio.[108] 'Really it is marvellous to have a great big light room like this all of one's own,' she wrote cheerfully of her new freedom.[109] But it alarmed her to discover that her art was not enough, not even in these changed circumstances, and soon a loneliness set in that was more intense than anything she had ever experienced at Tidmarsh. In 1931 Carrington painted *Flowering Cactus* as though anticipating disaster. The leaves mimic human arms held aloft and fixed in place, the flower resembles a bowed head, and the petals are rendered in startling orange against a sky blue wall: it is an image reminiscent of the crucifixion.

Towards the end of 1931, Lytton's fragile health began to deteriorate. Diagnosed as stomach cancer too late, suddenly it was critical. Panic and despair gripped Carrington. She retreated to the studio, only to shatter the glass paintings she was nominally working on through inattention, accident following accident, setting them aside to chronicle Lytton's illness to his friends, the broken glass and letters alike failed gestures of control that only attested to the futility of her situation. The afternoon before Lytton died, through a fog of medication, having barely spoken for days, Lytton stirred, and remarked that he had always wanted to marry Carrington. Carrington was standing beside him to hear it.

One of Carrington's final letters was to Gerald.[110] In many ways the letter is unremarkable: Carrington was dull and inexpressive, numbed by months of grief, and she knew it. Suddenly without access to language, she transferred the burden of expression to a pressed flower. Carrington would have been familiar with the Victorian language of flowers, and as such the snowdrop was a kind of letter within a letter, an assurance that the contentless text she did send was not all she had to communicate. The snowdrop represents consolation through death, a symbolic charge that had been circulated in Pre-Raphaelite paintings that Carrington and

CARRINGTON 75

her peers knew well. Through the snowdrop Carrington suggested to Gerald the depths of her hopelessness and despair, and her idea for a possible resolution. The snowdrop was a brief and final reprise of their intimacy.[111]

In March 1932, just over six weeks after Lytton's death, and five days after the letter to Gerald, Carrington took her own life. The snowdrop on Gerald's writing desk; in her diaries, unsure how to go on; a gun borrowed from the local farmer; a frantic call to Ralph and Frances in London. 'You gave me a much longer life than I ever deserved or hoped for and I love you for it terribly,' she had written to Lytton in 1921.[112]

consolation through death

'Lytton's affected by this act,' Virginia wrote in her diary afterwards. 'I sometimes dislike him for it. He absorbed her, made her kill herself.'[113]

Since then, chroniclers of the group have tended to agree with Virginia's damning final assessment: sympathy for Carrington, if not some difficulty in grasping her motivations; ill will for her

domineering partner. While I understand the impulses at play here – it is, after all, a sympathetic gesture – I do not personally subscribe to this belief.

'No one can be what Lytton was,' Carrington had written after his death, 'he had the power of altering me.'[114] Why dismiss these sentiments as inauthentic, mere fantasy? Here was someone who had received so much from Lytton, and a great deal more than most do from more conventionally arranged heterosexual relationships. 'We couldn't have been happier together,' she added.[115]

For their part, Carrington and Lytton were thoroughly uninterested in either the norms that governed straight couples or the expectations of their queer friends: they dreamt up an alternative commitment completely unique to them. Carrington was not unaware of the inevitable compromises loving Lytton involved, as she herself wrote with a clarity and evenness that is rarely ascribed to her: 'one makes attachments which complicate life, & also make life durable'.[116] She knew, as she told Virginia before she died, that his affairs with young men were unimportant, or at least irrelevant to her own standing with Lytton, not touching the integrity and meaning of what they shared.[117] Only then, with Lytton lost to her for ever, was the unhappiness Carrington felt at Ham Spray seen for what it really was: a series of inevitable temptations and distractions; a minor estrangement they would naturally recover from. As Carrington expressed in different ways after Lytton's death, their love was the driving motivation behind her life for all the years they knew one another, shaping its most minor decisions about dinner arrangements and train times to its greatest artistic achievements. Inevitably, the relationship was a magnet for insecurities, jealousies and disappointment, as most are, but there is not a single moment amongst Carrington's personal papers that suggest it was not a powerfully sustaining force for them both, a new way with being and feeling utterly inaccessible in one another's absence, and which Carrington justly felt enormous pride in having brought about.

On the envelope which enclosed the snowdrop, a scrawled note to self, not intended for its recipient, closer to prayer: 'How can I think of anything but you?'[118] It was an impossible question

about grief, purpose, new beginnings and possible growth. For Carrington, no answer would prove sufficient.

ᔈ

Iris Tree on a Horse

What would it mean to end Carrington's story otherwise, on a note of hope? Not Carrington at the door on that final afternoon, in 'her little jacket & socks with a twisted necklace' as Virginia described her, small and suffering and quiet and pale.[119] After all, fantasy and fabrication were Carrington's preference. 'I really hate writing accounts of what I have just done,' she wrote, 'I really prefer inventing.'[120]

Another telling begins in fact. On a summer evening in 1923, Carrington was steadily drinking cocktails at a party and watching intently from across the room a woman she had met briefly once before. Henrietta Bingham was an American socialite who had entertained taking Tidmarsh with her lover, Mina Kirstein, a few months earlier. Carrington had felt frumpy and invisible then, but now tipsy and surrounded by friends, Henrietta's beauty reached her as no less than a spiritual experience: like 'a Giotto Madonna', was how she described Henrietta.[121] Carrington was smitten, but it was not until the following summer that the women began an affair.

Carrington found that her disgust around sex did not carry through into relationships with women, and she shared the revelation eagerly and candidly with her friends. 'I had more ecstasy with her and no feelings of shame afterwards,' she wrote.[122] The ambivalent euphemisms disappear from her discussions of sex. Men had been the problem all along. 'I am very much more taken with H than I have ever been with anyone for a long time,' she wrote to Alix, excited about the affair blossoming into something more permanent, 'I now feel regrets at being such a blasted fool in the past, to stifle so many lusts I had in my youth, for various females.'[123] Confronted by such an electric present, for

Carrington her past mistakes soon ceased to matter. The women spent afternoons together eating fish in rich mushroom sauce and drinking cocktails that even in her veiled descriptions to a curious Gerald are bristling with sexual tension.[124] They painted Carrington's walls an optimistically symbolic 'pure white', suggestive of the new start their bond represented.[125] The simple interior gestured towards a different kind of interiority for Carrington – one that was calmer, quieter, more at peace – and yet for all its potential, the affair with Henrietta did not last.[126]

Although her correspondence with women became increasingly flirtatious – most noticeably with the artist with whom she was newly close, Dorelia McNeill, and her daughters – Carrington would not have had an affair like that with a woman again. The end of the affair was 'rather a blow' to Carrington, who cursed herself for the 'stupidity' of growing too attached, but this woundedness was not all she had to overcome.[127] If a line had been drawn under her experiences with men, then Carrington would have felt different. 'Probably if one was completely S it would be much easier,' she concluded to Gerald, her contraction of the word 'sapphic' as much out of respect to his bruised ego as it was a residue of her own reticence about her claim to that identity.[128] For as it was, Carrington explained to Gerald, she felt torn. Men and women; the old shame and some new happiness she could not quite allow herself to enjoy.

Not enough: in my mind Henrietta continued collecting Carrington in her sportscar, the women sitting together in all weathers as Henrietta sped through the countryside, later dining in charged silence again. The fantasy grew. In some unknown archival folder, letters, drawings and paintings which took their togetherness as their subject, their tone different, the prevailing aesthetic light, witty, erotic and fun. Carrington placing her hand in Henrietta's in a crowded room. Henrietta turning to face Carrington as she describes a Matisse painting she has admired at London's Leicester Galleries that summer, 1936 – a show Carrington did not live to see. To imagine a longer, different life for Carrington, one without men, or the attachments that so carelessly exploited her desire to please: sentimental, perhaps, but it possessed me.

A tinsel picture Carrington completed in the twenties readily accommodated these fantasies. The subject is her friend Iris Tree, but her cropped hairstyle means she resembles Carrington, creating a composite figure which moves between the first and third person. The dark foil that surrounds her states the time, and at this dark hour Iris wears a cape, and she is boldly riding without a helmet – although the shimmer and shape of her hair suggestively marks its absence – forgoing a shield or chain mail in favour of simple clothes, forging ahead into the distance. Transformed into a knight, Iris is at once more obliquely transformed into a queer heroine. Unattached to the home, she is a powerful, itinerant woman driven by passion and violence; a woman who has cast aside a worn armour, freed herself from the defences she has built up to bear the world. In using a character from chivalric romance, Carrington remarks on the courage required to live without these kinds of narratives, stories which are complexly intertwined with preconceptions about love. In these romances, men rescue hapless women who happily lose themselves in becoming their reward: they are tossed from one static set of circumstances to another, never with a will of their own. But, what if, Carrington asks, you were your own rescuer? What would it require to set out in pursuit of another life? What would you take with you and what would you leave behind? Or what if the knight you had long expected finally arrived, and it was not a man but a woman? What if it was that love that saved you?

'Preserve me from such society in my old age, children, babies, & golfing men and females,' Carrington pleaded after a brief spell in such dreary company.[129] Exchange Iris for Carrington, and watch as her silhouette moves at a clip towards the horizon, unburdened by dependents, joyless hobbies or an ailing body. Observe the fleet of childless women she saw as her artistic precursors joining her: the Brontë sisters, Jane Austen, Sappho, Katy Hester Stanhope, Queen Elizabeth I, Berthe Morisot, Le Brun and Julie de Lespinasse.[130] 'How I hate death,' Carrington had written after losing her father, observing the man he had once been reduced to a narrow coffin, a crowd of mourners, her sister's hardened expression, a single horrible morning in church.[131] Carrington dreaded the way in which death

wholly diminished a person, their spirit forgotten in sentimental platitudes and interchangeable rituals. Instead, grant Carrington this: her horse, a map folded in her pocket, a sword, garments for all weather, a cape blowing in the wind. This woman is no tragic figure, but a blazing image of queer possibility. The tinsel picture summons a world in which rewriting the myths of female rebellion earned Carrington the right to abandon the established story of her life, its necessary and brutal conclusions: in its place, imagine her always in motion, on horseback, under a mantle of darkness, moving towards an ending which was as yet undetermined.

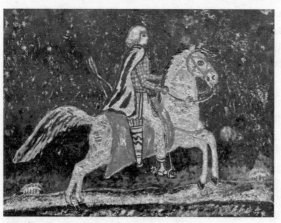

a myth as yet unwritten, unknown

EDNA

What survives of Edna Waugh?

Sketches of sailing ships on cream paper covered in dark stains, the look of wrecks pulled from the sea – anatomy drawings in sweeps of charcoal, legs materialising and striding across the page, modelling motion and strength – roughly executed ideas for larger compositions – drawings judged sufficient experiments in themselves – street scenes with figures, diaristic accounts of her passage through the city – a small bouquet of wildflowers left between the sheets, beside which a man closes his eyes, neck reaching back as though catching their scent – a sunset in stewed peach watercolour with an indigo blue that pours in from the margins; and if it isn't water or wind or the coming darkness, then what is it? – a single black feather, a talisman – Edna sets her pencil down, and the line falters – flower studies around smudges of coloured chalk like loosened earth – a woman leaning into a sketchbook, a woman reading at a window, a woman walking against the wind, a woman waiting by a door, a woman underneath a portrait of another woman, a woman…[1]

What survives of Edna Waugh is a cautionary tale of how a disastrous marriage jeopardised a woman's immense talents, so much so that it meant she narrowly missed having any work to be remembered by at all.

what survives

Judged proficient enough to enter the Slade at the age of fourteen, Edna went on to win the school's most significant prizes. She had met her husband the year before. Twice her age, William Clarke Hall was a barrister specialising in the rights of children. These professional concerns did not cohere with the troubling desires that animated his life outside of court, however. William has been described as 'enchanted' by the then thirteen-year-old Edna, a remark that fails to account for the extremely unsettling power differential that structured their relationship from its start, but might perhaps refer – in its romanticism and wilful naivety – to how William's fixation on Edna drew its emotional repertoire from the Victorian cult of the child.[2] For adults like William emerging from the nineteenth century, childhood was an exulted state of purity to be preserved and prolonged, but for men seizing upon these qualities in girls there were additional, darker motivations. A girl who remained young for ever retained her innocence, her inexperience, and ensured she had no desires, no will of her own,

no power, no ambition, no talents that might threaten his own, all of which prepared her well to become a wife.

Even Henry Tonks, famous for his hypercritical approach to teaching at the Slade – and who was known to be dismissive of women artists – urged Edna to think of her career, warning her that marriage would prove disastrous. Her friend Ida Nettleship agreed, insisting to Edna that her fate as an artist was already sealed, and so much had already been overcome in arriving at the Slade, that whether or not she loved William was irrelevant: she must not marry, at least not yet.[3] Edna did not heed this advice, but neither did Ida, who soon married the painter Augustus John, the charismatic brother of her friend Gwen, a fatal misstep. 'I hope for a different life later on,' Ida had confided to Gwen in August 1904, already solely burdened with the care of their three children, Augustus having lost interest in the pursuit of another lover, and a few years before she died alone giving birth to their fifth child at thirty.[4]

Edna eventually accepted William's proposal. A watercolour still life of her wedding breakfast shows the plenty and possibility Edna imagined entering into through marriage – bowls heaped with jewel-coloured fruits, their colour spreading beyond their bounds with an infectious brightness – but as a prediction, the work would prove unsound. William would go on to ruin Edna's career, and you might even say her life.

Edna's later assessment of the aftermath was lucid: 'I was put on a pedestal and forgotten.'[5]

If William could not have a girl as a wife, then what he wanted was a housekeeper: a woman willing to manage his affairs, direct the servants and appear by his side at parties, and a woman eager to give herself over to those concerns alone. William asked Edna to remove her paintings and drawings from the walls of the house. She obliged, hiding her materials too; she waited each morning for the slammed door, the sudden quiet; once sure of his departure, she began working in secret. 'I think it would be nicer for her to do other things,' Gwen John wrote to Ursula Tyrwhitt, politeness tempering her alarm, on hearing that Edna was unwell, unhappy and having another baby.[6]

a promise

Edna had begun exhibiting work while still a student, first with the Allied Artists' Association and then with the New English Art Club, a trajectory common amongst the most gifted members of her cohort. Marriage curtailed her productivity and confidence, but it did not stop her working altogether. She held commercially successful solo shows in London at the Chenil Gallery in 1914 and the Redfern Gallery in 1924; the ten years that elapsed between those exhibitions belonged to William. He mostly stayed away from his wife's demonstrations of genius, and his disapproval meant that Edna kept her distance from the social aspects of her exhibitions too: she skipped the opening nights, never directly receiving the praise or encountering new buyers and fans; if she experienced those successes at all, it was always necessarily after the fact, second hand.

What survives of Edna Waugh are the scores of watercolours produced for her project on Emily Brontë's novel *Wuthering Heights*; loose and impassioned and full of a transfigured anger, they would define the two decades that followed. In the novel, Edna found a framework through which to understand her own

longing and frustration; in placing the narratives of grief alongside one another, the agonising present pressed against the heightened fictional world, she could attach her suffering to a story larger than her own experience. She began illustrating the novel, and all the untapped intensities from her romantic life were transferred into a simulation of love over which she had total control. Assisted by Mark Gertler, Edna spent long afternoons rummaging for clothes to draw from in second-hand shops in the East End, returning to her fifteenth-century house in Upminster with bags full of material and a clear vision for her next composition. In the absence of models, Edna used herself as the basis for Cathy and Heathcliff. One recent historian claims that in modelling for Heathcliff herself there is a 'lack of strength and conviction' in Edna's depiction of men.[7] But he misses the point.

Edna extracted the idea of a passionate, devoted man out of her loneliness, and it shows. Naturally the fantasy lacked conviction: it had no precedent in Edna's life to work from. She was already accustomed to playing the part of both lovers, attending to her own needs in response to her husband's neglect. Why not use that experience of self-sufficiency in her art? Edna discovered more compelling than the realities of men were her own capacities for the erotic, which she was not afraid to use in the manner that the poet Audre Lorde insists women should: as a form of knowledge.[8] For Edna the erotic was an instinctual response that became a resource from which to explore fictional characters, and from these studies of anatomy and psyche it became a more comprehensive project, a means of mapping out an alternative version of heteromasculinity – one with its own power and principles, moulded by and through the interests of women.

Racked with a loneliness made worse by the atrocities of the First World War, Edna suffered a nervous breakdown in 1919. Omens in her sketchbook: a drawing of a woman's face which disintegrates below the eye, the rest of her features a succession of wavering lines. Neat plaited hair, those basic appearances maintained; her mouth gone altogether, her voice stoppered. The drawing communicates a

total collapse of the self – a crisis well known to Edna. Only under duress did her husband give her a studio.

omens

Much of her work was destroyed in the bombings of the Second World War – losses Edna met with indifference. By then, her hope in her art had run out.

One of the many sketches of women amongst Edna's papers has her subject in a billowing smock, entirely absorbed, her hand moving across a sheet of paper. For centuries on canvas women's hands were folded obediently in their laps, or women's hands were ineffectually guarding themselves from an oncoming assault, or women's hands were gesturing the eye to the most valuable parts of their bodies. Edna was gathering the means to retaliate against these tropes. Over the next few pages Edna crops the composition until it is simply the hand with charcoal balanced between its fingers, and it is an active hand insisting upon its ability to impress itself upon and remake the given world, and she draws it repeatedly as she chases the precise shape of that labour. Accuracy was as

desirable as it was for any artist, and for Edna the repetition of this charged embodied fragment allowed her not only to perfect its look, but also to explore all the determination, wilfulness and refusal art made under patriarchy necessarily involved. For artists like Edna, so much of the body would undergo a similar treatment, a reformulation informed by ceaseless empirical study: limbs redrawn, adjusted, practised, reconstructed again and again, then scrapped, the old associations resisted with every mark made.

Edna lived to be 100. Those hands were multiplying themselves over a sheet of paper in some drawer long after her husband died, and perhaps it was their promise, a kind of radiation that filled the house pervasively and soundlessly and forever, which sustained her.

what sustained her

3

ETHEL

Each interior has the emptiness of a show home, places vigorously cleaned and recently vacated. Painted in 1923, *A Dressing Room* is typical. Dabs of paint bring into focus patterned wallpaper, wool throws and wicker furniture, but patches of bare board untouched by any colour or form do the work of disguise. Absences replace hard surfaces. The blur is a betrayal given the avowed purpose of the space: the dressing room suggests intimacy and exposure, but there is no woman unravelling or adjusting herself according to the hour or need. The dressing room trades in one kind of transparency: that of openness, but this one trades in another: we see through it, and we therefore see very little. The painter ensures that the room is neat and simple and enigmatic, and in doing so insists on parts of herself to which nobody else could have access. Acts of concealment extend beyond the work's visible surfaces: another composition, even more sparse in detail – a few experimental lines feeling out the edges of another room – constitutes the verso of this work and represents an even more inaccessible world. The painting places the viewer before a peephole, our breath held, willing our bodies to become smaller and quieter, worthy of whatever revelation the room contains. For reserves of drama are implied in the room's silence. What is it that requires such thorough camouflage?

a guardedness

Before me were stacks of letters in an impossibly contorted script.[1] The words were completely unreadable: little scratches, flecks, static. Words were neatly arranged into lines, but these lines were then wrenched into other shapes – moving vertically, cutting across one another, creating a latticework – completely obscuring the content of the sentences. Any sustained narrative or detailed description was inaccessible. The occasional noun or recognisable letter had to suffice. Having set aside a week to read them, I had not predicted how this densely written silence might figure in my task, how it would slow my efforts to a standstill.

The letters were written by Ethel Sands to Nan Hudson. The pair first met while studying in Paris at the turn of the century, both eager to pursue careers as artists: they shared an American heritage, a captivation with Europe, and a refusal of their given fates professionally, sexually and emotionally.

In each letter, only the opening word 'dear' was legible, and then words broke down into enigmatic ink markings: sinuous threads of navy blue curving up and looping through themselves, unfurling

and running on and arching and stopping. The letters structured like latticeworks were the hardest of all to read, as intended: a method of saving space, this design also stated the privacy of these sentiments. Their texture was a caution, a dismissal: *not for your eyes*.

I immediately set aside the letters written in pencil, the letters written as if with a single thread of rapidly thinning fog.

The veil would lift for a moment and it would feel miraculous, a hand briefly extended in welcome, and I'd excitedly write down an inconsequential, lonely word.

More like patterned wallpaper. More like a concrete poem. More like an abstract painting. More like dust settled into the corner of a room. More like the pattern mould makes on the ceiling. More like an embroidered piece of cloth. I was so baffled by the letters I took to showing images of them to friends. What is this? I'd ask, what does this look like to you?

not for your eyes

The earliest letters between the women were arrangements, questions about time and location, accompanied by all the urgent

feeling concealed by those logistics.[2] The texts were prompts, practice, or a kind of script, a way for Ethel to kindle her feeling to the precise intensity the subsequent encounter demanded. Afterwards, letters relayed parts of the hours prior that deserved a permanent record, narratives that were suffused with gratitude, each seemingly plain observation inseparable from the day's vast repository of exciting and unfamiliar emotions; then the texts acquired another life – read and reread, certain passages learnt by heart, stored safely as they slept – during the absences that followed.

At the turn of the century close friendship between unmarried white middle-class women was rarely regarded as a proxy for or conduit to desire, even when both parties used the language of romantic love. Ethel was writing to Nan within a context where their charged, passionate letters would have been seen as preparing them for heterosexuality rather than drifting them further and further from it. Amongst other privileged young women these expressions of tenderness normally disappeared once a husband arrived, as by then their purpose had been served. Love had been safely practised, women primed for desire – and all through a bond that was considered disposable; men arrived at courtships with the ground already laid for their success. Perhaps Ethel and Nan's families were awaiting a similar transfer of affection. Yet these letters in fact marked the beginning of an ardent romantic relationship that would never be checked by the demands of heteronormativity. Neither married. They cohabited for most of their sixty years together.

'I love you so.'[3]

'I long and long to have you.'[4]

'My precious heart.'[5] 'I long for you every minute.'[6]

'Dear heart' was confident and effortlessly readable in almost every letter it appeared in. 'I kiss you' floated out, daring and flirtatious, in a handful of letters. The same phrases were repeated with remarkable consistency over the years, flashes of sentiment within a conventional script of sociality. Here were longing and love and loneliness and desire and sadness and abjection, but produced as identical units, without any of feeling's particularity. Ethel's formulaic style was partly drawn from the epistolary norms for a

woman of her class, but their flatness also constituted a further form of self-protection, akin to the inscrutable handwriting and the letters' cross-written texture. The letters present us with a form of double transparency familiar to those acquainted with the illusions of *The Dressing Room*: making claims to an openness of expression, clear as in intimate, they actually reveal very little, clear as in unmarked and contentless. The real meaning of Ethel's letters resided elsewhere.

I arrived at these intimacies by groping through darkness.

'I am every of your precious self.'[7]

I filled in the blanks as best I could –

There were possible verbs of relation, like *devoted, committed, besotted*; there were prepositions indicative of closeness, like *with*; there were nouns expressive of the reach of their love, like *inch* and *part*.

However, what became clear was this: the exact words were irrelevant. What mattered was how the line placed Ethel and Nan together, facing one another on either side of the clause with illegible text between them like lovers exchanging glances across a crowded room. The ambiguities common across these texts were not an attempt to say more, but were proof that what was said was of little importance. The letters were contact, as simple and unequivocal and even at times as mute as physical touch. The letters were less about their apparent content than a bracketing of the women into the same space.

To persist in reading these letters was to cease caring about finding a coherent narrative, and instead the letters disclosed their meaning in the manner of fragments. Little cries out of the darkness, a few murmured words overheard through a wall, they had their own enigmatic power. It was impossible not to think of Sappho, and how for queer women a literature structured by silences had its own rich history: those erasures that were necessary, willed and strategic, like removing a woman's name or a telling pronoun from a poem; and those that were unintentional, part of the precarious life of the text as a material object, such as the letters seized and burnt by family members, the censored novels and abandoned manuscripts.

A typical transcription of a letter was frustratingly partial and jumbled, tonally uneven, filled with uncertainties and possible errors, awkwardly lyrical:

Painful!!!!! Friday
 I am writing (scowling? Hurting?)

you in
 feel & effort & deny

which ended
(chucking, chuckling, clicking)
feel Darling
hoping <u>so</u>

A handful of phrases inside reams of text that might as well be empty space; glimmers of feeling amongst the arid formalities, like water illuminated by a divining rod.

By experimenting with the forms through which feeling was articulated, circulated and understood, Ethel's letters address issues that were central to the policing of queer life at this time. Lesbianism was understood, in a sense, to be born out of acts of expression. In 1921 it was decided that the 1885 Criminal Law Amendment Act would not expand to include acts of gross indecency between women. Not the case that lesbian desire was being discounted; rather, Parliament was gripped with fear. Speaking about lesbian desire would give form to otherwise formless urges, it was believed, or would prove a powerful education in desires women need not have any knowledge of at all. Better to 'not notice them, not advertise them', as Conservative MP John Moore-Brabazon advised.[8]

After 1921, more than ever, silence was the policy the state adopted, and was consequently what the state demanded of queer women. These women learnt to write themselves out of their own literature, lent their ciphers new and appropriately gendered bodies, and if they were artists, they noticed what was exhibited and praised and sold, and promptly erased themselves from their art. Women

disappeared, or women disguised themselves and their families, or women went deeper underground with their desires. While these measures succeeded in diminishing or destroying certain identities and communities, it was also true that in completely unexpected ways they cleared the way for new ones, and transformed for ever the possibilities of those that had through good fortune, or privilege, or skill, managed to survive. Because of her class, Ethel was better able than most to challenge these sanctions, and the letters reveal the methods she arrived at to do so as practical and even at times a little playful. Rather than choose complete silence, Ethel became a master of ambiguity and evasion. Platonic relationships between women of her class were understood to include a variety of intensities, confessions of love included, and Ethel skilfully exploited these norms, inserting exactly calibrated phrases into her correspondence, and never pushing beyond what she understood as the bounds of respectability. Nevertheless, the letters and their declaration remained, in effect, a gamble. Ethel trusted that the strategies she put in place in the letters, their formality and vagueness, were enough to deceive the disciplinary powers of the law and the family as to the true nature of her relationship. The risk was worth it. She would be proved right.

Elegant and withholding, the paintings aim to please as demonstrations of taste, placing the viewer at a distance from the home's inhabitants, Ethel and Nan: intimacy is not the aim. A partial image materialises: the women's heads are bowed, shadow surrounds them, and the sound of their whispered dialogue is indistinct but unmistakeable in its affection. A fragment of their private discourse, a flash into their decades of love – if that was all that was available, it would have to suffice. The trail of evidence Ethel left behind her was thin both in its quantity and in its apparent level of interest, and looking at it required a willingness to bore into its surface narrowness and composure, and to listen to the fierce, expressive vibrations that resound from her art, a supplement to all that was left unsaid in her correspondence. Only then can the more transparent fictions evaporate. Neither the worn spinster caked in white powder she plays in the correspondence of crueller friends, nor the frivolous,

old-fashioned hostess she appears as in others attests to the distinctive, courageous woman she was: a woman who never allowed these judgements any part in making sense of her life, dedicating herself instead to building a substantial self only she and Nan could see.

༄

The Chintz Couch

The curtains are drawn. For a moment, the darkness appears total. What slowly emerges from the shadows: spots of lilac, pondwater green, dirtied gold, a palette balanced between nature and artifice, and with it the creation of an exhaustive world unto itself. More: fabric that gives off static. Muffled sounds from the streets beyond: 41 Lowndes Street, Belgravia, a townhouse purchased a few years earlier. The glint of lacquer. Scenes from related worlds adorn the walls: more wealth, more accumulation, more pleasure. The scent of lilies; faint pollen stains underfoot. Dust that settles on the skin, and catches in the throat. A small fortune in a single room. A grand, calculated statement about status. A taste for eighteenth-century French decor, flawlessly executed, is placed behind a locked door, submerged in indifferent dim light: its function is to impress, to express something critical about the passions of its maker, and so without an occasion to draw out its meaning the room is simply this – an abandoned stage-set, tense with expectation.

Ethel grew up the pampered child of American socialites. Money had made life exquisitely smooth at its edges: weekends spent mixing with the English royal family, a stint spent living in a series of well-appointed rooms at Claridge's, holidays playing boules in the manor houses of the aristocracy. Raised to understand herself as the natural heir to her mother's role as a hostess, there was never any question of Ethel entering a profession; her own dreams were irrelevant, and their dismissal accepted without complaint. She woke at a time set by her mother to be dressed by others in clothes she never chose, and ate according to the tastes and schedules

a world onto itself

of the household. She did almost nothing for herself, and under constant supervision, spent almost no time alone. She received a small education in literature and French, enough to make her conscious of how little she knew, and the rest of the day was spent contriving ways to fill the remaining hours with a governess or companion in one of the rooms cordoned off for her leisure. This was the routine she lived by for years; some afternoons passed more quickly than others. Her life was frictionless, completely without fear or hardship or even much expectation, but it was not her own.

After her father's sudden death, scorning her future in the only way she thought possible, Ethel left her mother and two younger brothers and the responsibilities they represented altogether, setting out for a new life in Paris. Crossing the Channel with suitcases stuffed full of neatly folded cotton, satin and lace, Ethel imagined the pretences of recent years diminishing with the horizon. Who she was need no longer be so persistently defended or concealed. Never again would she stand in rooms enduring relatives calling her plain, and nor would she stumble over an appropriate response

when young men perfunctorily asked after her ambitions at balls. She could finally answer with confidence: I am an artist. While her mother had been painted by John Singer Sargent (*Mrs Mahlon Day Sands*), the highest possible success for a woman of her social position, Ethel saw herself on the other side of the canvas.

Very little is known of Ethel's first years in Paris. The prying relatives and acquaintances withdrew, and the space their departure created was miraculous. She enrolled at the Académie Carrière, determined to improve her technique, and it was there that she met Nan Hudson. Unclear whether the encounter occurred amongst a throng of others – a glance, a kind word, a lingering touch – or if the studio was empty save for these two women studying one another: curious. Once her mother died, Ethel became the legal guardian of her brothers, but she never allowed the practicalities that surrounded grief to curtail her plans, continuing to put all her available energy into her education. The selfless sister finished writing a letter of thanks, a response to the flood of condolences, and walked out into the streets of Paris once again the determined artist. There she was, exiting an atelier into the low hum of a balmy Parisian afternoon with her paints in a bag slung over her shoulder; or she was standing with Nan at an easel in the studio suggesting a grey glaze to convey the slow movement of a low morning sun; or she was edging closer to Nan in a heated discussion of aesthetics, comparing their rudimentary experiments with what they saw on the walls of the Louvre. She was engrossed in her own art and that of others, searching and restless, caught in the irresistible pull of the present moment.

Few women were able to live as she did. Ethel was immersed within a social hierarchy that had furnished her with all her privilege, freeing her to travel, paint and educate herself without ever questioning whether it was possible, but she did so as an outsider of sorts, and at a cost. Accepting her family's money constituted a tacit acceptance of the rules that governed high society. While some elements of that world were suffocating and obsolete, norms regarding desire and ambition and appropriate pastimes which were felt keenly as a limit on her own life, others

were irresistible – the parties and dinners and material possessions – and most were simply too habitual to even question. After all, this was the only world she knew, and she had learnt to thrive within its limits. Respectability enclosed a set of norms that allowed Ethel to move through her social world fairly anonymously – passing as a heterosexual woman of her class was easy enough if certain behaviours were learnt and reproduced – but however much she manipulated these ideas for her own gain, the performance involved a subordination of her true self. If Ethel were to entirely comply with the moral directives of her class, then marriage soon beckoned. In the life that awaited her, art could never be a serious pursuit. The unspontaneous, unsatisfying years of her adolescence would be relived with only minor adjustments, and expanded to fill the decades that followed. Above all, what Nan meant to Ethel would have to be concealed.

In *The Chintz Couch*, the couch presses into the bottom edge of the frame, the tips of the skirt invisible, filling a drawing room that has been vastly diminished in size through the crop. The painting hints at the compromises that came inbuilt into the immense material privilege of the conservative upper classes, and in doing so delivers a warning: beware the lure of the opulent room, for it might prove a gilded cage.

Paintings within painting are a signature of Ethel's work. Expecting a demonstration of skill, a microscopic recreation of an image, moving closer it becomes clear that the forms are blurred. Ethel wipes her hand over the images as though they were still wet from being painted, and what is left are smudges, vague as afterimages. While each occurrence has its own distinct meaning – they often remark upon the level of light, or direct the gaze to other objects – what this trick ultimately acknowledges is the control Ethel had over what people saw. Aware that her value was drawn from an aristocratic moral universe violently dismissive of her desires, Ethel began an

elaborate campaign of misdirection. She drew a vague outline of the woman she was, or rather how she wanted to appear, and it was accepted: unassuming, conventional, socially fluent but remote, dispassionate, poor raw material for a wife. There was a great power in that: the life prepared for her disintegrated. This act of disguise became addictive, the risk of any richly rewarded demonstration of skill, or it became entirely habitual, as any daily performance might, because Ethel never stopped. The social world marked out by *The Chintz Couch* was Ethel's for life, and it was not out of necessity that she remained there, but out of a stance of obstinacy, out of choice. As a society hostess she broke its most important rules surrounding sexuality and partner choice, but did so parading her transgressions as something else entirely. Through a mixture of her own guile and her circle's ignorance, Ethel broadcasted a carefully manufactured image of herself, and one that traded in the disorienting and liberating effects of blur. Nan at her side at parties and dinners: spinsters held together by shared circumstance, or close friends that behaved like lovers, or lovers who considered themselves life partners – for those around them, it was never wholly clear.

The line between subversion and self-protection was carefully navigated with each appearance the pair made together, and a version of those efforts plays out at the centre of *The Chintz Couch*. Popular in the eighteenth century – and by Ethel's time very much in its decline – chintz fabric signalled prettiness, refinement and traditional good taste, and was therefore a symbol of the kind of conservative, elegant upper-middle-class woman who would have chosen it for the drawing room of her family home. Ethel places this status object within her own domestic space, and in doing so ignores how her eccentric, queer femininity was not consistent with the values the material represents. Conscious her domestic life would never match the norm, aware of her exclusion from its fundamental ideas, and undeterred, Ethel simply remade it around entirely different coordinates: a wife in all but name, no children, friends, art. The chintz couch is about passing as a particular kind of woman and excelling in the impersonation, enjoying it

even. It condenses all the instances in which Ethel found herself smiling blandly amongst male company as discussion descended into vain posturing, then recounting their attempts to impress in satirical tones to Nan hours later. The countless afternoons spent making conversation amongst the wives of her circle, offering careful enquiries into the health of a husband, remarking upon the felicity of some new match, aware none of these questions had any bearing whatsoever on her own life. And the moments in which she overheard cutting remarks from friends and acquaintances, all of them judgements of lack and inadequacy – 'spinster' or 'virgin' – conscious they only stated the believability of her performance, indicating a complete ignorance of the experiences she shared with the woman she loved.

The ripple of sunlight is a measure of the room's darkness. Only the arum lilies are immune to the shadow, and they are strangely clear-cut, as though transplanted from another painting. If the arum lilies are uprooted from elsewhere, then it is from images of the Annunciation. These scenes depict Mary's transformation into the Madonna, a process that locates the miraculous in the gap between the seen (Mary's swollen virgin body, her baby) and the unseen (the Angel, God's message, her faith). Ethel's room reverberates with thought about appearance and disappearance, display and artifice, broad queer themes relating to the experience of secrecy.

Yet the allusion to Mary was perhaps a more personal metaphor for Ethel. While Mary's body betrayed the extremities of her inner life, Ethel's apparently virgin, spinster body was the sign that concealed her own spectacular act of faith: her rejection of heteronormative life and her devotion to Nan. Much like the myths that sprang from the Madonna, Ethel's self-presentation played upon received ideas

about women and sexuality: women are either marked by sex or definitively outside it, no in-between; Madonna or whore. While these myths were normally used against women, to control their behaviour and set unattainable standards, Ethel deployed them to her advantage. The body she presented to society did not appear to desire, and in doing so threatened no order; it was as pure and one-dimensional as the arum lily placed inside her painting. Through removing her body from the conventional sexual economy – dressing to stress her plainness, her thinness, her dowdiness – Ethel slipped free of her responsibilities as a woman of marriageable age. Mary transcended her straight, sexed body through a spiritual vocation, but Ethel's outward celibacy had more transgressive ends. To be dismissed by society as chaste, prim and unattractive was to bypass an unwanted life, and to settle into a queer one.

*

Ethel mined her own experiences for artistic material, taking inspiration from the Impressionists, who had engaged in a similar project, accessing the most heightened aspects of their daily lives in the city through depicting scenes at the opera, bars, music halls and nightclubs. Women are present – they dance, they serve drinks behind bars, they undress – but as these urban spaces were always more comfortably inhabited by men, there were limits to what roles they were assigned, and how real ultimately their representations could be. Flimsy and vacant, these women impart little else but a statement on the painter's dominion. Which is to say that women were subject to the one-dimensional thinking of men, and it showed. Not content to allow male painters sole authority over the definition and location of modernism, nor on the possible meaning of women within it, in her own work Ethel moved the gaze away from these scenes of recreation and leisure.

While Ethel shared with the Impressionists an interest in bourgeois social display and ritual, her paintings reimagine the

gender, sexuality and space at the centre of the frame. Glance out of the window, the hour has changed; absinthe no longer lends the room a blur; the darkened bar yields to a well-lit drawing room. The rooms are conventionally decorated, but the angles Ethel paints from are unexpected, with spaces entered aslant, encountered as thick slices of glass and fabric and hard wood, and the viewer is left stranded on the threshold, our vision askew: a queer orientation prevails. As for the women, they participate without any risk of voyeurism, as unlike in the Impressionist precedent – where women's function always fell under some form of service or consumption – Ethel refuses to allocate roles, to summarise a woman's purpose. She releases women into unrepresentable space; they circulate in the surrounding rooms and gardens, unseen. In so often depicting empty rooms, of which *The Chintz Couch* was but one example, Ethel alighted upon a more subtle and sympathetic way of conveying women's experiences.

Women linger as fingerprints on the objects, specks of dirt on the floor, a scent in the air, worn patches of pile in the carpet, a distant sound of laughter, the tension of a question left unanswered, a chipped edge of a cup, rouge smudged onto a handkerchief, a folded page corner in a book, a single hair on the sofa, a letter placed face down on a table. A material and emotional presence that is invisible to the detached observer – for men seeking out a certain kind of visual gratification, for instance – but not to someone intimate with what the painting represents. Ethel could see the women. As could Nan. There were many women in their circle capable of seeing themselves and summoning others in these works.

In some respects, what was radical about Ethel's work never wavered: the Impressionist painting is seized and reworked without compunction again and again. Yet it is difficult to account for how unsatisfying these paintings can be, how bland their address and conventional their thesis: property ownership and wealth are privileges entirely taken for granted, and the life these circumstances create is judged pleasant, ordered and exclusive. In Vita Sackville-West's caustic 1930 novel *The Edwardians,* the narrator passes

how women linger

through London rooms that resemble those in Ethel's work, all 'equally impersonal, conventional, correct'.[9] Vita has her narrator experience this monied homogeneity merely as tedious, a testament to the unimaginative mindsets of these homes' inhabitants, but it is unclear whether Ethel even entertained such mild judgements. The paintings shrug before the gruesome inequities that made them possible. This was not necessarily Vanessa Bell's target when she accused Ethel of a 'fatal prettiness', but the unchallenged niceness and rightness of these works can feel like a dead end of sorts, unwelcome ground for any nuanced consideration of the context in which they were created.[10]

The paintings present a clear vision of the personal coherence and contentment bestowed upon those with inherited fortunes, but these emotions were not necessarily always accessible to Ethel. In her letters, the woman of her pristine, cheerful paintings is unreachable: the rooms rearrange themselves, the light goes, mess piles everywhere.

'I feel particularly despairing this morning.'[11] (Days pass in begrudging service to her family.) 'Have you quite forgotten me dear one? I am beginning to wonder.'[12] (More hours alone with

her thoughts.) 'I feel quite suicidal this morning.'[13] (Impossible to always be apart like this.) 'I am feeling so wholly miserable and complaining when I ought to be so thankful that I have my own dear one.'[14] (Some rooms still too treacherous to navigate together.) 'Everybody had a lovely time, except poor Ethel.'[15] (Stalling over saying Nan's name at social events she feared inviting her to.) 'I am in such depths of blues that I cannot believe in any possibility of a bright future.'[16] (Watching suitable men approach Nan with a certain intention in their gait, a sinking feeling in her gut.)

These expressions of loss were the thread that bound her early letters, and their stern affect was only intensified by the difficulty in deciphering the sentences that preceded and succeeded them. Nothing was as stark; they were all I had. Attempting to align Ethel's blithe paintings with these mournful passages meant accepting their apparent incompatibility held some deeper meaning. A simple explanation once I arrived at it: these were complementary rather than contradictory states, her painting and her letters; one sought to repair the damage of the other.

Ethel's scores of flawless interiors animate her queer domesticity with refinement, taste and sophistication – a corrective to the norms of late Victorian culture in which lesbianism had been linked with criminality and moral bankruptcy. The art and literature the women encountered when they met at the turn of the century in Paris consistently aligned lesbianism with violence, disease, hedonistic excess and social death. The material was a schooling in appropriate desires, propaganda on casual homophobia and self-loathing. Contemporary sexology was no help: as Sigmund Freud's theories took hold, desire between women was dismissed as a product of arrested development, narcissism and trauma, an abhorrent quirk in the psyche that required a cure.

As documents for understanding themselves, such texts must have troubled many women, and Ethel's desperately unhappy letters from her youth in Paris no doubt bore the weight of broader cultural representations of lesbians. To accept shame as the necessary compromise in loving Nan was brave but unsustainable; the urgency of living otherwise pressed against both women, and eventually a

strategy was formulated. Ethel began to record their life together on canvas, a simple act of protest which proved revolutionary for them both. Only in dwelling over the luxurious particulars of her lifestyle with Nan was Ethel able to start addressing her deepest anxieties, moving her impression of her own queerness away from sin, perversion, sickness and degeneracy and towards pleasure.[17] On canvas, Ethel defied the belief that her desires doomed her to a life of irrational melancholic attachment and romantic disappointment, painting as though happiness were synonymous with a particular style, a state she might be granted access to if she repeated the same colours and forms with enough tenacity.[18] And as declarations the paintings came to exert a kind of magic. In the letters, the expressions of sorrow gradually diminished in volume and intensity, new emotions took hold, until years had passed and those fraught outpourings all but ceased altogether.

Cushion

Through the cushions it is possible to converse with the seamstresses, and to work alongside the maids. Observe the women bent over their stitching, their fingers advancing through tight, agile manoeuvres, unpicking errors if they arose, the pattern adjusted according to need. Their ingenuity survives in the seams. The cushions were boxed and transported. The maids received, carried, plumped and rearranged the cushions, their touch discernible in the dappled surface of the fabric, their methods shaped by a sensitivity to texture, density and movement. In years given over to a meticulous mistress, this work was hardly responsive to the talents and intelligence these women harboured, the art they might have cultivated in secret, and it was rarely recognised as anything other than menial work. Yet there was an art to it, this acute consciousness of a room's appearance, the alarm that sounded within them at even the smallest asymmetries. Their names are largely forgotten. Their presence shielded Ethel from the frictions of ordinary being for her life's entire duration. There is no telling what they would have made if this comfort had been their own.

Girl Sewing, Auppegard, France *(1920s)*

༄

Nan Hudson Playing Patience at Auppegard, France

They do not need to be in each other's arms. They do not even need to be looking directly at one another. Their intimacy is so utterly familiar, effortless and exhaustive as to be almost invisible, unnavigable to an outsider, more like an electrical current or a change in temperature than a single definite act. But if their love had to be identified anywhere it would be in the precisely observed heaviness of Nan's eyelids. Nan studies her cards, her eyes soft dashes of black paint suggestive of fatigue. Representation shifts on impact with care, formal concerns are abandoned, and Ethel's acute sensitivity to Nan's body breaks through the surface.

In not corresponding to established models of queer desire between women, Ethel and Nan's relationship was hard to categorise both to their contemporaries and later historians. Neither woman adopted masculine dress – occupying the role of butch to the other's femme – and unlike Gertrude Stein and Alice Toklas, or Radclyffe Hall and Lady Una Troubridge, they shied away from public attention. Neither woman was flamboyant or outspoken; there were no scandals involving other women, no incriminating attachments to queer social causes, no salacious

memoirs late in life. Their unconventionality and privacy, on top of a nervousness around laying claim to queerness before those social identities could be said to exist in the modern sense, meant their relationship was often defined simply as a companionship: mild, platonic, rooted in convenience rather than passion. Much of the speculation about Ethel and Nan assumes that their sexual identities or status as a couple should be wholly defined by sexual acts; it was not enough that their lives were entirely oriented around one another, and derived great meaning and momentum from their togetherness. Anxieties around defining their relationship all proceed from a version of this question: why presume they were lovers? No one asks: why presume they weren't? And neither question accounts for a reality in which all the available possibilities – inclusive of friendship, love and desire – played some part in the truth.

familiar, effortless, exhaustive

Partly the elusiveness of their relationship was a result of deliberate efforts on their part to make it so to others: at every juncture, whether in the epistolary or artistic frame, a clear view of the couple is blocked. So many of Ethel's paintings show rooms opening out onto other rooms, a common use of space in the Dutch genre scenes which she took as models, structures which give the impression that if enough rooms are entered and explored as the paintings encourage, then Nan might be found. Most of the time, the search is in vain. There are a few works with elliptically described figures that either are Nan or might be Nan, but even with the fact of an identity there is rarely a distinct emotion involved, so much so that she might as well be another object, as unalive and indifferently rendered as an antique chair. Accustomed to seeing her as a formal device, a way of structuring otherwise empty space, her presence in *Nan Playing Patience* is all the more surprising.

Played alone, patience works through laying out shuffled cards in an established pattern, then attempting to sort these cards into uniform decks of particular suits, using one prescribed movement at a time. The task is methodical, the stakes low, the pace entirely dependent on the player. Patience proved a popular pastime for women of Ethel and Nan's class precisely because of how adept it was at marrying so many elements of acceptable feminine behaviour, modelling to women the rewards of self-regulation, composure and idleness, encouraging them to engage in activities that were an end in themselves. As a training ground for the unproductive and inconsequential, patience helped middle-class women acclimatise to the comfortable emptiness of their lives.

In Ethel's painting, however, the game is laid out with a subversive edge, its title alluding to a decisive strategy the pair adopted in protecting their relationship. Patience and discretion had got the women far in their relationship

in public, shaping how they communicated and behaved and even how they painted; in private, it had served as a way of testing out boundaries with their friends. Virginia Woolf, introduced to Ethel through shared high society circles, after much wavering over her writing schedule spent three days with her and Nan in Dieppe in the summer of 1927: the women motored along together through the countryside, stopping to catch the steamers moving along the Seine, or to glimpse a stretch of startling blue sea from a churchyard on a cliff.[19] In the evenings, Ethel craved conversation while Nan was content to listen from an armchair, sewing dusters.[20] The mood evoked in Virginia's descriptions is sweet and uninhibited, but the playful atmosphere belied the calculations that necessarily accompanied any outsider entering their world. Only a closely guarded group had access to their intimate lives, and even then a stray comment or a misjudged friendship could prove disastrous, the veneer of correctness the pair had pieced together pretence by pretence over the years exploded in an instant. Each move Ethel made within their network of friends and acquaintances had to be deliberated over and monitored so as to eliminate any dangers, to harden the boundaries against some while creating points of entry for others.

What this meant was intimacies that developed at a glacial pace. Even after the apparently deepening closeness promised by the visit to France, Virginia still referred to them half-seriously as 'the two discreet ladies'. [21] A nod to their shared secret, the omissions and tact their friendship demanded, lingering in this term of endearment was a sense of the unbreachable distance between herself and the couple. With such elaborate defences, it was possible to only get so close, even if every available test had been passed, and you were accepted into the higher strata of their confidence. Patience is at its core a game of grouping alike things together, and echoes the fastidious work that Ethel and Nan did to sort through and organise those that composed their social world, filing them into categories according to their potential harm or potential use, estimations that at times appeared cold, even ruthless. Once the game had been won, the women were left

with a clear sense of who posed a threat, and a neatly assembled group from which they could draw their allies.

Patience is also about noticing patterns or logics where they are not otherwise apparent, and using that acuity to make connections. One way queer men and women recognised one other was through precisely calibrated forms of dress, behaviour, speech, geographies and taste; once those codes were learnt, they could be adopted, circulated and acted upon with caution. Evidence suggests that Ethel was conscious of this protected form of knowledge, and practised one of its most precious and devalued strategies in conveying vital, transformative information: gossip.

After an unimpressive first meeting with her future lover at a dinner party in December 1922, it was Ethel who deftly informed Virginia of Vita Sackville-West's 'sapphist' tendencies some months later, aware the revelation might prove useful to the newly acquainted women.[22] Patience stood in for the distinctly queer art of observation, analysis, connection and exchange, the coming together of intuition and empirical study which Ethel – without any formal guidance or even much precedent to work from – had perfected over years of identifying possible partners. Given a few masterfully steered conversations, Ethel could emerge from it with a conclusive statement: sapphist, or not. The heavy eyelids on Nan convey tiredness just as much as they do ease: the women could both play this game of identification as though it were second nature, or – as it were – with their eyes shut.

Virginia ultimately entered the pair's confidence to the extent that her observations of them are some of the most revealing indications of what the women were actually like. 'Nan is a sterling dignified upright character,' Virginia wrote approvingly, 'with more sound and fury in her than Ethel.'[23] Ethel did not necessarily fare well in these comparisons. Her performance as a high society hostess had a mannered demureness many could not tolerate, and her tendency towards flattery and surface sparkle when assuming this role felt, even to some of her closest friends, insincere. Her obsessions were harder to square with

what was considered moral or important during her lifetime: she was fascinated by the choreography of social arrangements, in parties and conversations, and she was interested in pleasing others, in the surreptitious powers exerted by charm. Or, as Virginia put it in more binary terms later in the same letter: 'She [Ethel] longs for society. Nan for solitude.'[24] Ethel agreed with Virginia's notes from the field. 'Although we love each other so dear, we don't like the same places, or the same things, or the same people,' she wrote.[25]

In the portrait that emerges, what is stressed is their difference. Perhaps Ethel corroborated these accounts so as to draw attention away from the more subversive charge of her and Nan's sameness: as feminine-presenting unmarried women, there was no need to further highlight the queer fact of their likeness. Differences in character were reiterated by their choice of subjects as artists: Nan painted exteriors, Ethel interiors, which ensured they did not threaten one another's artistic territory. At their joint exhibition at the Carfax Gallery in June 1912, Ethel showed twenty-one interiors and still lifes, while Nan had twenty-three paintings, all but two of which were landscapes. The rich vista of lush fields and exquisite rooms the women put forward for the exhibition were testament to the fruits of their contrary values, the entire world they made together.

In another couple the mismatched energies might have proven impossible, but Nan and Ethel made of them a test of their devotion. Imaginative split scheduling was one solution: the summers were spent together in France to accommodate Nan, and the winters were spent apart with Ethel in London so she could have her fill of parties. The work of balancing solitude with sociality allowed the women to continually display to one another the strength and flexibility of their relationship, their willingness to compromise and adapt so as to remain at the centre of one another's lives. Having vaulted so many obstacles to be together, these gestures were a reminder that nothing as trivial as divergent social preferences could stop them. One of the few surviving works by Nan shows the façade of their house in France, the same space that Ethel used in so many

their differences

of her interior scenes: in it their contrasting concerns are condensed. On the reverse of Nan's painting the inscription reads: 'Darling Ethel, from Nan'. Underneath Ethel and Nan's differences, the very ground on which they flourished, was their pledging of the most meaningful stuff of their lives to one another; or – put simply – their love.

Interior with Mirror

While visiting Ethel and Nan in France, Virginia arrived at an idea for a short story. 'Ethel Sands not looking at her letters,' she wrote in her diary, 'what this implies. One might write a book of short significant separate scenes. She did not open her letters.'[26] Virginia followed through on these observations, and wrote a story, 'The Lady

in the Looking Glass', centred on a woman named Isabella Tyson, the mistress of a grand home over which only she and a whirl of 'lights and shadows' and stray emotion presides.[27] Ethel inspired the story's protagonist, and she is present too in the looking glass, the centrepiece of Virginia's 1929 story as well as a luminous interior scene Ethel painted – perhaps inspiring Virginia – sometime in the twenties.

The mirror is many things to Ethel, a surface onto which various thoughts have been written and rubbed off. The mirror is a comment upon art itself, how painting and writing alike aspire to reflect reality back to the viewer. But mimesis is a slippery business: representation never quite approximates the real. In Virginia's story the looking glass holds the objects 'so fixedly', while the narrator watches these very objects subtly shimmer and darken, a disparity structured by an anxiety about the capacity of writing to capture the shifting idiosyncrasies of the world at any given moment. The 'passions and rages and envies and sorrows', or the aliveness of the room, Virginia suggests, is lost in her efforts to contain it.

her presence

Or it is easy enough to see the mirror as a tool of surveillance, a reminder of the mechanisms of self-regulation middle-class women were subjected to even in their most private space. The mirror as a prompt to continue performing; the mirror as a mark of women's relentless visibility. This was certainly true for her peers, but Ethel's engagement with the social rituals of upper-middle-class femininity always had an element of irony to it: she had mastered the performance, rather than it mastering her; so much of her remained stubbornly invisible. For Ethel, the mirror was more about withdrawal, or the victories of illusion and misdirection, than being watched.

Mirrors in paintings often function to illuminate otherwise unreachable parts of the scene, including dim or distorted glimpses of the artist themselves, but Ethel's use of it does not proceed from the same premise. There is neither the same urge to boast of the omniscience of the painter, nor the desire for recognition, to place a living signature of herself inside the work. All Ethel reveals is an outline of the decorative scheme on the walls, a stillness, a pearlescent oyster-shell shimmer, a powdery light. In Virginia's story the narrator complains about the presence of mirrors in rooms, how irresistible the urge becomes to stop and take stock of herself, to play into the oppressive functions they are designed to perform. Here the mirror is acknowledged, but Ethel only ever flirts with the temptation to scrutinise or reveal herself. Her face flashes against the surface and disappears. She holds herself apart, and makes a spectacle out of that ambivalence.

Ethel turns towards the mirror only to rub her likeness from its surface. The mirror had been a complicated object for Ethel. As a young woman her unusual appearance had flung her far from the centre of marriageable high society, and while this would have been disastrous for any of her childhood acquaintances, for Ethel it was profoundly liberating. The standard plot for a woman of her age and position was dismantled without even much effort or conscious rebellion on her part. There was one formal proposal, which she refused, and a few more casual attempts by men at suggesting marriage – Lady Ottoline Morrell recommended

Lytton Strachey propose, for instance, although it's unclear whether he ever did – and then years passed in which there were no suitors, until enough time had passed in the absence of male attention that it was clear she would be free for good. Many saw her, or failed to see her, exactly as Lytton did. 'Suddenly observed in the extreme distance,' he wrote, acknowledging – whether or not consciously – the remove at which he was always already placed, he described her as 'dressed in white satin and pearls and thickly powdered and completely haggard'.[28] The cruelty she inspired in acquaintances like Lytton was part of that same freedom, allowing Ethel to concentrate only on those she trusted, presenting the exaggerated powdered façade to everyone else, wandering out of parties with Nan when she pleased, unnoticed, even unwanted. *Interior with Mirror* is not interested in the injustice of being ignored or the emotional fallout of such vicious judgement, the inevitable pain, humiliation and diminishment of those experiences, and instead celebrates the covert pleasures of conducting a life in which nobody was looking. This was the joy of the peripheries, the privileges of the scorned. Ethel's invisibility was not about failure, but power.

Ethel was careful, sensitive, modest, watchful, secretive and shy – understated personal qualities which her painting hails as exceptional, heroic modes of self-protection rather than acts of concession or retreat. Ethel steps back from the mirror, but transforms this apparently hesitant act into a huge rectangle of light, into a shyness that is not shrinking but triumphant and powerful, a shyness that resembles the beaten-metal surface of a shield.

As a symbol, the mirror had other, more insidious ends in the history of representation: in the late nineteenth and early twentieth centuries, mirrors were used in baroque, overblown paintings in the decadent style to comment upon the nature of lesbian eroticism. Drawing on Freudian ideas of narcissism and homosexuality, these paintings place beautiful women before a mirror, and make of it a metaphor that underscores the regression, sterility and perversity of queer desire, all the while

eroticising those terms for an assumed heterosexual male viewer. Given her immersion in the art of this period, the galleries she frequented and books she read and male artists she studied under, Ethel would probably have encountered these paintings whether or not she actively sought them out. Her own use of the mirror subtly alludes to this tradition while erasing the women altogether, and not because she had no stake in reimagining the trope and its queer theatrics. For Ethel and many other women like her, understandably preoccupied with their own survival, revising the available representations of queerness meant aligning themselves in public with an identity that retained the power to completely ruin their careers, if not their lives.

Occasionally disasters centred around these anxieties made it into the press. There was the 1918 libel case in which the actor and dancer Maud Allan fought – and lost – a court action to quash rumours circulating in the press about her sexuality. Maud's leading role in a production of *Salome* was marshalled against her, but the deciding evidence was her understanding of the word clitoris, which (it was argued) only women with perverse desires would know.[29] There was the 1928 obscenity trial concerning Radclyffe Hall's coming-of-age lesbian melodrama, *The Well of Loneliness*, which culminated in an order for all copies of the book to be destroyed. Maud's performance and Radclyffe's book were hardly explicit in their expressions of desire, but the little there was – in both instances the critical transgressions were minor in scope, a handful of phrases or a single word – proved enough to incriminate them. Ethel's casual observation of these cases in the press would have shaped her own reluctance to appear in her work, let alone to defiantly reimagine a clutch of tired, enduring stereotypes. The empty rooms that define Ethel's work, *Interior with Mirror* included, highlight how as a queer woman it was not enough to reveal little – next to nothing even; if you wanted to be safe it was necessary to give the impression of not existing at all.

Virginia was probably not alone in being unsettled by the extreme reserve this attitude necessitated. 'It was strange that after knowing her all these years one could not say what the truth about Isabella was,' she wrote in 'The Lady in the Looking Glass'. For all

the time they spent together, Ethel's thoughts remained inaccessible to Virginia, and it was only through building a vision of her friend through fiction that she began to explore a psyche seemingly invulnerable to the excavations of intimate conversation. 'She was one of those reticent people whose minds hold their thoughts enmeshed in clouds of silence,' she went on.

Virginia ends her story with an act of startling cruelty. After stressing the impenetrability of Isabella, she then places her in front of a mirror, and the reserve collapses. 'She stood naked in that pitiless light. And there was nothing.' A thrill in the violation of it. 'She had no thoughts. She had no friends.'

In its concluding lines, the demureness of Isabella is identified as the source of her personal depletion, her weakness and emptiness, but other depictions of Ethel share Virginia's focus while telling quite another story. In a photograph of Ethel taken by Lady Ottoline Morrell in 1920, she is posed in front of an enormous painting: it is a talisman testament to the women's friendship as much as it is an unwitting analysis of its sitter. The hole at the top of the print suggests it spent time pinned to another surface, perhaps displayed in Lady Ottoline's home; despite the poor quality and composition of the photograph – the scene is overwhelmed by the vast black centrepiece – it has nevertheless been preserved, possessing a sentimental value that far outstripped its status as an instance of artistic expression. The women meet one another's gaze with ease; the centre of attention, Ethel appears confident and relaxed.

Yet what faults the photograph is also what makes it so unintentionally expressive. Behind Ethel looms a void, a gilded frame hemming in a devouring absence, an oil painting darkened by the film's poor exposure. Moving between this opaque, darkened surface and Ethel's mirror, a resemblance emerges, one reversing the absorption of light performed by the other. The ominous sibling to Ethel's mirror offers an alternative gloss to her talent for disappearance, as though the practice of self-effacement were more volatile and forceful than her outward appearances suggest: less a private withdrawal, a fading into the crowd, than a redoubling of her presence that was impossible to ignore. Primness is no longer synonymous with spiritual nothingness, as Virginia has it, but becomes a screen behind which flourish enigmatic intensities that defy representation or explanation. This was shyness as an obliterating vacuum into which lesser guests

risked being sucked. Consider it a warning: approach the recesses of the meek with care, for they are not as they seem.

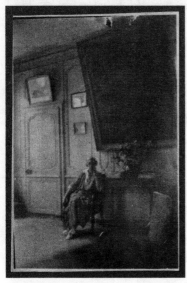

an obliterating vacuum

⌇

Tea with Sickert

Men were not, for her, desire objects, but could men offer anything to Ethel by way of intimacy? Might a man be a friend or a mentor? Ethel and Nan met Walter Sickert in 1906, when he was already a successful artist, and Ethel painted him in their home in 1911 in an interior scene that angles our attention away from Walter, the figure of cultural access and aspiration, and towards the satisfying glint and busy patterns of a tea service. Art in its most legitimate and rewarding form is pressed against the readily dismissed – easily consumed and tidied away – artfulness of the home, but Ethel is clear in staking claim to one side of this divide. The pleasures of the latter are freely available, more abundant and various, and clearer

than what Walter is there to represent, who sits recumbent in a distant chair. Given his power in the art world, Walter's attitude to the two women is easily guessed at, and here it is summarised by his higher position in the frame, stressing his belief in a hierarchical ordering of talents in which his superiority is assured.

Still stubbornly backward in his ideas about women, Walter regarded Ethel as closer to a wife or mother or sister, any role which placed service at its centre, and she certainly was not an equal, nor an artist in the same capacity as he saw himself. At meetings with artists in the Fitzroy Street Group, an exhibiting organisation Walter founded in 1907 to promote his own work and that of his followers, he expected Ethel – one of the only female members – to pour the tea. Perhaps Ethel's invite was partly conditional on her performing this function. Inside a space that Walter at least regarded as radical in its approach to aesthetics, the gender politics remained deeply unimaginative, basically unchanged.

When Walter was forced to acknowledge Ethel's identity as an artist, he did so with conditions: she must always remain an amateur lady painter, no competition or provocation. Testament to these principles are the letters that passed between them, which are full of instructions on how to better her paintings, advice Walter would often act on himself, taking his brush to the canvases in question, altering her compositions, adding colours and glazes and new structuring parts, thrusting himself into her work.[30] For all their claims to benevolence, the motivation of these contributions was transparent, with Walter less interested in teaching than boasting of his own talents, meddling in ways that made him feel more authoritative. Other women artists resisted these advances, these reluctant acts of collaboration, but Ethel's politeness and her earnest belief in Walter's talent allowed his narcissism to run wild. The effects of an ordinary mire of fear, hatred and paranoia – the basic misogyny that any man of the century risked absorbing – had proven drastic to Walter, resulting in a state of crisis in which any women painting appeared to trouble his ego, and the passing years only appeared to solidify this bias. The exhibiting society he formed in 1911, the Camden Town Group, differentiated itself from his previous project by barring women from becoming members altogether, in part, Walter claimed, so as to avoid accepting the

art and the home

unserious contributions of Ethel and Nan. Presumably there was a
different mood to these meetings: Walter and his chosen disciples
huddled in a room, nobody pouring the tea.

Walter's series of paintings that take lifeless unclothed women
as their subject provide pertinent supplementary information
regarding his views on women artists. Whether or not these
were eroticised retellings of the brutal murder of sex workers in
Camden, the paintings possess a chilling disinterest in the effects
of gendered violence, and have been hailed for their achievements
in every account of the modernist period in England without much
reckoning with the contempt for women they so explicitly harbour.
Walter pushes the women down into beds; their faces have fallen
off, and they lie in grimy sheets the colour of dead skin. A darkness
attaches itself to their limbs, the proportions of which are all
wrong. Walter wants you to take note of their breasts, which are
impossibly spherical, balanced on their torsos, or they are mashed
and flattened into mounds, the little light there is settling there,
serving as a spotlight. Mortally injured, the women are nevertheless
arranged for our consumption, laid out like fish on an ice block.

Women were not skilled or autonomous painters in Walter's eyes, but he and the Camden Town Group used women and their most habitual spaces as artistic resources, often in ways that engaged their own banal misogynistic fantasies.

Walter objected to Ethel's work in part for concerning itself with 'the drawing room' rather than 'the scullery'. For him only the latter possessed the 'gross material facts' art was tasked with expressing – a distinction in which a potent brew of prejudices about aesthetics, gender and class churned.[31] The spaces in which artistic authenticity flourished for Walter were populated by working- or lower-middle-class subjects, a choice which said a little about aesthetics – his objection to paintings as airless, status objects rather than mediums of experiment – and a lot about his fetishisation of those differently positioned to himself. Much to Walter's distaste, Ethel stayed inside the limits of her known world, which began and ended with the social horizons of the drawing room. His assessment of her, in a frustrated outburst of uninvited career advice, stated the worthlessness of her personal repertoire to his understanding of modern art: 'your own tastes in dress & your personalities should be banished as much as possible from your oeuvre'.[32]

Implicit in Walter's assumptions about the drawing room was a belief in the one-dimensional meaning and function of bourgeois domestic space, a simplicity that never held true for Ethel and Nan, for whom surface and depth were always necessarily drastically different. Blame his misogyny or his lack of imagination, but Walter failed to see the interest of what was readily accessible to the women, requiring no imaginative projection or appropriation. Ethel and Nan had a chance to explore the unexpected everydayness of a partnership cultivated in exceptionally hostile societal circumstances, and having staged and enabled those experiences of quiet transgression, the drawing room was the obvious setting for this radical, empirical work. Certainly working-class life had not had an adequate share of attention in the history of art, as Walter argued, but queer feeling between women – recorded by the women themselves rather than lascivious male observers – had hardly been touched in centuries of representation.

No explicit animosity comes through her correspondence, but it is possible to experience Ethel thinking about Walter, perhaps even brooding over his work, in *Tea with Sickert*. An expectant air fills the room: what shocking statement is the scene readying itself to accommodate? An assertion of value, and nowhere is this more offensive to arbiters of taste like Walter than when describing the domestic arts. The responsibilities that drew Ethel away from her painting are summarised in the tea service, which was one shrewdly put together gesture amongst a succession of others all designed to ease emotional and intellectual encounter. Ethel shows how the atmosphere of an afternoon might be carefully assembled: through the selection of one object or patterned cloth or guest over another; through pouring tea and slicing cake according to a few elegantly orchestrated moves; and all the while keeping the conversation afloat and engaging for all parties. The close attention to the props of this social ritual showcase the curatorial acumen involved in entertainment, elevating the domestic organisation that surrounded any offer of tea as equal to fine art in its engagement of time, effort, thought, specialist skill, invention and creative flair. The work that Ethel did during those afternoons was by its very nature ephemeral, departed with the guests, contained in streams of chatter and whispered counsel, in new acquaintances and informal agreements, in introductions and unanticipated connections, but it was nevertheless critical to the binding and flourishing of her literary and artistic milieu, and therefore to English modernism more broadly. Ethel pauses before she pours the tea, and reveals all the choices and decisions that went into a routine that Walter had dismissed as too menial to perform.

The painting bristles with retaliatory energy. Nan is in the foreground, powerfully filling the space, her clothes the colour of an open flame. Walter is small and brittle, pressed into the chair, crowded out by the effects of femininity that flourish around him like a rash, his frame disintegrating into formlessness in a poorly fitted suit, at the mercy of the women and soft furnishing. His facial features are a few grey divots, his body more scarecrow than

human. All the women Walter ever painted look out from Nan's eyes, their gaze eviscerating his body.

Just as Walter stressed women's distance from what he believed constituted art, here Ethel makes clear how he had no role in the subtle, complex art of the drawing room; the exclusion was mutual. Sickert is limp in his chair while an entire world of interestedness and delicacy and warmth and solicitude and attention unfolds around him unbidden. Ethel and Nan, scorned in various explicit and implicit ways by Walter and his peers in the Camden Town Group, assert themselves in this painting as artists with their own unique set of creative practices. There, dominion over their domestic space will not be challenged. The tea will not be poured simply on Walter's whim. The agency and dignity long denied to the women in Walter's field of influence is snatched back, and any humiliation reconciled by a thorough reappraisal of their successes.

Looking at *Tea with Sickert*, Meret Oppenheim's 1936 work of tea service transgression, *Breakfast in Fur*, comes to mind. Meret's sculpture is composed of a teacup, saucer and spoon covered with the fur of a Chinese gazelle: the result is a distinctly queer object that revels in the shape and texture of some female bodies. Drinking becomes a playful erotic metaphor, the queerness of

time, effort, specialist skill and creative flair

which is underscored by the setting in the homosocial world of society tea parties. What is it exactly, the work asks – gleefully inciting a strain of heterosexual male panic – that women do when alone together? What troubling intimacies might their most common shared activities elicit? The object attests to the transgressive potential of wandering thoughts: in the silences, in the bland and mindless chatter, in the formalities which saw women touch one another briefly and slightly and without emotion, what were those women really thinking? Through these works' dialogue, the untouched teacups at the centre of Ethel's painting become symbols of pleasure and seduction hidden in plain sight. For Meret and Ethel's work alike highlights the ease with which the most conventional social rituals can conceal radical desires.

Morning

Walter was wrong about the limits of the drawing room; but it would also be wrong to place Ethel and her interests solely inside the parameters of a single space. In her work she opened doors and moved through corridors that many other women dared not, and never is this more apparent than in her series of works focused on the bedroom. There are spare bedrooms with the hushed immaculate look of rare use, and bedrooms with guests absorbed in a book with their legs stretched across the covers, and bedrooms that have recently been vacated with the blankets still messily drawn across the mattress.

Morning is perhaps the boldest of all, and offers a distillation of the intimate life that Ethel and Nan shared in the decades that followed. Set at a watchful distance, full of affectionate touches that are nevertheless cautious about intrusion, a woman is encountered lying in bed, a book splayed on her lap. Clothed, but surrounded by sensuous folds of fabric reminiscent of exposed, flushed flesh,

her hair is undone in a metonymical hint at the other undressings and unravellings that occur between lovers. Nowhere is their relationship more alive than here: tenderness has been translated straight from sensation to paint.

As ever, Ethel's work is operating on two distinct levels: on that of the personal, recording her life with Nan, and that of the revisionary, with these bedrooms serving as a corrective to those she had encountered in the Western European canon. Ethel would have developed her voice as an artist amongst reproductions of – to name but a few – Titian's *Venus of Urbino* (1534), Diego Velázquez's *Rokeby Venus* (1647) and Jean August Dominique Ingres's *Grande Odalisque* (1814). In these scenes women are arranged lengthways, unclothed and supine on beds; the bedroom is merely a stage on which women can be laid out, undressed and possessed, transformed into objects without a will of their own and over which men had absolute dominion. The bedrooms themselves are rarely of interest. The objects tend to blandly remark on the status of the men they are aimed at pleasing. As the nineteenth century progressed, the bedroom became more real, as painters like Sickert turned to brothels and petit-bourgeois interiors for their settings. Despite these changes in tone, women continued to be more like objects than human animals, conveying information about society or the male unconscious, and very rarely expressing themselves.

Ethel's scene is so thoroughly different from these precedents that detailing all the points of revision is easy enough: the sitter is granted their own self; the space is no longer instrumental, but specific in its personal effects, heavy with dreams and shared silence and kindling emotion; the offer of blunt access is replaced by the promise of intersubjectivity. Of course it was more than a series of simple and satisfying reversals. The list does not account for what is so mesmerisingly, sweetly rebellious about the scene.

If Ethel was inspired by any bedroom scene, then it was not those of the realist tradition, but religious painting. In particular, *Morning* is reminiscent of a work by Vittore Carpaccio, *The Dream*

affectionate but inexplicit

of St Ursula (1495). The same muffled light, the neatly arranged stuff of a bedroom and a similar sense of privacy entered into by a trusted figure. Ursula is asleep, alone in the nuptial bed just like Ethel's subject – the blankets tight around her too so as to stress her chastity – and at the foot of her bed is the Angel who will inform her of her martyrdom through a dream. Martyrdom is a ready metaphor for the experience of queer social stigma: in these narratives protagonists suffer for a higher purpose their assailants cannot grasp; faith and queer feeling are simply two possible uses of a transgressive desire. The story of Ursula's plight has an especially queer resonance. Ursula accepts a proposal on the condition that she and her 11,000 virgin women disciples are permitted to set sail on a pilgrimage. Before her murder comes an intense, liberating

experience of social death. Ursula is at sea surrounded by her own society of women, floating further and further from what is expected of her, no longer tied to a nation or to the family, the buoyancy of the boat and fluidity of their passage suggestive of the new values that might define her life. Ursula discovers the pleasures and dangers of navigating a path entirely for herself: the women are all slaughtered, and Ursula ultimately welcomes the arrow of her persecutors rather than accept marriage to their leader. The women are brutally sacrificed and through it guarantee their togetherness. Who needs the ordinary society of the living? Those confines, that violence, men? Ursula's martyrdom represents the homosocial if not electrifyingly homoerotic promise of what might come from turning from given society and living for ever with a band of faithful female followers.

Ethel travelled to Venice on a few occasions, and would have visited the Gallerie dell'Accademia where Carpaccio's painting is displayed, but whether or not she actually saw it matters less than the vividness of this dialogue, how the queer feeling of one painting heightens the transgressive qualities of the other. In *Morning*, Ethel places herself in the position of the Angel, granting Nan the dream of a life apart from heteronormativity as a reality they woke to each morning. No dangerous rites. No need to actually die a grisly death – no actual martyrdom. But a sense nevertheless of being selected by some higher power to live differently, to bear its fruits as well as its wounds.

After all, Ethel and Nan's love had grazed extremities, even after the sadness and secrecy that had defined the beginning of their relationship: nursing wounded soldiers together during the First World War, learning the practicalities of care and cure under immense pressure; painting dozens more canvases only to have all of them destroyed along with their house during the Blitz; Ethel looking after Nan during a long and gruelling illness, to which she would eventually succumb. These paintings together whisper an erotics of refusal, suffering and self-sacrifice. Two women lie tucked in bed centuries apart, seemingly innocent and chaste, their true desires mysterious, about to enter into a life radically other

from the norm. The chronicle of Saint Ursula provided a model for Ethel of how desire might be removed from the straight world and displaced into a queer heaven of her own making.

queer heaven of her own making

4

MARY

At first she was merely a confusion of names, an inconsistency that asked to be resolved: she was Constance, and she was Miss Lloyd, and she was Mary, and she was Katherine – shadows with a similar shape, an address in common, a hand worn by the same work. Then she was those four strands of herself combined, she was Mary Katherine Constance Lloyd, a figure with a question forever hanging over her, a flash of talent and humour running through the correspondence of others. She was listed perfunctorily amongst the guests at a party or exhibition. She was an extraneous detail in an anecdote. She was an amusing story that Vanessa Bell made reference to in her correspondence with her sister, but the narrative itself – Vanessa's original letter – I sought out, but never found.[1] She became her few known paintings: an exquisite nude in fluffy dirtied pastels, a couple of still lifes set in cramped interiors, street scenes of Venice in which women edge along the water in blouses soaked in the same blues. Soon she was an acquisition note in a couple of works by Gwen John: the suggestion of a friendship. Later, she was a handful of letters in a neat script: the network expanded. She never revealed herself to me in a photograph. Instead, Mary became all the small details I gathered from what she allowed me to see.

Her taste for salad dressing.[2] Her poor eyesight, corrected later in life.[3] Her Parisian address, 118 rue d'Assass, which was made use

of by other women artists in her circle in need of accommodation.[4]
Her driving skills.[5] Her favourite Rembrandt painting – *The Jewish
Bride*.[6] Her friendship with Gwen John: in thinking of her, Gwen
wrote, she could banish any loneliness.[7] Her friendship with
Duncan Grant (it was his recipe for salad dressing she loved). Her
interest in literature.[8] Her love of Japanese prints.[9] Her sister, who
once travelled to Greece, and Mary's envy of that, although she
would have her own fun.[10] Mary travelled by train alone around
Europe, and she was unafraid of haggling for a good rate in a hotel
room in a foreign country without any knowledge of the native
language.[11] Her kindness.[12] The woman she lived with: Miss Ayline
Bayley, later her sister-in-law. Her inability to skate, despite her best
efforts – picture her gracelessly lurching forward, clinging to the
edge of the rink – one reason for her intense dislike of the cold.[13] At
least once, Vanessa came round for tea. Her evening rituals: drawing
classes at the Académie Colarossi between 4.30 and 6.30 p.m.,
then a short walk home, a quick change of clothes, and after a
few moments at the sink, ready to eat dinner at seven. Her work
with fabric, for which she designed her own exhibition mounts.
Her wallpaper designs, so esteemed that she was often working to
commission.[14] Her sense of humour: Mary sent her embroidery
and linens to be exhibited at the Chenil Gallery in London, and
joked about them being stolen. 'I and Leonardo are so appreciated
you see,' she wrote, probing assumed connections between genius,
masculinity, medium and the canon.[15] She lived in Paris from the
turn of the century through to the twenties; after that she returned
to England, and life was different, quieter. Long walks, rooms lit
weakly by fire, an ache in her hands once her letters were finished,
slipping under heavy bedding before it grew dark. What happened
to her practice is unclear. The joke about the possible theft of her
work drew its humour both from her uncertain commercial value,
and an acknowledgement of how, save for a tiny circle of patrons,
recognition had eluded her.[16] According to Ida Nettleship's scathing
description, she was 'nice & ugly & awkward' – a minor figure,
forgettable, wholly unexceptional.[17]

Interests, habits, routines, memories, friendships – from them, a sliver of Mary winked back at me.

*

One undated still life is typical in situating us inside a middle-class interior, surrounded by the props that make up its presiding social rituals. Colour brightens above the parrot's throat to mark the presence of its voice, but no song will ever sound from it. Middle-class femininity is invested with paralysis, loss of voice, even death, devastating affects which through the taxidermy animal are connected to a form of relentless, immovable visibility. Mary never married, but women she knew – Ida Nettleship included – had married and stopped painting, and what had been most vivid and alive in them had faded, stiffened. And yet they were never more simply and absolutely visible, more purely decorative and set in their identities, than they were as wives. No wonder Mary's preferences tended towards invisibility: ignored proposals, anonymous works, little self-promotion. There was freedom in existing as she did, as a series of charged impressions, connected only to a handful of letters and finished artworks, sometimes as Mary and sometimes as Constance, no husband or acquired surname to place her firmly within an established familial structure, the privacy afforded by living under 'Miss' only compounded with age. I learnt to let her slip away unnoticed.

5

GLUCK

A note on pronouns

On the underside of glossy prints of her paintings, the kind sent out for publicity purposes, Gluck pre-empted any possible errors. The message was clear. 'Please return in good condition to Gluck, no prefix, suffix or quotes.'[1] Often all that is specified, what is deemed the priority, is the instruction 'no prefix'. Yet in a sense each part of the demand meant the same thing: an appeal for respect. Creased edges, spillages or rips are as noticeable and belittling of the work as a lazy hypothesis about the artist's gender. Amongst dozens of prints, Gluck requested again and again that the recipients properly handle a self just as they would an artwork.

Images move by their very nature towards silence, but Gluck's commentary ensured there was always at least one statement resounding from her own. Whatever your assumptions are, the correction states, whether it is about gender or genre or artistic personhood, or the interaction of all three, you must suspend them. If a figure holding a brush before a canvas has begun to take shape, the process is arrested. The phrase effects an absolute focus on the image itself. This was how Gluck wanted to be regarded: an artist foremost, without the overdetermining effects of one gender or another. Styling herself simply as 'Gluck' – an androgynous contraction of her surname, Gluckstein – the role of artist offered freedom from the pressures of femininity and family alike.

Many of the letters written to Gluck nevertheless were addressed to 'Miss'. Gluck was confronted with how rarely her most simple requests were valued, how little she was listened to or seen or understood, from the moment most professional interactions began. This was what it was as a queer woman in flight from conventional femininity to live and make art under patriarchy. In the folder containing her photographic prints, I was surprised at how many Gluck had inscribed: there were dozens. There was reason to be so insistent.

no prefix

While writing about Gluck the question of what pronoun to use arose immediately. A prefix reshapes the body into a predetermined form, and the wish to be known without one suggests a general distrust in the binary gender system such labels uphold, as well as a particular alienation from the kind of woman marked out by 'Miss'. Occasionally within relationships or amongst other queer women, Gluck took on more masculine names, becoming Tim or Timothy with one lover, and Peter regularly enough in her youth – or persuasively enough in a single encounter – that she went by it in a painting by Romaine Brooks. However, the full title of Romaine's portrait is *Peter: A Young English Girl*; pronouns, prefixes and names did not necessarily come together neatly in the expression of a coherent gender identity.

Gluck's concern was with her given prefix rather than pronoun, and while this does not necessarily foreclose the pertinence of gender to these requests, it does appear to place a greater emphasis on the prerequisites of heterosexuality. 'Miss' describes a woman's

marital status, efficiently advertising her potential availability to men, and as Gluck never intended to marry – nor to enter into any standard, heterosexual courtship ritual – there was little point in placing herself within this framework. Not only that, but as an artist, to identify as Miss was to immediately plunge herself inside a misogynistic system within which being a woman risked being dismissed as an amateur. Gluck valued her work more than that. 'No prefix' was about resisting a variety of frames society placed around Gluck as an artist, as a lover of women and as a person assigned female at birth. Framing was a charged issue for Gluck in both her art and her life, so much so that she designed her own frames, patented them and never had her work displayed in anything else: three layers of wood graduated like a shallow set of steps and painted in an opaque, matte cream. The frames were Gluck's signature writ large, an insurance against her work ever being misidentified. I longed for a pronoun as distinct, unmistakeable and uncompromising as one of those frames.

As a statement, 'no prefix, suffix or quotes' was also a claim to being an iconoclast, the likes of which no formalities could contain. Gluck only ever exhibited work in one-man shows for this very reason. But Gluck was not alone in experimenting with gender expression. In the early twentieth century, women were cutting their hair and abandoning feminine dress, living alone or with other women, and nowhere were these bids for freedom and authenticity more visible than amongst the upper middle classes and aristocracy with whom Gluck mixed. Amongst communities in which non-normative gender identities were forever being constructed and adjusted, no doubt there were those who found a home in trans identity. Others, as Jack Halberstam argues in his comprehensive study of female masculinities, 'were content to live their lives in masculine clothing and take male names without completely letting go of their claim to femaleness'.[2] Exactly what Gluck's relationship was with masculinity remains unclear. Personal papers are not articulate on the matter. The paintings can hardly

be trusted as a primary source of data. Even the contents of her wardrobe, a selection of which has been donated to the Brighton Museum, suggest a measure of femininity intermixed within a predominantly masculine self-styling.

However, each sentence I wrote required a decision, to guess at Gluck's affinity with masculinity through the material I had at hand. 'She', 'they' and 'he' all possessed a certain rightness or relevance, each informing my understanding of Gluck's experiences, the assumption of one never precluding the presence of any other, a coexistence in which the available language briefly felt elastic, inclusive, capable of imagining the complexity and fluidity of Gluck's gender identity. Yet writing a life according to this principle of negative capability inevitably created obscurities: on the page, for clarity and coherence, a choice became necessary. Whatever pronoun I prioritised, experiences would be foreclosed, nuances lost. What if Gluck's identification shifted over time? Or according to social group? Alone, the pronouns felt overly confident, inevitably limiting – meagre, flat and static. I contemplated using Gluck's name repeatedly in place of any single pronoun, but the rapidity with which this strategy became unwieldy was itself instructive, revealing how much gender is implicated in ordinary language, and how ubiquitous the risk of misrecognition for trans and non-binary people.

After much consideration, writing and re-writing, I decided to use she/her, partly to acknowledge that these were the pronouns available to Gluck for her own use during her lifetime.[3] I do not doubt that Gluck was uneasy or dissatisfied with what 'she' conventionally meant. Yet perhaps for Gluck pronouns were simply not regarded as definitive statements, compelled to articulate only a single, conventional experience of gendered embodiment, and functioned instead as condensed descriptions that were loosely adopted only to be experimented with, manipulated, expanded and pushed against.[4] For Gluck, 'she' need not obey the strict narratives it appeared to perpetuate. 'She' could contain multitudes, including its own disavowal.

ᕤᲜ

The Pine Cone

Three objects are united by the colour green in a space that is compact and refrigerated, muted tones that suggest the peel and porcelain and glass are all cool to touch, each shining with a thin layer of condensation. The scene might be entirely ordinary, a standard catalogue of still-life subjects, except that the cup holds a pine cone. Rarely do pine cones appear in still life – they are of nature, properly belonging to the landscape genre – but as a formal feature, an instrument of cohesion, they work perfectly in Gluck's composition, accentuating the curved edges and soft accommodating surfaces that unite the subjects. The pine cone rises from the cup as though it were any other edible or drinkable substance; there's an absurdity to it, a reminder that what we regard as ordinary in the home is all arbitrary. With this nudging of domestic order, there lies the beginning of a broader rebellion.

nudging of order

To her family she was not Gluck, but Hig – another single unfeminine syllable. In an 1899 photograph, she is four: a daughter frowning in lace, an umbrella awkward in her clammy fist, already uncomfortable assuming this ladylike pose, already deeply unsure about the demands that lay ahead. In common with many girls of means, Gluck took music lessons, although she did so less to conform and more to please her mother, a former opera singer known for her brilliance, speed and ferocity: her nickname, hardly feminine either, was 'the Meteor'. Energetic and precociously talented, Gluck excelled at school, especially in music and art, so much so that St Paul's Girls' School recommended a curriculum specific to her talents. Gluck's family owned the J. Lyons and Co. catering empire, which included the hugely popular Lyons' Corner Houses and the Trocadero in Leicester Square. In the first decades of the century, lone women bought iced buns and cups of tea after their domestic chores were done, miraculously unwanted by others if only for an hour, and in a house a bus-ride away at the edge of Regent's Park their money had Gluck opening a silver-gilt paintbox of watercolours, the finest kind on the market, prizes for her draughtsmanship hanging on the walls. As she painted, Gluck could be heard discussing Napoleon with her brother, or the inner workings of the House of Lancaster, or her theories on the great Tudor kings, figures of masculine authority that modelled a way of being that was ruthless, aggressive and egotistical. History and painting provided whimsical routes out of the strictures of girlhood, whether as a military leader, king or artist – although none were appropriate aspirations.

Besides, the next few decades of Gluck's life were secured. Music, art and literature only in appropriate measure: that is, without progression or ambition. Courtship with a man selected by her parents, then making a marriage advantageous to the family line. Years of attending events fixed on her husband's arm, gruelling rounds of pregnancy and childbirth, their care swiftly delegated to others. What counted as friendship with other women in her position: playing bridge, sharing complaints about servants, promoting shallow philanthropic projects, blandly cultivating jealousies and rivalries; attending parties

that were joyless whether as host or guest, scaling the social ladder further, learning above all to dismiss her own loneliness. Gluck saw the outlines of this future as though through a crack in a door, and fled. An exit strategy was arrived at: art school promised to rupture the smooth flow of this narrative, at least for a time, and if Gluck deftly negotiated her way through the experience, if she evaded any parental interference as soon as it arose and without any fuss, then it might mean forfeiting that plot altogether. To succeed, the idea of art school had to shock, to bring about uncomfortable conversations, to cause dramatic fallout, to mark an end to a life under her parents' care. No luck. Glucks' parents agreed, but their cooperation was only partly about a belief in their daughter's talent.

Insisting Gluck attend the nearby St John's Wood Art School was presented as an act of generosity, but it ensured her continued attachment to the family and the home, and it was this Gluck understandably came to resent. Being denied any meaningful distance from her childhood might have been manageable if the school itself had felt more radical or rigorous. Women who were merely painting through the years before marriage surrounded her, none of them possessed by the same passions and fears, their thoughts drifting to suitors and the evening's letters, but Gluck focused on what was before her, assuring herself that the easel alone mattered, determined her time would not be wasted. Her parents hoped Gluck would lose interest, or lower her expectations, but they underestimated her resolve. Gluck dutifully attended classes, did the unchallenging tasks assigned to her, hardly spoke to her peers, and returned to her makeshift studio in her parents' garage, throwing on a threadbare jacket belonging to her father – casting off the genteel femininity she had spent all day performing – and holding her brush with the force of this sudden reprieve, she persisted.

The next opportunity for escape arose in the form of Lamorna, an artistic community in Cornwall that Gluck arrived at while plotting ways out of a slump intensified by the First World War. Still dependent on her parents' approval, Gluck spent a month there in 1916 with her girlfriend, Craig, and a few other friends from art

school eager to make space for their own freedoms. Rebellion was invested in the departure and destination as much as her partner. In a portrait of Craig, her hair is coloured with the same rich brown as her fur coat, and the effect is to frame the fur as her own, granting her an animal fierceness. A hint at the threat she was considered to pose – her parents immediately and predictably disapproved of Craig – the creaturely palette and texture also frame her glamorous, androgynous self-fashioning as wholly natural.

In Gluck's sketchbooks, a few small works capture the Cornish landscape, each like a ship in a bottle, a way of admiring and preserving and holding what is vast and intricate. In these pieces the landscapes rush over the paper, impulsive splashes of watercolour communicating the urgency of beholding such beauty, breathlessly translating vision into action with the materials at hand, conscious the weather might shift and the scene change at any moment. Other paintings lend Cornwall a monumental stillness, everything from the grass to the sky to the locals in colourful mackintoshes immovable as carved rock, as though Gluck were unwilling to accept that early intensity of feeling fading – the seemingly inexhaustible gratitude of those first months. In *Before the Races*, the landscape is a pristine marble unmarked by birds or clouds or trees; there is nothing but grass pressed beneath sky the colour of an unfettered hope. Men are reduced to flecks of colour, small and helpless and exposed, powerless as insects, and Gluck is omnipotent with her brush, moving and rearranging and discarding them, in possession of a kind of agency that was totally new to her. The painting measures the tension before a race begins, and a similar sense of expectation characterised Gluck's arrival in the county. The painting is buoyant with the happiness of a life finally beginning. With the claustrophobic home environment gone, the way ahead was cleared, and the huge, untarnished blue dominating *Before the Races* is testament to the power of that feeling.

The autonomy Cornwall offered seemed boundless while she was standing painting in the open air, or at night listening to the sea murmuring with Craig by her side, but once the summer ended Gluck had no choice but to return to north London. Her only consolation was

plotting a more drastic disappearance. With no ration card, and only half a crown in her pocket, Gluck left again for Cornwall but this time without a return date or her family's blessing.

a life beginning

After years of provoking her parents, Gluck had finally secured an origin myth she felt was suitable to an artist. The departure was central in an autobiographical sketch she later typed out and distributed amongst friends and acquaintances. Gluck handed these texts to guests as she might a glass of wine: as a gesture of welcome, an invitation to get comfortable within the environment; a means of accelerating intimacy that might in turn loosen the inhibitions of the recipient. A token of acceptance, it was also an exercise in self-invention that allowed Gluck to be known precisely as she wanted.

Yet the ties with her family had been frayed rather than cut, as Gluck's rebellion did not include snubbing their wealth. Putting aside their rage, concerned above all with remaining respectable, which a daughter living in poverty threatened, her parents became the reluctant patrons of her subversion. Their financial help had a profound effect on the kind of life available to Gluck, and it was a

life that was hard to refuse. Gluck rarely considered how she was able to live as she did, bathing in the sea by moonlight, observing Craig ahead of her softly illuminated in silhouette, sleeping in a cottage made all the more romantic by a woodlouse infestation: her family's capital bolstered every act, and each passing hour. After long afternoons talking with Laura Knight and Dod Proctor, exchanging theories about the value of figurative art and, having received wartime sketching permits, the best places to set up their easels at dawn by the sea, Gluck never once worried about the cost of those conversations, the work that might otherwise have filled those hours and replenished her accounts. If her family were uneasy enough about her survival to offer her money then the sensible response in Gluck's mind was simply to spend it, not questioning what kind of compromise it represented to her independence, instead dedicating herself to making best use of their generosity in the service of her art.

Summers were spent in Cornwall, and in the winter Gluck and Craig secured a flat on Finchley Road, supplemented by two rooms in Earl's Court that functioned as a studio. Gluck could paint without reusing canvases, encouraging the full realisation of experiments that might otherwise be considered unworthy of such attention, confined to cheaper mediums, and she could do so all day for months on end without distraction. Her goals could be grander, more experimental, rooted purely in aesthetics and expression rather than in commercial concerns. There was no need to attract patrons, and no urgency in selling work aside from the prestige. The approval of her peers or the press did not really matter either. Years could be spent on a canvas that came to nothing. Gluck was free simply to paint.

Gluck soon began, however, to cultivate other forms of retreat, regularly making disobedient use of the same money that appeared to tether her so stiflingly to her family and their values. Her signature dress sense became crucial in understanding her distance from binary gender, the essential inapplicability of conventional femininity to her own identity and circumstances. Observe her carefully buttoning a shirt picked up at Jermyn Street alongside

city patriarchs, worn with trousers she had meticulously pressed by her servants, under a smock made from stiff twill, and finishing it all with the long black coat she wrote proudly to her brother of acquiring from a dressmaker.[5] Look at her smiling from under a homburg hat, under which her hair was slicked back, cut short at Truefitt's gentlemen's hairdressers. The final touch, too elaborate for everyday use: a dagger in her inside pocket.

In her experiments with style, Gluck was never merely mimicking masculinity – her ambitions were bigger and more revolutionary than that. Clothes were deeply concerned with the formulation and expression of consciousness, constituting a vital, singular channel between mind and body in a society in which women, and queer women in particular, frequently felt unable to articulate their true, inner selves. Discretion placed so many limits on what Gluck and her peers could openly articulate, but clothes were bold, flexible statements about the self over which they had at least a measure of control, and which attracted less serious notice in using a medium regarded as feminine, and therefore trivial, harmless. Camp, imaginative and subversive, clothes were instruments of personal transformation, deeply private, and they were acts of social critique, a means of questioning the naturalness of sex and gender themselves, sweeping and incendiary in their ends. The studied elegance of Gluck's appearance was about projecting an image of the fastidious, powerful artist she hoped to become, and it was about quashing the accusations of regression and maladjustment that attended any deviation from the prescribed bounds of femininity. Gluck's style was a radical, utopian proposal in which masculinity was pried open to reveal a vast entanglement of possibilities, desires and aspirations, and each garment she wore absorbed this knotty promise of becoming. So much about identity and ideology and their coming together in a thrilling new world could be expressed in the precise roll of Gluck's cuff, in the shine of her polished leather brogues.

Clothes were one way of laying claim to and manipulating masculinity, and paintings were another. Gluck painted boxing matches, judges, music halls, acrobats and comedians, repeatedly

aligning herself with the public spaces most comfortably frequented by men. Their physical appearances and gestures and clothing are pored over with an anthropological interest. In these works, men are easily accessed, easily represented, and there is nothing sacred or untouchable or even powerful about them. Men are nothing more than accessories, ideas, prompts.

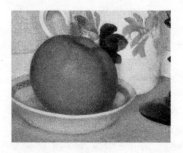

As a genre traditionally associated with femininity, still life was not the right fit for Gluck in this early period, and examples of it are rare; enough concessions had already been made. On first look, *The Pine Cone* presents itself as an exception. The apple, cup and glass sample and summarise an entire space, like a vial of blood drawn from the body, and as a millilitre of the home's current, a specimen placed under glass, what data could be gathered, what analysis could be drawn of the culture there? With its unfussy and pared-back aesthetic, a vision that makes even the apple look muscular, *The Pine Cone* studies the results of applying a hardened and unsparing focus to a feminine space, and as such is a reminder of where Gluck's experiments with style were headed. A new self required a new space in which to flourish, as experience had shown a dire connection between the home and expectations about who Gluck was or could become, one marking out the limits of the other. In *The Pine Cone*, a solution is proposed. Here Gluck begins to think through what domesticity would look like drained of conventional femininity, what exhilarating difference and unanticipated joy might emerge if an unorthodox masculine resonance were permitted to flourish within the home. No assumed roles, no punishing duties, no alienating artifice; no matriarch or patriarch. *The Pine Cone*'s atmosphere of forcefulness, resilience and composure, its magnetic absence of anxiety or embarrassment or bitterness, represents one possible vision of this uncharted world.

Flowers and fruit rot, they are reminders of the dogged rhythms of nature, our fleeting hold on this world as human animals – these being the usual moral directives of the genre – but the pine cone is more about transformation, about death opening into life, again and again across time. Gluck had left her old life behind, and the excitement of that, the willingness to plunge into a new season of experience, is everywhere evident in *The Pine Cone*.

Chromatic

The flowers are an impeccable white, the white of expensive lace and satin, each blossom opaque and lustrous, like new fabric repeatedly smoothed against a mannequin in a shop window, too flawless to be anything drawn from nature. The flowers will not be overlooked, each contour and variation in colour detailed as though placed under a powerful spotlight, their shine dulling their surroundings to a dishwater grey. An arrangement so stiff it looks held in place by metal rods, and all of it covered with a chilly and sterilised sheen. The flowers fan out, their throats exposed to the viewer, others with their heads bowed towards the marble, gestures that appear weirdly alive, each bloom as though in possession of its own will. The flowers turn to their companions, mouths open. The flowers jostle against one another, competing for attention. Style, interest, talk, suspicion and rivalry – a composite suggestive of desire – are all carried in the flower's mute, inhuman forms. And yet, surrounded by a stringently maintained perfection, what ultimately prevails is a fear of decay, which hangs over the scene, distinct and pervasive as the scent of lilies. For all its surface beauty, *Chromatic* teems with troubling thoughts that multiply just out of the bounds of the visible.

desire

By 1926, Gluck had enjoyed two acclaimed solo exhibitions. To the press and public, the works seemed plucked from another world, and Gluck – boyish in appearance, bold in dress, and still only thirty – was unlike anything they had seen before at gallery openings. Acclaim was essential for Gluck's inner resources as well as her outer material successes, and what followed was a surge of confidence along with a flurry of purchases, new friends and commissions. Her family's disapproval had now wholly dissipated, or at least it seemed that way once they bought her a home of her own, Bolton House in Hampstead. More suitable to an heiress than an emerging artist, Gluck was untroubled by the implications, accepting her parents' gift and moving in with a housekeeper, maid and cook.

Gluck's achievements had her longing for a different kind of partner – an equal, a collaborator – and it was out of this dissatisfaction that the relationship with Craig waned, and the writer Sybil Cookson moved in with her children a couple of years later. Little survives of the relationship except a portrait of Sybil's daughter. One of the lightest of Gluck's paintings, it is nevertheless attentive and empathetic, a real attempt at capturing a child's self. A young girl grins from underneath a flat cap, rosy and freckled, more puckish than girlish, radiating an unselfconscious warmth. Fun rather than flattering, it was not what Sybil expected, and she

made clear to Gluck her dislike of the portrait, so much so that it was sold to someone else. Seemingly a small disagreement, the misfire of *Gamine*, as it was known, in fact gestured to the different life experiences and world views the women brought to their relationship. What constituted a good portrait, a meaningful and lasting representation of a loved one, was one point of divergence; fidelity was another. While representation and relationships might not seem linked, both were in a sense tied to intimacy and its expression, and there were consistencies in Gluck's approach. Sybil likely objected to the irreverence of the portrait (the buyer later described it as 'delightfully ludicrous') and it was a similar lack of seriousness, emotional rather than aesthetic, which led Gluck to quickly tire of Sybil's attention, to seek out something new and fleeting elsewhere.[6] In her family home, inhibition had shaped the horizons of her intimate life as much as her art, and Gluck was now revelling in the sudden transformation to her circumstances, their heady freedoms, at times to the detriment of others. Once Sybil caught Gluck with another woman, she had hard evidence of the imbalance, and despite how fascinated she was by Gluck, her pride was irreparably wounded, and she left.

The break was unexpected and bitter, on Sybil's side at least, but Gluck's sudden coldness in her handling of the affair – with children's television presenter Annette Mills – was a capriciousness born out of anxiety rather than cruelty. Intimacy was a fearful thing when her own parents believed her attachment to women to be 'a kink in the brain'.[7] The measure of brutality Gluck reserved for her lovers spoke directly to how she had been raised to consider her own desires: as unnatural and irrational, inseparable from shame in some form. In spite of the strength of this conditioning, Gluck craved affection and companionship, and Sybil had not been gone long before Gluck fell for someone else.

Before Gluck met Constance Spry she had already fallen in love with her flowers. Prudence Maufe, an interior designer who later became the first female director of furniture store Heal's, introduced the pair in 1932. Prudence wrote to Gluck enclosing a white velour feather and a commission, asking Constance to supply Gluck with

one of her signature arrangements to paint. Prudence claimed it was merely a meeting of minds, but the feather was a talisman – a suggestion of desire in flight, of nimbleness and purity of feeling – promising a different, deeper connection. Constance took the call at her shop in South Audley Street, and sent her assistant Val Pirie out to Bolton House with a selection of her finest anthuriums, amaryllis, arum lilies and tulips, and a Warwick vase, all carefully set down in the back of the car. Gluck ushered her in, and Val set to work. Val placed the vase on a pedestal, fetched a bucket of water and, setting it down next to her, began to cut the stems, then arranged and rearranged those stems around one another in the vase – paying heed to the weight of each head, feeling the cool touch of the petals fleetingly against her skin, making minute movements until she achieved a balance. Gluck was mesmerised. How unusual it was to have beauty so explicitly carried into her life, to observe a display of care, attention and skill, and to understand the performance as intersubjective, a charged message from one woman to another. As a flirtation technique, a seduction by proxy, it worked.

Gluck began painting the arrangement, but was methodical and slow, and would not continue painting if any single blossom failed to meet her exacting standards. She closely watched the slackening of stems, the sudden heaviness of petals, minute bruising or curling at their edges. The flowers had to be as they were the moment they entered her life, untouchable and perfect, as anything else was inauthentic, a betrayal of that first encounter. For the next few months Gluck called the florist each time a replacement stem was required, and slowly the entire bouquet was replaced, each new flower never exactly the same as the one that came before. In this way the bouquet resembled the *Argo*: like the ship of Greek myth, gradually repaired until it was an entirely new structure under the same name, each component part of the bouquet was substituted while retaining the coherence of its original form. Gluck condensed all the flowers over months of work into the structure of a single encounter, one electric image, and in doing so dismissed loss altogether – be it organic

or emotional – preserving herself, the flowers and those feelings in one boundless elongated moment.

More so than ever, Gluck's choice of partner was motivated by artistic concerns as much as any rub of desire. A former teacher of home economics, later a shrewd businesswoman, Constance was now recognised as a radical innovator in the art of flower arrangement. Like any modernist searching for new forms and mediums with which to work, Constance sought out cockle shells, grapes, kale and red cabbage as often as lilies and bougainvillea, mixing together vegetables and flowers, making bouquets that were playful remarks on nature and artifice, blurring the distinctions between the beautiful and the merely humdrum. Constance was listening to a customer, or she was concentrating on making notes from one of her nineteenth-century flower books, occupied with the creation of another astonishing bouquet, and she was more successful than ever, but not so busy that she did not notice Val repeatedly taking calls from Gluck. This was not a usual customer, that much was clear, and Constance was interested.

For Gluck the drive for perfection was not just about privately getting the composition right; it also allowed her to showcase her ambition, commitment and originality to others, and to Constance in particular. These were qualities that made a good artist as much as a good lover, and as an elaborate gesture of courtship, a display of what she had to offer Constance, Gluck succeeded. Val rarely motored up to Hampstead again. Constance arrived at Bolton House, arranging the new stems for Gluck with a sense of performance, her hands delicate and pink, the cuffs of her sleeves damp and sweet-scented. Amidst all this aliveness so carefully handled, the weather in the wood-panelled room grew close, intimate. The *Argo* would prove a fitting resemblance for the bouquet, as Roland Barthes describes the phrase 'I love you' as renewing itself alike.[8] With each utterance the lover rebuilds the phrase, investing it with fresh significance, and it was as though the women were modelling this action to each other in the handling of the flowers before their affair had even begun.

A solo exhibition of Gluck's work, which included *Chromatic* and other works made collaboratively with Constance, opened in October 1932 at the Fine Art Society. Always meticulous in the presentation of her work, Gluck designed the exhibition room itself, transforming the entire space into a creamy white enclosure that echoed the appearance of her specially made frames. To this cohesive aesthetic environment, Gluck added displays of Constance's white flowers, the living versions of the images that lined the walls, an acknowledgement of everything her lover had contributed to the show's conception. Constance had proven her worth as an artistic collaborator, and she had excelled in the practicalities of promotion: the show was another rousing commercial success, drawing a diverse mixture of figures selected by Constance that secured for Gluck a succession of new patrons and commissions. Love can be a wild and careening thing, and it can be considered, intentional, at once deeply felt and rationally judged, and this was how the relationship developed for Constance and Gluck, for whom desire and artistic ambition met in a neat and productive union.

Constance was impressed by *Chromatic*, but coolly professional in her remarks: 'her painting of this group exemplifies the delicacy and strength, the subtleties and the grandeur of white flowers'.[9] The formality of Constance's critique was sweeter than anything more explicitly romantic. In so public a forum, her words are careful to tiptoe around their shared secret.

*

The appearance of glass recently rinsed in hot water. Soap suds sliding down china. Plates stacked by the sink. Scrubbed floors. Damp marble. Cabinets gone over with a duster. The gleam of a bathroom in which the grot has been painstakingly scoured (on hands and knees) from the tiles. A pile of starched white cotton shirts, neatly folded. Furniture carefully bleached of its stains. A great armoire moved to reveal stretches of skirting

board, recently dusted. Shirts under an iron, steam rising. In these paintings the rooms are sterile, the surfaces polished, the flowers rinsed in a substance that looks more powerful or clarifying than water. None of this was Gluck's doing. She watched, or she waited, or she forgot altogether that this was how her life was maintained, and what was done by others she swiftly undid.

Gluck was known to be particularly unpleasant to her servants. Screaming arguments over what she regarded as sloppy work; silences her staff struggled to navigate; eventual dismissals. The arduous, complex work undertaken by Gluck's servants performed the customary task of freeing up time and energy to allow her to paint, but more unusual was how much their labours lent her paintings their defining aesthetic. An unintentional collaboration, no gratitude or recompense; a set of unwilling muses. Without the servants, none of the still lifes Gluck completed in the thirties would look as they do: instead, imagine paintings marred by dust and grease and innumerable humdrum contingencies – the brilliance all gone.

When encountering these paintings in Gluck's studio, some final task awaiting them amongst sullied rags and congealed paint, did these young women pause before the easel, curious, their exhaustion briefly lifted, and wonder –

Is that my hand (calloused, dirtied) ghosting out the frame?

Or was it an urge, a command sounding through them in a low whisper: lift the drying canvas from the easel, quick, steal out the door, faster, and take what is rightfully yours . . .

*

*C*hromatic would be the first of a series of luminous flower paintings executed in collaboration with Constance, but she was not the only influence on Gluck's aesthetic. Gluck told her brother that she dressed for an 'old masterish' effect, an influence as palpable in her choice of dramatic dark clothing as it is in her still life.[10] Much of the basic iconography of that tradition remains. Opulent flowers are centred against an opaque fabric in a vase

that is as unremarkable as the surface it rests upon, with every element of the painting diminished in interest so as to highlight the extraordinary subject. Where the 'ish' in Gluck's phrase comes in, however – the suffix that dilutes and trivialises the hallowed term – is of more interest. Flattened and crisply outlined, and lit as though with a cascade of electric light, Gluck's works are less explicitly alive and more avowedly contemporary than those of the Old Masters tradition. Newly installed electric light bulbs illuminate the flowers evenly from above, the heavy textiles are thrown out, the wallpaper stripped – showing off the stark and economical lines favoured by modern design – and what comes into focus are surroundings cleaned by a team of domestic staff in possession of increasingly efficient methods for maintaining rigorous everyday hygiene. The obsession with inherited wealth and consumption endures in Gluck's revisions, but these conversative values exist in peculiar tension with the same work's queer potential.

For all the familiar coordinates that survive, one guiding principle shifts. The paintings do not shrink before a higher power. Darkness is no longer relied upon for drama, and there's an authoritative glee, a godly ambition even, in Gluck's decision to pull the gloomy fabric from behind the arrangement. A sheet of colour emerges behind each bouquet like the command *let there be light*, and the effect is to throw open the windows and doors; air fills your lungs, your spine straightens a little, it is easier to be around these works with your head raised and your eyes wide open, full of purpose, unafraid. Flowers have never looked more nourished and carefully conserved in the history of the genre, and their attractions to a viewer more obvious, and together what this effects is a deeper and more drastic transformation in thought.

Gluck is omnipotent, and in usurping the place of God, what vanishes from her take on the genre is the shadow cast by death. The Old Masters used flowers as a motif expressive of the brevity of all life, deploying an established set of visual tricks to draw attention to this theme. Flowers are depicted at the very edge of their bloom, the coming rot just visible in their curled petals and slackened necks; dew glistens on every available surface, punctuation

indicative of a momentary pause within an ever-advancing present; darkness slides in soundlessly from all sides. These paintings were known as vanitas, and stressed the proximity of human life to death in order to emphasise the worthlessness of worldly pleasures and possessions. Gluck's flowers exhibit none of these markers: they are flawless, at a remove from biological processes, as lifeless and deathless as the immaculate paint they are rendered in.

The paintings offer a visual counterpart to an experience of embodiment that was never attached to the ordinary cycles of maturation, reproduction and death. Queer lives organised themselves around their own markers of success, and without marriage and children, those lives need not be so oriented towards the future, and their own inevitable demise. Gluck's flowers feed on a queerness that's a resource of presentness, of presence, and the paintings propose their own vision of a life faithful to these alternative ethics. A life without the expected momentous events does not move forward with same headlong zeal, rushing from one prescribed achievement to the next – meeting, marrying, reproducing – and instead encourages indulgence and dawdling and miraculous repetition, offering those dissenters from convention an opportunity to stay inside their most heightened, precious moments for ever. Beauty can remain paramount, desire the highest goal. The flower paintings are a dance floor in which the lights never startle on in the early hours; the music surges onwards, the bodies refuse to tire, the crowd hums in perpetual motion; it is a queer utopia in which pleasure is boundless.

This emphasis on pleasure was a queer standpoint as much as a secular one. Although still close to her mother, Gluck had distanced herself enough from her family and their Judaism that the religious moralism embedded into the vanitas tradition no longer held any sway. Not answering to any power outside of herself, Gluck sought out the spiritual in expensive food and wine, antique furniture, cocktail parties, exquisitely tailored clothing and holidays abroad with her lovers. In removing the foreboding presence of death from her still life, Gluck was formulating a dissident personal philosophy in which there was no guilt, no mandatory sacrificial

violence, and no fear. Gluck's own doctrine was simple, and it is what makes *Chromatic* so arresting: to exist in communion with the most radiant, beautiful things – and without compromise. There was no god as masterful and gracious as herself, no god more willing to offer her redemption when she hurt those she loved, and no god more generous in her rewards. In the kingdom that Gluck built across a series of canvases, flowers do not die, nothing does, because given the choice, why accept loss as natural, and if it could be eradicated, then why live otherwise?

*

Given their lively dialogue with art-historical tradition, it is possible to see Gluck's flower paintings as part of a broader movement of British art in the interwar period. The losses incurred by the First World War led many artists to reject abstraction in favour of the firm ground of figuration. The formal dynamism and explosive violence of the machine age celebrated in Vorticism no longer appealed after the horrors of the trenches, and artists retreated to images untouched by those traumas. Watercolours focused on the countryside were sought after, pastoral visions of lush greenness and exquisite ecclesiastical architecture, all of them statements on an idyllic Englishness replete with a muted fear about its possible loss. The museum galleries left empty while artists swayed by modernist doctrine looked elsewhere to make it new were once again filled with figures hunched over sketchbooks, copying a Piero della Francesca so as to feel the simplicity of an imagined Mediterranean past eclipse the unsatisfying present. Roger Fry even anticipated the trend in an exhibition dedicated to copies and translations of Old Masters paintings at the Omega Workshops in 1917. The radical potential of abstraction, an aesthetic radicalism that had exciting ideological implications, vanished. Only ever dabbling with the principles of abstraction, Gluck's paintings never looked much like those of her peers, and even her manipulation of traditional representational forms bore

little resemblance to other contemporary examples. Partly this was because Gluck was fortunate enough that she did not personally brush up against the horrors of war. While her brother had fought on the western front, Gluck had been engaged in her own private battle: her uninspiring education at St John's Wood School of Art.

During her time at St John's Wood, women were still not allowed to draw directly from the nude. The principles of art school pedagogy insisted on the vital importance of life drawing, but women were only ever permitted to draw the model's head, or later, the draped body. The Slade had pioneered women's access to life classes, allowing women to progress alongside men in drawing from the nude, but not all schools were following suit. To expose women to the body constituted a grave moral offence, even if the bodies resembled their own, and even if those bodies were regarded as aesthetic rather than sexual objects. Accessing the body in a demystified setting outside the strictly policed realm of the family would allow women to better see and understand themselves, a fearful form of power. 'For a woman to look upon nakedness with the eye of an artist and not simply the eye of mother, wife, or mistress,' Virginia Woolf wrote in the foreword to an exhibition of her sister's work, 'was corruptive of her innocency and destructive of her domesticity.'[11] Gluck, like many of her contemporaries, had learned in depth how to draw flowers while the intricacies of human anatomy went relatively unexplored.

Gluck's rage against those years affects her flowers like a sudden surge of light, a chemical in the water, a pollination with a different species: it transforms them. Gluck uses a hyper-real figurative aesthetic that clearly specifies the flowers are flowers while also making reference to the most erotic zones of the body. The paintings obsess over flowers with the feel of skin, flowers that have done away with every last garment, flowers that ask to be touched, flowers that allude to taut muscles and the tissue underneath, flowers that resound with the hum of blood through its vessels, flowers that feel out the shape of organs, flowers that study the body's darkest crevices. Exposing the body through the very genre used to deny women access to their own bodies was a

fitting act of defiance, and it was funny too, exposing the absurdity of excluding women from anatomy lessons. The lurid physicality of the flowers mocks the faith in the efficacy of these tactics, as though a few anxiously placed sheets of fabric in the classroom would for ever deter women from removing their clothes before a mirror and learning the basics themselves. Or using their lovers as models. Or asking questions and exchanging information with their mothers, sisters and friends. Or going to a library and reading a book on anatomy. In Gluck's provocative floral aesthetic, the acquiescence, ignorance and silence expected of women is rejected outright.

Being restricted to still life not only restricted women's talents, but also involved them in creating and circulating propaganda that promoted an ideal of femininity that was passive, ornamental and frail. Gluck responds to these impositions directly. In *Lilac and Guelder Rose*, the blossoms are light and ephemeral, handfuls of confetti thrown into the air, a wedge of honeycomb, a flurry of snow, the notation left by a tinkling bell, soap suds rising from the sink. The depth of the greens suggest cultivation under glass, tin cans brimming with water, long hours of observation as light and moisture move towards their own intensities of colour. This is a femininity that's pretty and sweet, laboriously constructed, skilled and elaborate, beauty and complexity no longer mutually exclusive. Look at any of the flower paintings, *Lilac and Guelder Rose* amongst them, and there is no waste, nothing that is not there after much deliberation. Given that the social experience of femininity for so many women involves understanding themselves as inherently unmanageable if not irredeemably abject, impelled by unwanted emotions and physical events, the revisions that Gluck made to the form – how utterly loved, idyllic and flawless femininity becomes – are all the more radical.

After all, Gluck understood the hidden complexities of conventional femininity from experience. Outwardly ordinary – even, given her profession and social circles, a little prim – Constance was in fact gifted, sensitive and conscientious, and bold enough to plunge into a love affair with Gluck while accepting all the risks that came with it. When a vicar made a disparaging remark about

Gluck's dress when the couple were in a tea room together, Constance leapt to her defence, following the man out onto the road, furious and steadying her voice as she spoke, making the confrontation public and her alliance with Gluck unequivocal. Constance only reiterated her willingness to protect Gluck, and to make space for her transgressions, through commissioning designers to make daring new clothes for her, including black chiffon culottes made by Elsa Schiaparelli. The flower paintings capture the honour and fortitude that Gluck invested in Constance's femininity, and in their own covert way record how Constance herself resisted and reworked the expectations and moral standards that came with her gender, both as a professional woman and as a romantic partner.

The redefinition of femininity Gluck realises in *Lilac and Guelder Rose* was only one part of a broader project interested in bodies and identities, and the scant available means of representing them. Bypassing the dreary and habitual objectifications of the nude, Gluck also decided against portraiture, its optimistically simplistic use of the body as a transcript of character, opting instead in her flower works for something entirely new: an attempt to convey the visceral, sprawling experience of embodiment. With their emphasis on recurring shapes, precise movement and opaque patches of colour, these works are about reproduction, the ubiquitous and unending processes that underlie it, and they are about boundaries and flow – of blood and water and breath and hormones – all the growths, losses and unsteady equilibriums unfolding across networks of interconnected systems that constitute the foundation of our lived bodies. These energies, with all their dynamic and knotted and mysterious force, were what the traditional nude did not acknowledge – and they're not only explored in Gluck's flower paintings independent of any particular self, but also, and perhaps more radically, independent of any single gendered or sexed body.

Gluck's flowers borrow terms from the masculine and feminine, never bothering to heed anything so banal and restrictive as the binary system of gender or sexual difference, and instead her work naturalises an environment in which the connection between bodies and identities is complicated, slippery and expansive. Botanical

like a tinkling bell

classification systems in Gluck's lifetime continued to be shaped by the work of eighteenth-century botanist Linnaeus, who proposed that the reproductive parts of plants paralleled the sex organs of animals, and extrapolated from this a taxonomy in which plants confirmed the naturalness of binary gender, sexual dimorphism and heterosexuality. The botanical thinking Gluck engages in through her flower paintings thoroughly ignores the essentialist dint of this discourse. Gluck's 1936 *Lords and Ladies* is a study of arum lilies which is careful even in its title to state an ambivalence about the subject's sex and gender. Their resemblance to eroticised parts of the body is so explicit that Gluck herself addressed it, careful to reverse the most habitual of assumptions. 'How can these flowers be female?' Gluck wrote. 'Anything more male than this prominent feature I cannot imagine.'[12]

In claiming the flowers as phallic, Gluck took aim at received ideas about the natural world, revealing their close correlation with the myths about sex and gender that had plagued her entire

the experience of embodiment

life, and exposed the ways in which those same fallacies translated into a narrow way of seeing which could only reproduce clichéd representations of nature. Gluck was determined not to repeat those mistakes. Across the flower works, symmetry breaks down to reveal slight deviations. Rather than work with an idea of physiology that's entirely fixed and predetermined, Gluck frames her flowers as a mixture of patterns and spontaneous gestures, stunning symmetries and wild deviations, constructing a model of nature in which there is room for difference and surprise. Gluck's remark was intentionally mischievous, offhand even, and belied the seriousness of the work's ambitions: the notion that anatomy is destiny and gender is natural, the coherence and stability upon which so many other oppressive principles rely, is in *Lords and Ladies* challenged and dismantled. Rigid sex and gender binaries dissolve in a new kind of classification – one not based on aesthetic or social norms, nor on a strict divide between human animals and their environment, but on recognition, sympathy and belonging.

the struggle to be seen

Amongst Gluck's sketches, there are a series of written plans for the flower paintings: as mediums for conceptualisation and documentation, in them countless works are distilled. During their relationship, Gluck accompanied Constance on professional excursions to country gardens, both women taking notes on samples and cuttings, and the breadth of material in the archive suggests that this working habit endured. In some the bouquets themselves are loosely drawn, then deconstructed like a diagram: these dissections trace the passage of thought into action, and pause at a stage of Gluck's process where the endpoint is still unforeseeable, the finished painting pure potential. A few sheets pluck a single bud from the bouquet and bring it to life in watercolour, adding commentary on colour that adjusts what is visible into its most ideal form. These descriptions are instructions to herself, the seed for future works, and they are explorations of the limits of paint, aspiring to a granular precision in colour and form that for Gluck the written word more robustly guaranteed. Writers and painters alike are prone to seeing their own medium as inexpressive, longing for the

alternative. 'Words are an impure medium,' Woolf wrote in an essay
on Walter Sickert, but for Gluck 'the silent kingdom of paint' wasn't
enough.[13] Notes on the ineffable and the minuscule, which for her
fell outside the remit of the visual, surround the flowers: 'white
edge and lips; faint yellowing; white with fine blue purple lines'.[14]
These corrections refocus the paintings as though with a magnifying
glass, encouraging a closer look at each petal, an attention to the
gradations in tone that underlie even the most matt applications of
paint. Some plans are composed solely of passages of text, and move
beneath the refined surface of *Chromatic* and its many counterparts
to a realm of murmurs and mumbles, and everything language
cannot contain: erratic scribbles, sweeping lines and pensive dots
all rendered in smudged pencil. These documents expose the
deceptions of Gluck's sleek aesthetic, her apparent obsession with
surfaces, and reveal the inner life of these paintings as bursting with
labour, thought, knowledge, discrimination, accuracy and detail.

These texts were not the only working documents for the flower
paintings. In the archive, the flower drawings are stored inside and
alongside a vast supply of material suggestive of the rich and varied
ground from which the finished works were drawn. Out of images
from newspapers and magazines, quotations and phrases cut out or
copied onto scraps of paper in pen, technicolour advertisements and
fragments torn from religious treatises, Gluck conducted complex
acts of cross-pollination from which she cultivated her singular
flowers. The material reveals how each work was a complex act of
compression, tethered to the real world not only through Constance,
references to her work and their relationship, but through a
composite of intellectual and emotional resources. The unexpected
lyricism and sheer range of this supplementary material adds further
nuance and depth to the paintings, and even a small sample of it
reveals how experiences like redemption, struggle and happiness all
contributed something to the flowers' subterranean life. Saint Teresa
of Avila articulates in biro a spiritual intensity that intermingles with
the hurriedly reproduced words of Vincent van Gogh, his remarks
on creativity and suffering undercut by the simple joy of an elephant
in expressive charcoal, a reproduction of a Rembrandt drawing

a magnifying glass

ripped from a newspaper. The sudden accumulation of other voices felt eerie sitting before the mass of papers in the archive, as though I were suddenly attuned to a frequency at which the works could be heard whispering. And what they communicated was this: devotion is messier than we might like to admit, fraught with insecurities and errors and unseemly convictions, whirring with private questions and compulsive analysis, and however hard we try to make it appear otherwise, somewhere that reality is archived.

The relationship with Constance was proving endlessly productive, a true partnership of equals both intent upon making art, but Gluck could not necessarily be trusted to see the worth of such a stable, constructive bond. Constance was encountering resistance from both her husband and her business partner, while Gluck was increasingly restless, tiring of the 'very peaceful and sweet' nights she spent with Constance, and over time the allure of everything Constance once offered her began to dwindle.[15]

Noël

In a still life of 1937, the orderly world of Gluck's flower paintings
is forgotten and the door is flung open to the quotidian. There is
tinsel, a cut cake adorned with thick icing, glass baubles, popped
crackers and multicoloured streamers flying in from the side, and
all enclosed with sheets of patterned wallpaper. Unlike traditional
still life, and Gluck's own revisionary contributions to the genre, the
contents of *Noël* are cheap and disposable, frivolous and artificial.
Nothing about any of these objects is suggestive of status, of what
formerly united Gluck with her predecessors. Different values are at
play here. The work begs the question of what exactly had so altered
in Gluck's life to draw her attention to a spontaneous, sentimental
scene of domesticity seemingly so inimical to everything she had
ever painted.

One of the most productive new friendships Constance had
encouraged was with Molly Mount Temple, who considered herself
a patron of the arts, was fascinated by Gluck and commissioned
her to produce flower paintings suitable to adorn the walls of her
lavish Palladian mansion in Hampshire. Dinner parties commonly
concluded the professional visits Gluck made to Molly's home, and
while most passed without comment, it was during one of these
evenings that Gluck first met Nesta Obermer.

Nesta was a painter, poet and playwright best known for her
work in the theatre. She was exceptional for a woman of her time
not only for this range of creative pursuits, but in owning a pilot's
licence, a streak of daring that also saw her driving sports cars and
excelling in winter sports such as skating and skiing. Despite her
glamorous appearance, the furs and elegant slips and silk scarves,
Nesta's hobbies and talents revealed to Gluck her defiance and
distance from the very same gender norms she abhorred. Both
women were in their early forties, accomplished, confident and
experienced with their talents assured and their lives ahead of
them. An attraction was there, introducing themselves across the
table that night, and while their maturity might have made their
union easier, the feelings steadier and more controllable, a fervid

obsession which took no heed of age or experience set in during the summer of 1936. On 23 May 1936, a date she later defined as their anniversary, Gluck set off to spend her first full weekend with Nesta at her home in Plumpton in East Sussex. The trip was a success, and a month later – having discussed at length Gluck's love for music – the women went to see Mozart's *Don Giovanni* together at the Glyndebourne opera house. Gluck was overwhelmed by the intensity of the experience, how the exquisite music, the narrative of seduction, their proximity to the orchestra, the heat, and their bodies close and communing in the darkness all gestured towards the undeniable fact of their love for one another.

The bouquet in the hallway of Bolton House wilted, but Constance would no longer be called for a replacement. The servants swept the petals from the floor. The scent in the soft furnishings disappeared after a few routine cleans. But the women themselves experienced a more dramatic fade. What followed were a series of fraught exchanges, and increasingly sporadic visits that yielded everything from awkward silences over dinner to devastating accusations and tense walks alone in Constance's garden. In November 1936, Constance and Gluck dined together for a final time. 'Awful evening', was all Gluck remarked tersely in her diary.[16] Four years had passed, the roots of their love had felt irrevocably deep, but – in a surge of selfishness and obsessive passion that was becoming characteristic – Constance was removed from Gluck's life with ease. Or, more accurately, Constance was burnt. As were the others who came before. Nesta's entrance into Gluck's life was a force so absolute it promised to entirely eclipse her past, to raze every last attachment or affection, and it was the virgin ground that their love was subsequently built upon that Gluck wanted to honour, indeed to literalise. Gluck gathered all evidence of Constance, Sybil and Craig and threw it onto the pyre. 'I want to start such a new life that anything even vaguely smelling of the past stinks in my nostrils,' Gluck wrote. 'What would it matter if I destroyed everything?'[17]

The urgency with which Gluck incinerated all her most private paraphernalia drew on a new understanding of how a pervasive,

internalised homophobia had shaped all her prior intimacies. Suddenly every last letter she had written appeared compromised by doubt or self-loathing. 'How we waste time and precious love and sane companionship for a lot of idiotic shibboleths,' she wrote to Nesta. 'I don't want to force anything in our circumstances, but I will not let <u>myself</u> be side-tracked any more.'[18] This would be different, a new beginning for Gluck whether or not that particular relationship lasted, a chance to love freely without shame, to unlearn what she had been taught was right or wrong about her desires; to know she had given all she could if the affair came to an end, and to think back without the familiar disappointment or regret.

What Gluck gave to the fire: dozens of letters, volumes of diaries, thick stacks of receipts, a few paintings done in what felt like a previous life in Lamorna – saving only the fragments that depicted Gluck alone – and even a paintbox. 'I am practically fanatical on this question of freeing myself', she explained, and so it was not grief or loss but a 'glorious airy feeling' which possessed her once her efforts were complete, surrounded by 'torn charred scraps'.[19] Privately called *YouWe*, Gluck's 1936 portrait of herself and Nesta, *Medallion*, was made to mark the beginning of their relationship and visualises the devastating and electrifying effects of the blaze. Set against a singed grey horizon, Nesta is pressed against Gluck, with their features – carved cheekbones, swept-back hair, strong jawlines – so closely aligned that they look forged out of the same mould. With every prior emotional event and all its physical evidence reduced to ashes, Gluck believed she and Nesta were entirely free, and once the flames died down, the results of her labours were clear. Having destroyed all her personal effects, the raw material of all her memories and hopes, Gluck left behind a distinct self, and the close resemblance drawn between herself and Nesta in *Medallion* suggests the possibility now of a more complete union. 'Every little nerve and vein and pore strains to merge with you,' she wrote with characteristic intensity to Nesta, 'and breath with your breath and beat with your pulse.'[20] Nothing else need exist any more except their profound intersubjective encounter,

or what Gluck described as 'the power of our combined magic'.[21] Their love left nothing to be desired, no need unfulfilled. 'You have given me so much delight, physical and mental and spiritual,' Gluck confessed.[22]

The destruction of her personal papers prior to Nesta had another aspiration behind it, as anxious as it was romantic: it gave Gluck the ability to control her legacy. In the archive, attempting to construct any clear sense of Gluck's romantic relationships with other women is near-impossible. All that remains is evidence of her professional life, and the impression created is of decades spent alone, unwilling to compromise and certain a perfect romance was out there, a patience that was eventually amply rewarded. There is a vulnerability revealed in this impulse, the resolute erasure of all the disappointments and betrayals, as though Gluck wanted to be remembered not for her faults, the sudden recesses of coldness and callousness, but for her passionate tendencies, her single-minded devotion, her willingness to sacrifice everything for those she loved.

If *Medallion* celebrates the purge, then *Noël* addresses the aftermath. The aesthetic excess and material plenitude of *Noël* aim towards replenishing the absences created by the ritual burning. The painting was merely one act within a broader project aiming to formulate a cache of experiences and memories distinct to their relationship, and as Gluck was impatient, desperate to invent new ways to bind them closer and prove the meaningfulness of their bond – and all as quickly as possible – her only choice was to accelerate a process that might otherwise take years. With its contrasting patterns, assortment of colour and mishmash of forms, there is a sense in which every available material has been seized and exploited, and as such, *Noël* captures something of Gluck's desperate world-building in the months that followed. The women exchanged rings, and *Medallion* was hung prominently in Gluck's studio. A succession of mutual friends were deliberately paraded in front of the work so as to announce their partnership, crucial moments of witness which Gluck described in detail to Nesta, eager for them to experience together this validation as a couple.

Countless letters in floridly romantic language affirmed the immortality of their love, and contributed new narrative details or theoretical flourishes to their shared myth. To more concretely cement their strength as a unit, Gluck bought a pet – a huge Great Dane called Zar. Everything that Nesta enjoyed, Gluck immediately and passionately committed herself to, and that meant learning to ride horses, sailing, skating and skiing; photographs of them as a couple show them smilingly engaged in these activities. Putting the intensities of this new passion to constructive use, Gluck poured all of her available energy into building a relationship that was coherent, substantial and self-sufficient.

Sometimes the motives behind all these efforts felt just as they appear in *Noël* – simple and cheerful and crowded with hope; but there was a darker, bleaker undertow. Gluck wanted to make a life appealing enough to Nesta to draw her from the ease of a passionless but socially advantageous marriage. Having pragmatically assessed the cost of her freedom, Nesta had married a wealthy American playwright in 1925 who was decades older, and with it guaranteed herself security for life. Despite the success of the relationship with Gluck, her reluctance to ever really talk of separation – despite Gluck's hints, and her eventual outright requests – suggest she had no real intention of ever leaving him, and the desperation with which Gluck attempted to draw statements of commitment from Nesta imply she suspected as much. It did not help that the couple were not exactly on bad terms either, and continued to holiday together in Europe, much to Gluck's distress, who was left alone in England to write increasingly persistent and frustrated letters to Nesta during these absences.

From the beginning of their affair, Gluck wrote multiple times a day to Nesta, composing texts from various points in the home, including from bed – 'a crust and orange juice' at her side – acknowledging that if she and Nesta could not share a home, she would have to find novel ways to incorporate her into her everyday domestic life.[23] Effusive and digressive, the letters are full of details about her day and anecdotes from her past and grand theoretical conjectures about music and art, always eschewing what Gluck

considered to be the 'banal news' of other correspondence.²⁴ Typical
was a morning in October 1936 when Gluck wrote eleven letters in a
row to Nesta in which she described the burning of her belongings.
Scratched at the top of each text is a number tallying the pages.
Alone, many of Gluck's gestures simply read as sweet, attentive,
enthusiastic, or even practical – the letters numbered one to eleven
were designed to withstand their reader's possible carelessness,
or their divided attentions – but the daily surge of letters, their
heightened romantic language, sheer bulk and unwavering focus,
were not without a certain possessiveness. In a letter a month
earlier, for instance, Gluck placed inside her letter a lopsided circle
she claimed had been drawn around her own pursed lips. Gluck
was using everything in her repertoire, deploying her preferred
linguistic forms – her flair for dramatic storytelling and charismatic
self-mythologising – and when that did not suffice, when words
simply were not immediate enough, she made arresting use of the
visual. The clamouring address of the drawn kiss was typical in its
blend of eros and anxiousness, an uneasy energy that unites her
letters and makes them extremely hard to read in bulk, as Nesta was
often obliged to do. Gluck wanted to inscribe that kiss onto Nesta
as she had onto the paper, to mark her out as loved and taken.
Gluck was eager to make space for herself, and if she must, it is
implied, she would lay claim to so little: to a little oval of coffee-
coloured paper imprinted with her body.

so little

The letters alone consumed hours of Gluck's day, and as the relationship thrived she found that with the writing and anticipation of responses, not least the meetings themselves, she had considerably less time to work on her art. Nesta was voraciously social, and given how little claim Gluck knew she ultimately had over her – not recognised by the law, visible only to select friends – she was desperate to accompany her to cocktail parties and dinners, to practise in controlled conditions behaving more completely like the married couple she considered them to be. What this meant was that the studio was empty most of the time, 'cold and neglected' as she put it, and her work ground to a halt.[25] The obsessiveness, attention to detail and epistolary productivity Gluck experienced in relation to Nesta constituted its own consuming creative practice. No canvas had ever brought her this kind of satisfaction, and Gluck was content to shift her chosen medium for ever if she could, for her art to amount to nothing more than the uninterrupted worship of Nesta.

*

Noël was painted after the couple's first Christmas together, spent with Gluck's mother, at the end of the wholly transformative year of 1936. The women – a Jewish parent and child, along with her married lover – were presented with an opportunity to revise the holiday according to their own values. Without Christianity and its associated moral standards, without reverence and gratitude, without the family arranged by rank respectfully around a dinner table, without religious obligation and inherited rules, what would the festivities involve? Throughout her life, like many queer people, Gluck encountered ideologies she could either accept her exclusion from, or attempt to take possession of, adapt and build afresh, and Christmas was one set of rituals she made a concerted effort to put to new use. Placing togetherness, generosity and a disorderly pleasure at the centre of the work, *Noël* condenses years of resistance, experiment and improvisation into a single frame, and celebrates the rewards of those efforts. The cake has been eaten, the

party mask ripped through exertion, but just as enjoyable for these former exiles are the small, impish deflations of dogma. The cake is wrapped in a lilac fur stole that makes the holy star look more camp than communicative of divine authority. The multicoloured streamers recall the tunics of men in Renaissance paintings which take the Adoration of the Magi as their subject, or the iridescent beams that enter religious paintings aslant as representations of angelic messengers, references that reduce male and celestial bodies alike to flimsy, cheerful strips of paper.

Like a Christmas card, the painting circulates a shared happiness. In the archive, there are numerous black and white reproductions of *Noël*. Each differently shaped, and all of them smaller and less vibrant than the original painting, they are representations of the singularity of that first Christmas together, how nothing could rival its intensity. All the years that followed were merely inexact, faded copies.

Balloons

Happiness reigns at the funfair, and Gluck positions herself before children and adults clamouring for cheap thrills, games and gifts. One seller's wares stand out: more like boiled sweets, or snooker balls, the balloons are too solid, too weighty and opaque to look as though they would float, and yet at least one does, hanging in the air like a low sun. 'I feel I am defying the fate I have always felt lie in wait for me,' Gluck admitted to Nesta.[26] 'When I look back, as I have been compelled to do in the last days, I cannot believe I have lived the life I have,' she went on.[27] Decades of loneliness, intimacies gone awry, and now this: 'I fear nothing now,' she wrote.[28] Hope is an impossible, and buoyant, and bright, and fragile thing.

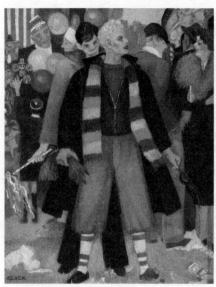

Bank Holiday Monday *(1937)*

Nature Morte

From the period that followed, paintings are scarce; Gluck, however, continued to visit her patron Molly Mount Temple, and *Nature Morte* was made from scouring the grounds of her house. Although generated through a similar process to her other floral works, through chance encounters with nature and people, *Nature Morte* is entirely different in its emotional register. Set against a muted palette, the flowers are intricate, architectural gold and copper strands resembling antique jewellery. Beautiful, they are also long dead; the familiar sheen of immortality – and the certainties it represents – has gone.

Whatever the couple did, regardless of the happiness they felt, certain issues remained inexorable, above all the spectre of Nesta's husband. While divorce was slowly becoming more common and

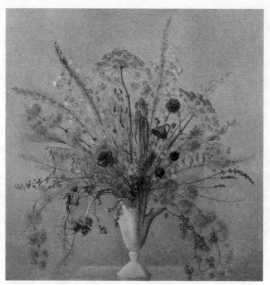

a darker vision

accessible to women, it remained bound up with stigma, and Nesta was aware of all she had to lose. Most of her wealth, her status and her professional contacts; even without those more superficial elements, and despite the liberal tendencies of those in her social circle, Nesta had every reason to worry about her friends, their ability to compassionately judge a transgression as extreme as leaving her husband for a woman. Instead, Nesta accepted a life that was torn in two, and Gluck was forced to do the same. During their separations, Gluck agonised over possible solutions to their predicament, and continued writing long, involved letters about her love for Nesta and their future together, but her desperation – and the inequities of their relationship – was beginning to show.

Nesta holidayed in St Moritz with her husband in early 1937, collecting her letters on the way to the ice rink with a casualness that exasperated Gluck, who was alone in her studio. Sinking into a deep despair following any delays to Nesta's responses, Gluck feared

she was asking too much, yet continued nevertheless to escalate her demands: wanting more reassurance, more extravagant displays of affection, more evidence that her absolute absorption in Nesta was reciprocated. Unable to work, struggling to find meaning or purpose in her life outside of Nesta, and deeply resentful of how her own days were now controlled by the timetable of her lover's husband, Gluck retired to her bedroom and stewed over their relationship for hours on end. The withered subject of *Nature Morte*, its pessimism about beauty and its endurance, reflect something of Gluck's suspicion that the relationship with Nesta was less sustainable than she had hoped. As the barbiturates she took to sleep set in, one question in particular haunted Gluck: did Nesta love her with the same fierceness? The letters move towards versions of this question only to lose courage, frustration dissipating in the blunt fact of her need, concluding with assurances that Gluck really only wished to be with Nesta, that was all, to prove to her everything she was missing.

Deals were struck. Gluck holidayed with Nesta and her husband a few times towards the end of the thirties, and photographs show the women huddled together against the cold, smiling unselfconsciously as though this were simply an ordinary romantic snap, no husband prowling on the margins. They worked together on charitable projects for Nesta, travelled together around the south-west coast of England, and continued socialising as much as possible. But for Gluck, even with all these concessions and demonstrations of love, it was never enough.

Anxious that no amount of effort could ultimately prevent Nesta slipping away from her, Gluck painted *Nature Morte* thinking deeply about what it meant to want any living thing to remain at the height of its resonance for ever. Finally acknowledging the limits of the genre – those Gluck had once so confidently set aside – the painting instead makes a spectacle out of death, accepting her own lack of control, her inability to follow through on the promised enchantment of the canvas. Glancing from her easel to her dwindling bundle of letters from Nesta, loss consumed Gluck. On canvas, her strategies to confront these facts were clear and

powerful, but in life they were frantic, miserable and destructive. In her diaries Gluck began to fastidiously track her encounters with Nesta, timing them, and arriving at dire assessments of the results. Other coping strategies were developed, equally masochistic. From the late thirties and early forties the letters begin to change, almost imperceptibly at first, not in their content, but in their physical texture. In some, entire paragraphs have been torn off – leaving passages poised on a random, insignificant word. In others, black crayon has been used to redact words only for those attempts to be judged insufficient, and so holes have been snipped into the page – darkly outlined, evidence of Gluck's preliminary efforts – taking with them names or entire sentences. Particular people, events and phrases disappear from the narrative. Nesta's name is one of the most common and easily identified subjects of erasure. Presumably these edits were made once Nesta had returned Gluck's letters, and the evidence of what they shared could be pored over. How tempting it was to locate the turn of their relationship in a tiny narrative detail, and to censor her outpourings as though to punish the naivety of that past self. Possessed with bitterness and regret, Gluck was nevertheless too bound to Nesta to burn the material, as she had done without compunction before, and so she had to be content with these small incisions, their attempt at annotating and editing the past, such meagre bids at control and absolution.

editing the past

Gluck's other name for *Nature Morte* reflects the spirit of that moment: translating '*morte*' with a morbid literalness, Gluck

referred to it as '*Dead Group*'. Melancholic thoughts possessed her, and little wonder: in public and private, loss pervaded. Fascism had taken hold in Europe, and after mounting aggressions and failed attempts at keeping the peace, Britain declared war on Germany in September 1939. Gluck lost Bolton House when it was requisitioned for the war effort. At first she did not mind, welcoming the opportunity to start again, and seeing it as a chance to move to Plumpton to be closer to Nesta. However, months of poorly managed expectations, disappointments and growing bitterness – which for a time in 1940 manifested as a total physical and mental collapse – culminated in an ordinary drift of affections that Gluck neither shared nor accepted, and she lost Nesta too.

The impossible pitch of intensity at which Gluck demanded Nesta live could no longer be sustained. Being the 'wild, untamed, truthful you' that Gluck so cherished came with great pressure to realise that ideal, and the peace and flexibility of Nesta's former life called out to her.[29] Soon enough that was it, the decision was made, and the affair ended.

Nature Morte imagines a world in which loss might be dignified, in possession of its own grave allure, but there would be no honour in Nesta's departure.[30] Not in how Gluck responded at least, rereading the letters with as much fury at herself as Nesta, who refused to be drawn into protracted battles about the relationship's demise, until Gluck had no choice but to take a pair of scissors to the offending name, over and over until it couldn't harm her. Not in the lonely doodles Gluck did in the months after – a meal set for one, scribbled onto a torn-off corner of paper, her isolation resounding from each unsteady splotch of biro ink – and not in the pitiful notes she kept on Nesta's withdrawal. Nor was there much grace to be derived from the relationship Gluck then began with Edith Heald, a woman she was forever drifting from into dreams of Nesta, and with whom she would sustain a highly combative relationship until her death.

The most fragile items in Gluck's archives are flowers pressed between the pages of her sketchbooks. A flower curves over the page surrounded by a spattering of red ink – resembling pollen,

blood, cloud formations from the day they were picked – and is set alongside the abandoned beginnings of sketches, framed by a few numbers forming additions and subtractions, flashes of the practicalities from which these notebooks were intended as a reprieve. There is so much feeling in these carefully preserved fragments. Instilled into each specimen is the knowledge of nature that Gluck had cultivated through her most intimate partnerships, her perseverance with it when those bonds collapsed, and her excited practice of it alone, botanising as she walked. These fragments are reflections on what survives, the small legacies of a person, how feelings might persist and circulate beyond the horizons of individual lives in unpredictable forms. They are dispatches from the furthest reaches of Gluck's self because, for all her bravado, her gregariousness and egotism, if a single substance was drawn from her heart, in all likelihood it would be this: flattened petals, bits of ink, sturdy stems. These were the parts of her that were attached to the world, nostalgic and hungry and hopeful, wanting nothing more than to be present in her surroundings through whatever means possible, dirt on her hands and sweat gathering on her brow, stopping and starting as she moved through the field, intent upon her task, which for now was simply this: amassing further evidence of beauty.

The dried flowers scattered across the sketchbooks are a companion piece, or a primer of sorts, to the flower paintings that defined Gluck's career. The flowers she pressed between paper remark upon the inevitable distortions and compressions made by memory. Much of the aliveness and presence and particularity of an experience is lost in the act of preservation, in our attempts to hold on to it, in our desire to have it slot neatly within the established narrative of a life. Concessions have to be made – compromises – and so a history hardens around a single feature, a sole theme. Often, you cannot choose what endures. Years of desire are reduced to a set of images, a series of luminous paintings. To a few crumbling handfuls of organic matter.

dispatches

from the self

6

WINIFRED

If you were to visit the Omega Workshops at 33 Fitzroy Square, London during the years of the First World War, Winifred Gill would almost certainly have been there – bent intently over a pattern at the table, wearing one of her prized collections of pretty blouses, or guiding customers in the showroom towards a purchase suited to their needs.[1] Winifred began working at the studios shortly after they opened in July 1913, and was involved in the business until it closed in 1919. Her aim was to link fine and decorative art so as to demonstrate to the general public that artists could design items of practical and general use. It was a vision drawn from Omega's founder, artist and critic Roger Fry, and co-founders Vanessa Bell and Duncan Grant.

In November 1910, when Winifred was still largely known to him as his children's babysitter, Fry opened his controversial exhibition 'Manet and the Post-Impressionists' at London's Grafton Galleries, and shattered the norms of the Edwardian art world. Manet's works provided an anchor to tradition for the more sceptical amongst the show's audience, revealing links between earlier Impressionism and the more radical aesthetics of Cézanne, Van Gogh and Gauguin, as well as more recent work by Matisse, Picasso and Derain. No women artists were included in the first Post-Impressionist exhibition, despite the profile and output of Berthe Morisot and Mary Cassatt, to name the most obvious

examples. However, the modernism that Winifred explained and created through Fry's project advertised itself as rooted in ordinary domestic objects, through 'ashtrays, inkstands, letter-weights, jam pots, cruet stands, salad bowls, jugs'.[2] The business Winifred managed set itself defiantly against the ideology of separate spheres that had excluded women from cultural production, and did so not only by taking special interest in these everyday things and the routines they necessarily described, but by elevating decorative art practices (ceramics, textiles, wallpaper) long considered minor precisely because of their association with women. Winifred's work with Omega was a striking intervention, an attempt to put the defining concerns of modernism within women's reach.

Winifred ran errands. Winifred took calls. She compiled what was known as 'the bank of designs', the collection to which Omega artists contributed their work anonymously. Winifred did the accounts, an important aspect of which was paying the artists: working for the Omega Workshops promised a small regular wage, a policy which appealed to many in Roger's circle, and which was established after hearing that Duncan Grant had missed a portrait commission because he did not have the fare for a bus from London to Guildford. Winifred stood at writer Arnold Bennett's side as he inspected a candlestick. She helped W. B. Yeats pick out a large green pottery water-cooler, which he then took away in a rucksack.[3] At the Second Post-Impressionist Exhibition in 1912 she stood next to Vanessa Bell, feeling 'very lost and low', overwhelmed by the changes heralded by the art on show and what it meant for her own burgeoning practice – only for Vanessa's infant son to take her hand and kiss it.[4] She took a nap while Wyndham Lewis tried on a new hat before a mirror, and woke up in time to catch him posing with an extravagant air of self-regard. Lewis remained unaware of her watchful presence in the dark, for Winifred was practised in making herself invisible.[5] She arranged herself next to Nina Hamnett – vibrant silk pulled over Nina's old wool jumper, an oyster-coloured cloak just covering her walking boots – the women smiling at one another rather than the camera before them.

Winifred rarely gets credited for her immense contribution to the Omega Workshops; for many she was simply a shop girl. 'I served as a connecting link,' Winifred herself insisted, accustomed to underplaying her role.[6]

Winifred responded to the name Winnie, although later admitted to never liking it. She rang through sales and wrote up receipts. Winifred worked through designs for a cloak with Vanessa, carefully sending back alterations, responding to critiques, offering solutions: raise the hem, fold the collar just so, add a tassel to the sleeve. Though in possession of 'a lot of the rather boring routine jobs', Winifred nonetheless acquired a central role in the project, becoming an expert on 'who designed, who made, who painted, and who bought' what at Omega.[7] She was the project's eyes and ears, and later a kind of archivist, a repository of memories and a historian of the Workshops' transformative years, who would be called upon for that information for decades to come.

When she went home at night, Winifred would continue with one of her own watercolour still lifes, or add further texture to a pastel drawing of the countryside. Folders full of her work reveal Winifred's imagination to have fixed with great intensity on projects outside of the Omega Workshops. She was fascinated by ecclesiastical architecture, manor houses and show gardens. Women fill page after page of her sketchbooks. Figures are sketched in life-drawing exercises from her year at the Slade School of Art, the time constraints rendering them anonymous, flashes of pure physical form. There are sheets of surreal illustrations for children showing little creatures with bulbous heads and bird-like legs inspired by the fantasy bestiaries of Pre-Raphaelite art. 'You've very nearly done what we are all trying to do,' Roger Fry said of a work Winifred showed him, dated 1917, according to her own proud annotation on its underside.[8] Sweeping, geometric lines assemble a girl engrossed by a book, and she is not as fragile she seems, sculpted from the same material as the patterned chair behind her – hard as chiselled wood, all the motion in her body instilled into a cascade of hair.

outside of Omega

Winifred's sketchbooks are startling in their creativity and range, but her talents were not enough – or this was the implication at least in Fry's advice to her to pursue craft rather than fine art. Although Fry valued craft enough to dedicate years of his life to advancing its seriousness as a practice, and he was aware of her family's worries about affording art school, the carefully worded letter he sent to Winifred's father insisting she set aside her dreams for more practical ambitions was partly shaped by a bias, conscious or not, against women as artists. Winifred was accepted to the Slade, and attended part time, but Fry's judgement of her potential stuck; her own art practice always remained secondary to her work at the Omega Workshops. Her significance within the canon of English art might have been very different.

A collection of Winifred's larger watercolours, rolled up for storage purposes, are now fixed in place as cylinders of coloured paper, each one impossible to lay flat, their laboriously produced images inaccessible. More like sculptures than drawings, these works radiate defiance. Disinterested in posterity, they insist on not being looked at.

Roger Fry was delighted to hear of Winifred's engagement in 1917, although it meant accepting that she would not be involved at Omega in quite the same way. 'I don't know how it could exist without you,' he admitted.[9] By this point Winifred was the shop manager, and entirely absorbed by the role. As Roger's remark predicted, the Omega Workshops did not continue much longer once Winifred married: after floundering for a couple of years, in 1919 there was a clearance sale and the following year they closed completely.

Winifred reported to Fry all the gossip at Omega, but often in separate letters from those that dealt solely with her own affairs,

at his request. Roger knew that Winifred saw everything – the minutiae of the shop's practical affairs as much as the emotional complexities of their customers – and wanted to preserve that vision. The story she told of watching Wyndham Lewis admiring himself in the dark was typical: the artists that surrounded Winifred exposed to her their most private selves, too absorbed to catch her watching. 'I was never, in his opinion, worthy of notice,' she said of Wyndham Lewis.[10]

Rarely was Winifred laid bare in the same way. What was she thinking while she worked at her little table? Her early journals are tidy narratives of her social calendar, following shopping and sketching and taking tea with friends, occasionally bored by the low stakes of her strictly governed world – her voice decorous and at times lightly satirical, no doubt inspired by her reading of Jane Austen. Typical was a morning spent 'wood-cutting, reading *Pride and Prejudice* and washing my hair', all exercises in self-improvement which entailed an attention to aesthetics.[11] As Winifred grew older, the journals fill up with complicated accounts of her dreams and their symbolic charge, passages from theological tracts, and admiring accounts of female mysticism and witchcraft, all of it concerned with what it was as a woman to live with and through spiritual extremities. Ecstasies and practicalities naturally coexisted in Winifred's studies. Other exercise books move through potted visual histories of furniture; most interesting to her were objects used by women to juggle maternal work with household management. Notes on cots and kitchenware eventually became a much broader project chronicling the global history of pattern design, the thesis of which radically departed from Eurocentric conceptions of decorative aesthetics. The young girl accustomed to her insular middle-class lifestyle and its dreary demands on her time and energy can be observed turning from those knowns, and transforming into a woman with voracious intellectual and artistic interests. Yet very few people discovered any of this in Winifred. During her numerous visits to the shop, Virginia Woolf said nothing to her, only fixed her with 'an unblinking gaze'.[12] In her diary, Virginia dismissed a nameless shop assistant at

Omega – almost certainly Winifred – as 'a foolish young woman in a Post-Impressionist tunic'.[13]

Like many quietly ambitious women of her time, Winifred kept notebooks full of copied-out passages from her favourite books, grafting together an education and identity from the material at hand, and while some of it was classical scholarship and theological work authored by men, much of it was drawn from the radical philosophical tradition of female spiritualism. Winifred was formulating her own contributions to this private canon. In a notebook entitled 'Notes of Stories to Tell', I expected lists of events and characters, even snippets of dialogue, but instead what Winifred set down were seemingly impersonal sets of instructions: on how to create furniture cream, bath detergent and other household products; on how to make fudge, lollypops, lemon and raspberry fondant. Cleanliness and sweetness, work and reward; here some private ritual is briefly glimpsed.

The stories Winifred wanted to tell were about domesticity and dailiness, the most familiar frustrations and pleasures, and the form she perfected to screen these experiences was recipes, instruction manuals and lists that constitute a series of verbal still lifes. These were notes towards the story of Winifred's life, condensed into the most ordinary domestic matter.

VANESSA

Vanessa Bell draws her paintbrush across the canvas. We cannot see her face – only a silhouette; it's unremarkable, obscure – but we can see her painting, the beginnings of a still life. Lemons heaped on a silver dish, their rind dirtied with shadow, each dark tip like a pupil. The lemons are there on Vanessa's canvas, and there on the table in the centre of the room, establishing two orders of reality within the frame – a spectacle of the work's painterliness.

Another statement of artifice in the tiny sliver of sky at the window: fragments of blue, brown and rust that transform the outside world into an abstract painting. These aesthetic strategies guide us into an enclosed world pervaded by creativity, and mark it as a space of its own making. Yet for all its play with illusion the room appears lived-in; it has an almost subterranean feel – like the den of an animal – and a sense of warmth and comfort, though with a claustrophobic edge. There's furniture everywhere, objects on every surface. The ceiling presses down upon the room, bulging and iridescent like bruised flesh. A narrow gap through which Vanessa might manoeuvre her body, and if not her then the other sitter, a man in the opposite corner of the painting with books piled at his elbow. The pair are mirror images of each other, their heads bowed in concentration, one painting and the other writing, two variations of an identity defined by creativity.

In Duncan Grant's interior of 1918, it was the warmth of the scene that first moved me. The companionable quiet, the shared

absorption, a typical long afternoon punctuated by snatches of conversation. How appealing it seemed. Only gradually did its ambivalence emerge: the lack of space, the muted colour, the removedness of the sitters and the tension it all communicates. The uncanny size of the furniture. Dark patches that look like rot on the wall. The faceless clock. The purple chair in the corner, turned towards the sitters as though it were listening. No visible door. The queasy colours above. The lemons like eyes rolling in their sockets. As such, the painting proves a revealing introduction to a vibration central to Vanessa's character: the swerve between a deep identification with and a seemingly indelible estrangement from the promises of domesticity.

I was compelled by the scene, and if I could place where I first noticed Vanessa, felt suddenly startled by her, it was here, absorbed in activity in a room taut with secret emotion. There was Vanessa, hunched, her back broad and powerful, her frame as sturdy as the table that dominates the room. Depicting her at work, Duncan has Vanessa carving out her own space and meaning within the parameters of the painting: she is not a passive sitter, but an active presence, her canvas adding to and competing with his own. The lemons are about agency and imagination, and speak to an artistic identity that was absolutely fundamental to her approach to experience. This strength, this resilience, this commitment, how unlike the saintly feminine aura, the submission and the sadness I had once understood to be Vanessa.

'Essentially a lavender talent.'[1] 'Essentially derivative.'[2] Critical responses tend to agree that Vanessa's work is fine, but nothing special – of interest only for the devoted few, fans who have let their critical faculties slip. Works are glanced at, then dismissed. These readings demonstrate the limited evaluative criteria of much art historical criticism, as well as its blandly misogynistic tendencies. And as a woman? Vanessa's beauty is what's remarked upon, over and over. Here her face won't be yielded – Duncan is sure to turn our attention elsewhere.

Duncan has Vanessa holding a number of other brushes in her free hand. The painting within a painting is in its earliest stages,

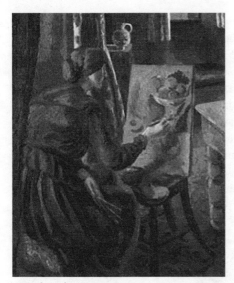

strength, resilience, commitment

and there is a sense that there's so much labour still to come. The coffee cup and the plate of food are placed on the table beside the bowl of lemons, and the room unfolds behind, but none of these other details are yet set down on her canvas. Vanessa gazes out. The brushes will be dipped in paint, used, rearranged, set aside. How will Vanessa reimagine her domestic world? What will be removed, and what will be emphasised? How will Duncan perceive these shifts, and what involvement will he have? Watch as the brush continues to move across the canvas.

ᔕ

Iceland Poppies

Stall for a moment before a canvas that looks made out of a bare, polished stone. All around us is the quietness of a vault, and from the grey light that fills the space, it could be any hour – the shadows cast

by the objects suggestive less of sunlight than the sudden illumination of an enclosure wrenched open after a long spell shut. Painted between 1908 and 1909, *Iceland Poppies* is Vanessa's earliest known still life. Three simply rendered objects of different sizes are placed together with a precision that feels talismanic, as though they are being stored there to retain their power, awaiting some higher rite. The heightened solemnity of the scene might be ascribed to the artist who was still new to her practice, surprised at the intensity of what might happen on canvas, suddenly believing in her talent's possible alchemy.

a possible alchemy

The dramatic hold of the work arises in part from its air of subdued desperation, as though given enough time a plea might sound from the canvas: a woman's voice, hardened with need, asking for more. Resounding with a quiet menace, the scene describes how a life might be pared back to its most basic components and locked below ground. When Vanessa completed *Iceland Poppies* she was already an expert in this experience of suspended time. After the premature death of her mother and, a few years later, the even more tragic and unexpected loss of her half-sister, Stella Duckworth, Vanessa slipped into a filmy mourning dress covered in sequins, and accepted her entombment in the family home in

Hyde Park Gate, Knightsbridge, a powerful stasis wrought from grief and obligation. 'Our particular hell', was how Virginia later described their isolated, macabre adolescence to Vanessa.[3]

After her mother's death, Vanessa calmly took control of the domestic matters that her 'melancholy, deaf, rather helpless' father (her words), claimed to fear, listened to his weekly rages over their largely unwavering accounts, and in the rare hours of peace left her sister to her study of Greek and rode her bicycle up to art school.[4] Flying down Queen's Gate with the wind in her face, able to put aside calculations about the price of salmon and possible economies with cream, Vanessa had a premonition of the freedom that would follow some years later. The death of her father in 1904 allowed Vanessa to abandon the family home for an address in Bloomsbury: 46 Gordon Square, chosen largely for its distance from the old house, would become a totemic site for Vanessa and her sister's recently granted autonomy.

'The promise of the family is preserved through the inheritance of objects,' Sara Ahmed observes.[5] And so for Vanessa there was no better symbolic rejection of her father's legacy than the sale of furniture from the house in Knightsbridge. Dreary armoires, unsteady side tables, patterned rugs heavy with dust, all of it gone, and with it memories of boredom and misery the women were relieved to rescind.

The idea was that in transforming a room you might redefine a life. 'It seemed in every way we were marking a new beginning,' Vanessa later explained with a nostalgic sense of that's moment's gravity, 'to have one's own rooms, be master of one's own time.'[6] The clearing out, the stripping back, the hauling away of old furniture were all emblematic of the manner of thinking that was to be cultivated within their new home. Doubt became their new guiding principle, expressed through a questioning of everything assumed to be moral and right, all the women had absorbed unconsciously from their upbringings or arrived at through unchecked bias, whether it was in the sphere of aesthetics or politics. What the sisters aspired to was nothing less than a transformative, universal enlightenment. At Gordon Square, one of the first decorative decisions Vanessa

made was to whitewash the walls, symbolic of the blank slate onto which they could inscribe their new values.

Once refusals began, Vanessa and Virginia grew bolder. They drank coffee rather than tea. The social advances of elderly relatives were ignored. Their afternoon freed, they addressed themselves to the most urgent contemporary debates; typical was the 'six hours consecutively' the sisters spent arguing about 'the Ethics of Empire'.[7] They no longer dressed for dinner. They met men without chaperones. When invitations were accepted, they could behave as they pleased. Vanessa danced until past two in the morning while Virginia excused herself to read Tennyson alone in the corner of the ballroom, stirring only to argue with an acquaintance about the Roman Empire.[8] The sisters now made their own fun. Each Thursday evening, with their brother Thoby and his friends from Cambridge, the women drank whisky or cocoa, ate biscuits, and talked until late. Vanessa recalled their reading of the philosopher G. E. Moore's *Principia Ethica* (1903), challenging the basic moral precepts they were raised on, giving serious thought to the actual 'meaning of good', and formulating their own axioms.[9] Queer sex was discussed through the sexologist Havelock Ellis's ground-breaking writing on inversion, and they returned repeatedly to what they had learned from classical culture, which might be summarised by Virginia's claim that she discovered sodomy through reading Plato.[10] There were casual discussions of incest, frequent too if Virginia's diaries are to be believed. 'One can talk of fucking and sodomy and sucking and bushes and all without turning a hair,' Vanessa wrote in 1914, her pleasure in their shared transgression bolstering each explicit word.[11] What was once confined to those evenings together spread into the hours apart. Virginia confessed to a friend that after her first sexual experience with her husband, she judged 'the climax immensely exaggerated'.[12] Vanessa learnt bawdy poems off by heart.[13] Itching to stir up a dull dinner party, in a provocative mood, Virginia shouted 'after-birth' at a man across a table – much to Vanessa's amusement.[14] In the company of both sisters, Lytton Strachey remarked of a

stain on Vanessa's dress – 'Semen?' – the women's instinctual horror quickly and emphatically yielding to laughter.[15]

To be freer in their expressions of desire, to make less of the gravity of sex, these concerns acknowledged how attitudes to sex were (and remain) closely interweaved with misogyny and homophobia: how those with the most power over the meaning of sex were the conservative institutions of religion, family and law. Transforming how they spoke about sex, even within their small social circle, was a way of challenging broader oppressive ideologies. Each conversation constituted a nick in the edifice of normativity: with enough effort it might shatter entirely.

*

In *Iceland Poppies*, the palette is muted, sombre, all those greys subtly suffused with light, evocative of the grim regalia of half-mourning, the silver, mauve and white women wore to index the endurance of their loss. Yet the colours also carry with them broader intimations of Vanessa's life at that time, a premonition of what might emerge from her grief. Clear wintry mornings that stung her eyes, clouds suggesting rain, unmarked sheets in her sketchbook, water running over her paintbrushes, the beaten mirror in her mother's armoire – one of the only objects Vanessa kept from Knightsbridge – steam rising from a bath run on a whim, the 'silver point press' she bought for printmaking a year into her independence, the rustle of her underclothes in the drawer, the feel of polished cutlery in her hands at dinner.[16] Specks of pleasure from her everyday life are scattered across the surface of the work, seeds left in the hope of pollination, as though these simple contentments might flower into the substance of an entirely new life.

One of the men who entered Vanessa's life through these evenings was Clive Bell. Immensely confident, rich, decadent and vain, Bell quickly alighted upon Vanessa as a possible wife. Vanessa, however, was unconvinced. Life was already so full, purposeful and pleasingly disciplined. The companionable solitude she shared with

Virginia at Gordon Square allowed Vanessa more time for her art than she ever thought possible, and to shatter their homosocial idyll seemed reckless in the face of an autonomy so hard won.

Yet Clive would not be deterred. Vanessa refused Clive more than once before she changed her mind and accepted his proposal, just days after the sudden and devastating death of her brother, Thoby, from typhoid. It was not exactly true that her attitude to Clive altered, or the appeal of her freedom dimmed; rather it was her notion of what marriage might be that changed. 'If marriage were only a question of being very good friends and of caring for things in the same way,' she wrote in response to Clive's proposal in July 1906, 'I could say yes at once.'[17] Vanessa imagined a marriage that was a warm, practical partnership founded on shared values rather than romantic connection, and while she used the undesirability of such an arrangement as reason once to refuse him, in the uncertainty that surrounded Thoby's death, the guarantees Clive represented suddenly appealed. Vanessa's once speculative revision to the institution of marriage would in practice be exactly the kind of bond that offered her power, flexibility and – ultimately – happiness. Wearing a mauve dress and with only a few witnesses present (including her sheepdog Gurth), Vanessa married Clive in a quick and simple ceremony at St Pancras Register Office in February 1907.[18]

For Vanessa, matrimony did not signal a passive acceptance of her fate: she was determined not to allow it that power, and instead she began to make adjustments to the form – initiated by the idiosyncrasies of the wedding day itself – which emphasised a continuity between her identity as a young woman and a wife. Above all, she would not cede the freedom to paint.

What it was that Clive offered might be summarised by a biro drawing in a sketchbook Vanessa took to Paris in 1952.[19] Page after page of portraits, done so quickly the ink becomes messy, making the faces look haggard and pockmarked, the hair as though fussed by the wind. There is one sheet that seems to articulate something of the decisions that had led Vanessa decades before to arrive in Paris newly married to Clive. Sketched roughly, a man sits upright with neatly combed hair, moustache, tie and jacket, thoroughly conventional down to the rush of ink for a watch. Seen as though seated at a bar, only his upper body is sketched; Vanessa's calculations for her daily

expenses are running below his waist, functioning as a substitute limb, the work of addition – of production, of generation – a joke about the crotch (the sex organs) the drawing conceals.

Vanessa's relationship with Clive was less about desire than it was about the practicalities of daily accounting, or what a husband offered as a concrete and enduring form of capital or status. Which is to say that marriage promised Vanessa an additional and far greater form of freedom. She could be the matriarch of an affluent household, and while it was not common for wives to have control of the accounts, she recognised that Clive was unconventional enough – and her own resolve sufficiently fierce – that she might never need explain her expenditures again. Vanessa understood that only in thinking seriously about her prospects would she secure the ability to paint, and it might mean making ruthless, self-serving decisions. 'Ought I to tell you that it's very bad for you?' Vanessa warned Clive in the same letter of rejection in 1906, encouraging him to marry only in circumstances where his love was reciprocated.[20] A year later, after careful consideration of her options, the inequity had ceased to matter to Vanessa. Other needs took precedence. If the choice was effectively between romantic love and a more assured and enduring access to her art, then Vanessa's decision was simple.

the husband as capital, status

In *Iceland Poppies*, the bringing together of vessels and flowers invites reflection on forms beyond the couple, or how a triad rather than a dyad might bring about a flowering of life, a feeling of being held and contained. The objects at once bear a relationship to death. The green bottle carries poison, the jar an antique salvaged from a pharmacy, and the poppies are narcotics, established symbols of mortality for those acquainted, like Vanessa, with the Pre-Raphaelite imaginary. This is not a broad reflection on human mortality – the conventional remit of still life; it was more specific than that. In *Iceland Poppies* Vanessa considers whether experimentation beyond her marriage would lead to an experience of social death – disapproval, castigation – or worse, the death of the heart.

Yet it is possible to see the pessimism of *Iceland Poppies* alongside a different set of intensities. The objects resemble a form of offering, and if Vanessa were casting a spell, then it is a magic that might be guessed at. Two pearlescent white flowers laid down against the cool stone, anaemic and merely ornamental, but there's an awakening, a hopefulness, in that dash of red.

hopefulness

*

Vanessa and Duncan first met on her honeymoon in Paris in 1907. Duncan was introduced to the newly married couple after Vanessa and Clive had spent a few evenings dining with Virginia and Duncan's cousin (and former lover) Lytton

Strachey. In some 'eccentric tavern' in Montparnasse, enraptured conversation about beauty and art unfolding around him, Duncan was fresh from days spent painting at Jacques Emile Blanche's studio, twenty-one, scruffy, handsome and – how had Vanessa put it? – 'living on air', with a small sum of money from his aunts.[21,22] Vanessa had wandered for hours through the Louvre, observing mournful images of Christ and vast historical scenes, purchasing 'strange plumes and draperies' with her sister, briefly forgetting again that she was married now – and free.[23] With her napkin folded at her lap, surrounded by those she loved or was eager to befriend, she was so happy and at ease Virginia would marvel at it in letters to friends.[24] Did Vanessa and Duncan talk that night? Duncan returned to the room he was renting on the rue Delambre and wrote a letter that hardly mentions Vanessa. Virginia, yes – she was dazzling – and Clive too, who was happiest steering conversation and confidently ordering food in accented French, but Vanessa made little impression on him, and the feeling was mutual. The only possible explanation was a disagreement about Rembrandt: Vanessa found his chiaroscuro too closely echoed the sedentary figures and dark rooms of her childhood, while Duncan loved the melancholic drama of his work with the straightforwardness of someone untouched by any comparable malaise. And maybe that was enough – a few harsh words, an awkward silence – to repel them from each other for the rest of the night.[25]

Whatever the reason, Vanessa and Duncan stepped out into the streets of Montmartre that night barely more than acquaintances. Years later, Vanessa copied Rembrandt's *Woman Bathing in a Stream* into a sketchbook, with carefully written notes about colour and shadow where colour and shadow should be.[26] Tentative swirls of pencil, subtle but insisted-upon distinctions in tone: colours shimmer through one another, aspiring to some impossible in-between, or new nuances – *grey green, pink grey, worn white* – none of the gloom she had once seen as definitive of Rembrandt's work. There is a cautiousness, a desire to get it right, nevertheless Vanessa captures much of the woman's pleasure in this act – her slight smile, her

body rapt as it enters the water – the exquisite sympathy Rembrandt shows to the woman's inner life, which was amongst the work's most obvious attractions when she first passed it in the National Gallery in London, where this sketch was done. The drawing offers a reassuring conclusion to their inauspicious introduction: Vanessa's views on Duncan – as they had on Rembrandt – would change.

reassurance

〜

Apples: 46 Gordon Square

Surrounded by yellow fabric that resembles bars of solid gold, it is clear that the world is bright enough, there is no need for sunlight. The rest of the composition confirms it. The urban landscape is condensed into a few strips of opaque colour, bland greens that show up the radiance of the apples; the lawn and the railing and the street are stacked one after another, indistinct because insignificant; the perspective is angled down, leaving the sky entirely sequestered, the china dish the only blue – a clue to the scene's erasures. The room is a self-sufficient, rich and detailed environment that eclipses the meagre

offerings of the city beyond. Vanessa had good reason to paint 46 Gordon Square as a world unto itself with such explicit satisfaction.

Once Vanessa and Clive returned from their honeymoon, 46 Gordon Square became theirs alone, and with her siblings gone, Vanessa asserted complete control over the matrimonial home. Painted shortly after her marriage, *Apples: 46 Gordon Square* is as much about the value of this autonomy as it is the surprising happiness of marital life with Clive. The dish in the foreground of the painting has been moved away from its habitual setting at the table, out onto a ledge where it might be more clearly viewed. Concerned with ensuring ample light and an arresting formal structure, this practical gesture had a broader significance, as reorientation of this kind would become a defining emotional principle in the artistic project that Vanessa made out of the domestic. In an imprecise but compelling impersonation of the contented new wife, a role that customarily required women's submission, Vanessa was picking up and examining all that dissatisfied her with the home, and motivated by a scepticism for tradition, she made decisions: what might be preserved, and what had to be abandoned. Already portraits of her mother taken by her great-aunt, the pioneering Victorian photographer Julia Margaret Cameron, had been retrieved, dusted and polished, and prominently hung in the corridor; what dour prints or blandly sentimental family shots they replaced had been packed into boxes. The reorganisation of her family photographs was a simple but powerful statement of intent about Vanessa's own ambitions and the new function of the home, and as a loaded curatorial intervention, it was only the beginning. The old associations could be dislodged, the traumas dissipated, her everyday life transformed, and it might be as simple as moving objects across the room.

What followed was a thorough redecoration of the home that for Vanessa was never solely an exercise in aesthetics, nor merely a kindness to herself, a means of starting afresh; it also represented a radical transgression of societal norms. For women of Vanessa's class and generation, the home was where they spent their days, their entire lives even, and had therefore long been considered a feminine space. However, it was men who decided on decor and furnishing, selecting objects that best boasted of their social status. Men placed another marble trinket suggestive of imperial power or nationalistic

ardour or basic sentimentality upon the mantelpiece, delicate egos in search of appropriate props. Women stood blankly and obediently at their side – commodities, indistinguishable from the furniture. Without property rights or independent wealth, a woman might commit to a home, she might exist within it for years, subsume her identity entirely with its upkeep, but it would not belong to her, neither as an economic asset nor as a creative space. Vanessa had little say in the home she had shared with her father, but Clive's respect for her taste – more than his distance from gender norms – allowed her to decorate the house as she pleased. A small concession, perhaps, but for Vanessa repainting those walls was a measure of power.

Identifying cracks in the patriarchal ideal, seeking out those coercive activities that might be recast to their own ends, it was a pursuit that appealed to both sisters. 'Does housekeeping interest you at all?' Virginia wrote to her old friend Violet Dickinson in 1906. 'I think it really ought to be just as good as writing, and I never see – as I argued with Nessa – where the separation between the two comes in.'[27] Writing and homemaking alike are creative acts, Virginia argued, a comparison that questions the valuing of the traditionally masculine pursuit far above maligned feminine duties, underlining how each requires labour, care, invention and sustained attention. The shared potential of these practices, as Virginia saw it, was about their ability to build a world, or how literature and domesticity alike are capable of creating new emotional possibilities for women. A room might be as effective as a narrative in offering women a chance for identification, for seeing themselves in settings through which a different self might emerge. Vanessa's exploration of this idea can be observed in the contrast between *Apples: 46 Gordon Square*, in which the home is a point of departure, and the inertia instilled into her earliest extant work, a portrait of Lady Robert Cecil.

Painted in 1905, the portrait was Vanessa's first commission, and it reveals Lady Robert Cecil – known as Nelly to friends – as a serene feminine archetype hemmed in by the necessities of the drawing room. Nelly wears a sombre black dress with a ribbon of red down its front like an artery, a reminder that this is a body sitting on the floral armchair, a necessary sign given how rigid she appears, how polished and artificial, weighed down and defined through these gendered, upper-middle-class effects.

'She's just the kind of middle-class woman I am always wanting to paint,' Vanessa later wrote of Queen Victoria – although the same could be said of Nelly, 'entirely dressed in furniture ornaments'.[28] Everything in the room stresses Nelly's decorative function: the symmetry of the side table with her own form, the plants on either side that frame her as her own variety of flower, the emerald curtains that allude to her body upright – briefly raising her from the chair, letting us see her full height – the roses on the upholstery chiming with the piping on her dress. The drawing room was a semi-public space in which women submitted to the rituals of their gender and class, at times mindless, at times edifying – entertaining guests, reading novels, embroidering cushion covers – and more so than anywhere else in the house, fulfilled their ornamental purpose: to Vanessa, this was an unappealing prospect. A wall-mounted gilded mirror unexpectedly reveals a monochromatic study in abstraction, a strategy that conceals the painter, who in catching her reflection there risks confining herself to the drawing room. The figure of the painter glimpsed in the mirror of a society portrait had many illustrious precedents, one of the most famous of which Vanessa would have seen at the National Gallery: the distorted flicker of Jan van Eyck in *The Arnolfini Portrait* of 1434. She alludes to this tradition, only to refuse its honour, its offer of permanence and recognition. Vanessa would not be tempted to place even a partial shadow of herself inside the scene.

no permanence, no recognition

A photograph taken during the sitting with Lady Robert Cecil shows Vanessa standing before her easel, her model sitting surrounded by fixtures recognisable from the finished work. However, the elaborately set mirror has no correlative: in its place is a framed print that is faithfully replicated in the early version of the painting just visible on the easel. Vanessa chose to revise the reality available to her; the framed print would not do; out of some resistant part of her, a different and more fitting object was drawn. In replacing the framed print with a mirror, Vanessa was able to stage her own disappearance from the scene and all it represented, as if reassuring herself that escape was truly possible.

a possible escape

Nelly has a book open in her lap and her gaze meets that of the painter, a smile just visible in the upturned corner of her mouth. From these small details comes the strengthening force of a nascent self-possession. For all the stasis Vanessa observes in this room with such dread, she is careful to leave her sitter with hope: the means for a similar departure to her own.

*

From what distance was the sister's interest in housekeeping cultivated? An observational distance, for instance, or even further, from the distance of absolute inexperience? Can either Virginia or

Vanessa be taken as a reliable promoters of cleaning and cooking? Are domestic tasks more likely to be interesting as an occasional novelty rather than as a humdrum, grinding necessity? Where, after all, did the apples at the centre of the canvas actually come from?[29]

Vanessa stripped the elaborate wallpaper and threw out the furniture, but kept on the staff. Vanessa's juggling of motherhood, love affairs and her art has been marvelled at, but it is clear how such a full and various life was achieved: her meals purchased and cooked for her, her children cared for, and her house swept and cleaned by others, for decades. All of the autonomy Vanessa would subsequently enjoy would be facilitated by the availability and cheapness of female domestic servants, and her inherited entitlement to their presence and service. These women are rarely acknowledged as creating the conditions in which Vanessa conducted her successful art career.

Sophia Farrell, Maud Chart, Trissie Selwood, Mabel Selwood, Flossie Selwood, Nellie Boxall and Lottie Hope, *temporary cooks* (unnamed), Louie Dunnet, Jenny Paton, Emily Paton, Mrs Brereton, Phoebe Crane, Grace Germany (later Higgins). The invisible co-producers in the most celebrated decade of Vanessa's practice. Their names should be on gallery labels.

Individual liberty was the Bloomsbury Group's central tenet, but Vanessa's attitude to her domestic help reveals how this principle rarely extended meaningfully past their circle. The 'servant problem', as Vanessa and Virginia had it, was not some reforming desire to abolish the class system, but was a matter of controlling and disciplining their servants without alienating them entirely. Vanessa's 'problem' of holding on to servants stemmed in part from an excruciatingly slow redistribution of wealth and possibility brought about by broader social change across her lifetime. In the new century, working-class women could train to become shop assistants, secretaries, nurses and teachers – roles that remained in their essence about care and servility but with a more impersonal distance from the employer – and understandably for many such conditions were considerably more attractive than domestic work. The expanded horizons of working-class women meant the contraction of the pool from which white

middle-class women drew their servants, and many did not welcome these changes, even those who were interested in the liberation politics of the feminist movement.

Looking at *Apples*, certain questions arise: who went to the market with the instruction in hand, who returned home acutely conscious of time (not her own); who rinsed the apples in the sink, who placed them in china (recently polished), who peeled and sliced the apples, who baked them into a pie (not for their own consumption), who washed and dried the dishes afterwards, who brushed the crumbs from the floor, who disposed of the waste; who (by hand) removed from clothes any stains left by the fruit, who then hung up those clothes one by one, and ironed them once dry?

In the spaces between artworks, these relations are at times briefly revealed. In Vanessa's sketchbook, between biro still-life studies and heads on their way to portraiture, a sheet of paper is hastily inscribed with the words *Please do not TOUCH*: a message to her servants, who, in her eyes, could not be trusted to distinguish between art and life, real mess and its creative equivalent. The fear in this command is partly about inconvenience, but perhaps more vividly about contamination, hence the exaggerated emphasis on touch: for a servant to touch the apples would be to undo their transformation into a different order of object, reversing what was on its way to transcendence back to the merely banal.

A 1943 painting of Grace Higgins, Vanessa's longest serving cook, discloses a similarly unselfconscious jumble of detachment, anxiety and delusion about her staff. Grace is in the kitchen, the table laid with vegetables she will go on to wash, chop and cook. Hours of work are ahead of her, but none of the difficulties of those impending tasks are evident, or even hinted at: the surfaces are clean, the crockery unused, her apron and dishcloth unsullied, her unmarked hands hovering over an apparently empty mixing bowl. A stack of cooking pots gleam behind her, a skeleton of metal that mimics her stance; the shape is picked up again in the glowing string of onions hanging by her side. Her white apron glows in response to the cupboard. Grace is one domestic object amongst a room of others, her body useful and orderly, her subjectivity entirely collapsed into her labour. Who Grace

is is incidental: her face and uniform are plain and featureless. Yet, for all the eerie disregard that attends the representation of Grace, the image remains one of absolute harmony – a smug kitchen pastoral. While working at Charleston I would pass the painting several times a day where it was hung in the second-floor corridor, and feared that simply in walking by I would shatter the work's composure: a clatter of pans, spoiled fruit underfoot, a rush of unwanted steam. Perhaps it was easier for Vanessa to think of the kitchen in this manner, as a space threatened by any outside presence, a calm over which only Grace could preside.

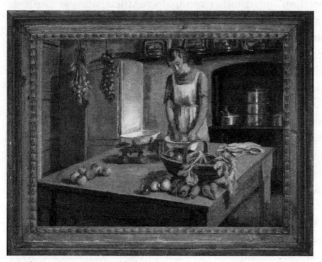

one object amongst a room of others

The kitchen still life makes clear the conditions of freedom put forward by *Apples: 46 Gordon Square*: Vanessa was only able to live as she pleased through instrumentalising the labour of other women. For Grace and so many others, rooms were more about domestic bondage and essential rest than they were guarantees of autonomy and self-knowledge.

*

Unconvinced that she would make a good mother, Vanessa nevertheless fell pregnant, as was expected of her: a son, Julian, was born in 1908. Reproduction and artistic production were not considered compatible, sexist ideas about genius colliding with the practicalities of impossibly divided attentions, and almost no women Vanessa knew who made art had attempted both. Vanessa was more fortunate than most in being able to commit time to transforming motherhood into a creative medium: when she wanted to work – and sketchbooks full of Julian attest to the deepening presence of this desire – she simply placed her child in a nursemaid's arms, and slipped off into another room alone. The artist was satisfied, but the wife was distracted: Clive found Vanessa's preoccupation with Julian an annoyance, and quickly became jealous and restless. Clive wanted Vanessa, but he also continued to need the attentions of other women, including her sister, with whom he conducted an extended flirtation during a holiday to Cornwall shortly after Julian's birth. Aware of his misbehaviour, Vanessa saw that she could either accept the ordinary disappointments of her marriage, what so many women before her had borne without comment, or she could draw a different kind of relationship out of its wreckage.

Clive began taking mistresses, but Vanessa wasn't expected to remain faithful either. Marriage became meaningful only as it served as a defence, an image projected to the wider social world which enabled both parties to privately push against its conventions – and to ultimately live more freely. Vanessa could paint, meet with her friends, take lovers and raise her baby without much consideration of what her husband required of her. The arrangement meant that Clive would not be a burden to Vanessa, the morass of unmet needs that so many husbands became, and over the years that followed their letters are surprising in their tone, consistent in their warmth, love and humour. They met each other's partners, and all slept under the same roof on many occasions. Vanessa even painted a portrait of Clive's lover – the writer Mary Hutchinson. Contemptuous and unflattering – or so it's been said – the portrait has been interpreted as clear evidence of Vanessa's jealousy.

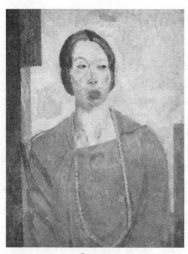

contemptuous? unflattering?

Mrs St John Hutchinson (1915) is in fact satirical of conventional femininity in a way that the fiercely intelligent Mary would have participated in, rather than an instance – the kind that society delights in pointing out – of women propelled by sexual competition into attacking one another. Mary wears a lime green dress, her face a tart grapefruit pink, her cheekbone an arrow of turquoise, her eyebrow fearsomely arched, and the whites of her eyes a startling blue, their pupils darting beads of black. Holding herself very straight and tall, she resembles a tropical plant. Her expression is unimpressed and uncompromising. The reptilian eyes lend her a litheness, a wiliness, the effect of which is a sharp and unsettling eroticism. The women were aware that what flowed between them was in excess of the simple, temporary bond between painter and sitter, the pair's lingering pride and new tolerance for one another structuring every small gesture – how much conversation was attempted, how long each sitting lasted – and Vanessa allows that complexity to power the unreal, audacious colours, Mary's ambivalent expression, and the entire work's weird intimations of desire.

'It's perfectly hideous,' Vanessa wrote of it, motivated less by cruelty than defiance.[30] In freeing her sitter from a one-dimensional definition of beauty – and in so public a medium – Vanessa was questioning the reductive way in which women's value was measured, a criterion applied even to those like herself and Mary who had made every effort to distance themselves from those absolutes. The effects of this distortion were persuasive enough to Vanessa that she would apply the same process to herself in her later series of startling self-portraits. The portrait of Mary reveals how in deviating from monogamy and its implicit logic, Vanessa could begin curing herself of one of its most damaging side effects: regarding other women solely through the prism of mutual threat and rivalry. Mary is a fully realised subject, neither an enemy to be reviled nor a possible competitor to be flattered and neutralised, and the painting is all the better for it.

This spirit of compromise and improvisation – of making do with the limited forms that heterosexuality offered – would become an important precursor for the years ahead. Vanessa wrote to Clive in 1910 that he continued to make her 'astonishingly happy', and from their correspondence it seems that he, or rather this mutual lack of possessiveness, did satisfy Vanessa, offering a freedom and independence she hadn't expected from marriage.[31] Marriage had a way of fixing the lives of her friends, setting them on a course that could be predicted in its entirety – brief marital bliss, then stagnating in the suburbs, then bitterness, then death. This would not be Vanessa's lot. Her future was cleared. Their open arrangement would prove practical and durable, and was animated for the rest of their lives by a mutual respect and affection. To a judgemental friend some years later, Vanessa staunchly defended the transformation to their marriage she had brought about, unapologetic and proud in the decision she had made to live for something other than Clive. 'My married life has not been full of restraints,' she wrote, 'but on the contrary full of ease and freedom and complete confidence.'[32]

Jug

The room of women and their wards is more than it appears, and it is its own exclusive universe: the carpet is pulled up to reveal a stretch of clipped and vibrant turf, the walls are knocked down to a blue sky pockmarked with cloud. Milk and bread are laid out to be served; hunger and impatience etch features into the children's faces. Little tyrannies are implied. The girl is stern, a defiant heat rising in her cheeks. A knife glints before her. The nurses have faces smooth as pebbles. One is blue, slightly bent as though in prayer; the other is lilac, and alert. They are unknowable, impenetrable. Their kin are the objects: the jug that matches their uniform, the neutral translucent glasses, and the length of starched tablecloth that's hard as a slab of marble.

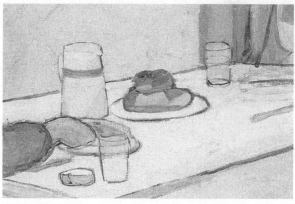

Nursery Tea *(1912)*

Oranges and Lemons

In the spring of 1914 Duncan Grant sent a package to Vanessa from Paris, a branch of oranges and lemons he claimed were clipped from amongst the relics of Byzantium. 'They are so lovely,' she responded, 'that against all modern theories I suppose I stuck some into my yellow Italian pot and at once began to paint them.'[33] With their outsized, antagonistic forms and radioactive colour, there is nothing sweet

about these fruits. The lemons are a lurid, sour yellow, lacquered with turquoise – an electric blue not found in nature – and the black lines that outline them make their edges look charred; the oranges are small, brittle dark balls that hardly resemble oranges at all; their leaves would shred the skin of the palms if touched. Neither is there any comfort to be found in the elliptically described domestic space the work is situated inside. Through the brash and incoherent pattern on the wall, tightly orchestrated dazzling splinters slashing into one other, Vanessa positions the home not as a space of compassion, but of conflict and experiment. The messiness, the chaos, and the violent contrasts in colour together constitute a work of ugliness, wilful unnaturalness and brazen pleasure.

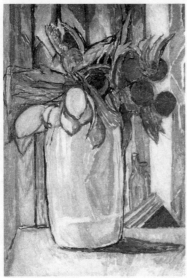

ugly and brazen

The years prior to *Oranges and Lemons* had witnessed Vanessa's gradual disenchantment with heterosexuality. Love of that kind had presented her with a dreary binary in which she either accepted men's disinterest or endured their possessiveness. The first relationship she experienced outside marriage, her passionate affair with the critic Roger Fry, started off in 1911 replete with possibility,

only to end two years later after a string of collaborative artistic projects, European holidays and declarations of love in a series fraught, accusatory and – eventually on Vanessa's part – firmly dismissive letters. Vanessa was discovering that love even more than childbearing posed the greatest risk to her autonomy as an artist: there was no obvious way of outsourcing that labour, and no means of controlling how much time or energy it consumed.[34] However, only through Roger's ultimately oppressive attentions did Vanessa come to understand what she actually wanted from a lover: a shared commitment to art now seemed both essential and achievable, but more elusive was a mutual self-sufficiency that meant the emotional responsibilities of the relationship did not become stifling. It was no surprise given her recent experiences with men that during a holiday to Italy with Roger, Clive and Duncan in 1913, it was her new friend, Duncan, who appealed.

The pair had been gradually seeing more of one another, having spent a quiet, relaxed Christmas together in 1912 due to Vanessa's ill health, and while part of that thrill had been the distance from her children and in-laws, a heady privacy unfeasible in Italy with her husband and former lover present, they nevertheless welcomed an opportunity for a more extended intimacy. Besides, it was easy enough to imagine themselves alone, with Roger leaving the hotel early in the morning to draw, and Clive following soon after, tramping through the towns sunburnt and jolly, a Baedeker guide in hand, craning his neck periodically to catch some famed architectural feature. Neither wanted to sightsee – Vanessa steadfastly refused to see 'more than one thing a day' – and instead wandered around companionably, shopping for antiques and curios.[35] 'I find that Duncan sympathises with me,' she wrote to her sister, in an understated admission filled with hope.[36]

Once the holiday ended their correspondence flourished. 'It will be most exciting when your Tunis mystery arrives,' Vanessa wrote to Duncan on 17 February 1914, just before the oranges and lemons arrived, 'it all sounds too tempting.'[37] Acknowledging the gift as if it were a token between lovers, Vanessa built playfully

upon the gesture, suggesting they elope. 'I believe we should potter very harmoniously,' she assured him. To potter is to move in a manner that is undemanding and relaxed, idle even, without any specific end in sight. What is sweet about the verb is its promise of futurity: pottering conjures images of older couples, arms linked, decades into their familiarity, all urgency dissolved; the verb was Vanessa marking out the parameters of a love she hoped would endure. Yet more resonant to the couple is the possible queer dimension of 'potter', how it is expressive of an intimacy that was not predetermined by the standard arc of courtship, marriage and reproduction. They were simply enjoying each other, and without a pressing sense of where that pleasure might take them.

Painting the contents of the package she received from Duncan was a visible and lasting marker of Vanessa's gratitude, a kind of collaboration that combined his eye for nature and her strengthening talent for distortion; it was an indication to them both of just how central his attention and input were becoming for Vanessa's art practice. What accompanied this creative affinity was more difficult to reckon with. The gift had entered Vanessa's life as a substitute for Duncan, an apology for his extended absence in Paris, and underneath the veneer of flirtatious joking that cast them as parted lovers, Vanessa was coming to terms with her genuine need of Duncan. What Vanessa felt for him was a fierce attachment without a precedent in her own life, neither in its intensity nor in its uncertain promise of reciprocity. *Oranges and Lemons* proposes a form of female desire that eschews the daintiness, decorousness and productivity required by a society that continued to regard women as chaste reproductive vessels intent only upon the controlled satisfactions offered by marriage. With its spectacle of sterile and distorted organic matter, this work is evidently not interested in the emotional guarantees that Vanessa was raised on, their half-measures of feeling, but in the uncertainties of desire, its potential wildness and perversity, its ability to disturb social mores and normal perception, altering every particle of the lover's given world.

The abstract background in *Oranges and Lemons* is not uncommon in Vanessa's work, and is often used as a way to state

her sitter's artistic identities, alluding to a shared social world in which an interest in aesthetics underlay everything. It is seen in her 1915 portrait of Mary Hutchinson (blue, purple, lime, teal), Virginia in a bright orange high-backed chair in 1912 (grey, navy, indigo) and her 1915 self-portrait in which she paints herself with a powerfully outsized shoulder (yellow, pink, green, cerulean). Yet in *Oranges and Lemons*, the colours articulate more than that: the distracting variousness of the backdrop, the refusal to follow a set pattern, reflects the invention and improvisation that animated Vanessa's relationship with Duncan. As a queer man and a married woman, their bond was all improvised – disarticulated from the established social scripts. They were learning what they wanted from each other, what they might receive and give in return, entirely through their own experiments, governed by their own criteria. Their relationship could derive its meaning from shared vocation, respect, and an intensity of feeling it was hard not to name as love; it could alter and expand in ways that couldn't be foreseen, as it needn't ever attach itself to the fixed signposts of courtship and marriage, and their inevitable emotional drift.

An example of their resourcefulness: the figures they created to populate their shared imagination. Vanessa and Duncan did not conceive of themselves as lovers, or versions of husband and wife, nor even as a woman and a man – those established kinship models and dreary binary frames were abandoned altogether. Instead they were 'Bear' and 'Rodent'. They were creatures with distinct habitats, behaviours and instincts who, contrary to their apparent incompatibility, found parts of themselves met in one other. Their chosen totem animals were a kind of statement of intent: their relationship would build itself around cooperation, humour and a compassion that embraced difference. Signing off letters to Duncan with a drawing of herself as Rodent, Vanessa frequently depicts herself in a compromised or inelegant pose, eating alone with her paws scrabbling after food or sobbing huge tears that pool at her feet. With her family and friends Vanessa adopted the persona 'Dolphin', a figure that was elegant and serene, untouchable and unknowable. Only through her relationship with Duncan could

Vanessa become radically other to this impassive self: scrappy and dirty and small; impolite, wily and quick.

A few slender glass bottles rest behind the pot, pearlescent and semi-transparent, scaled down and emerging from a nook. Doodles – practice, distracted touches that have little to do with the overall formal arrangement, or the beginnings of another composition – they draw the eye down to the table on which the subject rests; to its colour, a dirty, watery violet suggestive of the soil from which the plants were pulled. I wanted to peel that anaemic lilac off the surface of the canvas to keep. Cool and luminescent, like the surface of an ice rink, it is delicate, shimmering, on its way to greater intensities: the colour of growing devotion.

There's a reverberation of this work decades later in a canvas at Charleston, one that has been forgotten, packed in a box for years. Likely never to have left Vanessa's domestic space, the piece is a clear retelling of her 1914 work. There are oranges and lemons in a bowl, their leaves neatly trimmed, all done in a plain figurative idiom that might be unremarkable if it weren't for the ghost of the original painting – the neon yellow of the lemon. Assuming the painting was executed towards the end of her life, Vanessa and Duncan would have known each other for at least four decades, and it was only natural for their emotions to have changed over time, their repertoire of behaviours – their ways of showing love to one another – revised. As love deepens, the obsessiveness and uncertainty and anxiety of courtship are lost, the mixed feelings that sharpen all the forms in *Oranges and Lemons* and fill them with a luminous strangeness. In the later work, the subject is the same but the mood is now calm, the forms simple and unobtrusive: so much turmoil has been weathered, and in its wake there is assurance, contentment. And yet, the opaque glowing yellow of the lemon gestures to the extremes of the earlier painting – a trace of that former ardour. Years of experience separate these works, and a different kind of happiness courses through each of them, but when seen together they express a single emotion: gratitude for love's endurance.

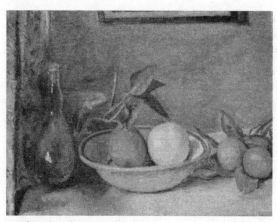

simple and unobtrusive

*

Vanessa and Duncan's intimacy created its own set of problems for their work, which was doomed to be crudely and unimaginatively compared during their lifetime. Institutional misogyny meant Vanessa came out worse from these evaluations. Duncan's work was considered more avant-garde by their peers and more impressive by critics; on the occasions their paintings were mixed up, stronger work by Vanessa was attributed to Duncan.[38] Left dejected by these judgements, unable to see the bias they were operating through, Vanessa acquiesced, and came to regard her work as inferior. In 1912 she reported defeatedly, 'my still life which I have spent the last 3 days on is I'm afraid a failure, Duncan's is very beautiful I think but I don't know how interesting', eventually concluding – after that glimmer of insight in her doubting of Duncan's attempts – that 'mine is simply dull'.[39] She later insisted they paint in separate rooms, fearful that she would otherwise mimic his work.

Vanessa's first solo show in 1922 came two years after Duncan's, and to considerably less fanfare in the press. Roger Fry wrote a

monograph on Duncan's work that was published by the Hogarth
Press – a rigorous engagement which constituted a powerful gesture
towards adding Duncan to the canon, and an accolade which
Roger did not extend to Vanessa. During her lifetime Vanessa never
enjoyed the same prominence as Duncan: she exhibited less, sold
less, and was not commissioned as regularly. For everything the
partnership with Duncan fulfilled for Vanessa, emotionally and
artistically, their intimacy would compromise her confidence in her
work for the rest of her life.

*

Then a complication arose, or so it initially seemed: a third
element. On 6 January 1915, Maynard Keynes sat Bunny
Garnett between Vanessa and Duncan at a banquet at the Café
Royal, prefiguring the triangle that would dominate their lives
for the next four years. Duncan and Bunny had met before, but
a new interest flourished between them that evening. Hours later,
Vanessa had gone home and Duncan was clasping Bunny's hand as
he drifted off, and while Duncan was on the floor and Bunny on
the bed that night, the two were soon sleeping together.[40]

Duncan had reason to be cautious, not having fared well in
recent affairs. George Mallory, a schoolmaster whom Duncan
adored, had just married a woman, as too had his former lover –
Vanessa's brother – Adrian Stephen.

Vanessa watched the men interact at dinner that night, and
quickly realised that keeping Duncan close might entail bringing
his lovers into her life. It was a practical solution, but it was also
a real desire to relate to Duncan, to empathise and accommodate,
which brought Vanessa to Bunny's flat off the Fulham Road a week
later, averting her eyes from the room's dingier corners, carefully
eating a chocolate éclair Bunny had purchased for the occasion.[41]
Vanessa was contemplative on the bus home. 'Bunny really does
care a good deal for him,' she told Roger, assuring herself as much
as him of Bunny's good intentions.[42] The conversation with Bunny

suggested to Vanessa that three people could be close to each other while meaning and offering different things.

What Vanessa realised, what she had in some ways already figured out through her marriage to Clive and her affair with Roger, was that love was not a fixed resource, but was rather a feeling that could be experienced in various ways, and which was responsive to a range of needs. For commitment and companionship; for passion and sex. Vanessa, like many women of her generation, had been led to believe that all this would come neatly packaged in the form of a husband. A 1924 painting by Vanessa addresses the limits of this idea.

Clive is posed as the traditional man of the manor, in heavy tweed with a haughty demeanour, his hair thinning, his eyes blank and toad-like. Children surround him, attendants to his throne, and land rises behind them. The arrangement alludes to eighteenth-century family portraiture, a form contrived to convey a sense of the subject's power and wealth, always more interested in inflations of the sitter's ego than realism. Clive has dominion, but over a disquieting simulacrum of the pastoral idyll: it is flat and out of proportion, like a single adhesive material that could be peeled off the surface entire, or swept off like a stage backcloth. The sitters are as strange as their surroundings: Clive's putty face, the dark expression of his son and the cartoonishly rendered girl. Whether or not intentionally, the work speaks to the impossible theatre and grotesque fantasy of both the couple and its desired by-product: the family. Partly the painting is so unsettling because it is poorly executed, amateurish, neither a close enough copy of a historical form nor a recognisable revision. Yet the badness of the work might bear a relationship to the idea it represents: the inadequate, illogical and ill-fitting belief that Vanessa might find all her needs met in Clive, her satisfactions fulfilled and dreams realised by the conventional family form.

Through meeting Duncan, it became clear that cultivating intimacies outside the tight unit of blood families and the strictly monitored rituals of courtship, marriage and child-rearing would come with its own rewards. A later double portrait of Clive

and Duncan demonstrates the successful outcome of Vanessa's experiments. The work was painted years into the group's intimacy with one another, and it shows, not only in the absorbed, harmonious activity of the sitters, but also in the scene's lack of polish, its hurriedness, its failures. Clearly this work, with its stiff marionette figures and the lurid colours, was more significant to Vanessa in the emotions it recorded than in its aesthetic merits. Vanessa sought the kind of love that involved trust, happiness, support and care – the fundamentals – but simply shared outside the usual heteronormative unit. The painting states the ease of such an arrangement: the scene is about the effective construction of a fulfilling emotional environment, and how this warmth, familiarity, pleasure and contentment might be built around two men rather than one.

two men rather than one

Questioning the sovereignty of the monogamous couple led Vanessa to rethink the connection between love and sex. She wrote to Duncan of coming up against the more conservative views of friends, relaying the disagreements as much to register her surprise as to try and involve Duncan in making sense of their own unconventional bond. 'They think it (copulation) should be kept for one person and that it is monstrous & fatal ever to copulate

from kindness or for any reason but lust, love or intense curiosity –
I said it was sometimes difficult to know where to draw the line.
What do you think?'[43]

Her thoughts clarified by these conversations, Vanessa saw
that sex need no longer be the aspirational high point of love,
nor did it necessarily possess a fixed meaning or purpose, and
nor should it be reserved for a single partner. While her friends
continued to regard sex as a rarefied act, loaded whether or not
consciously with moralistic connotations about women's purity,
for Vanessa sex was more interesting without the established
context of superlative meaningfulness; that way it might be used
as liberally as she (or anyone else) pleased as an additional form
of connectedness.

Implicit in Vanessa's investigation into a new ethics of desire was
a more radical analysis of the constraints on women's emotional
lives, the laws and customs that kept them in check, and an arrival at
a possible resolution. The stifling hold that romantic love had on a
woman's sense of self, and the notion that only marriage measured
a woman's success, could only be corrected if the overvaluation of
those experiences, or the reliance on strict links between desire,
enduring partnership and personal achievement, were questioned,
perhaps even abandoned altogether. Women relied on men and
marriageability almost wholly to establish their meaning and
worth, and it was impossible to draw a coherent self – let alone a
creative or ambitious one – from such a meagre, unforgiving value
system. In challenging the role of intimacy in her social world,
Vanessa was rejecting these prescriptive ideas about function and
fulfilment, and laying the ground for a greater self-sufficiency.

In 1915 Vanessa painted a self-portrait that is significant in its mixture
of power and apparent clumsiness. The line where Vanessa has added
extra bulk to her shoulder is clear, and no effort is made to integrate the
stuffing with the rest of her already large and awkward frame: the pattern
of her clothing is not matched, nor is the intensity of the pigment. Yet
what appears to be an accident is an intentional gesture, a rejection of
the superficial prettiness of women's faces in the Victorian portraiture –
Griselda Pollock insists these are so overdetermined by fantasy as to

no longer even qualify as portraits – an anti-patriarchal flourish which had broader emotional implications.[44] Vanessa is more interested in conveying an idea of process and experiment, gesturing towards a self that was increasingly seeing itself not through conventional ideas about desirability or respectability, but through its ability to endure and adapt. The additional material is a

form of armour, a promise to herself that her identity would never be engulfed, either by a man or the duties of marriage. The self-portrait is significant in being produced while Vanessa was adjusting her ideas about sex: self-renunciation yielding to self-assertion in one aspect of living – such as desire – could spread, the portrait implies, into the very stuff of being.

Bottle

Nothing is sturdy here. The bottle and decanter would shatter if touched, the lamp spark hot against the flesh. The wallpaper going to pieces. Flashes of gaseous blue. A ragged inhale of breath. Floorboards collapsing under foot. The glint of scissors as Vanessa cut the material that surrounded her: a world made up of rough patches of paint – small and scrappy and inadequately covering the

board – and ripped-up receipts, maps, newspaper clippings, debris that speaks to expense and excess, a crisis of space. A compulsion towards destruction.

Triple Alliance *(1914)*

ب

View of the Pond at Charleston

A still life from 1919 shows a pond glimpsed from a window sill dressed with Omega objects, the gardens beyond a softly rendered pastel-coloured pastoral framed by the window panes as both a physical space and a painting within a painting. With an immersive quiet and contentment, surrounded by colours and textures that ask to be seen and touched, the work invites entrance, encourages participation. The setting is Charleston, the farmhouse in Sussex to which in 1916 – after a series of false starts in other rural locations – Vanessa, Duncan and Bunny transferred their servants, art supplies, gardening tools, children, animals, bicycles, and twenty-five-plus cases of luggage. The exaggerated calm of the work was partly derived from the intense relief with which Vanessa welcomed the armistice in 1918, as well as the lingering sense in which Charleston had been a refuge during the turbulent years before.

entrance and participation

War had been declared in August 1914, and at first, despite the quick succession of battle deaths in her wider circle, Vanessa felt removed from the realities of it, claiming that once she left London she happily lived without newspapers, allowing the texture of rural life and her art to absorb her to the exclusion of even the most violent of world events. Yet soon, with military deadlock on the western front, Zeppelins that sounded like threshing machines had attacked British cities, marking the beginning of a devastating embroilment of civilians in warfare. Clive had written a controversial pamphlet entitled 'Peace at Once' – which was later confiscated and destroyed – calling for a negotiated peace and making clear the Bloomsbury Group's stance on the war. In 1916, following catastrophic casualties and the escalation of fighting on the front, the government introduced conscription, meaning that Bunny and Duncan could only avoid imprisonment as conscientious objectors through taking on farm work. The farm they had been living on in Suffolk proved unsuitable, and Vanessa could no longer remain indifferent. The men faced a military tribunal to determine the legitimacy of their claims and possible alternative contributions to the war effort, and urgently needed a new and suitable place to live

and work, and so, deeply uncertain and anxious about the future, Vanessa sprang into action.

But it was Virginia who first raised the possibility of her sister taking Charleston. Initially Vanessa wasn't impressed. Going on her sister's suggestion, and the resounding recommendation of Bunny, Carrington and the artist Barbara Hiles – who had travelled down to conduct the first assessment – Vanessa moved reluctantly through the warren of interconnecting rooms, all of them freezing cold, covered in ugly wallpaper and smelling of the farm animals that had recently been stabled there. Instinctually she felt the house was unsuitable. A disappointing bicycle ride back to Lewes, the train crawling back to Victoria: but Vanessa could not get the house out of her mind. After a couple of nights in London thinking on the decision, and another train ride from Victoria, Vanessa had secured the lease. 'It's most lovely, very solid and simple,' she wrote to Roger. 'It will be an odd life,' she continued, 'but it seems to me it ought to be a good one for painting.'[45] Vanessa emphasised art rather than politics as the motivation of the move, but the safer and more secluded location would also protect her from everything she feared and had grown to despise: the women in London placing white feathers on the chests of the men who would not fight, the questioning from family and acquaintances about the status of the men around her – Would Duncan fight? Would Bunny? – and the constant demand in public to play at nationalistic fervour.

No pumped water and no electricity made the earliest days at the farmhouse short and cold. The men initially slept on the floor, and woke to basins of water glazed with ice. Neither having any experience of physical labour, Duncan and Bunny exhausted themselves working all day in the fields. Vanessa busied herself with other domestic duties: she tended to the artichokes, dug up potatoes, considered what to make with the apples sent by her sister, picked sloes and blackberries that she made into jam, helped ducklings hatch from their eggs, went to Brighton to buy a donkey, and baked nine loaves of bread in a single afternoon.[46] Once the working day ended, Duncan might be found hunched over a watercolour as Vanessa sat sewing a small brown coat, and

in the evenings the men drifted off as Vanessa read aloud from Dickens.[47,48] Absorbed in the practicalities of rural life, Vanessa was frequently exhausted too, but proud of what she was doing there, aware that fashioning any happiness out of the given circumstances was an achievement, further proof of how far her independence had come. Her successes didn't go unnoticed. 'Nessa seems to have slipped civilisation off her back, and splashes about entirely nude, without shame, and [with] enormous spirit,' Virginia wrote in 1917 with a mixture of light derision, envy and admiration.[49]

Vanessa and Duncan took cans of paint and decorated the entire house. The principles exercised at Gordon Square – of redecoration gesturing to a new way of living – were pushed to their logical extreme at Charleston. The aesthetic had been more subtle then, when Vanessa was first testing out her freedom: tins of white paint, exchanging a dark-hued curtain for a brighter shade. Vanessa had her own studio, but in a sense the entire house was there to accommodate her art, becoming an enormous living canvas. Modernism need no longer be an idea, the abstract subject of debate, framed by the canvas and hung at a distance; it could be lived through, with domestic life and radical aesthetics forever intermingling and bolstering one another. No surface was left untouched: door panels, window embrasures, tables, wallpaper and soft furnishings were all covered in vibrant colours and abstract forms. Ignoring one set of norms, those that dictated the appropriate dressing of a room, was to make room for broader, bolder transgressions.

For Vanessa and Duncan, and many of the friends in their circle who took advantage of Charleston, the home had been a space in which concealing or minimising their presence was essential to their survival, whether to avoid their transgressions being noticed, for Duncan and his lovers, or to extricate themselves from the lives forecast for them, for Vanessa and her peers. The emphasis on spontaneous creative expression and the aesthetic of lurid, exuberant visibility marked Charleston out as possessing entirely different aims. They need not hide here: that is what these stylistic decisions meant; they were free simply to be themselves. The artistic traditions in which Charleston was steeped – a camp

eclecticism that embraced decorative art, Italian culture and still life – constituted a highly politicised style which made clear their departure from patriarchal society and its values: the taste-makers, the authority figures, the cultural heroes and models of wellbeing were all drawn from a world of women and queer men.

Perhaps as vital for Vanessa was how the transformation of the home into a consuming creative project settled once and for all the apparent incompatibility of being a woman – a mother and wife – and an artist. The home would not be an obstacle to her practice, a source of drudgery and distraction, but a prompt – a means of recontextualising and thinking through her ideas that demanded constant invention and adaptation. Living inside an artwork rather than selling it brought to the fore different aspirations. Once walls were painted with a design, years might elapse before they were adjusted or painted over, a process of revision more related to the artist and their changing ideas than any fixed statement on aesthetics. More radical still, in both its domestic setting and the collaborative use of Vanessa and Duncan's talents, Charleston was set in profound opposition to the hypermasculine world of gallery exhibition and private exhibiting societies in which individual male genius was prized above all.

*

In the archive, having spent days lifting landscapes, flowers, farm animals and babies from a box, I encountered a single sheet, stark as a proposition. The paper was yellowed with age and marked with what looked like coffee stains, suggestive of other fluids, and moving across it were unclothed bodies, scribbled as though in haste, but precise in their musculature: urgent need and enraptured focus meeting in long sweeps of graphite. Hairless and faceless, smooth and anonymous, two male figures wrapped around each other, fucking. The tension between the bluntly erotic mode of expression and the chosen support – flimsy and translucent, throwaway sketching paper – complicates the drawing's candour: the daringly

explicit image destined never to realise its full transgressive power, to be destroyed or forgotten about. Here were desires that were fully and passionately inhabited that had learnt to disappear on demand. The sheet is at once a declaration of the pleasures that sustained Duncan's life and a relic of the shame that served as their constant backdrop. I dipped my hands back into the box. The ordinary rhythm of material returned.

I looked for more bodies, but for weeks they were camouflaged by a procession of wholesome rural scenes. I placed another cow, or another denuded landscape under tissue, and waited.

Over time, I collected these men. They are wrestling, or they are absolutely consumed in sex acts, or they are simply lying together tenderly, and it was always their bodies alone, contextless and floating in space. These works are resolutely private, executed on scraps of paper in pencil or biro, and buried beneath or inside sketchbooks. The works vibrate with desire: there is an erotic ambitiousness to them, a sense of Duncan letting his most wayward fantasies materialise, as well as a formulaicness, the same lewd poses and athletic bodies exploited over and over. Yet their concealment and their self-consciously minor medium hints at the anxieties that must have plagued Duncan. Homosexuality between men was not only illegal, punishable with incarceration, but subject to unpredictable phobic violence from which the law offered no protection. The blank space into which Duncan placed these men adds to the mood of unease and impossibility, unable to imagine a setting in which his desires could be accommodated.

The private world built around Charleston served to answer the needs outlined by Duncan's blank sheets of paper. Those carefully maintained reserves could be dismantled. The sensually detailed nudes that adorned the furniture were in part an invitation to relax, and to reclaim those spaces, to insist on their duty to hold whatever desires happened to arise there.

It was no surprise that these longed-for emotional freedoms proved generative for creative work. From that environment came a wealth of paintings, drawings and decorative schemes. The dozens of still lifes that Vanessa completed in the years that followed: in a

plain figurative idiom aiming simply at observation and description, their function closer to diary entries, experiment secondary to the urgency of a small, daily record.[50] And so much else. The drawings of the surrounding landscape: trees in hurried charcoal, lavender smears of dusk over a field, each intent upon capturing a precise way with feeling and light.[51] Watercolours that address a single flower on each sheet, bottles and glasses rendered in spare sweeps of pencil, coffee cups in black biro, lamps in tougher zigzags of pencil – marking their sturdier materiality – observational drawings that arrested quiet moments amidst Vanessa's daily routine. There is Duncan drawn from below the waist: a kind of inverse portrait in which he is represented only by his crossed legs, with paper so thin that the study of a child pushes through from the sheet underneath: all the intimacies of Vanessa's life pressing in on one another, just as they were able to at Charleston.

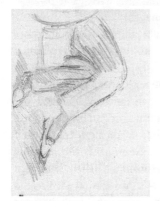

all her intimacies

Others took advantage of the intellectual and creative possibilities of Charleston's queer arcadia. Keynes wrote most of his 1919 tract, *The Economic Consequences of the Peace*, in the upstairs bedroom there. Lytton Strachey had his 1918 collective biography *Eminent Victorians* in mind during one of his many weekends at Charleston. Other writers and artist joined them: E. M. Forster, Raymond

Mortimer, Angus Davidson, Peter Morris, George Bergen and Paul Roche all visited Charleston, and seem to have found inspiration there. Perhaps even more than creative vocation, what united these men was their shared ambivalence about coupledom, matrimony, family and friendship. They knew what they did not want, but did not yet have a clear sense of what kinship structure they might rely upon and invest meaning within instead. To these men, Charleston offered a concrete space in which to speculate and improvise, to establish new foundations: to share experiences, to dream of a better future; to fall in love, to offer counsel; to build and maintain their own elastic, chosen, loving family. Couples formed and disassembled – Lytton and Duncan, Duncan and Maynard, Bunny and Duncan – but the friendships endured. Sexual monogamy was never regarded as the most authentic and meaningful expression of commitment. They fought, but they forgave each other. Jealousies and rifts were resolved. Their emotional ties with each other – disarticulated from sex – held total primacy.

Then, in a decision which rethought the family even more radically than the open structure of their home, a baby was planned for, and conceived. Although it was only a fleeting moment of reciprocal sexual desire in a much longer narrative arc of their love, Vanessa's subsequent pregnancy permanently changed her relationship with Duncan. Having found conventional father figures lacking, Vanessa discovered an alternative: a queer man who she loved unconditionally and respected as an artist, and a family in which the standard patriarch was redundant. Their daughter, Angelica, was born on Christmas Day 1918. At Charleston, Vanessa completed a process she had initiated years ago in her flight from Knightsbridge to Bloomsbury: she had now thoroughly dismantled and rearticulated the expected set-pieces of contemporary heterosexual womanhood, their chronological sweep and emotional content. In the world Vanessa presided over, filled with like-minded creative women and queer men, domesticity, marriage and reproduction were no longer determined by the needs of the father or the husband. Why tolerate those compromises when something else was possible?

The difficulties Vanessa experienced in loving Duncan Grant are much commented upon, although the precise nature of those difficulties is debatable. The problem, or so it's been said, always with recourse to certain damaging stereotypes – of women's submission and gay men's sexual licence – was an inequity of power in which Vanessa was doomed always to be pliant, overly permissive, quietly jealous of the relationships Duncan continued to pursue with men.

Perhaps: to a degree such ambivalence was inevitable. Yet Vanessa's own account suggests the problem pivoted on another order of difficulty. The feeling of being surplus to Duncan and Bunny initially troubled Vanessa: her letters bristle with the discomfort of observing from the margins lives led so thoroughly in concert. By her own admission at least, however, the feeling did not last. 'I suppose I ought to feel *de trop*,' she wrote to Clive, 'but I can't say I bother about it too much.'[52] Quickly the difficulty had shifted, becoming one of language, with Vanessa confiding to Roger: 'I don't think I can write about my relations with him – not that I couldn't tell you probably most of what you want to know but it's too difficult to write.'[53] Vanessa's inability here to summarise her feelings in writing attests to the constant pressure she was under to invent a narrative that might justify or explain what she and Duncan shared, with no ready framework through which to describe a mutually loving, supportive, playfully erotic but only occasionally sexual relationship between a woman and a queer man.

Vanessa's struggle to articulate how her relationship with Duncan felt has contributed to the endurance of certain received ideas: how her love for him constituted a form of retreat, a rejection of a more meaningful and fulfilling romantic relationship she might have had with a straight man. What this ignores is the exhaustive efforts Vanessa made in trying out – and quickly tiring of – whatever it was heterosexual men offered, research which was so troubling to wider society precisely because it suggested a redundancy to traditional spousal roles, the salience of man and wife. Acknowledging Vanessa and Duncan were happy would mean accepting that for women, a stable and fulfilling relationship animated by desire, shared values, creative work and a mutual understanding could function in the

absence of heterosexual men. Vanessa and Duncan were brave enough to imagine something completely different from the social choices at hand. 'It seems to me,' Vanessa wrote to a friend in 1917, 'that being in love is never what other people have described.'[54]

*

View of the Pond at Charleston is one of a number of works by Vanessa that, throughout her life, focused on bodies of water. Having spent cherished parts of her childhood by the sea in St Ives in Cornwall, Vanessa was already instinctually drawn to bathing scenes. However, they later acquired a different and heightened significance in her relationship with Duncan. Before they were close, both artists had completed acclaimed work on bathing (Vanessa's 1912 *Studland Beach* and Duncan's 1911 *Bathing*), a coincidence suggestive of an intimacy of imagination – a shared interest in beauty and embodiment and threshold states; or desire – which would become crucial to their partnership. Early on in their friendship, sharing a bath was a milestone Vanessa delighted in; it laid the ground for the moment not long after when Duncan stood shaving in the bathroom mirror, and having caught sight of Vanessa intently watching him, first realised, it was later said, that she was in love.[55] Charged with intimations of vulnerability and exposure, shaving and bathing alike came to symbolise to Vanessa her ability to see Duncan as nobody else could: her access to a more authentic self, one without artifice.

Much later in their lives, when another world war seemed inevitable, Vanessa and Duncan moved from London to Charleston permanently. Some renovations were required, amongst them the conversion of the larder on the ground floor into a bedroom for Vanessa. On entering this room, what you see is not a bed, but Vanessa's bath. Bathing scenes in art trade in compellingly uncomplicated theories of change, cleanliness standing in for all manner of spiritual transformations, and Vanessa's bath summons images – of her body recuperated, free, each ritual marking a

starting afresh – which allow it to exceed its status as a long-retired domestic object, making it a part of that genre, a painting come to life. Duncan's self-portrait was hung above the room's sink, so Vanessa could see it as she bathed, a placement which defies the fantasies of the traditional bathing scene. The metal handle on one side of the bath, the kind that assists mobility – a vivid trace of Vanessa's ageing body and the passage of time – acts as another challenge to the genre's usual message. This three-dimensional bathing scene is less about transformation, or how easily the self might be absolved of its attachments, than it is about perseverance, devotion, obsession, the very endurance of those bonds, how some forms of love prove rich and flexible enough to stay with us for decades.

8

GWEN

One of Gwen John's earliest interiors shows a woman playing a violin. The scene is quiet with the insularity of a turn-of-the-century middle-class adolescence: with no windows and doors, the only marker of the social world beyond is the man's hat hung on the door, making clear who is able to freely traverse the boundaries of the home. That power and mobility is not her own; the faded gold that surrounds the sitter suggests a long duration in which the riches of an only partly chosen solitude have begun to wear thin. Alone, her talents lack an audience. This is not a private concert held by a professional, but an amateur dutifully undertaking her practice: music is on a chest at her feet, a laundry basket behind her; nothing in the setting is formal enough to place us inside even a casual recital. The woman is unassuming and industrious, intent upon self-improvement, modest and disciplined, her creative work aspiring not to glory or recognition but to a solid competence. The laundry is a reminder that art is not her natural domain; domestic work will soon take over, which is to say that her humble ambitions have cause: her gender.

The young woman's steadfast commitment to her craft is powerful, but it is not the whole story. Fascinated by hagiography throughout her life, Gwen was thinking here about Saint Cecilia, the patron saint of music, who is normally pictured with an organ, but who in a number of famous examples plays the violin.

unassuming and industrious

On the wedding day of the avowedly chaste Saint Cecilia, her resistance to the ceremony manifests through singing to herself, addressing God alone. The female voice is the path to a higher power, and it is a path out of the humdrum expectations of a woman's life. In Saint Cecilia, music and refusal are intertwined. In Cecilia, marriage is transformed into a radical heretical act. Converted on Cecilia's urging – for female sound is both divine melody and transformative rhetoric – her husband is condemned to death, and Cecilia is set to follow. Three times the sword falls on Cecilia's neck, but no mark is made; no man can destroy her, not unless she wills it; she survives, if only for a few more days, after which she rises into heaven, triumphant. Cecilia's narrative links wilfulness, tenacity and inviolable belief with female creative acts that emerge out of necessity from the margins. The story – which Gwen chose to convey the experiences of a young woman and to showcase her own burgeoning talent – is about commitments that eclipse one's own frailties and the cruelties and ignorance of others.

Gwen's model for *Young Woman with a Violin* was her friend and music student Grace Westray. To observe the woman behind the easel, who was so fierce in her theories about art, look to another interior scene – this one with Gwen at its centre, painted by another friend, Mary Constance Lloyd, in 1905. Rarely do we see Gwen like this, her body made of light marble, her skin the peach of pale wine, nude yet unknowable, toes poised like a ballet dancer, silence packed around her like cotton wool. The room is unremarkable, functional, and the bedspread is inelegant, dirtied from use. A glimmer of white and yellow by her hand – so small it's easily missed – has the structure of a book. Her fingers just touch the book's spine, which brings us back to her own curved back, its downward slope revealing her other hand, steadying. The bouquet of flowers turns to her, inquisitive. The yellows and browns that embroider the bedspread mark where the fabric catches the light, a study of colour and shadow, details that point to the women's shared interest in aesthetics, their vocation as both artists and models. Those same muddied hues bear traces of blood, sweat, charcoal and coffee, observing Gwen's body moving through space and time, and allude to an intimacy between sitter and painter which far exceeded this encounter.

What do we know of Gwen, looking at these rooms? Foremost, how her friendships with women were experienced as inspiration and context to her art. And there is Gwen herself: her curiosity and confidence, her strength and sociality. Her knee touching her breast. Not a hair out of place, piled on her head. Her face a cool, refusing mask. The apricot mousse of her skin. Her astonishing leg! Gwen's forceful presence in Mary's interior, along with the explosive charge underneath her *Young Woman with a Violin*, counter the general theme of much critical material available on her life and work.

'Slight and shy', claims one typical assessment; 'introvert' another. Worse still are the descriptions blending ideas about the feminine and the spiritual with a neurotic state of withdrawal: like 'hermit saint'.[1] All of them variations on a myth that stress Gwen's powerlessness, how her art possessed her as any destructive pathology might, how little control she exercised in the life that surrounded her practice.

The Gwen of Mary's portrait, interested and self-possessed, bold and at ease, asks questions about gender and autonomy and their seemingly insurmountable prerequisites, or what it meant in the first decades of the century to be a woman living alone in a rented room. The assumptions about Gwen's character, and the interpretations of her paintings I encountered repeatedly – their eagerness to define her scenes as melancholic – hinged upon a fixed answer to that question, and more broadly on what it meant as a woman to have a meaningful and successful life. What if a painting like Mary's was not considered a shorthand for sadness, but for joy and interestedness, pleasure and love?

Interior with Figures

Gwen painted *Young Woman with a Violin* shortly after she arrived at the Slade in 1895. Ethel Hatch was amongst the young women she met in the first few weeks, and finding Gwen's shyness more enigmatic than aloof, she described her as though she were a precious artefact shipped from another world: 'very fragile looking', she recalled, 'very quiet'.[2] The other students were equally captivated by Gwen, her obvious talents, her glinting hairpins, her seriousness, the hat she wore regardless of the formality of the event. 'A strange little animal' was how another friend put it.[3] Classes over, her peers went to cheap restaurants and bars around Tottenham Court Road. They talked about their teacher, Henry Tonks, who had been in favour in his class that afternoon, about what was required of them in the hours spent in the Life Room bringing flesh to paper, but quickly any barbed remarks about popularity or relative skill were set aside in order to address art itself: which works in the National Gallery were in their heads as they woke up in the morning, and as the night progressed it was each other's affairs, and the question of what would happen, what would become of them all once this was over.

Gwen walked back to the flat she shared with her brother on Fitzroy Street and listened to their landlady read aloud from the Bible.

The Lord is my shepherd, I shall not want. What did Gwen want for in this period? After long evenings practising her draughtsmanship, she would wake in the early hours to the sound of her brother's keys slipping from his hand and catching in the door, returning from nights out drinking with friends. During the day, without the money to buy lunch, Gwen would wander the corridors of the Slade to fill time. One afternoon, stalling behind others, Edna Waugh turned and caught sight of her. Gwen was drawn, always so pale – hungry surely: Edna insisted on buying her a boiled egg and cup of coffee. It became a ritual repeated at noon each day. The pair of them sat in booths, politely ordering from the chalked board.

Before life-drawing classes in draughty rooms, tentative pacts with women, hours turning over a problem in painting – there was driving rain on the Welsh coast. Gwen and her sister Winifred would watch their mother paint watercolours, an indirect pedagogical practice. For months, everything damp. Their mother's work was stacked in drawers, left to spoil, hidden from view. Their father was a solicitor, a stern man with hobbies evocative of the gloomy domestic atmosphere: he played the organ, creaking melodies that carried up the stairs towards the nursery; he cultivated a prized collection of stuffed doves. More rain. Their mother's death. Gwen, Winifred and their brother Augustus surrounded by darkest silk and bombazine. Grief had the family relocate from Haverfordwest to Tenby, and forced them to find solace in each other. The sisters lay on the floor while taking lessons to accommodate Winifred's bad back. The young women learnt to work around inadequacy and restraint. For Gwen had been quiet then too, albeit deceptively so. The sisters had invented their own language: before dinner each evening, they would confer over meanings, investing the slightest movement of their hands, shoulders and mouths with the weight of a whole dialogue. That way dinners could be conducted in total silence, their father's preference. The sisters quivered, touched, raised, blinked, turned, the food going cold on their plates. 'When I was a child,' Gwen told a friend years later, 'I used to cry all the time.'[4] The siblings left for London one by one.

Putting space between herself and her childhood meant the move to London ultimately was not enough. Before she settled there for good, Gwen spent time in Paris with friends from the Slade, Ida

Nettleship and Gwen Salmond. In a work painted during that visit the women stand in an interior, bent into one another and a book, the pink of Ida's dress a speck of excitement inside an otherwise muted palette. The exploratory mood that led Gwen to Paris, the experiment in location and kin and work it represented, is stressed by the central presence lent to books, with reading standing in for all the other forms of research the women undertook: visiting the old cathedrals across the city alone, reading Russian novels together, spending entire days painting and sleeping in adjacent cots in heavy nightgowns against the cold. The cavernous space is entirely oriented around the books, the room yielding no other function but a broadly defined learning and a sharing in that pleasure, and as a glimpse into their life, the scene was accurate. Ida wrote warmly in her letters of a room not unlike this one, designed solely for themselves and their work: she described to her mother 'the lovely bare places furnished only with looking glasses'.⁵ Fortunately the looking glass was all the women needed: outfits could be styled, and self-portraits painted. Whimsical yet staunch in its focus, Ida's description corresponds with Gwen's painting in placing art, style, vision and intimacy at the centre of their new city.

learning and pleasure

From the descriptions that fill her correspondence, Gwen's life in Paris made good on the promises of her early work. She spent afternoons dozing under the trees in the Luxembourg Gardens.[6] She urged Ursula Tyrwhitt, her closest friend, to visit, and in her absence Gwen arranged to see other women, to take tea with them, to attend exhibitions, to model for one another, to take trips outside the city together, all the while encouraging them to paint and sell their artwork.[7] If money allowed, she commissioned friends to sew patterned silk dresses, and in the meantime collected fashion plates.[8] She fixed her hair with a pin, and pressed creases from her skirt before the glass, but was sure – as she stated sternly in her diary – not to waste too much time over these rituals.[9] She painted. She took her sketchbook out with her into the city, and mostly drew the silhouettes of strangers. In not meeting their gaze, in showing the backs of their heads like this – across scores of flimsy books, small enough to slip into her pocket in a hurry – Gwen captures the mood of the crowd, the privacy it made possible in the city.[10] She forgot to eat, and remembered her hunger hurriedly in simple cafes. She shopped for gloves and stockings at the Bon Marché. When money was short and the weather fine, Gwen sat by the Seine, eating her dinner and watching the crowd for interesting new subjects. Weeks upon weeks were spent in the Louvre. On special occasions, Gwen took lunch at Bernard's, and tea on the rue Royale. There were day trips to the countryside: a knapsack big enough to store a book and a bread roll, but so small she could hold it against her body as she napped in the forest. Gwen considered exhibiting work, wondered about picture frames and worried about the risks of transportation and careless packaging. She sought out new paint, scrupulously noting the differences in quality and colour. She exhibited at the New English Art Club in London, but agonised over every canvas she shipped to their annual show. Her efforts did not go unnoticed. Vanessa wrote to her sister in 1911 on attending one of the shows that: 'Miss John seemed to me so much more interesting than anyone.'[11]

It was a life that was forever closing the door and rushing into the centre of things, and it was a life that began and concluded each

day by looking inward. Gwen studied at the Académie Carmen with Whistler, she investigated Paris and its array of possible human subjects, and on returning home she examined herself rigorously, eager for growth. Gwen filled notebooks with questions to better her nature, to ensure she behaved with the greatest possible attention to her art.[12] She wondered about her habits, and whether they were the effect of her circumstances or the people around her, and regardless of the solution she arrived at (to clean her rooms, to wake earlier, to spend more time alone) whether she might somehow exact even more control over the woman she was becoming. The two sides of Gwen's life productively coexisted: discarded drafts for letters were turned over, and on their underside Gwen wrote private notes to herself; her flights into inwardness were – quite literally – supported by the ground of her sociality.[13] More than anything, what the diaries from the time introduce is a young woman finally achieving a measure of self-knowledge. Gwen was at once curious about and frustrated by her own limits, self-reflexive almost to a fault, and filled with a sincere hope that if enough work was done to her character, all her thoughts set on the appropriate course, her weaknesses gone, then something great might come of her ambitions.

Chair

One gesture that recurs throughout the work: a woman braces herself against a chair. Buffed pink nails, lineless hands; balance and strain. That contact tells us more about the women than the sitters ever could themselves. The women are anchored inside their bare domesticities with a fierceness and tenacity that is absolute, but their pose is not cautious, nor is it fearful. The women have found something there that cannot be refused, a foundation, a sustenance, a reason to go on, and with that they have absolved themselves of all their trying prior needs.

The Student *(1903)*

ↄ

The Thinker

In almost every label that accompanies Gwen's art the first biographical detail that is mentioned – sometimes judged the only salient feature – is her involvement with the sculptor, Rodin. Auguste Rodin is rarely introduced by way of Gwen. His figure looms large in our understanding of her, but what is stressed is her role as his model, and not the function Rodin served to Gwen.

The imbalance could be addressed on labels like this:

Auguste Rodin, *The Thinker*, 1903. Bronze, H. 180 cm, W. 98 cm, D. 145 cm. During an affair with the painter Gwen John, Rodin proved crucial in her urgent, ongoing project of self-formation. Gwen stripped Rodin for parts she would craft into tools of suffering and endurance and redemption. From him, Gwen crafted hundreds of texts. Through him, her imagination acquired strength and developed a range of tones and styles applicable across her chosen mediums. His usefulness to her,

however, had limits. Like the self-sufficient subject of this sculpture, Gwen's inner life would acquire an absoluteness that precluded all contact with others, including Rodin. Ultimately, her thought would obliterate him.

*

By 1904 Gwen had grown accustomed to the anticipation, tension, disappointment and accelerated intimacy involved in modelling for fellow artists. There was much to be discovered in placing herself on canvas, in holding forms before she beheld them in others, and Gwen approached these encounters with a keen sense of their possibility. Nevertheless, a nervousness gripped her as she walked down the rue de l'Université, aware that an introduction to Rodin would demand more than was required by her usual clients. Rodin was sixty-three, celebrated, at the height of his career. A photograph from the time reveals what was behind that door: a frown, thickets of hair, a hard and monumental figure, more the visual shorthand of a patriarch than a real man.

Gwen had stood waiting outside studios on many occasions now, holding herself like stone, anticipating frightening men and poorly lit spaces stuffed with canvases. A routine was established: piling her clothes neatly at the edge of the room, going inside herself for entire afternoons in silence, watching the wall record the day in streaks of light. Over time, women had proven easier clients, talking amiably to Gwen as the hours stiffened her bones. It was one of these women – the sculptor Hilda Flodin – who first suggested Rodin might require a new model. Gwen rang the bell at Rodin's atelier.

She stood in Rodin's studio, and watched his fleet of female models embody poses she would later see set down in pencil and carved in rock, observing how their bodies became malleable under his touch, suddenly perfectible things. There was no nervousness in how Gwen undressed. By then she was aware of what was required of her, offering up poses she knew articulated a potential to be

formed, disassembled and redrawn, and whatever sensation it was she produced in Rodin, it was enough for him to hire her. It wasn't long before Rodin began a sculpture, *Monument to James McNeill Whistler*, which took Gwen as the model. During those long afternoons Gwen held her body as she was told and as she knew how, but beyond the workshop Rodin instilled into her routine forms of waiting and discomfort to which she was largely unaccustomed.

At first, the little hints and behaviours that constitute a nascent desire. The exchange of drawings, poetry and pet names; discussion of literature, ancient Greek culture and Rodin's art. In their letters – which began with a formal tone that would soon be lost – Rodin called her 'Marie', the name of his younger sister who had died of smallpox in her twenties. What to make of the comparison to the long-dead sister? Gwen did at times go by Mary – it was, after all, her middle name – including in correspondence with the Church, suggesting the name had a spiritual charge for her as much as a sexual one. For Rodin, evoking his sister in their letters obscured what was potentially coercive about their relationship, disguising it in the simplicity of a fraternal bond.

However, if there was a single purpose behind the swirl of eroticism, sentimentality and risk that surrounded the name, then it was this: an attempt to inscribe a power imbalance into their very mode of address, and Gwen had as much – if not more – to do with this fantasy than Rodin. Rodin relished a desire born out of an apparently assured dominance, given his position in the art world, his gender and the nearly forty-year age gap, and as such it is too predictable to even warrant much description or explanation. Far more interesting was how and why Gwen embraced *Marie*, and more broadly what she gained in constructing the apparently disempowering language and imagery that would define their relationship. In streams of letters that skilfully move across themes and through different epistolary modes – and all written in her second language – Gwen wrote herself into the role of a passive, vulnerable little girl.

Ceding power can amount to its own seizure of control, of course. For what the nickname made clear was Gwen's requirements: a

figure who was older, successful and egotistical, tyrannical in the quiet and small way of so many men. Someone who was aroused by all the expected feminine attributes, the pantomiming of meekness and acquiescence, and so was easy enough to possess.

Gwen let go of herself. There was no violence to it – not as such. As simple as responding to a letter, adopting a voice slightly different to her own, then doing as she would on any ordinary day. Arriving at work, removing her clothes, and spending hours facing Rodin, gazing off into the distance; having decided to return his look at just the right moment, an electric current bouncing briefly between them, then returning to the face of studied indifference, the model and nothing more. Walking home, and writing again, but with ideas on what might be adjusted, ultimately improved: intensifying the sound of her need, bowing a little lower at his feet. It was an experiment that would quickly accelerate, as after a couple of weeks of Marie, inquisitive and flirtatious letters, a suspense that lengthened the hours together, one day in the studio while she was posing naked to the waist – her head bowed, leg raised – Rodin kissed her.

You might say Rodin was charmed by her obedience, her acquiescence to his vision and will. Perhaps the attraction was merely obedience and acquiescence in themselves, unmoored from any specific woman. This was not discontinuous with Rodin's previous behaviour: the boundary between professional and sexual relationship with his models had been blurred before.

Gwen had previously faltered in choosing the right kind of romance. The artist Ambrose McEvoy had disappointed her some summers ago while they were holidaying together in France, announcing after they parted his engagement to another woman. Michel Salaman, a close friend in her circle, failed soon after to meet Gwen's intensities. Tepid in their affections and unremarkable in their ambitions, these men each failed to engage Gwen enough to prove useful as tools of self-mastery. Gwen could see from the beginning that Rodin would be different. The letters that followed their initial encounters attest to the immediate scale and magnitude of feeling, and are full of happiness and need. 'All my days are so

delicious when I pose in the mornings and it's sunny and I know you're coming later.'[14] It seemed possible then that desire might merely have been a balm for Gwen, a straightforward experience of transforming pain into pleasure, the same principle that meant the inevitable discomfort of modelling melted into the deliciousness of those thrilling new encounters. Yet such simple alchemy was of no interest to her.

*

Amongst all the ordinary declarations and invitations, the happiness that resonates from the early letters, it was impossible not to notice another note, one which was astute, and steelier. Rodin's usefulness.

Longing lent her days a tighter structure. Gwen would not be the lover she understood to be the norm: languorous, passive, inert in all the hours that did not include the beloved. Gwen was exceptional, and she could prove it, making rules that reinvigorated her routine. 'Spend little time on letters', she wrote under the heading 'LAWS': 'lie in bed no longer than 5 minutes after waking, study for a part of every day'.[15] Each law Gwen established aspired towards the creation of new ideas or to the healthy maintenance of her mind, and these resolutions were repeated only slightly changed across her notebooks for decades, some versions running into scores of rules in bold script fiercely underlined. Gwen saw that love was unique in possessing intensities that might be harnessed; she suddenly had more energy, and a more compelling reason to eliminate any distractions; the laws multiplied with each day in thrall to its power. The sheets full of punishing reproaches suggest that for Gwen love quickly became an all-consuming spiritual calling which taught her discipline, rigour and self-rule.

The rules she set herself were partly practical: through Rodin, Gwen had more work than ever, and it was not confined simply to modelling, as her encounters with him increasingly came with

related literary activities. Rodin began sending Gwen extracts of his own work and of those he admired to copy out or translate. Much of the work was essentially secretarial, the poet Rainer Maria Rilke performed similar tasks for him, but it had intimations of the sexual. For Gwen there was little quite as intimate as taking each word of the beloved and expressing it anew, modelling their movements, their thoughts briefly and thrillingly aligned. These translations became a further form of dialogue, a way of securing hours alone in Rodin's company without the ordinary worries: no competition, no portioning out of affections, no source for doubt. Translating required trust, and a certain amount of intuition – were some meanings better left unarticulated, others amplified? – and in this manner modelled the intersubjective mode promised (if rarely realised) by their intimacy.

The project offered the possibility of a private language with Rodin, but Gwen shared the translations with her friend Ursula Tyrwhitt. Together they created a circuit of impassioned feeling, reading and writing that only tangentially included Rodin. Looking at one example in Gwen's exercise books, Ursula's sustained attention to their shared labour is clear: there are scores of underlinings, crossings-out, loops around words, question marks and comments.[16] Each annotation marks time spent thinking with her beloved friend, and points to all the hours that went into the corrections themselves. Consulting her French dictionary to freshen her memory, thinking further on the precise denotation of a word late at night, and each day waking in anticipation of Gwen's response. One passage in French became a series of letters passed between the women in English. The women challenged one another, and the women agreed, and the text itself faded, and all that was left were these gestures – of generosity and interest and commitment – and what they confirmed about their friendship. Gwen claimed to need Ursula's help, but these exercises were much more about cultivating their own intimacy than achieving accuracy. The thinking together of the translations engaged the women in their own intense and flirtatious correspondence that required Rodin to remain unremarkable, within the established

bounds of a platonic female friendship. Proving Gwen's complete trust in Ursula, the letters also revealed how readily Ursula would set aside her other duties and dedicate herself to Gwen alone. Each time the translation changed hands, their devotion to one another was restated.

The translations had an additional function, communicating more about how Gwen felt about Rodin than she could have articulated plainly and comfortably to Ursula. Gwen led Ursula to the wall of her heart and pressed her ear against its vibrating surface. Rather than confessing the laboriousness of her affair with Rodin, its evasions and slippery meanings, her unfamiliarity with its territory, Gwen had Ursula experience it for herself. The translations were a metaphor of sorts, a practical exercise in the kind of ambiguity Gwen was struggling to resolve in her emotional life. Sometimes mere explanation won't do, and maybe Ursula understood what was being communicated, knew that in skimming the biography of some long-deceased military figure and consulting the dictionary over *strength* or *battle* or *courage* she was also watching her friend laying the grounds for a thorough crisis of self.

There is an etching by Augustus John of Ursula from 1903. Ursula is haughty, scowling, her hair in waves that jump from her forehead, lending her disdain an electrical charge. What was Ursula thinking? She had turned down Augustus's advances – and there is definitely a quality of defiance to her expression, in her refusal to meet his gaze, in her palpable disinterest in being pretty or agreeable. Yet Augustus's admiration of her is evident. It is difficult to look at etched portraits without thinking about Rembrandt, but there is a chance Augustus had Ursula channelling him here so as to align their seriousness, their artistic identities. This commanding woman was the same figure who waited for the post, who broke the seal of a letter with a knife, and who Gwen so wanted to write. A woman who had fought for her artistic ambitions, coming to art school later than most, after five years moving between home and stuffy finishing schools attempting to negotiate an agreement out of her parents. Ursula succeeded, and she valued her time at the Slade School of Art more than most,

but further challenges lay ahead. Ida Nettleship wrote to Gwen in
1904: 'I suppose Ursula is feeling altogether restless – it is a pity
she cannot settle down to love, art or a man.'[17] Ursula chose, or
the choice was made for her: her husband, their house in Oxford,
an address at which Mary Constance Lloyd stated she was hard
to reach, estranged from her life as an artist both geographically
and emotionally.[18] Ursula's life was ultimately quieter, if no less
meaningful, shaped by different responsibilities: the church,
charitable causes, her husband's work for the Oxford Art Society –
her own practice always the lowest priority. The few works that
survive have a softness and ease that make their execution look
effortless, but Ursula did not think these watercolours 'serious
enough' to be exhibited.[19] Ursula continued exhibiting long after
Gwen – her flower paintings, it was said, were the finest of their
kind – although her persistence is not immediately obvious, her
work having faded almost wholly from history.

not enough

However, Rodin complained that Gwen and Ursula's collaborative
translations were of poor quality. Productive errors, premonitions
of sorts, they registered uncertainties, misaligned ideals and failures
of communication within a discursive space at a remove from the
particulars of their relationship. Gwen relayed Rodin's response to

Ursula in slightly puckish tones, unapologetic. 'Those translations we did together were not quite a success.'[20] And? Gwen was unconcerned. 'I think that was very unreasonable,' she wrote.[21] It is not inconceivable that these mistakes were conscientious insertions, attempts to disrupt the assumed hierarchy of teacher and student, employer and employee, man of experience and his novice, as though a need to articulate their relationship on Gwen's own terms was working its way out of her.

When not working on these translations, a glance at the notebooks illustrates Gwen's engagement in other private intellectual pursuits.[22] Over time Gwen had cut, copied out and rearranged canonical texts of philosophy, science, art and theology, forming idiosyncratic wholes from snippets of Dante, Donne, Hogarth, Wilde, Carlyle, Saint Augustine and Henri Bergson. Gwen selected and copied out resonant passages, and organised works so as to place them in dialogue with one another, creating her own distinctive anthologies of voices. Where necessary she did her own translations. Some books show her writing and rewriting the same passage over and over, stopping mid-sentence if an error arises, abandoning the sheet altogether – leaving evidence of her mistake intact, a reminder of the worth of these exercises – then on the next page the French slightly adjusted, determined to get it right. Texts move from examinations of beauty and perception to theories about the soul, from passages on English prose style to arguments about the role of women in society. Occasionally a thesis of sorts emerges. In one book, ideas about artistic and spiritual expression taken from Arthur Clutton-Brock are interspersed with reflections on femininity drawn from the work of Italian writer Gina Lombroso, and Gwen moves between them as though attempting to explain her own search for a distinctive visual language. Some notebooks are full of neat, black cursive script, each passage announced by a heading and firmly concluded before another text is introduced. Others are written in hurried, impenetrable pencil, the words faded and piled on top of one another, the paper resembling a palimpsest. Gwen could be ordered, rational and practical with these exercises, and she could be urgent, impassioned, driven by a desire to access the text in the moment through whatever means necessary.

Even when the logic of these texts is elusive, their purpose is clear. In the absence of a more thorough education, copying was a widely practised pedagogical tool for women, and it could be a transgressive one, as in more formal academic settings women like Gwen would have had limited access to the texts her exercise books explore for fear of what that knowledge might do. Copying opened up an additional step in the act of reading that stressed the lack of distance between reader and text, and for women it created a fantasy space in which these words, or the social and cultural capital they represented, might be their own. For a woman who commanded herself in her diaries to 'talk as little as possible', the notebooks are unique, articulating on a grand scale – in a way Gwen's public pronouncements never would – the interests that resided at the centre of her practice.[23] The notebooks are documents testament to Gwen's diligent work ethic, her intensities of attention and devotion, and they are evidence of an intellectual boldness, of a woman passionately engaged in philosophical texts, not merely echoing the tastes of others, but formulating her own canon.

Yet there was more to these exercises, more joy and possession and anarchic pleasure. The exalted figures of Western European thought face each other on opposing pages of her notebook. Reduced to the written word, they start resembling one another, and their distinctions cease to matter. The identities of the writers fade, and individual authorship becomes unimportant. What prevails is Gwen. Gwen steals into a text, takes what she likes, fixes what is valuable in her own hand, discards what bores her, keeping only the brightest shards. She does so again and again, growing bolder through books that chart the years of her life. The men are held down, and whisper to one another in Gwen's voice. These slim, unassuming notebooks are repositories of years of deprivation and intellectual curiosity, perseverance and rage. They are talismanic objects, to be approached with caution, and I turned their pages half expecting Gwen's voice to sound out.

In the portrait series known as *The Convalescents*, the figures hold books not dissimilar to those found in the archive: in these paintings the self and the written word are aligned not simply with

one another's subsistence, but with sickness and recovery. Reading and writing and copying were always more than an intellectual exercise for Gwen; they were a vital form of reparative work, a counterbalance to the doubts and dark moods that gripped her, the only tonic in which she ever found a lasting cure. With the notebooks before me, I was witness to a small part of an exhaustive, ongoing emotional convalescence.

Where did Rodin figure in the notebooks? Rodin recommended texts to Gwen, and it is possible that some of the texts were read on his suggestion. Rodin wanted to reshape Gwen's mind into a version of his own, and while that is a commonplace tactic within patriarchal culture, a way of reinscribing particular texts with value, incorporating Rodin into these exercises allowed Gwen to model something – a bravery? a recalcitrance? – she was conscious she could not express in their encounters. Gwen was careful not to disturb Rodin's fantasy of her intelligence, and so she acquiesced when he instructed her to read William James, or when he highlighted a passage in Schopenhauer. However, Gwen then went home and rewrote these texts, altered them, manipulated them, and occasionally nullified whatever it was Rodin was attempting to communicate to her through them by placing a passage under the heading 'PAS COMPRIT'.

In the notebooks Gwen occasionally drew a solitary woman alongside her texts. These women are made up of a few spare lines, little colour or detail, opening themselves to the words that surround them, words that visualise their thoughts. The women are fluid, and move limb by limb across the notebooks. The women float and fade, repeat themselves, disappear and re-emerge elsewhere. Their dresses collapse at the hem, their faces scribble over themselves with makeshift veils. Ink flecks elsewhere in the notebooks, lines that start but don't go anywhere: stray bits of hair in a brush, footprints, fragments these women have left behind. The women are encased in frames, so it is likely they were ideas for compositions. Many of her portraits look like this in their simplest form: a woman, arms at her side, a blank wall, eyes fixed straight ahead. The drawings of women were practice, first steps towards future paintings, and they were ideas about Gwen's own becoming. The notebooks were mediums of

reinvention, a means of escaping the agony of a single, fixed self: the women in the notebooks were all Gwen, traces of her formulating a succession of alternative identities through a variety of texts which could be abandoned and redrafted once she turned the page.

Using a range of literary texts and page after page of her own *rules*, *laws* and *questions*, these notebooks show how Gwen was forever evaluating and reconfiguring the self. 'What good has reading done me?' she asked. 'What books have done me good? What books harm?'[24] In asking these questions, the notebooks bring us closer to Rodin's true worth. Like the books Gwen took pains to copy from, Rodin was a catalyst for thought, feeling and effort, and like those texts, Rodin was a material to which Gwen only ever mimed obedience. Gwen would learn to mould her identity around and against Rodin as much as she would develop an artistic, spiritual self through answer and resistance to the male writers in the notebooks. Gwen could score through these passages of text, and she could rip pages out, and she could throw the notebooks into the fire. Gwen's letters suggest she exercised a similar agency over her relationship with Rodin, severing herself from it through increasingly severe commands to herself – pages and pages of RULES centred around the failures of intersubjectivity – when suffering was what her art required. Rodin was merely another exercise, another question about herself and her limits. 'What helps me most?'[25] she wondered in one set of queries, and Rodin was a way of reaching the answer to this question more quickly and dramatically.

Surrender could not have been further from it. 'Guard your thoughts,' she warned.[26] Gwen was polishing her armour, and admiring her glittering cache of weapons. Rodin was amongst them, an instrument through which to sharpen the boundaries of the self: he was a whetstone, a provocation, a promise of struggle. Some chinks were embedded into her armour, scolding words: 'remember always that you are timid'.[27] Tender parts of her that were left exposed, their invitation to wound. They were tactics with a clear coda. 'To what end leads mental dissipation?' she asked at the conclusion of another sequence.[28] The answer had to do with glory, spiritual opportunity – experiences Gwen knew nothing of yet, and longed for. Rodin would be the ground Gwen pushed off from on her way to transcendence.

～

La Chambre sur la Cour

The pink of Ida's dress in *Interior with Figures* returns in a painting of Gwen alone in Paris, colouring the curtains in the window of a room beyond in her 1907 interior *La Chambre sur la Cour*. Dress had ultimately proven pivotal to Gwen's time in Paris. Her relationship with her father collapsed for good through a misogynistic remark he made about a dress Gwen had designed for herself, questioning the morals of any woman who wore bright and closely fitted clothes, a remark bitter with fear about his daughter's freedom. Yet the pink was also about a more positive continuity. The echo of the earlier work makes clear that Gwen was creating a rich and fulfilling life out of the fabric of that initial independence: now alone, her life would continue to take art, thought and friendship as its guiding principles.

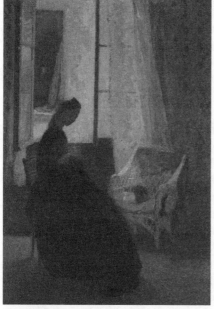

art, thought, friendship

Between 1905 and 1911, Gwen made a series of works depicting three rooms in Montparnasse which she successively took as her home: rue St Placide, rue du Cherche-Midi, rue de l'Ouest. However her first rooms in Paris have no visual correlative. Gwen had not intended to end up in Paris – an excursion to Rome with the artist Dorelia McNeill had faltered in the south of France – but she was there now, manoeuvring past the junk shops and cafes with her luggage, keen to take whatever room was available. The Hôtel Mont Blanc was a lodging house at 19 boulevard Edgar Quinet, close enough to the maternity hospital and a military hospital to hear the cries of new life and death as she wandered home. Smells stayed in her clothes: human waste, the acrid notes of densely packed bodies, a sourness cut with the occasional ceremonial bouquet, and so much else from the surrounding streets, what Hope Mirrlees in her 1919 poem about the city identified as 'cloacae, hot india rubber, poudre de riz, Algerian tobacco'.[29] From her room Gwen could hear trams screeching along the street and the low hum of crowds: it was freedom, but it was not peaceful – and for now that hardly mattered. She was still largely painting portraits. What the Hôtel Mont Blanc represented was not yet of interest to Gwen.

Nevertheless, Gwen would remain in rooms at the Hôtel Mont Blanc for two years. Having felt keenly the constraints of living in a pristinely maintained family home, she was sure not to let those standards – and their implied connection to ideas about morality and chastity – penetrate her own space. Papers, clothes, painting equipment and cat food were strewn all over the room. Rodin had once asked, horrified, for a fishbone to be removed from the bed. The fantasy was tempered, compromised: her sweetness and purity – such crucial qualities for Rodin – were revealed to be local in their reach, inapplicable to the areas of Gwen's life that unfolded outside their relationship. It was following one of these visits that Rodin insisted Gwen keep her accommodation more orderly – and it was not long after that the wayward, messy Gwen vanished from view. For Gwen, adapting and rearticulating her interior space became a process equivalent to the translating and modelling Rodin had previously demanded of her. In each instance

there were his expectations, and there was her devotion, energy and
tenacity, and their capacity to labour over and transform any given
thing – a text, her body, a space. Her next room would be spotless.

A worthy project was just ahead of her. In the spring of 1906,
Gwen moved to 7 rue Saint Placide, the first rooms she committed
to canvas: *La Chambre sur la Cour,* titled in French so as to
announce her assimilation in her adopted home city. The omission
of the Hôtel Mont Blanc had cause, or it acquired a retrospective
significance: Gwen wanted to reveal the happiness of living
simply and alone, the freedoms of that, without any of its possible
compromises, to convey the fullness that Ida Nettleship marvelled
at to Gwen in August 1904 in a checklist that said much about
the restrictions placed on women's lives, artists included. 'You have
Rodin & work & streets & museums,' Ida wrote, measuring her
own lack against this tally.[30] Although it was Rodin who suggested
the move, in *La Chambre sur la Cour* Gwen's contentment and Ida's
dreams prevail over Rodin's demands.

A presiding quiet, a huge sheet of sunlight that is also the
neighbouring wall, Gwen's hands emerging from all that shadowy
cloth, almond-shaped and delicate. Darkness runs on out of the
hem of Gwen's dress and haloes at her feet, a spilling over and out
of herself, as though it wasn't just an intensity of colour, this black,
as though she were actually made of ink, ash or oil.

The room promises a solitude in which sociality is always at
hand: the windows open out onto another near-identical room
in the distance, the framed picture suggestive of a kindred spirit,
its sounds and sights and smells a guarantee against loneliness.
Gwen was accustomed now to the delicate manoeuvres of self
that were necessary for navigating between rooms of her own and
those of others, her most habitual spaces and the studio, her work
environments and the street. In one sketchbook Gwen's gaze moves
from people's heads seen from behind and drawn from a distance
in cafes or churches, only to lurch suddenly back into her room,
and with that movement comes a change in form, from drawn to
the written. Accounting for her room and its absences, she writes
a list in her still uncertain second language, beginning with '3

tables, 1 *armoire à glace*, 2 *glaces*, 1 *sommies'*, and going on to pick up side tables and chairs before returning to drawings of the street on the next page.[31] Between one sheet and another, Gwen's mind rearranges itself. The list imagines the distinction between a private and public self as a difference in perception akin to the visual and verbal, or English and French. Perhaps one is a more natural fit; perhaps the other requires practice.

'The floor is of red bricks, and there are tiles in the fireplace and two little grates,' Gwen wrote in a verbal precursor to the interior scene, 'and all the furniture is brand new.'[32] The 'white lace curtains at the window' of *La Chambre sur la Cour* are described, but not the pale turquoise fabric overlying them, a colour that redeems the obstructed view onto the courtyard in its suggestion of an open expanse of sky. Out of sight is the plank the concierge fitted to serve as a windowsill, a space Gwen filled with potted plants. This was Gwen's room, but the painting is careful to make space between the room as she experienced it and the room she commits to canvas. Quotations from art-historical precedents stress the divide between reality and illusion, and it is with Dutch genre painting that Gwen has most fun. These works see male painters stealing into women's private spaces, observing them at leisure and in vice, asking the viewer to extract from them a moral worth. Women's silk skirts glimmer against dark wood, and light moves through windows illuminating their faces, indicative of their virtue. They read; they are good wives; they play music; they are good mothers; they sew; they are good daughters; they make lace; they are productive and obedient; they are the glowing centres of domestic spaces. When women's vanities are glimpsed, they are quickly chastised. With its iridescent light and contained space, Gwen's work absorbs the idiom of the Dutch genre painting, and in doing so makes visible the years of research given over to this apparently spontaneous everyday scene. Not content merely to copy, Gwen sets about rewriting the values at the genre's core. In the Dutch tradition, the painter's control over and distance from domesticity is stressed, while Gwen explicitly places herself inside the scene. Nobody would define the space on her behalf,

nor would they instruct her on its true worth. Gwen paints herself into the tradition, and slips into its implied virtue, but without any attachment to a household, and with a life centred around the distinctly self-serving pleasures of solitude and art. The challenge is clear. Under Gwen's direction, virtue might accommodate an entirely different kind of woman.

In Dutch genre painting, embroidery is synonymous with feminine virtue, but in Gwen's work it might be as much a marker of goodness as it is, in art historian Rosika Parker's formulation, 'a weapon of resistance', which directly responded to its function for women as a 'source of restraint'.[33] As Parker details across her comprehensive study of the subject, the history of women and needlework is one of ingenuity and resistance, and reveals the lengths women went to in making art out of the conditions of oppression. With formal training denied to so many women, they were forced to make do with the materials at hand, and to ignore the practical or emotional servility of the few opportunities they had to practise their skill. They made and fixed clothes, for themselves and their dependants; they embroidered samplers that broadcasted moral messages; they kept the small worlds around them from unravelling. The embroideries were modest, and in never claiming the same high cultural space as painting were destined to be dismissed as trivial, but they were essential in the development and professionalisation of women's creativity. What was designed as a method of rendering women more pliant, to fill their time and exploit their labour and limit their ambitions, became a covert form of artistic self-possession. Gwen understood from experience the capacity of women's sewing to empower its creator and unsettle others. The dress that so offended her father was an interpretation of a garment from an Édouard Manet painting. At once a considered creative response, a synthesis of paint and fabric, and a celebration of female sensuality and joyfulness, the immediacy of which was enhanced through being worn on the body, the dress was a meeting of intellect and embodiment transgressive enough to enrage her father. In *La Chambre sur la Cour*, Gwen takes the needle to acknowledge all the women who came before her, and to make

clear that her own practice was made possible not by a lineage of male Old Master painters, but by women who sewed.

Sewing spoke to a historical consciousness as well as a distinct artistic ethic. Demanding endless patience and an exacting attention to detail, needlework is slow. The attractions of it were obvious to Gwen, who had been resisting an art of speed since her education at the Slade: she would dedicate months (even years) to individual works. Her notebooks show how each painting was drawn from a wealth of research and planning: pages announce a subject – be it *bonbons* or *forget-me-nots* – then notes on their thematic resonance and studies into colour fill the space beneath; some titled pages remain completely blank – not enough time having elapsed for the work to have come to fruition.[34] 'Do not be hurried' was practical guidance to herself, a note on her routines and methods; it was also an aesthetic instruction, reflecting Gwen's tireless commitment to working through a single theme or composition – portraits of women, and bare interiors – and even to a particular painting process.[35] Over the decades Gwen's style altered only subtly, and the same subjects were repeated across scores of canvases. What this ultimately effects on canvas is a sense of suspended time: every work in Gwen's oeuvre looks as though it were completed in one elongated moment.

*

In the painting, Gwen is dressed in black, in contrast to the luminous colour that surrounds her, as if proposing a contrast between her subjectivity and its surroundings. The beauty you see here is not my own, it states, nor this lightness. This is not as melancholy as it might at first appear. Gwen liked reticence, liked solitude, liked withholding from others, liked shyness, liked what some might call gloom, liked her penurious conditions, liked to dwell in the more painful aspects of her craft. The black is about pleasure, the dress shining against her like the dazzling dark carapace of a beetle.

Gwen wavers between disguise and disclosure, announcing herself while hiding behind images of others. Gwen adorns herself with allusions to Saint Jerome, the patron saint of scholars, translators and librarians famed for his intellectual pursuits. Like many saints the story of Jerome is one of hardship overcome. Jerome retreats from society and heads for the desert, and spends years moving through a wilderness that is his own penitence. Faith transforms him, and on his return to Rome theological tracts follow, impressive in volume and skill. A wounded lion terrifies his peers in the monastery but moves Jerome, and his healing of its paw turns the wild creature into a faithful pet, an eerie reversal that gives him further cause for belief. Jerome is depicted in paintings as Gwen is here, engaged in a precise private activity – he reads or writes, while Gwen sews – and like her he is alone except for his cat, fierceness softened into docility by his side. There is an aspirational quality to Gwen's identification – to be so accomplished and righteous! – but there is also a certain impudence, a puckish disregard for patriarchal figures. The distance between an ordinary woman and a symbol of intellectual and religious authority is collapsed, and radically so. Our labours are not so different, Gwen's pose states.

The evocation of saints was also always part of a theory about vocation and its necessary trials. 'I must be a saint too,' Gwen vowed in 1919, 'I must be a saint in my work.'[36] And so behind the playfulness, coterminous with it, there is also a reckoning with sadness. Jerome wandered the desert not knowing then what was ahead of him, the divine recompense that would arrive in the study, a space to enable and shelter the miraculous successes to come. The rocks, the hunger, the thirst, his body exposed – then, finally, satiation and quiet. Perhaps Gwen thought of her room in similar terms. The room was a reward, a higher recognition of what had once felt uncertain, under threat or simply too private to garner recognition – her talent.

A Corner of the Artist's Room in Paris

In the spring of 1907 Gwen left these rooms and moved to the attic of the eighteenth-century Hôtel de Montmorency at 87 rue de Cherche-Midi in Montparnasse. Rodin judged 7 rue St Placide to be too humid, as rooms that opened onto inner courts often were; lacking in thorough ventilation, and shared with concierges that saw to the building's waste, they were cheaper and more readily available than rooms with a view of the street. Gwen was tiring of the rooms on St Placide anyway: despite the achievement of *La Chambre sur la Cour,* she found the room did not work well in compositions. This could not be said about rue du Cherche-Midi.

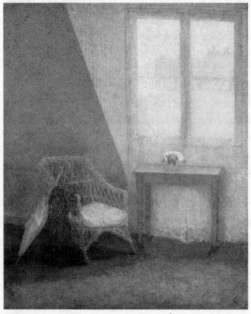

the colour of waking

While the Impressionists had sought the exact tone for the sky at sunrise, setting up their easels in the open air, in *A Corner of the Artist's Room in Paris,* Gwen suggests a colour for the experience

of waking in bed. Ultimately the ambitions of the Impressionists were too general for Gwen, who stations herself before the room as morning breaks, a threshold that is at once spatial, temporal and psychological, between rooms and hours and states of consciousness.

A study of space and light and ordinary objects, *A Corner of the Artist's Room in Paris* was clearly more than a formal exercise. Gwen smears her presence over every one of these objects, in the chair she sits in, in the parasol she opens against the sun, in the navy shawl veined with gold she wears against the cold. Gwen loved this room, the harmoniousness of the life she made here, and that love is the painting's real subject. The painting is like hair sealed in a locket, or a photograph tucked in a purse, a form of preserving the beloved at the height of feeling.

There are around a dozen paintings that place the viewer inside Gwen's room; many more that are not explicitly studies of an interior – the many portraits of women, for instance – take her room as a backdrop. Rooms are observed, cropped, refocused and rearranged. Each room represents a slight but tangible reconstitution of another composition, a hand twisting a kaleidoscope. A sturdy table, the wicker chair delicate as fish bones, the parasol's nose resting on the tiles, a shawl like a slice of night sky and all of it under a thin coating of buttery light. And again, except now a teapot has been placed on the table, with cups and saucers, or a set of china is placed under cloth. A gilded birdcage fills the frame like a house hollowed out by fire. Far closer now, flowers bloom in a tiny translucent glass on the table on the other side of the room. Anchored into a particular place, repeatedly guided towards the same surfaces and shapes from different angles, the stuff of life itself is pared back to a simple scaffold, and Gwen studies the unexpected joints, the meeting of objects and hours on which so much depended, the parts of her own everyday structure that bore the most weight.

These repetitions give a sense of hours unfolding in near-identical ways, and evoke all the nondescript, habitual and pragmatic acts that Virginia Woolf once called the 'cotton wool' of everyday life.[37]

In Woolf's description, washing, cooking, cleaning, eating and walking through the house all fall under the category of 'cotton wool' non-events. This 'cotton wool' is mostly experienced as static, as an encounter with distraction or numbness; nevertheless it is unavoidable in the progress of the self through its given hours, and represents a rare moment when social consideration and self-image do not interfere; these behaviours are therefore powerfully indicative of character, Woolf argues. Gwen's work suggests a similar revelatory quality to ordinary spaces and behaviours, but without the frustration that always tempered Woolf's own interest in those same states. Gwen wanted the small, quiet gestures of her rooms to be her own, to exist within them so thoroughly that they became part of her, as substantial and alive as a new organ, as imperceptible and transformative as a hormone in her blood. Such mildness was not native to Gwen, but she could see its possible benefits. 'The work of everyday builds up your strength,' she assured herself in 1911 with a vagueness that made reference to her painting as much as the effort of moving daily through that 'cotton wool' without complaint or incident, how it might grant her a necessary resilience.[38]

As the years passed, and Gwen worked hard to refine her identity and art practice further, outwardly her life altered very little. Contained experiments, or so they seemed: after all, she ended up with the same kinds of rooms, the same subjects in her work, even the same commands in her diaries. Perhaps, but only if working with a crude theory of change. 'Give a survey of your mind from time to time – of its rhythm and current,' she told herself, and although her notebooks record a version of this, there is a counterpart to *A Corner of an Artist's Room in Paris* which performs a similar function and far more evocatively.[39] The same title, the same long composition date, and the setting is once again Gwen's attic room, in a scene that appears identical at first. For Gwen, these rooms and their repetition were assertions of presence: here I am, they state, I survive, I go on living. However, attention is drawn to the works' small differences, and seen together, the variations illuminate subtle shifts in Gwen's life.

beneath the cotton wool

In the other version, the curtains are drawn, the window ajar to reveal a sky in dazzling turquoise beyond, the shawl replaced with a heavier coat, and a book splayed where the flowers once were. The painting suggests that the self can transform while still largely resembling what it once was, and we must notice, attend to and celebrate these shifts, however small, or lacking in legibility to others. These works insist

that we must learn to see beneath the 'cotton wool', to a scale of personal transformation that is no less seismic in being narrow in focus, modest in aims. Gwen instructed herself 'not to think when your head has touched the pillow' and after weeks of struggling to abide by this rule, she succeeded, and woke feeling brighter, compositions already assembling in her mind.[40] 'Lie in bed no longer than 5 minutes after waking' she insisted, and the

next morning she rose as soon as her eyes opened, feeling rested and happier, quickly crossing the room towards her easel.[41] 'Walk well' was a command that returned to her hours after she had underlined it forcefully in her notebook, hurrying to a modelling appointment, a lightness suddenly in her step.[42] These gestures were as simple and transformative as the window that is now propped open, and the light that is beginning to pour through.

As a formal method, repetition was a way for Gwen to explore the experience of being in time, and never is this interest in temporality and style more explicit than in her sketchbooks. In a series of highly unusual compositions, Gwen divides a single sheet of paper into as many as twenty parts, and draws the same interior scene, normally a single object – a vase of flowers, a Madonna figurine, a cup and saucer – over and over.[43] The drawings look like a minute parsed into moments. They propose a form of looking in which every tiny difference in light and additional detail is worthy of attention. Yet their feverish record carries a warning. The drawings show the day pulled through the same room again and again; they look like identical months that have gathered into years, even decades. In doing so, the drawings evoke a kind of repetition common to women's lives. Gwen had seen certain friends ruined by the responsibilities of housework: faced with a lifetime's worth of monotonous, interminable labour, women who had trained to be artists (such as her brother's wife, Ida) had no time or space to think, let alone to create work. Cleaning was always undone hours later, and cooking was the same: no evidence of their labours ever remained. Gwen had worked hard to ensure her life would never be controlled by these routines, and so her fascination with repetition was also a kind of dread, a way of glancing sideways to the life she'd almost had.

There is an energy to these drawings – a tendency towards frantic lines, the breakdown of images into pure form – that suggests a more radical charge to repetition. Griselda Pollock explains that as women were not regarded as 'normal occupants' of urban space they did not have 'the right to look, to stare, scrutinize or watch'.[44] Walk with your eyes trained on the ground, or risk – as Peter Walsh's pursuit of a woman who meets his glance in Woolf's *Mrs Dalloway*

illustrates – being read as sexually permissive, followed and even violated. Gwen's preference for repetition responded to the limits she experienced in urban space, asserting her power to look, record and remain present in her surroundings regardless of her gender.

What Gwen learnt alone in her room she took with her into the city in the form of her sketchbooks. The images held within them follow Gwen as she trails strangers identified only by their hats, chignons and capes. Gwen stares. She loses interest. She finds patterns. She goes for what is pretty in a woman's dress or unusual in her bearing. Men hurry away from her. Most of the sketches are abandoned, only part finished, whether through disinterest or rebelliousness: why bother drawing that man in full (he is only the vanity of his slicked-back hair)? why allow him that permanent record (or a curve of dark felt for his hat)? why not leave him merely a silhouette (his flesh and muscle one wavering line)? unable to frighten or pursue her?[45] These new abilities clearly enthralled Gwen, and the sketchbooks fill with the thrills of its practice. The men are in pieces; the women are elegant necks drifting free of their petticoats. Gwen's head was held high, her shoes clacking against the pavement, one hand gripping a pencil. The room was only the beginning.

*

In the early twentieth century, and for the first time in British history, a large number of young middle-class women were leaving their suburban family homes, and with it all that the space represented as a curb on women's desires and ambitions. Women accepted places at university, and positions as typists, secretaries, shop assistants and teachers, and in doing so they embraced a different future.

But where might these women live, if not with a mother or father, and if not – at least not yet – with a husband? Renting rooms in boarding houses and hotels provided an answer, and became a radical alternative to conventional domesticity. Rented rooms came with none of the expectations of familial life, and precluded certain

rituals central to the feminine domestic ideal. No more constant supervision. Meals were eaten out, or provided by a landlady. Possessions were kept to a minimum. They were single-occupancy, and in the more respectable boarding houses male visitors (and thus heterosexual relationships) were forbidden, meaning that friendship amongst women rather than the heteronormative family – or its precursor, the couple – prevailed. These were spaces for women who earnt little and saved just enough to buy iridescent face powder or a nightcap. Once the money ran out, women could move on, and the residue of their hand-to-mouth life could be washed off with the ease of old rouge. Arriving in Paris, Gwen had eaten ham and day-old bread in candlelit rented rooms with her female friends, their hair daringly down, exchanging library books and dresses, and none of them (at least for a time) concerned with societal convention.

Rooms allowed women to live differently, and this was especially true for women artists, who could paint, model for one another, exchange ideas, debate aesthetics and exhibit their work in spaces that were not dominated by an aggressive heteromasculinity prevalent in certain avant-garde circles. The rooms offered alternatives to clubs, restaurants, cafes and bars, many of which remained actively hostile environments for women; they fostered cooperation, care and a reciprocity of interest rather than competition. Never confining herself to an exclusive circles of artists, Gwen worked and shared ideas with amateur women painters and sculptors, women unaffiliated with artistic groups, elderly women, women who had trained but subsequently given up their work for wage labour, women who were models or single mothers without a practice but with an interest in art, and women who worked in forms afforded less cultural space, like crafts. Inside rented rooms these anti-establishment connections flourished.

A room could be taken one week and abandoned for a better view or a bigger bath the next, animating casts of characters known briefly and without enduring significance, enabling a succession of fleeting intimacies unimaginable to the previous generation. Some establishments advertised themselves as more permissive,

whether explicitly in low prices and shifty proprietors or through the hushed recommendations of former tenants, and there desire could operate freely, with rented rooms staging love affairs the home could not contain – extramarital, queer or cutting across lines of race or class. These freedoms amounted to a feeling of sexual possibility that easily risked slipping into more threatening territory. Concierges were seldom discerning or strict, and could easily yield to the right kind of bribe. Money occasionally went missing from drawers, Gwen discovered, and she grew accustomed to the odd sounds that punctuated the nights. Men could not always be trusted to be discreet, and there was no telling whether the promised anonymity of the rooms would mean liberation to them or a licence to carelessness, or even worse.

Gwen's paintings, however, reflect the pleasures of a spatial independence that was profoundly psychological in its effects, and lend the broadly defined freedom a concrete physical form. The room both enabled and modelled a new sort of identity for women, one oriented around emotional self-sufficiency as well as a financial independence. The room was about understanding yourself – your creative aspirations, sexual desires and much else – as worthy of a discrete space. The window ajar at rue St Placide was one way of describing how renting rooms could be a way of continuously floating onwards rather than travelling along the strictly demarcated route mapped by straight coupledom. It was a powerful feeling, this turning loose of the obligations of family and futurity: no longer performing as a sister and daughter, or aspiring to be a mother or wife, women like Gwen felt their world suddenly expand around them, finally enjoying the conditions in which they might figure out their own needs and desires.

Self-Portrait with Letter

In a self-portrait dated between 1907 and 1909, Gwen holds a letter to her neck, its sharp edge pointed at her vocal cords. Sharing a

colour and translucence, her hand is aligned with the paper, stating the investment of her entire self in these texts, as though they were literally written on skin torn from her own body. The female voice and violence are closely intertwined, and not for the first time in her work. Like her earliest interior, the painting warns against the powers of female self-expression, and does so through alluding to representations of saints. The portrait resembles works in which saints pose with the object through which their martyrdom has been achieved. Saint Lucy carries a dish from which her plucked-out eyes stare, Saint Agatha reveals her breasts like jellied fruits on a plate – and Gwen holds a letter. From her reading of hagiography, Gwen knew how a particular kind of masochistic, absolute love undid a person only to remake them into a figure of divine fortitude. The conclusion towards which the letters were headed was clear: nothing so banal as a future with Rodin, but to a salvation that would place her amongst the saints she so admired. 'What can love do?' Gwen asked herself in 1920, but this painting over a decade earlier shows she had an idea of the answer.[46]

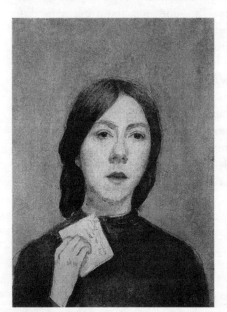

masochistic, absolute

Like God, Rodin was a simple authority figure Gwen longed to place herself beneath, and the moment she focuses on in her letters is the yielding to that weight, how it might feel, whether she could withstand it, and if so all its possible rewards. 'Would not a perfect submission be all – to have nothing to fear,' she wrote, 'would that not give rest?'[47] For Gwen, submission could be chosen, and it could be active and strategic. In her notebooks and letters alike, Gwen refers to herself as destitute, childlike and small, but from her reading of the saints' lives she knew that only through these states of wretchedness could a state of higher repletion be achieved. 'I see a little how degraded I am,' she wrote the same year, 'how sensual I am, how strong is my amour propre, how attached I am to the world, how little faith I have.'[48] In the tales of saints that Gwen pored over in the evenings, spiritual transcendence awaits only those who have lost everything: their profession, their freedom, their most basic resources, their loved ones; parts of their physical bodies, their lives entire. Gwen compiled what she had learned from these narratives, and considered how their lessons might be distilled into the experience of a single loss. Rodin would be that catastrophe.

As Gwen anticipated, Rodin took every cue, and swaggers through the letters like the patriarch she required. The pair discussed their respective practices, and while Rodin occasionally offered compliments on her abilities, the focus was on his genius. He was a sensitive reader of the classics; he refused to empathise with Gwen's position; he was in possession of the greatest talent of his generation; he was selfish; he was playing Gwen off against his other models, enjoying the tension. Rodin saw some of Gwen's works, even sold a few on her behalf, but it is hard to feel satisfied by these concessions. Rodin was concealing their relationship from everyone, including his closest friends. When Rodin wrote back to Gwen, it was often his secretaries who constructed responses. I leafed through a collection of his abrupt and functional letters, a series of scrawled-over calling cards, and the occasional telegram. Their hurriedness and indifference are unmistakeable.

The letters Gwen wrote but left unsent (and subsequently kept) offer a striking counterpoint in their intensity and affect to Rodin's many transactional letters. A means of practising handwriting, epistolary styles, emotional conditions and forms of desire, these experimental texts were directed more towards Gwen than anyone else. Sheaves of blue, cream and lavender tracing paper covered in smudged ink, crossings-out, blank space, unfinished line drawings and the occasional scrawled diary entry. Most begin in the manner of her mailed letters to Rodin with the vocative 'my Master'. These documents of entreaty and erotics function as both a private notation and a form of intimate address, and it is this in-between space, a world that bore no risk of rejection, in which Gwen discovered a certain boldness. 'It was a great pleasure to kiss you,' she wrote, 'but I want more.'[49] Modelling jobs, cleaning and sewing are described, but it is not long before desire slips into the narrative: 'I waited for you against your instruction,' she wrote, 'because I wanted you.'[50]

Gwen anticipated the corrections necessary to these blunt statements of want, the emotional extremes that went censored in mailed versions. 'My letters should be calm, tender, clear and delicate,' she wrote at the top of another draft: a reminder to subdue her passion and anger, to follow the script of naive and mellow affection she maintained in her dealings with Rodin only with great effort. Those years of labour must not be wasted. However, the drafts frequently trace a path between this composure and its collapse, some breaking off mid-sentence, overcome. 'I'm sure I was unfair when I told you…' – the letter stops, reconsidering its judgement, thinking better of being so plain in its desire to please.[51] Others drafts are more transparent in their needs. 'I write to you crying', another begins.[52]

In bringing into focus a wholly private emotional world, the drafts suggest that Rodin assumed a more secondary role in Gwen's life than her intense epistolary activity and agitated diary entries imply. As much about identity and its reformulation as the notebooks, the draft letters allowed Gwen to tunnel towards the perilous outer edges of her longing and abjection. Gwen was aware that Rodin alone could not destroy her; she knew better the strength of her own will. The draft letters were a contingency that

anticipated the disappointment of Rodin's attention, a means in inadequate conditions of hastening along her private martyrdom.

*

'Love the difficulties', Gwen assured herself, underlining it, scoring the command into the paper as though it were her own flesh.[53]

And yet. These habitual destructions of the self, this continual lying down underneath the weight of another's will – however controlled they were, they did not come without risk. The tone Gwen adopted in her letters to Rodin only intensified over time, and ultimately reached an extreme that saw her struggling to exist outside the suffering she had so carefully cultivated for herself. Beware long exposure to such hazardous conditions. Gwen had become acclimatised to those depths, she belonged there like any forsaken creature might, and she could not see light and air as necessary to her any longer. The letters were about this endurance, its requisite adaptations, and more pertinently its dangers. How long could Gwen spend in this darkness without losing herself entirely?

Gwen's control over the situation began to slip. She lost interest in everything that was not directly related to the designs she had on Rodin. 'I desire you so much my Master,' she wrote, 'that I can't take pleasure in my room now.'[54] The modest pleasures she had cultivated in Paris were no longer sufficient, while the trying, wily joys – painting amongst them – were even less of a priority. Some afternoons, bereft, she would sit emptily in the Luxembourg Gardens until close, the light going, hoping that a greed might arise in Rodin the following day. Brutal declarations were pushing through her show of girlish love. Gwen was tired of that now, and determined to make something out of the ugliness that lay beneath. 'If you are full of faults and vanities how can they be any better for your presence?' she wrote.[55]

One sheet in her notebooks lists the days down the right-hand margin, and to the left of these dates are pencil marks shaped like the letter 'I'.[56] A thin and arcane journal, all the meat of her days picked clean from their bones, deciphering it is a struggle. Some

days there are many of these marks grouped together, toppling into one another, on other days the 'I' falters, collapses, rubs itself out. Alongside this calendar are a few repeated words, many unreadable, but one of which reads 'desolation'. The patterns look like a log of sorts, as though marking the recurrence of certain acts: counting letters or their absence, visits from Rodin, crying jags or hours of sleep. More than anything they look like Gwen reminding herself of her own existence, of an *I* outside this feeling, how amongst all this 'desolation' at least one thing must be preserved: the self.

Justifications were arrived at: 'would it not be best to choose the most difficult & the thing with the least pleasure in it, to do, each day?'[57] Rodin lent her the Euripides tragedy *Medea* – a play about a woman's vengeful rage against a man who leaves, and Gwen reported feeling very taken with it, fascinated by the violent lengths of this love. 'Look the worst in the face,' she wrote.[58] What did she see? 'Remember the despair and what it makes you.' A woman's face is drawn in profile alongside this statement, a literal rendering of the idiomatic instruction, but it was also true that it was a woman, a particular version of herself – besotted, passive, unwanted – which Gwen was being forced to encounter in her sorrow.

'Rule – never pity yourself – struggle always.'[59] Alongside an insistence on the rewards of suffering Gwen draws a pair of eyes; they're her own and they're not her own, narrowed and cruel, quite unlike anything I'd ever seen in her hand.

She remained unwilling to apportion blame, despite everything. 'Do not speak ill of people', she reminded herself.[60] On a sheet of paper titled 'dangers' – with a sketch of a priest on a bench that suggests it was hurriedly done while sitting in the Luxembourg Gardens – she mentions 'fatigue', 'lack of time', 'my painting', 'fear of the world', 'pleasures of the world', but never alights exactly on the most potent threat of all.[61]

*

During working hours at his studio, Rodin demanded his models pose as if masturbating, caressing, fucking. There are around

7,000 drawings on this theme. These were the commonplace, tedious desires of an ageing heterosexual man, but they were rarely treated as such. In an exhibition catalogue, one optimist claims that Rodin was 'the first sculptor to want to make women's sexuality important'.[62]

One of these drawings is mounted on stiff cream card, the paper so thin as to be almost translucent. The colour is thinly applied, a watery peach that looks less like paint than a bodily secretion, a blush heating the neck or blood on a tissue. Little freckles all over the paper, released from the woman's skin like sweat. The woman is almost subaquatic in appearance: boneless, headless, hairless, skin lightly and loosely worn on its frame. Wriggling as if struggling for air, a fish caught on a line. A body reduced to an arched back. To supple folds of flesh. An oyster that might slip down your throat in a single gulp. The appeal of such an existence, without substance or personality or any function beyond the sexual, to be only in relation to Rodin and his imagination, tormented Gwen, and it felt for a time as if she would settle for nothing less.

a fish caught on a line

Whistler Muse was still missing its arms. Gwen's dwindling attachment to Rodin was taking on an explicit, public form. When Rodin eventually exhibited *Whistler Muse*, unfinished, critics lauded

the figure's back. The back was said to be truly remarkable, as if Rodin could not bring himself to look at Gwen's intensity of feeling directly.

Gwen produced little work and barely left her room. '*Everything interests me more than painting*,' she admitted to Ursula.[63] When she did venture out, she bought ribbons from the department store – Rodin had urged she be more frivolous, fun, and she practised at it. Rodin paid her rent; months passed; eating whatever she could manage in a small restaurant on the rue St Placide; Christmas spent alone; her body haggard with it, so thin that her clients complained, and even her brother became concerned. She was sleeping more and more, rousing herself only to water her ferns. This was no ordinary weariness; rest seemed only to darken Gwen's gloom further. Picking apart the self she had taken years to construct, she insisted to Rodin: 'I am not an artist, I'm your model, and I want to stay being your model for ever. Because I'm happy.'[64]

Happiness? Gwen's letters to Rodin had long spoken of death, desperation, deprivations of essential needs. 'I suppose you let your dogs and all your other animals die of hunger,' she told him years earlier.[65]

Important to see these expressions of pain as part of a performance that was reaching its climax. Their lessons were harsh, but crucial to her vocation: 'You are not worth anything if you cannot rule yourself.'[66] The notebooks filled with new, searing exhortations: some in French, others in English, many unreadable. 'Groping in the dark' was how she described it.[67] The demands on Rodin escalated, who now required visitors to arrive with a permit, and Gwen waited in vain to receive one. By the end of 1911 Gwen was exhausted, despairing, desperate to be loved in kind, aware her efforts were failing and her health deteriorating, battling her thoughts from the moment she woke, scribbling it all down in her notebooks. 'Rage & despair. Romance. Sick headache.'[68] There was hardly anything left of her will, her spirit was quite gone. 'I am the weakest of women,' she wrote.[69] On the other side of this nothingness, however, the ecstatic self-negation she had been preparing for years, another self was in waiting.

*

Asheet of paper opens on a command held in anxious parentheses: '(Make the decision –)'[70]
Blank space unspools below.
In it, a different self is slowly materialising.
New aspirations: 'Let me flee from what hurts me.'[71]
No more admonishments.
More sheets of squared paper; hurried notes; women's faces drawn in tight spidery lines then crossed out. Weeks pass like this.
'Be what you want to be,' she wrote doggedly from that darkness.[72]

Blue Dress

The women in the paintings are sallow but upright, their heads cast down, wearing their sickness only in their common uniform, tunics in a cornflower blue. A blue that's blood under almost translucent skin, a blue that's bruised, a blue that's cold and numb, a blue that rustles darkly from under a starched sheet, a blue that bleats a muted alarm. It is not a common image of the sick, but afflictions come in many forms, some unamenable to representation. To convalesce is to be in a state of recovery, but the term implies some duration, a committed taking of time; it is the verb of rest-cures and sanatoriums; it is a slow way back to the former life.

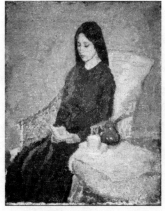

The Convalescent *(1923)*

ᒐ

A Lady Reading

Although Rodin remained in her thoughts, and the visits sputtered on, the intense spell of experiment was over, and from its burning core Gwen had drawn another identity.

'I am exhausted, but I am now not hopeless. The storm has passed,' she concluded in the spring of 1911, although it wasn't until a year later that Gwen was seriously asking herself questions about life after Rodin.[73] 'That is how I should live – perhaps,' she wrote, without making clear what 'that' entailed, only to rephrase the question again a few lines later, 'how should I live then?'[74] A pair of interior scenes, *A Lady Reading* (1911) and *Girl Reading at a Window* (1911), both works started during the height of her anguish with Rodin, record the beginnings of this reorientation of self, and gesture towards the end that Gwen could only faintly see in her notebooks. Their settings are harmonious, and nearly identical: surrounded by personal effects suggestive of creativity, two women stand absorbed in reading by open windows. As she began to withdraw from Rodin, Gwen's practice returned to her, and with it came many other rewards: her paintings from that time attest to it. In them, window frames, door frames and picture frames speak to various ways of being confined, while the curtains – both of which look animated by a breeze, slightly blown out – point to the possibility of freedom.

By the autumn of 1909 Gwen had moved again, this time to 6 rue de l'Ouest, a street within a few hundred yards of the Gare Montparnasse. She took art classes, painted, modelled, wrote letters to Ursula, copied passages into her notebook, prayed and slept. Months passed. At the beginning of 1911 she took a flat in Meudon, the suburban district outside Paris that had long been Rodin's home. There were few amenities: no bathroom, no carpets and a bare minimum of furniture, to be expected for only forty-five francs every three months.

In taking 29 rue Terre Neuve, Gwen discovered a means of withdrawing from Rodin while retaining a vestige of closeness, without the same heightened emotional demands. For that woman was gone, that life ended, and in its place were these rooms with their views out onto the forest. She had arrived firmly now at a choice: 'don't expect anything more from love'.[75] After all, Rodin was growing old, insisting that he was unable to give Gwen what she wanted, writing to her in 1908 that he was like a broken vase, and once touched he might fall apart completely.[76] His whims in old age were taking different shape: a mahogany gramophone, a collection of 78rpm recordings and a new muse, Claire de Choiseul. Rodin's appeal for mercy was a warning as much as a plea: Gwen was not one to touch, especially not now – at any point she could ruin everything (his reputation, his health) and would be liable for the damage done. What Gwen thought of this is unclear. The notebooks had swerved elsewhere. Observations strewn across the sheets like seeds: 'faded primroses and dandelions', 'cyclamen & straw & earth'.[77] Gwen was preparing for new growth, observing how beauty might be drawn from all that was sharp and stinging and covered in dirt.

Just before the move to Meudon, Gwen began painting *A Lady Reading*. With her rosy cheeks, gold hair falling down her back, symmetrical porcelain face, and suggestion of a collarbone emerging from her jewel-toned bodice, the woman is conventionally beautiful, a familiar art-historical archetype. As a measure of feminine worth, dainty hands ranked highly for women of Gwen's class. Yet the precisely rendered hands are ill-matched to the woman's face, a dark rusty pink to her radiant white, tiny against the scale of her head, and only when observed closely does the woman herself look artificial, like a doll put together incorrectly. However in *Girl Reading at a Window* – painted simultaneously with *A Lady Reading* – the model is Gwen, dressed in the sombre and voluminous clothes recognisable from other works. Two wall-mounted pictures of her cats from the other scene have been removed, as though in the first painting the cats are a kind of signature, a reminder that the woman – despite appearances – is Gwen.

Gwen and an archetype

The woman's face – her high forehead, arched brows, pouting lips, long nose, smudge of an ear. What led Gwen to disguise herself like this – glowing, placid, imperfectly proportioned, not quite real? She told Ursula quite simply: 'I did it because I didn't want to have my own face there.'[78] A defensive gesture, then, equivalent to raising her hands to cover her face.

Gwen had felt disregarded and ignored for months, and the mask functioned as a protective layer, a means of reasserting control, offering space in which she could take leave of herself in more dramatic, visible ways than reality allowed. The scene's precise detail assists her disguise: everything in the room is fully illuminated, faithfully rendered – except for Gwen. Unwilling to expose herself in *A Lady Reading*, Gwen changes heart in *Girl Reading at a Window*. There is a neatness in seeing the revision with Gwen's own face as self-effacement turning to self-possession, a retaliation against the modesty and meekness of the earlier work. In *A Lady Reading*, Gwen is the idealised, girlish figure she was with Rodin, the model and the lover, the fantasy derived from norms and her own dreams, a weird and rough composite: milky

skin at her face, meat for a hand; thought and action out of sync. In *Girl Reading at a Window* Gwen removes her mask, just as she had disowned that persona, and in doing so is finally able to fully access an authentic self and its accompanying strength. The impish grin that Gwen wears in *Girl Reading* is as an acknowledgement of this shift: mischievous, quiet yet triumphant.

Reading has long functioned as the privileged sign of women coming into knowledge. In images of the Annunciation – the moment where Mary is visited by an angel, and told she will conceive Christ – Mary is pictured just as Gwen carries herself in both versions of the work, holding a book by an open window. Gwen planned for *A Lady Reading* to resemble a Madonna by Albrecht Dürer.[79] In this representation and many others, Mary is celebrated for her humility. Mary looks up from her book, and in doing so accepts her destiny as a holy vessel, renouncing her independence, all in the service of a higher good. In essence the knowledge Mary is granted is faith, an acknowledgement of the glory of God, but with it comes an equally vital and correlative understanding of the unimportance of her own will, her body or desires. The Angel disappears in Gwen's paintings, leaving only an allusion to their drapery in the curtains; the women do not stir, and continue reading. The women are steadfast, and absolutely in control; they refuse to be sacrificed in service of an abstract power judged superior to their own desires. In Gwen's revisions to religious iconography, it is self-belief and resolve that elicit awe – not submission, nor God. 'I have often been without high aspirations,' she wrote in 1912; 'I have wasted my time over little things not thinking of what I wish to be.'[80] But nothing could be larger or more compelling – or more concerned with the question of how 'to be' – than the ambition of these works, their interest in redefining what might render a woman worthy and miraculous, her life profitable or revolutionary. Gwen's modern Madonna insists upon the right to live simply for herself, and the sacredness of choice and autonomy in a culture which had long valorised women's willing renunciation of those freedoms, even integrating it into its founding myths. In this context, the woman standing

reading alone in her room, undisturbed and invulnerable, becomes a radical, heretical figure.

*

In her essay 'Women and Fiction', Woolf describes one of the transformations in women's writing as a movement away from the self and towards other women.[81] No longer bound simply to plead their own case, as she put it, women were able to mine the experiences of their peers, challenging the existing representations of women authored by men. Aside from their personal significance, what this pair of paintings registers is an interest in the activities of women. Lest we forget, and many do, Gwen was not merely a marginal presence in the lives of the men who surrounded her. She spoke to women, wrote letters to women, lived with other women, had love affairs with women – those her personal papers do not betray – travelled with women, admired the artwork of women, modelled for women painters and sought out women models for her own work, worked alongside women at Rodin's studio, and employed women to make her clothes.

It is worth listing them, these frequently invisible women.

Gwen Salmond, Hilda Flodin, Fenella Lovell, Chloë and Grilda Boughton-Leigh, Mary-Sophie Ludlow, Anna Wood Brown, Mary Constance Lloyd, Charlotte Lloyd, Faith O'Dogherty, Louise Norledge, Dorelia McNeill, Ida and Ethel Nettleship, Edna Clarke Hall, Eily Mary Monsell, Katie Lethbridge, Marguerite Joy, Louise Gautier, Mabel Parmenter, Maud Gonne, Mary Anderson, Bridget and Louise Bishop, Margaret Sampson, Alice Rothenstein, Ottilie Roederstein, Jeanne Foster, Rosamund Manson, Ruth Manson, Nona Watkins, Véra Oumançoff. They were friends, artists, models, in-laws, mentors, neighbours, lovers, flatmates, collectors. They were part of the everyday texture of her life, informing major decisions and defining artistic practices. Out in Meudon, when her solitude yielded, it did so only to women.

All of Gwen's portraiture is of women, save for a series of drawings of military generals – all of them staid, formal – and a couple of drawings of the poet Arthur Symons. The most beautiful part of one of these drawings is Arthur's shirt – a blue that thickens into navy at his collar and ebbs into the sparest periwinkle at his elbow, light and semi-transparent, as if he is wearing bathwater. The drawings of men are otherwise forgettable, while the images of women are astonishing in their clarity of focus, their attention and tenderness, and their sheer bulk.

Gwen's portraiture shares a manner of thinking with an item in Winifred Gill's archive: a chain of paper dolls.[82] A single image of a group of girls reading gives way to a series of reproductions. The women stand alone, but in being stretched into a chain the women reveal their inner depths, their former selves and hopes for the future, as well as their essential connectedness to one another. The women are given three-dimensional structure, bulk and strength only through the presence of the other women; they are, in a sense, composed through the other women. Gwen's portraiture is similarly inspired by a belief in intersubjectivity: tug at the edge of one of her frames, and a string of identical women – relationships, artistic influences, ways of being – spools out.

Inside her interiors, Gwen cultivated her passionate interest in women: their habits, the way they move, how their thoughts emerge through subtle gestures in their bodies. How a woman's hands work patterns into a stretch of cloth, and how a woman's lap steadies itself to support the weight of a cat, and how a hat brings out a certainty that shapes the slope of a woman's shoulders. A glance at Gwen's catalogue raisonné reveals pages and pages of women. They are sitting together, their mouths opening in speech, crowding around each other shoulder to shoulder. There are women in cloaks, women with clasped hands, women with pursed lips, women cradling pets, women reading books, women reading letters, women sewing, women sitting gazing ahead. Many of them look identical. Most inhabit an identical setting. One removes her dress and passes it to another; they pin their hair into matching shapes at the mirror; they mimic each other's looks of repose, lose

composed through other women

themselves in the same thought. What is it that these details – these differences, repetitions, clusters of alike women – articulate?

Put simply, it is this: that Gwen's most valuable, definitive intimacies were with women, not Rodin. After all, as Gwen grew older, her love for a woman in her village, Véra Oumançoff, became a consuming passion equivalent to (if not more pressing than) that which she had felt for Rodin. Letters, drafts and books full of exploratory notation take Véra as their subject, although much of the substance of these texts is now lost – the true scale of that relationship remains unclear, possibly understated. Gwen's focus on women throughout her life and career proves her attachment and identification with them ran deeper. There is no reason not to remove Rodin altogether, to observe the space that opens up, and let the women rush in.

*

During the First World War, Gwen remained in Meudon, helping wounded soldiers in the local Catholic church to confess across

the language barrier. Many fled, but Gwen remained steadfast. 'Regularity is of value – is necessary', she assured herself.[83] Living as she chose required a recalibration of happiness. What mattered now were gentle pleasures that did nothing to stir the placid surface required by her practice, visions that were small and enlivening and quick, a candle briefly moved into an unlit room. *The Little Interior* (*c*.1926) suggests a shape for these revelations. The pearlescent cream palette evokes waking to patterns made by condensation on the glass at dawn; noticing light glancing off women's necklaces as she walked, a succession of shining décolletages in the covered arcades; the cream bought as a treat, poured into coffee; the sensation of laying her tools one by one back in her tin box; fine chalk dust brushed from her skirts after sketching her cats; painting until the tips of her fingers were stiff, her skin the same translucent pinks and blues that glaze the canvas after long frigid hours working at the easel. The painting is instilled with the same desire to name and conserve that is expressed in her cryptic, lyrical entry of 14 April 1921: 'nettle leaf yew tree cut elderberry fish flying lilac heart'; her own held breath creating space between words, the addition 'leaves' written and turned on its side, crushed into the margins as they were underfoot.[84]

small miracles

*

Rodin did not visit her at 29 rue Terre Neuve, despite his proximity.

No matter. Gwen did not need him. Scribbles in her notebook: 'in the day – control – effort –'[85]

What was it Rodin had written to her: that fear of shattering like a flawed vase?

Years earlier, a question had troubled her: 'If I should die now, what sins especially should I ask to be forgiven?'[86]

Much later, in a sketchbook, tucked between sketches of nuns: 'Thought – there is something to vanquish, be faithful –'[87]

Rodin died at 4 a.m. on 17 November 1917.

*

Gwen had converted to Catholicism in 1913. Belief was a decision, and one with a clear ambition. She required love and purpose to remain hopeful, productive, and in faith she not only found this resource, but a space in which intimacies amongst women flourished. With God she finally found a symbol of authority who made her feel seen, and over whom she had a high measure of control. To access him, she copied out whole passages of notes on saints and long theological disquisitions, and began painting religious subjects. Her series of portraits dedicated to nuns in the local convent, some from life, others from prayer cards, possessed her for years; the countless hurried sketches executed during church services, their quietness and attention evocative of prayer. Other devotional objects: the still life of a prayer book in which the backdrop is the glowing red-blue of bruised skin; an extension of her body, as useful to her as ears or eyes, a vital organ through which she apprehended the world. Through religious thought a rewarding formula had been arrived at: her sense of self and her art practice had never before been so closely meshed. 'I shall work for

my solitude,' she wrote in the summer of 1912, and over a decade later she finally felt the rewards of those efforts.[88] Towards the end of her life, she knew well what she had worked for: 'your pictures', she wrote, 'the transformation of your sins, your faults'.[89] There were no more odds to rail against; Gwen's ascension was complete.

In Meudon, Gwen built a life out of prayer, parish life, art, a circle of caring female friends and supporters. Of the later works, notable are the paintings poised on the rooftop of her Meudon home. Powdery markings and provisional forms amongst vast barren expanses of untreated board. A ledge going nowhere in terracotta, the rest of the architecture concealed, and the surrounding nature alluded to only in a fragment of pockmarked olive. Here we are asked to decipher a shorthand, but not for the sake of speed or urgency – it is a form of record fit for a long duration. Gwen stares at the same stretch of land, unwilling to say everything so that the landscape might prove inexhaustible.

unwilling to say everything

These uniquely outward-facing paintings, in which hilltops crumble into nothing and forests compose themselves of a few twigs, record Gwen's sustained, rigorous desire to reimagine

intimate space, even towards the end of her life. Gwen was looking ahead, drafting and restarting, gesturing towards alternative ways of feeling held and beheld, contented, loved and seen. It meant abandoning the certainties she had been fostered through, the stable coordinates of her social reality, and it meant navigating a world of her own making, which might – at least at first – look sparse, unfinished, a few meagre daubs of paint, colourful lines and half-made forms.

Ultimately, however, Gwen had made a life for herself that bore little resemblance to those of her peers; she was loved, needed and fulfilled outside of the heteronormative frameworks that so smothered the women she came of age with. Gwen discovered there was greater happiness in being alone, in ignoring proposals, in remaining unmarried, in cutting out certain kinds of romance altogether, in acquiring few material possessions, in being childless, in cultivating only those friendships she trusted would not hurt her, in filling reams of paper with thoughts that never aspired towards publication or recognition, in channelling every last available speck of time and energy into art. Interested in process above all, the fragmentary late landscapes perfectly embody these refusals, the improvisation and invention that would define Gwen's way of living until her death.

9

NINA

Nina Hamnett set her glass of liqueur delicately down on the table, and as she stood up began to remove her clothes, working swiftly and continuing to talk as she did so, expectation kindling in the small crowd that surrounded her: Paris, a street off the boulevard St Michel, just before the outbreak of the First World War; an ordinary evening at the Fauve painter Kees van Dongen's studio.

In another corner, a boxing match between a pair of amateurs was in full flow, but all eyes were on Nina, the boxers' brute physicality dimmed before her own, her willowy body now bare save for a black veil she danced beneath, throwing it up and pulling it tight to a rhythm of her own making, the music hardly audible above the sudden joyful chaos, the cheers of encouragement, the snatches of song, the crescendo of emboldened gossip. The critics in attendance had requested she dance, and she obliged – this was how she recalled that evening in her memoir – but there was more calculation to it, more skill and intelligence, than her description implies. Nina knew how to work a room, how to captivate an audience, how to use her body and desirability to dramatic effect, how to radically remark upon femininity and embodiment without saying a single word, how to reveal the subtleties of one form through contrast with another – pale flesh and dark silk – and it was this art of limitless excess and charisma, of modernism and feminism, wildness and aliveness and feeling, which shaped her entire career.

From the beginning of her life, Nina had established her
identity through emotional extremities, and while as an adult it
was desire that had her thriving through intensities – in feats of
dancing and drinking and flirting – as a child that same experience
of becoming had been rooted in anger. She argued endlessly with
her grandmother, a woman Nina never took seriously enough to
appease, claiming she regarded her as 'stupid and sentimental' even
as a girl.[1] In a fight with a butcher's son, she recalled pummelling
him in the stomach, knocking his tray of meat from his hands, her
shoes flecked with dirt and blood, an animal stink on her petticoats.
Her justification: she never liked his face. Nuns eventually dragged
her home. She fought with her elderly Sunday school teacher,
another arbitrary figure of authority she found it impossible to
obey, after which she was locked in her bedroom to sit out her ire.
She learnt to swear from local boys, and screamed those profanities
at her parents. Acts of defiance were small, but constant: an oyster
on her birthday she spat out onto the floor; frequent removals
from children's parties; the new dress she wrestled off as soon as
it was pulled over her head. There were countless scenes in which
a burgeoning dissatisfaction, a sense of her own wrongness in her
given world, manifested as cruelty and coarseness. The family
despaired at their ferocious daughter: could she be fixed, suppressed,
silenced somehow? Her father gave Nina a doll, hoping to stir a
more conventional femininity into being, but she was not so easily
swayed: she stripped the doll and beat it with a cane. These are
stories of a child's tantrums, but Nina tells them with seriousness
as parables of the usefulness of anger. Fury was the only available
response, as she saw it, to the awful recognition that she had 'been
born a girl', and, despite her young age, the distressingly clear idea
she had of what that burden meant.[2]

The first painting Nina mentions, one of her earliest works which
is now lost and exists only as a brief description in her memoir –
there are no reproductions – is known as *Dead Soul*. 'Pale faced and
half starved', that's basically all she says about the work, the wasted
body of the woman – an acquaintance involved in occultist circles –
and the 'yellow tulip' she holds.[3] Everything else is speculation: a

huge canvas enveloped in a deep shadow made from the blackest possible pigment, a thickly painted darkness out of which fragments of luminous flesh glint, like a painting by Rembrandt. From the sparse details, clearly the portrait holds a terrible knowledge. Some forms of damage Nina could paint from experience: after the physical fights, tempers, punishments and loneliness of girlhood, she knew well how isolation and social death clung to normative femininity. The flower the sitter holds is a dark joke about the expectations inbuilt into her gender, the interminable wants and demands of a patriarchal world. The soul does not matter: the flower condenses years given over to sustaining a blandly feminine prettiness – a life in death, for sure. The injustice of this trap, an inevitability in which women were nothing but their bodies, was what Nina's art forged itself in opposition to for decades, from this disappeared early canvas to the seizure and reappropriation of that idea represented by her daring performance in Paris. Imagine the yellow of the tulip as the colour of a flinching, scalded thing – as a litmus of rage.

*

By 1911 Nina was sick of the stuffiness and surveillance of her home in Acton, west London. Her parents had ignored her continued requests to be sent to art school, and instead she was enrolled at the Regent Street Polytechnic to train as a post-office clerk: it was practical, far more respectable, marriageable too. She had not spent long secretly practising her draughtsmanship on the blotting paper before her difficulty with numbers made it clear she was not destined for the profession. The environment proved so oppressive that Nina lost all sensation in her hands, her lack of agency acquiring a physical manifestation. Doctors prescribed rest, but the ailment stubbornly remained, and it began to seem less like a condition of surrender than a means for her body to fight back. If she could not paint, some resistant part of her insisted, then she would not do anything.

Nina had an idea of a future self, and it was inextricable with the trips she was now regularly taking into London, getting the train each week to widen the distance between herself and home, hoping she would never come back. Nina returned to 23 Avenue Gardens in Acton each time with a mounting sense of defeat, watching the architecture change from the window with an all-too-familiar dread, slowly readjusting her posture as the journey progressed until she again resembled her parents' daughter. She was desperate to leave all this behind, her family and the suburbs and their limited horizons, but it simply was not possible, that much was clear. Nina did not have the financial means to move, let alone to survive in the city alone; her family were doing all they could to quash her loftier ambitions, and could not be relied upon to help. Her father was the biggest obstacle, a man whom Nina described as permanently furious, who mocked her copies of Whistler, and later sniggered with his friends about the morality of art-school students.

Every possible resource was exploited in the small world Nina inhabited. As much time as possible was spent in the local library, reading Kant, Schopenhauer and Baudelaire, committing passages to memory, despite her mother's protests that the material might prove too difficult. There was a clear motivation behind this research, as she remembers it: 'I had to find out something about life at all costs.'⁴ After years fighting for recognition from her parents, it was her aunts and uncles who acknowledged her talent, noting the piece she had just exhibited, her first, a pastel portrait at the Walker Gallery in Liverpool. This is another work that has vanished without record, but the spirit of it might be guessed at. The pastel portraits of the Impressionists were an inspiration, given the small book on their work Nina treasured, but their presence was broad and much rested on her own innovations to the form. Delicate features rendered in strokes of wayward colour, and the sitter is neither her mother nor her father, the setting neither the polytechnic she loathed nor the room in which she had spent weeks restoring her strength – the sitter was a neighbour, the background a void – and a playfulness of line evocative of the pleasure she felt in her hands finally doing

as she wished. Pen and ink became Nina's preferred medium, those simple lines that shaped numerous spare and wryly observed drawings of urban life, but this confidence, its searing look, would come later; the blur and ambiguity of pastel were fitting tools for the uncertainties of youth. Nina accepted £50 – the small stipend her uncle offered – with glee. The sum from her relatives was small, and it meant compromising on accommodation, settling on precarious, unappealing rooms: withstanding the occasional infestation of pests, working around the damp, growing accustomed to noise and cold. In her essay on women's independence, Woolf ambitiously suggests £500 a year as an appropriate stipend for someone in Nina's position. Indeed, Nina struggled on the meagre amount she had; in her memoirs, money is always running out.

Nina was willing to do almost anything – including dance in a chorus line dressed in eighteenth-century costume, as she had the year before – to supplement her income, save what little she had, and remain at this cultivated distance from her family. With little prior experience, she sought out modelling jobs and teaching positions, learning her best angles and preferred pedagogical methods as she worked. She hardly ate unless it was paid for by someone else, and sat all day in cafes lingering over a single cup of coffee. She wore blouses until they had completely fallen apart, accepted parcels of old clothing from friends, hid her threadbare shoes under the table in grander social settings, and made out of those necessities a style that appeared to others as deliberate, a nonchalant and boyish revision to traditional elegance. Drawing in snatches of time between lessons and appointments and jobs, she then sold as much work as she could. She returned to Acton often enough for a decent meal, and sat in silence, cowed by her father, to remind herself of the purpose behind all this punishing economy.

Nina searched Bloomsbury for a suitable room. Eventually she took the keys to a tiny, evil-smelling bedsit off Fitzroy Square: 41 Grafton Way was seven and sixpence a week, a short walk from the basement on Howland Street that Gwen John had briefly occupied a decade before.[5] Cramped and dirty, infested with cockroaches, the rooms were horrible, inhospitable, but they belonged to her

however tenuously or briefly, and for now that was more than enough. Nina could now dress and behave without any recourse to her family's morals, and she pursued every intellectual and sartorial instinct she had learnt to temper, regardless of how provocative. She observed herself in the glass, her hair tucked behind her ears and her body swamped in a man's red woollen jumper. This was the kind of outfit that horrified her grandmother, who – in accordance with the beliefs of her generation – insisted that women's spines were so frail that they risked collapsing altogether without the support of a corset. Nina knew better, having learnt about anatomy at the Royal Academy lectures, filling a notebook full of details on the vertebrae, even borrowing a model of the spine from a family friend. In her rooms she practised rendering muscles, stretching them by increments with the slightest move of her pencil, stripping them to bone, then clothing them in rippling cloth. Once finished, she read Rimbaud in bed, or went to the cinema with friends to see the latest Charlie Chaplin film, afterwards heading to bars to argue about aesthetics. She purchased colourful stockings and flat-heeled shoes. She invited Mark Gertler and Carrington round to her rooms, preserved the tea cup Gertler used on her mantelpiece – a relic representative of the art world's sudden accessibility – and with Carrington in mind soon after had a male friend chop off most of her hair. She dreamt about the dancer Isadora Duncan, whom she longed to see perform; and about men with hands as Filippino Lippi painted them, like those of the first man she desired; and about the procession of costumes at the art-school parties that happened each year at the Botanical Gardens.

Strategies were arrived at to access avant-garde circles; one in particular was proving successful: an openness to male friendship. Walter Sickert began inviting Nina to his weekly salons on Fitzroy Street, and she attended each one with an awareness of what might be gained professionally. Nina listened to Walter as he pointed at this brushstroke, at that play of colour and light, and noted the qualities he claimed were the spirit of the age – although she would not allow herself to be swayed by his preferences. She steadfastly ignored the advice he characteristically insisted on giving her about

improving her work. In possession of her own ideas, Nina moved on. A conversation with Lucien Pissarro in Walter's rooms turned into an invitation to Nina's bedsit to show off her paintings. There is no record of his response, but Pissarro's shimmering pastel worlds, their delicate handling and ethereal forms, must have felt at a great remove from the corridors of Grafton Street, the canvases Nina was now using to address the life she was building there. A friendship was then struck up with Wyndham Lewis, a powerful arbiter of contemporary tastes (despite incendiary political beliefs that later embraced fascism), who offered something distinct to Nina's burgeoning identity which her vague, misguided statements about him disguise ('I had always got on very well with him and regarded him as a great man') but might be gleaned from a drawing of his, some years after their meeting.[6]

A woman with a polished steel body is bent into a book. At least Wyndham was honest about wanting a woman only as a symbol, an object, a mechanism that might be remotely controlled, without thoughts of its own, unable to speak or move at will. And yet, how engrossed the woman appears, it is unmistakeable: her silhouette an arrow of concentration, that concentration made forcefully visual in the chrome yellow of the book, and her hands finely detailed so as to lend her dexterity, even a measure of power. Her hair is neat as a helmet, scored by lines that echo the slope of her nose as it marks the buffed metal of her face, her eyebrows framing absences where her eyes might be. Although the model was the writer and curator Iris Barry, the woman resembles Nina. After all, this was precisely what Nina wanted, to take leave of her body – to become something armoured, iron, her femininity all but abandoned.

The writer T. E. Hulme and the sculptor Jacob Epstein entered Nina's life around this time too, and much like Lewis, their work aspired to the erasure of emotion, the stripping back of art's narrative content, and the development of an abstract, dry and hard aesthetic. For these men the turn to abstraction was not only motivated by a modernist drive towards newness, but was also a necessary assertion of masculinity. Sharp, hard and angular, their forms telegraph anxiety and rage and a hunger for power: landscapes

taking leave of the body

and sitters alike transformed into weapons, rock faces, enclosed rooms, lengths of steel.

Vorticism was London's short-lived artistic movement dedicated to these ideals. Art was supposedly their focus, but rivalries, fights and public slandering – various performances of heteromasculinity – took up a great deal of their time and energy. Nina recalled Ezra Pound, another member of this circle, requesting Henri Gaudier-Brzeska sculpt him 'like a sexual organ', recording a mythologised version of his own subjectivity that began and ended in assertions of virility and power.[7] Henri's 1914 bust of Ezra is striking in the way so many of his works are: they share a muscular, simplified idiom that remains startling when seen amongst the fussy Victorian sculpture of decades earlier. *Hieratic Head of Ezra Pound* is made from marble the colour of burnt cream, his chin like a knife, the skull a bulging mass

with a quiff rising obscenely from its centre, like the horn of a mythical animal. Pictures of Henri at work reveal the sculpture to be enormous; the stone is at least his height, invulnerable, solid and wide as an ancient tree. Intended as a monument to male genius, the bust is replete with unintentional bathos, ridiculous in both its vast size and its extremely literal imagery; for all its public bombast, it is also unexpectedly private, the sheer fragility of Pound's masculinity never more self-evident.

Aside from opportunities to align herself with avant-garde culture, these men served a more subtle psychological purpose for Nina, allowing her access to an aesthetic that chimed with her own complex relationship to her femininity. It was as though the very qualities that made her feel so self-estranged could become a principle of fellowship, the resentment she felt towards her gendered body recast as a radical artistic sensibility. Nina stood before another abstract canvas, feeling the raw edges of herself finally met in kind.

～

Glass, Book, Inkwell

A woman is sitting absorbed in a book, her hair carved and shining as if made from wood, a frown etched into her forehead the shape of a wishbone. A squat little inkwell matches her jumper and echoes the shape of her torso, and a bookshelf rises behind her like her thoughts made visible, their colourful spines creating an abstract panel. Reading and writing and thinking and drinking are pressed together, as closely interlinked as the chain of objects arranged across the desk. Knowledge, introspection, pleasure and style are compressed inside a small and capacious room, a room that stands in for the self. What more could the sitter possibly need? The scene mounts an answer. Nothing: the woman is alone, and in her solitude is completely fulfilled.

Portrait of a Woman (1917)

Der Sturm

From decades spread across a succession of rooms, of which 41 Grafton Street was Nina's first, there exist only a few still lifes interested in housing those experiences: *Der Sturm* from 1913 is one. Moving from room to room involved stuffing all of her belongings into a few boxes, a recurring necessity that was also a reckoning with everything Nina had accumulated, the trace – however small or chaotic – of the existence she had built and dismantled. Encountering Nina's still life is equivalent to being handed one of those boxes with its top prised open, the contents just visible: a concise, deeply personal impression of the worlds contained in those rooms. Looking inside her bedsits is never simply voyeuristic, detached, but constitutes an extension of confidence, an acknowledgement of trust, an invitation to bear and share in the weight of the life she had made.

an extension of confidence

In a dark and squalid room, a glimpse of a single crowded surface: a jug, tea cup and candleholder are placed above a pile of reading, writing and drawing materials, including the German arts magazine *Der Sturm*. The spare, mismatched contents of *Der Sturm* reveal how Nina's most habitual surroundings were forever reminding her of the necessary compromises of the independence she had longed for, and through her own efforts and courage, finally brought about. Nina accepted the stigma, risk and lack of support that came in rejecting the heterosexual bourgeois ideal, in living alone and without the ordinary social ambitions. Her father, she recalled, quickly gave up on her being 'decent' (within his moral rubric) or making a good marriage, and instead began to harbour cruel hopes that, in her words, she might end up in an 'awful mess' – a comprehensive, flexible euphemism which perhaps most obviously alludes to an unwanted pregnancy. However, for Nina, the rewards of the rented room far exceeded its drawbacks, the attempts her family made to instil within her some vague but damning shame: in taking a bedsit, she was handed a future without a script.

No alternative vocation studied for at the Regent Street Polytechnic. No silent dinners with her parents. No books concealed

underneath her mattress. No man suggested by her mother. No courtship. No lying awake at night wondering if he was right. No promises. No proposal. No modest wedding at the local church, well attended by family and friends. No honeymoon tense with quiet disappointments. No home purchased in his name. No lonely years with the baby while her husband worked. No souring of affection, accelerating with the passing years. No fantasies cultivated in private, buried the instant he returned from work. No ambitions to mourn. Inside the rented room, those certainties dissolved.

Der Sturm reports back on the practicalities of those rooms as much as their possible emotional freedoms. For the painting is fascinated with the geometrics of small, enclosed spaces. The crop removes any horizon and flattens the perspective, and in compressing the available space, each object is forced into some form of relation to another. The congested arrangement stages a broader principle of living in bedsits: togetherness with strangers; a willingness to cede the boundary between public and private. Rooms never belonged to tenants – paying rent was merely about occupation, each payment a reminder the room was not your own – and were only private in as much as they were the single allocated part of the home that other tenants could not physically enter. Corridors, common rooms, bathrooms and hallways were shared, and what could be overheard, smelled, touched and glimpsed through keyholes all tampered with the already narrow bounds of the single room and its given privacy. Tenants all heard each other creak around their rooms, slam doors, run baths, perhaps even talk softly to their partners or friends. Nina brushed against other tenants as she filed through the corridor, pressed her body against the wall to allow her neighbours to pass as she climbed the stairs, discovered hairs slick against the ceramic in the bathroom. The ethic that emerged there, in better moods at least, was of a broad openness towards strangers, because anyone might become the more or less accommodating presence on the other side of the wall.

Every overlap in the painting alludes to these unexpected intimacies, their partial antidote to the indignities of rent – of giving over most of your earnings simply to live – as well as the

statement implicitly made by rooms pared back to a single person's needs. You were more than the envelope of cash handed over each week, and you were never completely alone. You were also unlikely to be there for ever: rooms were not permanent, and could be lost with little notice. Landlords were guided by avariciousness alone, and could hardly be trusted to be sympathetic, and yet the rooms were occupied for long enough that tenants' natural wariness softened, and they grew comfortable. Knowing a neighbour might be gone the following month massively lowered the emotional stakes, and eased the development of relationships. Tenants grew attached to their given spaces and, however loose or arbitrary those bonds were, to one another too.

The objects in *Der Sturm* are placed inside a frame that suggests a familial resemblance, but no pattern or similarities hold. Similarly, the people who inhabited these rooms were not blood family, but also not – certainly after a while – unknown to each other, and inside the frame of a conventional home, new kinds of kin developed. The mismatched objects figure these composite families, and they gesture towards the different forms of inheritance fostered by the boarding house: these objects would not have belonged to Nina, and were more likely to be an assemblage of unwanted goods left by previous tenants; these idiosyncratic legacies were for many the only transfer of property or possession they ever experienced.

The traditional home maintained a chronological march of the hours, each day precisely divided according to task and need, assisted by the separation of its inhabitants into clear, prescriptive characters: mother, wife; daughter, sister; housewife, domestic servant. When women woke, ate, worked, rested and slept were all set, mapped according to the needs of others, and were destined to be repeated with little room for variation until they died. Without a man or a family to shape her existence, however, Nina was able to live according to her own distinctive routine. She might dance until three in the morning, and not stir until after noon, and then walk for hours or sit in a cafe thinking vaguely about her art. She might model for a few hours for cash, then meet a friend for a drink, only then arriving at her easel after dinner, astonished at the hour, and she might stay

there until after dark, retiring to bed with the poems of Paul Verlaine only when her eyes were too heavy to continue looking at the canvas. The day might be abbreviated and intensified, and the day might be lengthened into hours of drifting through the city achieving very little. The day was her own to define. There was spontaneity in each decision, genuine need in all her choices, a freedom to rigorously schedule or leave everything to chance, and to never have to explain or justify how her time was spent. There was nobody waiting up for her return home. Whatever course it took, Nina's calendar was oriented largely around the self, its vocations and pleasures.

Renting rooms was for most a freedom only if a future security could be guaranteed; being outside the fold of property and reproduction was felt as an acute, unending insecurity for many tenants. The housing shortage born out of the expansion of the urban centre in the late nineteenth century had driven a diverse group of people into these rooms. Single young women were common, as too were queer men, and they shared a desire to make out of these rooms different kinds of lives, but they were joined there by retired army officers, older women and émigrés who ended up there less by choice than necessity. For those with more conventional aspirations, the bedsit resembled that of the ageing and melancholic Miss Brill in Katherine Mansfield's short story of the same name: 'a little dark room like a cupboard'.[8] That is, a sign of failure, of dispossession; of the smallness and worthlessness of their lot. On balance, there is an echo of a similar dread in Nina's painting: the darkness of it all, the squalor conveyed in colour, the claustrophobia of its tight structure. For all the freedoms she felt, the risks of living as Nina did were never far from her mind.

Yet Nina courted precisely those things that Miss Brill fears. For Miss Brill, respectability is vividly tied to appearance. The story opens on Miss Brill meticulously brushing and mending and rubbing clean her fur coat, a self-soothing mechanism that communicates something essential to her about her own worth. From Der Sturm, however, it seems Nina was unconcerned with the same slippage between physical and moral hygiene. Moving through an array of dulled primary colours, muddy browns and yellowed creams, the

painting has the feel of a space filled with a choking dust, the objects smeared with muck. The palette of *Der Sturm* is one gesture amongst an entire system of self-fashioning that was focused on dirt. Nina's memoirs are full of gleeful references to dirty forks, dirty glasses, dirty clothes, dirty hair, even her dirty body dragged to a public bath by a friend after weeks without washing. Nina's dirtiness mocked the material culture and moral norms of the bourgeoisie, and that included many of the artists in her circle, but more broadly it highlighted the close association between dirt, sex, gender and class. In the anthropologist Mary Douglas's definition, dirt is understood 'as matter out of place', a principle which, broadly applied to the organisation of patriarchal society, explains how those marked by gender, race or class difference, in existing aslant to or outside of the norm, are always understood as dirty.[9] For Douglas, dirt is about power, order and identity in a general sense; but for people who menstruate it is also specifically about blood, an extraneous and often deeply shameful substance that embodies something of 'the in-between, the ambiguous, the composite', which philosopher Julia Kristeva describes as fundamental to the abject, an experience of self-alienation and revulsion, which singles out its sufferers and threatens to propel them into a state of psychic disintegration. Women might transcend their essential uncleanness, or so they were told through a range of cultural sources – in housekeeping manuals, advertisements for household goods – but only if they devoted themselves to a spotless domesticity and a closely watched sexual chastity.

Advancing age or infertility offered no clear way out of this bind, the pressure merely took a different, and indeed often a more punitive, shape. Nina's revelling in dirt was a way of refusing to participate in these assumptions about women's bodies. With her greasy hair, scruffy clothes and unwashed stink, Nina acted to make her body more ugly, more inconvenient, more indecent, and maintained a domestic space to match. I am all those unpleasant things you claim, her performances stated, only more so.

〰

Still Life No. 1

These were Nina's days: austere but chosen, their own vision of freedom. *Still Life No. 1* is poised somewhere between those waking hours and the surrender Nina contrived to follow them. The painting is a highly unusual reinterpretation of the genre's key elements: there are no opulent material accompaniments, no food, no heightened lights and darks lending the scene a sober drama, merely these simplified forms. What resides in this wine glass, as yet untouched: a belief in solitude as pleasure, as presence, as intoxication; a promise about the spoils of the coming night.

In the hours before parties, Nina would stop by her flat to change, selecting her best silk stockings, her hands moving through her hair before the glass, absently hitting cockroaches with her shoe, and then set out for the night. Walking through Soho before the crowds spilled out onto the streets, she'd peer into the windows of bars; all it would take was the wrong sort of men, a bad atmosphere, or one strange evening that had stuck in her mind, to make her stall over her choice.

pleasure, presence, intoxication

Drinking was only the liberating ritual Nina desired if it was done right, and harnessing its magic meant doing it in public. Nina needed a table at a restaurant, booked on recommendation, a distinctive proprietor with a story to tell, a cheap wine available by the carafe which might be sampled before others arrived, because she needed her friends, preferably artists, to burst in once a glass or two had been drunk, setting aside an ink drawing doodled onto her napkin; she required conversation, music, dance, and the door banging open at intervals with the possibility of new acquaintances. *Still Life No. 1* does not betray its setting, but the accounts of drinking that run through her memoirs place it outside her rooms.

Nina attended parties, drank, talked until she was hoarse, and, as she parted, promised to paint any new friends with faces she judged interesting enough to stare at for hours. The unpredictable pleasures and boundless curiosity of those nights are what *Still Life No. 1* draws from, and it is how the portraits emerged as well: they were records of encounters her memory could not be trusted to preserve, ways to draw an enduring thing out of those apparently fleeting intimacies. It became clear that the London School of Art, where Nina was enrolled, had nothing of this spontaneity. She attended classes there with a waning attention, already considering the collision of art, friendship and event that would define the night ahead.

The perspective in *Still Life No. 1* is angled straight down towards the assembled objects – not observing Nina, we *are* Nina – and it is a compression of space that looks inward, turns from the world, asks not to be spoken to, insists on the importance of solitude in bringing together a nocturnal identity. A single glass of chilled white wine: this was how Nina shed the self she hauled around in the daytime hours, hoping to arrive at someone bolder, expansive, capable of articulating themselves with force and precision. The iridescent yellow at the centre of the frame is the wine glass tipped to her mouth in one elegant flick of her wrist, a smoothness sliding down her throat into her thighs and down to her ankles. A yellow that's the feel of skin against a cool glass. A yellow that's the precise uplift in pleasure that accompanies the thud of another drink on the counter. A yellow that's hearing her speech gather momentum,

with each breath more brazen, and seeing it blaze impressively across the face of her listener. The consequences of those nights hardly mattered to Nina, and the luminous calm of *Still Life No. 1* attests to that. This was time that Nina preserved for herself alone, to be unproductive and self-serving and pleasure-driven away from her art, education and wage labour. The hours each night could be filled with activities only for the memories to be discarded, because remembering precisely what had happened was not the point. The ritual itself was what Nina loved, its practice and repetition: the anticipation building all week, carefully dressing up as the light changed, and the first drink alone. Then, drinks bought with a mounting excitement as everyone arrived, emotional conversations with friends in private corners of the bar, the possibility invested in strangers, the shared mischievousness of tipsiness; the dwindling of energy and slow departures, nightcaps as the closing bell was rung, the fresh air hitting her as she stepped out onto the street, the feel of her cool bedsheets wrapped around her limp, exhausted body. These simple pleasures confirmed the value of the sacrifices Nina had made in living outside domestic and economic certainties: only a woman without attachment or responsibilities could live as she did, and she would enjoy it for as long as it was available.

The significance of the tight crop, and the erasure of all detail beyond the table is partly about solitude, but it is also a comment on bar culture. The bars Nina frequented, most famously the Domino Room at the Café Royal, were lined with mirrors, making them an ideal space for surveillance and observation. Yet here that whole network of looking is foreclosed, with Nina insisting upon an experience of the bar that was not just about the promise of sex or hollow social display. The experience she wanted to preserve was that of sitting with a pile of newspapers in a corner alone, her sketchbook open, sipping her cocktail of choice, a crème de menthe frappé. The space can be contemplative, this painting suggests, wholly disconnected from economies of desire.

Once the Café Royal closed for the night, the party moved to the Cave of the Golden Calf, a few minutes around the corner in the basement of a cloth merchant's on Heddon Street. It was owned by the writer Frida Strindberg, who had commissioned decorations from

London's avant-garde: murals, drop curtains, programmes and posters by Spencer Gore, Charles Ginner and Wyndham Lewis, and a stone statue of a calf by Eric Gill, an eerie, phallic creature with glaring, frightened eyes. The curation of the surroundings built towards an atmosphere that came with its own statement: dancing and drinking and talking were all art forms in themselves. Nina surveyed it all from a round table draped with white cloth, and described the Cave of the Golden Calf as 'a really gay and cheerful place', an endorsement reflective of the straightforwardly liberating nights she spent there.[10]

Nowhere in the painting is the jagged, feverish energy of drunkenness, its carelessness and volatility. Nothing of the dulled perception, the distortions, the errors of judgement. All these affects, which Nina knew well, have been wiped from the surface of the still life like the previous night's make-up. As a corrective, what Nina emphasises is discipline. There's the formal restraint of the arrangement, an abstemiousness in its muted colour and simple forms, and a quietness draped over the scene, distinct as a length of silk. For Nina, painting was a remedy to the previous night's excesses, similar in its effects to carefully preparing a prairie oyster and swallowing it whole. There was a curative aspect to it, entering into the strict regime of work, imposing upon herself order and consequence, and there was a chance to prove to herself that she could exercise restraint.

Extreme accounts of Nina drinking flicker through her memoirs. Staying up until 5 a.m. drinking cheap wine. Staying up until 7.30 a.m. drinking cheap wine. Later even: 8 a.m., 9 a.m. Not going to bed. Not going to bed for three days. No matter if they were partly myth. The story of Nina drinking eleven cocktails and having to go home to be sick.[11] Vermouth cassis![12] Champagne at fifty centimes a glass![13] Absinthe, like cough drops![14] The taste of small plums in kirsch![15] Letting businessmen buy her drinks; smiling as she took the glass from their outstretched hand, then a beat in which a decision was made – were they worth her time? Invariably, no – then giving them the slip to hang out with Amedeo Modigliani. Having Modigliani carry a copper kettle full of beer through the streets of Paris, taking swigs to keep out the cold. The kettle emptied, the pair wrote poems together in their favourite bar, taking turns to

offer a word, to finish a stanza, or to find a rhyme, steadily getting drunker until Modigliani fell asleep on her shoulder.

In *Still Life No. 1*, pairing the wine glass with the sketchbooks lays claim to links between creativity and drinking. As poets, artists and writers had believed for centuries, some modernists held that alcohol granted access to a more authentic truth, stripped inhibition, collapsed boundaries and encouraged the free flow and association of ideas. Jean Rhys's heroine Mayra in her 1928 novel *Quartet* reflects characteristically on how 'significant, coherent and understandable it all became after a glass of wine on an empty stomach'.[16] Yet Mayra, in common with modernist artists and Rhys herself, was fooling herself with optimistic theories about alcohol. Rhys's novels are full of women who slip into the grips of dependence after deluding themselves about their habits, and rarely does their drinking energise anything but self-destruction. This is how a speck of ambivalence emerges in Nina's work: the radiance of the wine glass as a summoning of temptation, a force that draws the eye away from the sketchbooks below.

The men who surrounded Nina believed their drinking to be a necessary precursor to creative acts, and the performances that so often attended those nights, feats of endurance and fights and flirtations, were merely a bonus. Nina's drinking engaged with these fantasies, but it also had other ends. For if Jean Rhys's novels are to be believed, women drank differently. For Mayra, drinking is about entering into a state of vulnerability and abjection that pre-empts the violence of a patriarchal world. Mayra will ruin herself, rather than accept the ruin imposed on her by others; she will not allow men that pleasure. Despite all the damage alcohol inflicts, for Mayra drinking remains a source of power.

The power was in knowing the terms of her own destruction, remaining one step ahead of those who sought to harm her, and in that sense the experience was private, but the power was also drawn from the act's transgressive qualities. Perceptions around public drinking changed as society itself transformed at the turn of the century, but the restrictions on women were relaxed rather than redrawn. Bars remained male spaces where, if women were not excluded altogether, their behaviours were strictly policed and circumscribed. Drinking in

public spaces as a lone woman, especially as a working-class woman, retained an immense capacity to unsettle. The temperance movement had gained popular support in drawing links between moral decency and sobriety. There was a type of woman who drank, or so the broadly held perception went, and she was most likely lonely, promiscuous, self-indulgent, unfeminine, wasteful, helpless, unrefined and overly concerned with pleasure. Consequently drinking meant estrangement from a white middle-class femininity that coalesced around ideas of self-effacement and retreat, decency, niceness, respectability, reticence and self-control.[17] For women, drinking meant giving up on upright domesticity and its promise of social acceptance, and although Nina had already long rejected these terms and their mediocre returns, each night of excess was a powerful restatement of that resistance. Men's drinking rarely attracted equivalent attention or opprobrium, and within certain class backgrounds – and certainly in artistic circles – it continued to be excused if not romanticised, understood as a necessary antidote to the intensities of existence as a man, a reward for their labours, no risk to the stability of their minds or bodies.[18]

Drinking was an assault on all that had been socially imposed on Nina since childhood, but in escaping these strictures she merely found herself facing another kind of emotional impasse. Her peers were quick to reduce her to the butt of a joke, and being mocked always brushed against being ostracised completely. She was the sort of guest who was invited and enjoyed for their charisma, then ejected hours later after too many drinks, the host having tired of them. Fickle in their affections, and easily embarrassed, her peers could be cruel. Fatigued and anxious at a social event, Virginia dismissed Nina in a parenthesis full of contempt: 'was in the midst of a crowd (Nina Hamnett drunk) my head aches'.[19]

When Nina drank she was refusing to make herself small or quiet or clean. Drinking to excess was a means of extending herself into her surroundings, revelling in her body as perverse and despicable, resistant to social control. Like the drama she made out of her own filth, Nina's drinking radically underscored how women's bodies are always perceived as uncontrollable, degraded and worthless, formless and porous, regardless of how they behaved, whether or not they were dirty or drunk. This was what Virginia and many other women in her

circle missed in their catty dismissals of Nina: how her transgressions boldly charted a way out of a collective experience of shame.

Still Life with Blue Jug

A broom has worked its way through the room, a damp cloth has gone over the surfaces, and any clutter has been eradicated. Although Nina uses the same brown palette, and again places a magazine strategically within the frame as a structuring device, so much else has shifted: the magazine is fully visible, and other forms are glimpsed in the reflective surface of the smooth blue ceramic, each of these gestures outwards opening up the small space captured on canvas. The filth and crowdedness of the previous work are gone. Instead, with their clearly demarcated boundaries and appealingly solid placement in the world, the objects suggest a simple, uncomplicated existence, and a new clarity of perspective, a sense of rightness and fit, for Nina.

a simple, uncomplicated existence

For most of her youth, by her own account, Nina's autonomy was total. She possessed an early curiosity about sex, seeking out

gruesome descriptions from women she regarded as knowledgeable on the topic, and described her first encounter with a characteristic wit and anti-sentimentality: 'I did not think very much of it,' she said. Her memoirs observe one-dimensional male figures entering and exiting her life with little consequence, and it is difficult to glean from these pointedly breezy accounts where exactly Nina's affections lay. Writing to her husband Clive in 1913, Vanessa Bell describes spending the morning with Nina at the Omega Workshops, working together while listening to 'the appallingly sordid histories of her love affairs. She is known in Paris as a – could it be a "Lesbian"? Amorous Sapphist will do as well.'[20]

Partly Vanessa's anecdote was directed at Clive so as to dramatise her own innocence, to profess her ignorance of an identity so beyond her own experiences she is unclear how to define it, confining it to scare quotes. The evasiveness with which Nina accounted for her desires, however, meant that Vanessa would not be the last to waver over her sexual identity. Little else exists to develop a fuller picture: only a handful of Nina's letters survive, individual sheets of perfunctory and unrevealing formalities scattered across a number of archives. Despite its confessional impulse, memoir is by its nature partial and heavily curated, the more banal material cut for the purposes of narrative interest, and the more flammable details deliberately withheld. If necessary, entire plots can be discarded, the privacy of certain events defended, a cover-up made all the more convincing by the inclusion of other profoundly personal material: the memoirs bury queer experience beneath compelling accounts of Nina's bids for independence, her friendships with artists and permissive romances with men. As a result, Nina's affairs with women endure only in forms related to Vanessa's remark: as unsubstantiated gossip, at times with questionable ulterior motives; as speculation, dream and possibility. While living in Paris, Nina surely knew about the lesbian salons being held by the poet Natalie Barney and happening each week in the Latin Quarter, but they do not appear in a memoir which otherwise signposts at every opportunity her alignment with the city's artistic countercultures. Maybe their paths never crossed, or maybe Nina simply wanted to convey that impression. 'There seemed so much to do and so many amusing people about,' she wrote, as if as justifying her

inscrutability on the matter, 'one had no time to concentrate on such a serious subject.'[21]

By her own admission, there were three desire objects in Nina's youth – all men. The first was the sculptor Henri Gaudier-Brzeska. In 1913 Nina exhibited five pictures with the Allied Artists' Association at the Royal Albert Hall. Nina had already encountered the twenty-one-year-old's work, and when she saw an amused, bearded figure standing before her pictures she recognised it as Henri, and was delighted – happier, even, than when she received press coverage in *The Times* – but an uncharacteristic shyness prevented her from introducing herself that afternoon. Nina let Henri leave on that occasion, but she acquired his details from a friend and under the guise of having a lead on a job, they met, quickly becoming friends.

Henri and Nina shared a sense of exclusion from the wealthier artistic circles of Bloomsbury: both were making art while working odd jobs, returning from glamorous parties to bare rooms and meagre meals. Henri slept on an iron bed more commonly used for servants, and his aptitude for discomfort surprised and pleased Nina, as if he was made out of the same rock from which he worked. They drew each other to save money on models. They combed the stonemasons' yards in Putney for materials, and Nina once kept watch while Henri stole a slab of marble that would later become one of his celebrated torsos of her. The pair increasingly filled their spare time with each other. They roasted chestnuts on Sunday afternoons, and in the evening cooked spaghetti together at Grafton Street. They drank pints together in Soho pubs, walked down Tottenham Court Road together in matching jumpers that elicited stares. They attended anarchist meetings in which Henri would translate: the radical political agenda, and Henri's conviction, impressed Nina. 'I decided that it was dreadful not to have been born in Whitechapel and that the proletariat were the only people capable of anything,' she recalled.[22] Any eroticism was offset by assertions of their shared vocation. Taking turns in their rooms modelling nude, they could possess each other's bodies without recourse to sexual acts. The pleasure of it all was simple,

and it was definitive. 'I thought he was the most wonderful person that I had ever met,' Nina wrote.[23] After all, Henri claimed to be single, and living with his older sister.

Sophie Gaudier-Brzeska was not Henri's older sister. She was not quite his lover either. Theirs was an unusual simulacrum of a heterosexual relationship, which took many of the form's common features and exaggerated them to their logical extreme. Sophie supported Henri emotionally and financially, side-lining her own creative aspirations to ensure that his genius, as she saw it, could be accommodated. Her three-volume autobiographical novel was continually interrupted in the service of Henri's work. She was housekeeper, cook, cleaner and accountant, with little time outside of her domestic duties to do much else, let alone find her own social circle – all the more important as she had arrived in England from Poland knowing nobody but Henri. Unable to see her value outside of Henri, Sophie was cripplingly lonely and deeply unhappy. According to one biographer, she was 'hypersensitive, suspicious and resentful', 'highly strung', 'too intense', 'ferociously jealous and possessive',[24] which is a way of saying that she was dissatisfied with her lot – and who could blame her?

It only took a couple more beers than usual, the success of Nina having sold a few of his drawings, and Henri confessed to Sophie's actual role. Nina took in this information as indifferently as she could, stopping the 'sobs' that rose in her chest, not wanting to expose the depth of her feelings, conscious her dim romantic hopes for Henri were now impossible.[25]

The question remains of what happened to Sophie's three-volume autobiographical novel. The description online of her manuscripts states their 'poor physical state, often heavily water marked and dirt stained', and offers glimpses of a handwriting that is near impossible to decipher.[26] A mixture of French, English and Polish. What it would take to excavate her version of events.

*

By early 1914 Nina was adrift, and after a friend offered her £20 she took the opportunity to leave London for Paris. Another set of squalid rooms, this time in a hotel on boulevard Raspail opposite the Café du Dôme, ideal for slipping seamlessly between day and night, and then a studio on the boulevard Edgar Quinet, the street on which Gwen had taken rooms some years before. Accompanied by Modigliani in a black hat and corduroy suit, saving the change from her drinks to buy his drawings, Nina arrived at another bar, the Rotonde, where she watched rich Americans play poker, and cherished the sensation of moving through a place that looked like a Toulouse-Lautrec drawing.

Being surrounded by artists might have promised a new and productive environment for her work, but one night at the Rotonde transformed the nature of the experiences Nina had that year in Paris. The myth she made of it goes like this: judged solely initially on the silhouette of a man she glimpsed between people's shoulders, Nina felt mysteriously drawn to Norwegian artist Edgar de Bergen. Introductions at the bar led to a conversation that eventually took the couple out of the crowd and up on the roof of her studio to watch the sun rise. Those few hours were decisive. 'I was by then desperately in love with him,' she recalled.[27] And yet it wasn't as romantic as it appeared, with her own telling of their first encounter ending on a question that challenged the reciprocity and worth of their entire relationship. 'Whether he liked me or not I have never been able to discover,' she concluded.[28] Nina's stated ambivalence about Edgar reflects the general evasiveness of her own accounts of her life, particularly those that would normally carry meaning or momentum, but more interestingly suggests that romance was never necessarily the goal. Edgar was less meaningful to Nina as an individual than as an entrance into a culturally sanctioned emotional project, one that had been hailed as generative for art, and which after years of disinterest, Nina was now ready to explore.

She had not been experimenting with love very long when war broke out. The members of Montparnasse artists' community worked hard to help one another, and quickly produced a young matriarch to manage the chaos: the artist Marie Vassilieff ran a canteen from her studio that allowed artists and writers to dine for only one franc fifty. The price included a glass of wine, a

Caporal Bleu cigarette and guaranteed good conversation with those assembled around her tables. Nina embraced these changes, striking up a friendship with Marie and making just enough money through portrait sittings to eat at the canteen every night. Nevertheless, and much to her distress, she soon had to go back to England. As she waited to cross the Channel, her last twenty francs in her pocket, Nina filled her sketchbook with the landscape she was leaving behind, hoping the bread and cheese she had splurged on would last the return journey.

Edgar later followed Nina to England under a new name, Roald Kristian – his Germanic-sounding one having attracted increasingly negative attention in Paris and culminating in a period of imprisonment. Impoverished, fearful for Edgar's arrest, and still barely knowing one another, the pair took attic rooms in Camden Town. Nina's father reluctantly paid for a marriage licence. She was no more thrilled.

Nina met Henri in London just before he left for the western front. They lay in the long grass in Richmond Park, ate plums, and observed the deer come close enough to touch. Both frustrated at what could have been, it was a bittersweet final encounter. 'He was very sorry I got married and so was I,' she wrote.[29]

The marriage to Edgar did not prove felicitous. Nina quickly found him tedious, intolerable, inscrutable, Victorian in his values. Alarming discoveries about one another were followed by heated arguments – 'he seemed to think that I should always be at home waiting for him', she wrote – all of which created tensions that neither were willing fully to address or resolve.[30] On the evenings they could not afford the bus, they walked back to Camden from Piccadilly Circus in silence. They lived off bone broth, porridge and margarine. The rows worsened. Nina received word of Henri's death, and skulked down Euston Road, determined not to let her desperation show.

On Sundays, she and Edgar would visit her family in Acton and eat a proper meal – the same ritual she had grudgingly participated in as a single woman. There they played the parlour game Exquisite Corpse, in which players take turns drawing body parts on slips of paper and continue until an entire human form is drawn – a

possible metaphor for Nina's condition, the many different parts of herself grafted into a strange and unconvincing whole: the artist, the hedonist, the model, the daughter, the lover, the wife. War at least proved a fruitful time for the side of Nina that still craved excitement. She narrowly missed death on a number of occasions, stepping over rubble and broken glass on Chancery Lane, watching a Zeppelin explode in a shower of gold from her window. Powerless, she clung to whatever defences she could: cigarettes and port, parties that lasted for days at a time, dining at the Eiffel Tower Restaurant as though nothing had changed, ignoring Edgar more and more. Naturally there was not the time to make art, little incentive either. London was falling apart around her, and so too, it seemed, was her identity.

Paintings from this period are scarce; none address her relationship with Edgar. An interior scene by Walter Sickert of the pair from 1915 must suffice as a record. On either side of a crimson chaise longue, a slick of blood indicative of the violence that is being staged, she and Edgar are seated in sober greens and browns, a sour mood seeping out into their clothes like sweat. The striped walls align the room with a cage, and everything within its bounds looks worn: the wallpaper itself, their skin and clothes, the furniture, their features. Edgar fiddles with his foot, a pink sock emerging from his shoe like burnt flesh, a lit cigarette on its way to his mouth, his mouth collapsed in on itself, his eyes like puckered raisins and his skin blotched and distorted, less a man than a length of tenderised meat. His legs are crossed, his knee protruding significantly to one side, claiming the space, crowding Nina into the corner. They do not look at each other. Nina's face is an anonymous smudge of white and beige, and with only one arm clearly painted, and her feet fading into nothing at the floor, the loss of self incurred by their marriage is vividly transposed onto her body. The decline of their love – it is tangible, filling the air between them like its own colour. 'We looked a picture of gloom,' Nina later remarked.[31]

This scene of passionlessness and obligation was what women spent their entire lives working towards, and although Nina never had, still she had ended up there, in that room, in service to a man

the decline of love

she did not like. Her coat is the scene's only comfort, the only kernel of resistance. Nina is dressed to go outside, poised at the lip of the chaise longue as if her presence were only temporary. Smudged and unseeing though they are, her eyes are angled out of the scene, watching the door. Nina is close to abandoning the scene and all it represents, the quiet congealed unhappiness of so many marriages.

Not as close as she might hope, however. The clutter of ordinary social ritual remains by her side, fatigued bits of china that glow the impossible white of things forever being wiped clean, suggesting that Nina's efforts are not yet entirely over.

Still Life with Saucepan

Stripped of any extraneous detail, the space is still identifiable as a kitchen: hunger has swept across the room, removing the matter that makes up traditional still life, eating up every last crumb,

scrubbing any residue from the surface and using every available receptacle. What remains is clean and austere. Arriving at the scene, so much has already been lost; nevertheless, hope endures: it is there in the sturdy pot, the reassuring weight of it, and in the cornflower yellow package too, its promise of sweetness. Whatever deprivations have been suffered, practical or emotional, they can be survived, the scene states, and overcome with even the smallest, plainest pleasures.

When Nina and Edgar returned to London from Paris, unemployed and short of money, they had both turned to Roger Fry for help. Since their inception, Nina had used the Omega Workshops as practice for her decorative work and a steady source of income. The Workshops enabled Nina to live, but they also answered questions about labour that were especially pertinent to women like her. How to survive as an artist without the financial support of a family or husband? How to have a career when your art was less marketable, less desirable to collectors, less likely to be commissioned or to acquire patronage, and remunerated as such? Nina was delighted with the thirty shillings she could earn by working in the studio for three mornings a week, and the relief was extreme: 'I made two or three pounds a week and felt like a millionaire,' she remembered.[32] What that sum meant: little pats of butter in the larder, dinners alone at the Sceptre Chop House on Warwick Street, bottles of wine in paper bags swinging between her and a handsome Italian officer on her way to a party thrown by a rich friend. It was not much, but accustomed now to bare cupboards and tense silences with Edgar, for Nina these luxuries were enough.

She knew she was not necessarily in her element doing decorative work, but, like Virginia – who said she enjoyed Omega because it meant not worrying about her underwear – the anarchic spirit suited Nina; it was never just about income.[33] The Workshops did not enjoy much commercial success, but compensated in the war years by becoming an important centre for meetings, exhibitions and performances of experimental theatre. Vanessa and Duncan had decamped to the countryside, and they were not the only artists who had left or found themselves otherwise occupied during the

war, meaning there were very few employees left available to assist Roger in his work. In February 1916, Nina, Edgar and Dolores Courtney – a friend of Nina's from art school – contributed to an Omega decorative scheme for the private art collector Arthur Ruck. It was during this time that Nina grew close to Roger.

Edgar excelled in his work at Omega but, after two years, having failed to register as a foreign national, he was arrested and sentenced under the Aliens Act to three months' hard labour. Nina was alone again, but relieved: revelling in her freedom and not wanting her husband back, she dreaded the period of his internment coming to an end. She needn't have worried. Edgar was ordered to return to France. Nina accompanied him to Waterloo Station – a ceremonial touch that paid tribute to what they had once briefly shared. She would never see Edgar again, though they remained married until her death.

Nina sold some work and with the proceeds took a studio on the top floor of 18 Fitzroy Street: the autonomy she had enjoyed years ago on Grafton Way looked as if it might be recovered. It is possible to walk between Nina's two Bloomsbury addresses in under five minutes, but the rooms themselves were incomparable, like two different worlds: no. 18 was large, airy, with a separate bedroom and kitchen. The contrast proved transformative: 'I was happier there than I had been for three years.'[34]

She was also only a couple of doors down from Roger Fry. Soon there developed between Roger and Nina, in his words, 'a kind of intimate companionship in little things'.[35] Still stinging from the bitter end of the relationship with Vanessa, Roger was desperate to be loved. The affair with Nina repurposed much of the energy he had been channelling into his former lover and his subsequent heartbreak, and he was soon describing her as 'the most fascinating, exciting, tantalising, elusive, capricious, impulsive, beautiful, exasperating creature in the world'.[36] Nina does not write of their affair in her memoir. Roger is introduced in an impersonal light, as a 'charming man with grey hair', and although she mentions staying with him in the countryside – and her surprise success in a parlour game with the Strachey family – little more is said of him.[37]

Indirect impressions of her life with Roger occasionally emerge
in Nina's work. Alluding to the explosive fights that characterised
her marriage to Edgar, Nina recalled with characteristic candour
how 'we threw saucepans at each other'.[38] The saucepan had been a
weapon, a symbol of deep marital incompatibility, but with Roger
it was part of a shared creative life. Virginia described Roger's studio
on Fitzroy Street: 'rows of dusty medicine bottles stood on the
mantelpiece, and [...] frying pans were mixed with palettes; some
plates held salad, others scrapings of congealed paint'.[39] In Virginia's
interior landscape, the saucepan is shorthand for a domestic
environment in which traditional tasks are always subsidiary to art,
and in which food and paint are equally important as sources of
nourishment. In the denuded kitchen of Nina's still life, the same
principle applies. With Edgar gone, the saucepan acquires a subtle
romantic charge: it symbolises a sturdy and generous love that
could bear the heat of the quotidian; a practical and productive
emotion that was ready to hand, and with so much possible use.
Looking at the saucepan you are looking at the difference between
two men, and two experiences of love. On the one hand violence
and apathy, on the other artistic productivity and mutual passion.

In Roger's celebrated 1917 portrait of Nina, look behind her
signature haircut, and the saucepan reappears – a self-conscious
borrowing Roger made to build a more distinct sense of her
character. An allusion to her status as an artist, it is an assertion
of their equal ground, a refusal of the prescribed role of muse.
The finely detailed hands visualise their skill and further hint at
Nina's vocation. The cushion cover is a flash of bubblegum pink,
reminiscent of the colourful accents in Vanessa's work, inserting
Nina into a female modernist tradition: like the pink Vanessa
uses to adorn her sitters in her 1915 portraits of Bunny and Mary
Hutchinson, the pink collar of her self-portrait in the same year,
and the pink fabric her sister holds in the evocative faceless portrait
of 1912. In Vanessa's work, pink possesses a subversive edge, it is a
prettiness turned in on itself; the pink of organ tissue and muscle,
lewd and uncompromising, it is femininity recast as an incendiary

creative power, which – as Roger appears to recognise – described Nina perhaps even more than Vanessa herself.

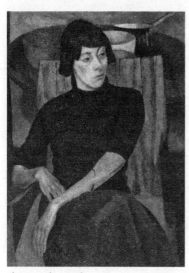

their equal ground

Edgar had been a hindrance, a distraction from Nina's work, and an alienation from the identity most precious to her; through Roger she finally regained that artistic self. There she is, in Roger's portrait, a woman returned to herself, who had spent years only half-conscious, her mind never far from the terrible error she had made in becoming a wife.

A year later, Nina held her first solo show in Cambridge. The press were more complimentary than expected, and she was elated at the sales. Buoyed by a set of stellar references, Walter Sickert and Augustus John amongst them, Nina began teaching the fundamentals of drawing to large classes of young artists at the Westminster Technical Institute, revelling in the authority of the role. It was progress, without question: her career was flourishing; life had begun again.

*

Understanding why the relationship with Roger ended involves looking at two paintings Nina completed between 1917 and 1918: they are portraits of bedsit landladies with revealing still-life details. For Nina, these women were real figures drawn from her own experiences. For Roger, however, who bought one of these works for his own collection, these women were signposts of a way of life he romanticised, and the purchase of the painting neatly illustrates the fantasies of urban lower-middle-class life he cultivated, the realities of which were always kept at arm's length. Roger's neighbouring bedsit on Fitzroy Street is often mentioned in conjunction with Nina's, but given his status and identity – a wealthy, upper-middle-class man with unimaginable quantities of cultural capital – not to mention the opulent country mansion in Surrey he owned, what was shared was merely an address.

The different attitudes Roger and Nina inevitably had towards these scenes reflected a broader mismatching of needs. Marriage had taught Nina that she had no wish to be tied to a single man or a family unit, the loss of autonomy having been ruinous to her art, which in turn had thrown into question the very foundation of her identity. Never having agreed on monogamy with Roger, and judging what it represented as deleterious to her life, Nina continued taking lovers. Roger acknowledged that the terms had never been set, but nevertheless wrote resentfully to Vanessa of his sense of rejection. 'She's incredibly light and easily turned and acts without any reflection,' he complained.[40] Vanessa agreed, and having already made a few poor attempts at hiding her disapproval of Nina – 'I hope she still doesn't think I don't like her,' she commented to Roger the summer before – she was now able to respond to Roger with her own theories on Nina's character.[41] 'I think she is too undependable and evidently the last person to hope for any kind of domestic happiness from, which is what you really want,' she wrote,[42] adding – with an unconvincing aside about her own feelings – 'I don't think Nina (though I really like her) nearly

good enough for you as a character or a mind.'[43] Vanessa comes close to framing Nina's disinterest in marriage or monogamy as a moral failure, but the truth was that Nina wanted a different life, without the assurances of the kind of contentment recommended by those around her, dedicated to a more difficult and hard-won satisfaction, obstinate and alone, and as such it was imagination, self-belief and ambition, rather than any depravity, that was her problem.

Roger continued writing transparently bitter, disturbingly misogynistic critiques of Nina's character for years to come. Untroubled, Nina continued living and working in bedsits, selling and exhibiting work; she wrote two memoirs, the second born out of the enormous popularity of the first. Her evenings remained a source of social excitement and inspiration: she became a local celebrity in the Soho pubs, spending evenings telling raucous stories, circulating an exaggerated oral history of the century in that district in which she cast herself as a central player. Responsive to how her work fed upon the visual pleasures of social encounters, her routine did not differ hugely from those she cultivated as a young woman. Her uncompromising nature meant she lived precisely as she wanted: without boredom, without dependants, without a clear sense of what the future would bring. Much has been made of the squalor Nina lived in for the decades after she and Edgar separated – as though it were impossible such circumstances might be chosen – as well as the mysterious fall from a window that ended her life in 1956 aged sixty-six. The focus is revealing: how quick society is to dismiss women's attempts at independence, and to question their successes; how eagerly it hopes to see women fail.

Vanessa's remark on Nina's unsuitability as a partner says a lot about the promise invested in the domestic at this time, the belief above all else in its show of stable, mature happiness, the achievement of which was the sum total of many people's aspirations, apparently Roger included. Some women, Nina amongst them, remained immune to the seductiveness of the home's apparent guarantees, and having found a different kind of comfort in rented, single-occupancy rooms, failed to develop an interest in the principles that might have led them back to

a socially acceptable life: wealth accumulation, coupledom and reproduction. As a woman, ending up in one of those rooms meant deviance or defeat, but this judgement said more about the fragility of the sustaining illusions of heterosexual family life than it did the validity of the alternative.

Across Nina's work there is a drive to reformulate these ideas about space, self and social attachment. A different kind of woman, unattached and unneeded, enters the frame: a woman who renounces nothing that gives her pleasure. What the landlady paintings show is how an attention to alternative domestic space might complicate and elevate the lives of women too readily branded as failures. The once unredeemable become aspirational. In these works, the women are sitting at tables in the boarding house common area, the objects that surround them far more expressive than their bland, implacable demeanours. In one, a lamp fills the right side of the frame as if it were a partner to the woman sitting down, facing the viewer with the same blank stare; behind lies a telescope, a baroque detail confirmed by Nina's account of the work. In the other, a woman wears her scarf indoors and gazes out from a table laden with fruit. Alluding to illumination and vision, intellectual enquiry and the discovery of new worlds, sweetness and affluence, and strategies for survival, the objects communicate Nina's admiration of her sitters, and create new measures of value – such as imagination, intelligence and grit – entirely distinct from portraiture's traditional criterion: wealth. Borrowing from Cubist portraiture, Nina painted her sitters with a monumental stillness, as though they were carved from wood or rock; they look capable of enduring any weather, any encounter, immune to the elements.

What the landladies and their animated surroundings reveal is the fullness of lives considered empty in the absence of a husband and children, as well as the virtuosity, skill and resilience required to construct a different kind of life within a world beholden to patriarchal social arrangements. To Nina, these women were domestic pioneers, spinster matriarchs presiding with great dignity over their unconventional, solitary and transient kingdoms. In the boarding house, few were interested in inheritance, longevity or

security, and these works celebrate the creation of environments in which those aversions became their own resource for happiness. For decades to come these women were Nina's guiding stars. Nina learnt their resourcefulness, the defiant, creative subsistence these paintings so proudly unveil. She never stopped following their blazing trail; she rented rooms alone until her death.

domestic pioneers

HELEN

Helen Coombe is rarely allowed more than a sentence in accounts of the Bloomsbury Group: known solely as its patriarch's enigmatic wife, the woman who married Roger Fry in 1896 and in subsequent years almost wholly disappeared. There she is, in one of the few surviving photos of the couple: set delicately against a wall, her face inscrutable, all of her small and brittle next to a man smiling rakishly at the camera. Discomfort radiates out of her. 'It is as though all trace of her had been lost,' a friend of Helen's remarked.[1]

An ambition. An ability. An enchantment. An aberration. A burden. A hopelessness. A distant memory.

Helen entered the Royal Academy Schools as a painter in 1883, and while many women struggled, their home educations inadequately preparing them for the challenges of art school, Helen did not. She excelled, won prizes. Her motivations were bigger and more political than most. She successfully campaigned for a woman's right to draw from partially draped figures.

Helen was penniless when she met Roger and considered a bad match by his family. No matter, he was besotted. 'I fell completely in love with her in one afternoon's talk,' Roger later confessed to his lover, Helen Anrep. Roger declared Helen Coombe's work brilliant, animated by 'delicacy and strength and impressiveness'.[2] Real passion brought them together. She bore him two children. They remained married until his death in 1934.

Helen pushes in faintly from the edges of Roger Fry's archive. There exists a collection of letters sent jointly with Roger, full of practical family matters, and one letter alone in her own hand. Sent to her young son, it is a note of assurance and thanks, signed not Helen but 'Mummy'.[3]

A sketchbook from early in their marriage sees Roger drawing Helen in profile; turn the page and she is there again, her head bowed; after that Roger observes sheep, landscapes, a cathedral, a woman in an 1890s shawl and hat, and ducks.[4] Through every other sketchbook, the hope of seeing her remained: maybe her torso this time, the other side of her face, a smile – but no luck. The elegant pocket diaries in yellow and blue that Roger filled with book recommendations, addresses and notes are entirely focused on a world of art and sociality in which Helen appears not to exist. Her silhouette in red chalk was all I had.

Helen was unusually skilled across mediums, working on canvas and in decorative schemes. Her only surviving painting is a meticulous, impressive copy of a work by Bellini. Mary gazes out, the miraculous baby in her arms, flanked by Saint John and an angel. Mary is the familiar mournful matriarch, the blue veil she wears encasing her in the very stuff of self-sacrifice. In this work Mary's sorrow is borrowed, darkly charged with private feeling: after the birth of her children, Helen drifted into depression. Even with servants her routine rarely yielded free afternoons to paint, as she managed the household and generally maintained appearances while Roger travelled for work. Life shrank to a set of rooms. The same formal exchanges with staff, unread novels piled before her in the drawing room, headaches as the night drew in, a suffocating dread at dawn. John is a saint of record, of bearing witness, but there would be nobody to recount what Helen endured during those years.

Helen was 'not made happy by marriage', according to a friend, who visited her a few years after the wedding and found her 'battered and dissipated'.[5] The adaptations that were demanded of her, to her aspirations, routines and identity – always wavering between Helen and Mummy – were too much. All her bargaining failed, and there

were few options for women like that: broken, unwilling, unseemly in her refusals. Confined to an institution in 1910, Helen remained there until the end of her life.

The diagnosis was vague, as for many women of her generation who struggled to have their problems precisely named by a predominantly male medical establishment: now thought by some to be schizophrenia, it was categorised then as melancholia and nerves. Seeing Roger often made Helen more angry and unstable, a symptom Virginia Woolf had also experienced on seeing Leonard during her first breakdown. Their moods distressed their husbands, but they were not without cause. After decades of fear and avoidance, desire and the illusion of choice, the women were undone by rage at the defeat their marriages represented.

In Roger's archive the most revealing document is one of Helen's short stories from the late 1890s, a unique testament to her literary ambitions. The story offers a warning on the deathliness of bourgeois life. She describes 'a dreary monotonous street, evidently of the suburbs', then lingers over the more abject details: 'the once white lace curtains', 'the grinning stucco head over each doorway', and the sheer number of houses, multiplying 'interminably on into the hundreds', all of it bathed in a 'steady drizzle'.[6] The street's inhabitants are observed attempting to reckon with this atmosphere of frayed virtue and threat. A young girl watches with curiosity as a dishevelled man stumbles towards her, down a street so circumscribed by a middle-class gentility that it is literally unable to contain the stranger's presence: he quickly falls and rolls 'heavily into the gutter'. When nobody else assists, the girl goes out to help, and her mother watches from the house, horrified that her daughter is hatless – fearing her neighbours' judgement – certain that she will spoil her clean pinafore. Embodying the callousness and hypocrisy of her class, the mother remains a figure of pity nonetheless; she is sad, lonely, vulnerable and alienated. Her silk dress, limp and black and inexpensive, conveys that, as too do 'her minor worries, her ceaseless little cares' that dog her as she paces the house. 'Hers was a life absolutely without a history,' wrote Helen, 'naked she had come into the world, and so far as the world's

interest was concerned so she would leave it.' Mounting a critique of the social world Helen hoped one day to leave for ever, the story also unwittingly foretells its author's own dire fate: a woman left in the drawing room, waiting for her husband to return; a woman the world ceased to see; merely a silhouette, a woman who slipped clean out of history.

In an exhibition catalogue, happened across by chance, her work emerged colourless and condensed in a pair of standard entries:

Helen Fry, *Robert Trevelyan*, undated, pastel and watercolour, 19 x 14 ¼

Helen Fry, *Florence from Fiesole*, c.1896, oil on board, 9 ¼ x 12 ¾

(No reproductions.)

What else? In 1896 Helen contributed to the decorative scheme of a Dolmetsch green harpsichord, work which was considered exceptional, and is now held at the Horniman Museum. (Not currently on display.)

'A mind of singular distinction,' the art historian Tancred Borenius wrote of her in 1940, she produced work that was 'akin to Manet in his late phase'.[7] 'One of the truly great "might have beens" of English art', he claimed.[8]

Following the publication of Virginia Woolf's biography of Roger, Dr Mary Louisa Gordon wrote to her criticising her representation of Helen. She and Helen had once been close, and Mary cannot stress enough the injustice of the rendering of her friend, how poorly Virginia understood her. Mary was now elderly, but her vision of Helen was vivid: the pair of them talking through the minutiae of life over coffees, conspiring over the rejection of suitors. 'She is only the pitiful nebulous ghost,' Mary insisted. 'I wished your book could have said something about the courageous charming young Helen of those days, so eager to live and learn, so full of ideas, the most promising open minded of women.' Mary went on, 'she opened windows – and round her was always clean air.'[9]

'Akin to Manet in his late phase.'[10]

As he grew older, Édouard Manet painted a number of small still lifes – hams, asparagus, fish, oysters, brioche – most done in the last years of his life when illness limited his mobility. In the absence

of more work by Helen, there is a thrill in claiming Manet's work as her own, a change in attribution that feels nothing less than an essential meting out of justice. It would mean replacing countless labels on gallery walls, apologising for decades of error: these works can no longer be said to belong to Manet; their true creator has at last been discovered.

One work in particular. *The Lemon* is no longer an 1880 painting by Manet. A lemon is placed on a tarnished silver dish, chosen for its heft and shine. The table is swept clean, the room beyond is bare, unimportant. Helen's hands working over her easel. Light filling her studio. Yellow paint under her fingernails. Specks of silver on her smock. The form materialising bit by bit before her, the colours following her through the night: dreams washed in butter, gold, chrome. Moving past the peel and the pith to the flesh, until the lemon's bitter taste fills her mouth. Nothing else on her mind but this. Showing it to Roger. Not showing it to Roger. Keeping it as a private message of hope for herself, a reminder of her talent. Helen Coombe, *The Lemon*, 1910. Oil on canvas, 140 x 220mm.

Notes

Abbreviations

AJ	Augustus John
BL	British Library, London
BO	Bodleian Libraries, University of Oxford: Archive of Winifred Gill
CB	Clive Bell
CT	Charleston Trust Archives, Lewes, East Sussex
DC	Dora Carrington
DG	Duncan Grant
ES	Ethel Sands
G	Gluck
GA	Gluck Archive, London
GB	Gerald Brenan
GJ	Gwen John
HR/DC	Harry Ransom Center, University of Texas, Austin: Dora Carrington Collection 1912–1965
HR/GB	Harry Ransom Center, University of Texas, Austin: Gerald Brenan Collection 1911–1978
IJ	Ida John
JMK	John Maynard Keynes
KC	King's College Archives, Cambridge University
LS	Lytton Strachey
MCL	Mary Constance Lloyd
MG	Mark Gertler

NC	Noel Carrington
NH	Nan Hudson
NLW	National Library of Wales, Aberystwyth
NO	Nesta Obermer
RF	Roger Fry
TA	Tate Archives, London
UT	Ursula Tyrwhitt
VB	Vanessa Bell
VD	Violet Dickinson
VW	Virginia Woolf
WG	Winifred Gill

INTRODUCTION

1 VW to Nick Bagenal, *Collected Letters* Vol. 1, 15 April 1918, (London: Harcourt Brace, 1975) p. 230.

2 Richard Davenport-Hines, *Universal Man: The Seven Lives of John Maynard Keynes* (London: William Collins, 2015) p. 266.

3 Zachary D. Carter, *The Price of Peace: Money, Democracy and the Life of John Maynard Keynes* (New York: Random House, 2020) p. x.

4 JMK to VB, 23 March 1918, KC, CHA1/341/3/1.

5 Virginia Woolf, ed. Anne Olivier Bell, *Diaries*, 18 April 1918 (London: Penguin, 1979) p. 140.

6 Eve Kosofsky Sedgwick, 'Queer and Now', in *Tendencies* (Durham, NC: Duke University Press, 1993).

7 Virginia Woolf, 'Professions for Women', in Woolf, ed. David Bradshaw, *Selected Essays* (Oxford: Oxford World's Classics, 2009) pp. 144–5.

8 Selina Todd, *Young women, work and family in England*, (Oxford: Oxford University Press, 2005) p. 6.

9 Virginia Woolf, *To the Lighthouse,* (Oxford: Oxford World's Classics, 2008) p. 42.

10 Ibid.

11 CT.

12 Jack Halberstam, *In a Queer Time and Place: Transgender Bodies, Subcultural Lives* (New York, NYU Press, 2005), pp. 13–14.

13 José Esteban Muñoz, *Cruising Utopia : The Then and There of Queer Futurity,* (New York: NYU Press, 2009) p. 65.

14 Eve Kosofsky Sedgwick, 'Queer and Now', in *Tendencies*, pp. 144–5.

I. CARRINGTON

1 Virginia Woolf, *Diaries*, 18 March 1918, p. 128.

2 'And I went on amateurishly to sketch a plan of the soul so that in each of us two powers preside, one male, one female; and in the man's brain, the man predominates over the woman, and in the woman's brain, the woman predominates over the man.' Virginia Woolf, *A Room of One's Own*, (London: Penguin Modern Classics, 2020)

3 VW to DC, *Collected Letters*, Vol. 1, Christmas Day 1922, (London: Harcourt Brace, 1975) p. 596.

4 KC, CHA1/59/4/6, VBRF 158, VB to RF, 1914.

5 Lady Ottoline Morrell, ed. Robert Gathorne-Hardy, *Memoirs of Lady Ottoline Morrell, 1915–1918*, (London: Faber & Faber, 1963). p. 52.

6 Ibid.

7 John Woodeson, *Mark Gertler: Biography of a Painter, 1891–1939*, (London: Sidgwick and Jackson, 1972) p. 88.

8 Nina Hamnett, *Laughing Torso*, 1932, (London: Constable & Co Ltd), p. 36.

9 Carrington's early diaries are now lost. Quoted in David Garnett, *Carrington: Letters and Extracts from her Diaries*, 13 April 1917, (London: Jonathan Cape Ltd, 1970) p. 63.

10 Michael Holroyd, *Lytton Strachey: The New Biography*, (London: Pimlico, 2011) p. 407.

11 BL, MS62888, DC to LS, 13 June 1916.

12 Garnett, *Carrington: Letters and Extracts from her Diaries*, 1971, p. 1.

13 BL, MS62890, DC to LS, 21 June 1920.

14 HR/GB, Box 14 Folder 5, DC to GB, 9 February 1928.

15 HR/GB, Box 13, Folder 3, 18 January 1925.

16 Rachel Cooke, *Carrington's Letters* Review, *Guardian*, 17 December 2017.

17 HR/DC, Box 1 Folder 7, DC to MG, April 1915.

18 Virginia Woolf, 'Mr Bennet and Mrs Brown', 1924, in *Selected Essays*, p. 121.

19 Virginia Woolf begins using this nickname in letters and diaries from around 1918.

20 Nancy Cunard, 'To the E. T. Restaurant', quoted in Lois Gordon, *Nancy Cunard: Heiress, Muse, Political Idealist* (New York: Columbia University Press, 2007) p. 29.

21 HR/DC, Box 1 Folder 2, DC to NC, undated, 1917.

22 Morrell, *Memoirs*, p. 49.

23 TA, TGA 797/2/30, DC to John Nash, 2 August 1913.

24 HR/DC, Box 1 Folder 7, DC to MG, July 1919.

25 Michelle Rheeston and Charlotte Wytema, *Painting Pairs: Art History and Technical Study 2017–2018*, attributed to Dora Carrington, *Standing Female Nude/Landscape with Mountain Bridge*, c.1910 (London: Courtauld Gallery), p. 12.

26 VB to Angelica Garnett, 18 October 1950, ed. Regina Marler *Selected Letters* (London: Bloomsbury, 1994), p.529.

27 HR/DC, Box 1 Folder 7, DC to MG, September 1916.

28 HR/GB, Box 14 Folder 4, DC to GB, May 1927.

29 BL, MS 62889, DC to LS, 21 January 1918.

30 Morrell, *Memoirs*, p. 207.

31 BL, MS62888, DC to LS, 8 September 1916.

32 HR/DC, Box 1 Folder 6, DC to MG, undated.

33 HR/GB, Box 10 Folder 4, DC to GB, 12 January 1920.

34 HR/GB, Box 10 Folder 5, DC to GB, 6 October 1920.

35 HR/DC, Box 1 Folder 2, DC to NC, undated, 1917.

36 HR/DC, Box 1 Folder 7, DC to MG, 21 September 1917.

37 DC to Christine Kühlenthal, December 1915, in Anne Chisholm (ed.), *Carrington's Letters: Her Art, Her Loves, Her Friendship* (London: Chatto & Windus, 2017) p. 25.

38 Ibid.

39 HR/DC, Box 1 Folder 7, DC to MG, December 1915.

40 Quoted from Garnett, *Carrington: Letters and Extracts from her Diaries*, p. 64.

41 Ibid.

42 VW to VB, 17 January 1918, *Collected Letters*, p. 212.

43 HR/DC, Box 1 Folder 7, DC to MG, May 1915.

44 Ibid.

45 BL, MS 62888, DC to LS, 13 June 1916.

46 HR/GB, Box 10 Folder 4, DC to GB, 23 May 1920.

47 Simone de Beauvoir, *The Second Sex* (London: Vintage Classics, 2007), p. 19.

48 HR/GB, Box 10 Folder 5, DC to GB, end of October 1920.

49 BL, MS62888, DC to LS, 10 August 1917.

50 BL, MS 6289, DC to LS, 9 September 1919.

51 BL, MS62889, DC to LS, undated.

52 Virginia Woolf, *Diaries*, Vol. 1, 12 December 1917, p. 89.

53 Ibid., Vol. 3, 5 September 1926, p. 108.

54 HR/DC, Box 1 Folder 4, DC to NC, 15 July 1921.

55 BL, MS 62888, DC to LS, 20 October 1917.

56 BL, MS 62888, DC to LS, 7 December 1917.

57 HR/GB, Box 10 Folder 5, DC to GB, 6 October 1920.

58 KC, CHA/1/114 (D/8/4) DC to VB, undated.

59 BL, MS 62889, DC to LS, undated (1919).

60 HR/GB, Box 12 Folder 1, DC to GB, January 1924.

61 HR/GB, Box 10 Folder 6, DC to GB, 20 May 1921.

62 HR/GB, Box 11 Folder 2, DC to GB, 20 December 1922.

63 HR/GB, Box 10 Folder 6, DC to GB, 20 May 1921.

64 Eve Kosofsky Sedgwick, *A Dialogue on Love* (New York: Beacon Press, 2000), p. 72.

65 HR/GB, Box 10 Folder 6, DC to GB, 20 May 1921.

66 HR/GB, Box 12 Folder 5, DC to GB, 14 August 1924.

67 BL, MS 62889, DC to LS, 10 June 1918.

68 Virginia Woolf, *Diaries*, Vol.1, 5 January 1918, p.100.

69 HR/GB, Box 13 Folder 4, DC to GB, 27 April 1925.

70 HR/GB, Box 12, Folder 3, DC to GB, 13 April 1924.

71 For accounts of women and botany in the Victorian period, and how plants acquired meanings both sexual and racial, see: Jane Desmarais, *Monsters under Glass: A Cultural History of Hothouse Flowers from 1850 to the Present* (London: Reaktion, 2018); Elizabeth Hyde, *Cultivated Power: Flowers, Culture, and Politics in the Reign of Louis XIV* (Philadelphia: Penn Press, 2005); Ann B. Shteir, *Cultivating Women, Cultivating Science: Flora's Daughters and Botany in England, 1760–1860* (Baltimore: The John Hopkins Press,1999); Ann B. Shteir and Bernard V. Lightman, eds, *Figuring it Out: Science, Gender, and Visual Culture* (New Hampshire: Dartmouth College Press, 2006); Andreas Stynen, '"Une mode charmante": nineteenth-century indoor gardening between nature and artifice', *Studies in the History of Gardens & Designed Landscapes*, Vol. 29, No. 3, 2009, pp. 217–34; Caroline Jackson-Houlston, ' "Queen Lilies"? The Interpenetration of Scientific, Religious and Gender Discourses in Victorian Representations of Plants', *Journal of Victorian Culture*, Vol. 11, No. 1, Spring 2006, pp. 84–110.

72 HR/DC, Box 1 Folder 9, DC to MG, January 1919.

73 HR/GB, Box 10 Folder 4, DC to GB, April 1920.

74 Ibid.

75 BL, MS 62890, DC to LS, 11 May 1919.

76 BL, MS 62890, DC to LS, 14 July 1919.

77 BL, MS 62890, DC to LS, 9 June 1919.

78 Ibid.

79 HR/DC, Box 1 Folder 4, DC to NC, 10 October 1922.

80 BL, MS 62891, DC to LS, 13 February 1920.

81 HR/GB, Box 10 Folder 5, DC to GB, 30 September 1920.

82 Ibid.

83 BL, MS62893, DC to LS, 9 September 1922.

84 HR/GB, Box 10 Folder 4, DC to GB, 5 May 1920.

85 HR/GB, DC to GB, Box 10 Folder 6, 20 May 1921.

86 VW to VB, 22 May 1921, *Letters*, Vol. 2, p. 470.

87 BL, MS62892, DC to LS, 14 May 1921.

88 Ibid.

89 Ibid.

90 BL, MS62892, LS to DC, 20 May 1921.

91 BL, MS 62892, DC to LS, 19 May 1921.

92 BL, MS62892, DC to LS, 8 May 1921.

93 Virginia Woolf, *Diaries*, 23 May 1921, p. 119.

94 HR/GB, Box 11 Folder 3, March 1923.

95 HR/GB, Box 11 Folder 2, DC to GB, 5 June 1922.

96 HR/GB, Box 10 Folder 5, DC to GB, end of October 1920.

97 HR/GB, Box 13 Folder 13, DC to GB, 30 January 1925.

98 BL, MS62893, DC to LS, 6 November 1922.

99 BL, MS62893, DC to LS, 25 September 1922.

100 BL, MS62893, DC to LS, 23 June 1922. Discusses the 'baby remedy' for her and Ralph's ailing relationship.

101 HR/GB, Box 10 Folder 4, DC to GB, 15 December 1919.

102 HR/GB, Box 11 Folder 1,14 March 1922.

103 HR/GB, Box 11 Folder 3, DC to GB, 14 January 1923.

104 HR/DC, Box 1 Folder 3, DC to NC, 12 December 1919.

105 Frances Marshall, *Love in Bloomsbury* (London: I.B. Tauris, 2014), Location 1375 (Kindle Edition).

106 HR/GB, Box 11 Folder 4, 20 November 1923.

107 HR/GB, Box 13 Folder 6, 20 July 1925.

108 HR/GB, Box 12 Folder 1, DC to GB, 13 January 1924.

109 HR/GB, Box 13 Folder 3, DC to GB, 23 February 1925.

110 HR/GB, Box 14 Folder 5, DC to GB, 6 March 1932.

111 In the recent edition of Carrington's letters, Anne Chisholm offers her own reading of the flower and its presence in the archive. As it was 'impossible that a snowdrop picked in March 1932 could possibly be intact and folded into a letter in a library in Texas eighty years later,' Chisholm writes, 'the sensible explanation must be that someone working on Carrington's life and death quietly left it there as a tribute.' Perhaps Chisholm is right. However, throughout the time I spent researching this book I was surprised not only at the hardiness of similar organic matter, but also at the very fact of its presence in the archive at all. At the TA, there are feathers and chains of flowers pressed between the pages of Edna Waugh's sketchbooks, and these date from the early 1900s. In the Gluck Archive, there are leaves and flowers torn from the ground and left loose in notebooks and folders, and all without the controlled conditions associated with institutional archives. While acknowledging Chisholm's scepticism, I decided to imagine an eventuality in which the snowdrop was an original part of the letter.

112 BL, MS62892, DC to LS, 14 May 1921 (inscribed 3 o'clock Saturday, so written the following morning).

113 Virginia Woolf, *Diaries*, Vol. 4, 17 March 1932, p. 83.

114 BL, MS 65159, DC, diary and commonplace book.

115 Ibid.

116 HR/GB, Box 13 Folder 4, DC to GB, 19 March 1925.

117 Virginia Woolf, *Diaries*, Vol. 4, 12 March 1932, p. 82.

118 HR/GB, Box 14 Folder 5, DC to GB, 6 March 1932.

119 Virginia Woolf, *Diaries*, Vol. 4, 12 March 1932, p. 81.

120 HR/GB, Box 10 Folder 6, DC to GB, 8 June 1921.

121 HR/GB, Box 11 Folder 3, DC to GB, 1 June 1923.

122 HR/GB, Box 13 Folder 6, DC to GB, 21 July 1925.

123 BL, MS 65158, DC to Alix Strachey, winter 1924.

124 HR/GB, Box 12 Folder 4, DC to GB, 13 June 1924.

125 Ibid.

126 Ibid.

127 BL MS62894, DC to LS, 7 December 1924.

128 HR/GB, Box 13 Folder 6, 21 July 1925.

129 HR/GB, Box 10 Folder 7, DC to GB, 9 August 1921.

130 HR/GB, Box 10 Folder 5, DC to GB, October 1920.
131 HR/GB, Box 1 Folder 9, DC to MG, 3 January 1919.

2. EDNA

1 TA, TGA 8226, Edna Clarke Hall, Ten boxes of sketches, sketchbooks, poetry, photographs and miscellaneous writings created by Edna Clarke Hall between *c*.1894 and *c*.1979.

2 Max Browne, 'Edna Clarke Hall (1879–1979) and *Wuthering Heights*', *British Art Journal*, Vol. 16, No. 2, 2015, p. 108.

3 Rebecca John and Michael Holroyd (eds), *The Good Bohemian: Letters of Ida John*, Ida John to Edna Waugh, Friday, 17 April 1896 (London: Bloomsbury, 2017) p. 38.

4 NLW, MS 22307C, IJ to GJ, August 1904.

5 Undated letter from Edna Waugh to Michel Salaman, quoted in Alison Thomas, *Portraits of Women: Gwen John and her Forgotten Contemporaries* (London: Polity Press, 1994), p. 57.

6 NLW, NLWMS21468D, GJ to UT, 4 February 1910.

7 Browne, 'Edna Clarke Hall', p. 108.

8 Audre Lorde, 'Uses of the Erotic: The Erotic as Power', in *Your Silence Will Not Protect You* (London: Silver Press, 2017).

3. ETHEL

1 TA, TGA 9125, Papers of Ethel Sands.

2 TA, 9125.1.5.6, ES to NH.

3 TA, ES to NH, 9125.1.6.1.

4 TA, ES to NH, 9125.1.10.10.

5 TA, ES to NH, 9125.5.3.

6 TA, ES to NH, 9125.1.6.3.

7 TA, ES to NH, 9125.1.6.2.

8 C. Derry, 2018, 'Lesbianism and Feminist Legislation in 1921: the Age of Consent and "Gross Indecency between Women"', *History Workshop Journal*, Vol. 86, No. 1, pp. 245–67.

9 Vita Sackville-West, *The Edwardians*, (London: Vintage, 2017), p. 137.

10 KC, CHA/1/59/4/2, VB to RF, August 1912.

11 TA, ES to NH, 9125.1.6.7.

12 TA, ES to NH, 9125.1.7.7.

13 TA, ES to NH, 9125.1.9.6.

14 TA, ES to NH, 9125.1.8.10.

15 TA, ES to NH, 9125.1.7.1.

16 TA, ES to NH, 9125.1.8.1.

17 Laura Doan, *Fashioning Sapphism: The Origins of a Modern English Lesbian Culture* (New York: Columbia University Press, 2001), p. xi.

18 Heather Love, *Feeling Backward* (London: Harvard University Press, 2007), p. 6.

19 Virginia Woolf, *Diaries*, Vol. 3, 8 August 1927, pp. 150–1.

20 Ibid.

21 Ibid., Vol. 4, 3 January 1933, p. 139.

22 Ibid., Vol. 2, 19 February 1923, p. 235.

23 Virginia Woolf, *Letters*, Vol. 3, VW to Vita Sackville-West, 3 August 1927, p. 407.

24 Ibid.

25 Quoted in Wendy Baron, *Miss Ethel Sands and Her Circle* (London: Owen, 1977), p. 258.

26 Virginia Woolf, *Diaries*, Vol. 3, 20 September 1927, p. 157.

27 Virginia Woolf, 'The Lady in the Looking Glass', in *The Complete Shorter Fiction*, (Boston: Houghton Mifflin Harcourt, 1989) pp. 221–5.

28 Michael Holroyd, *Lytton Strachey: The New Biography*, (London: Pimlico, 2011) p. 279.

29 Toni Bentley, *Sisters of Salome*, (New Haven: Yale University Press, 2002) p. 49.

30 See TA, TGA 9125/5, Letters from Walter Sickert to NH and ES.

31 'The plastic arts are gross arts, dealing joyously with gross material facts. They call, in their servants, for a robust stomach and a great power of endurance, and while they will flourish in the scullery, or on the dunghill, they fade at a breath from the drawing-room': Walter Richard Sickert, 'Idealism', in *The Art News*, 12 May 1910, p. 217, quoted in Helena Bonett, Ysanne Holt and Jennifer Mundy (eds), *The Camden Town Group in Context*, Tate Research Publication, May 2012, https://www.tate.org.uk/art/research-publications/camden-town-group/walter-richard-sickert-idealism-r1104279, accessed 23 April 2020.

32 TA, TGA 9125/5, Walter Sickert to NH, undated, summer 1907.

4. MARY

1 Virginia Woolf, *Letters*, VW to VB, 22 May 1921, p. 470.

2 KC, CHA/1/369, MCL to DG.

3 NLW, NLWMS22308D, MCL to GJ, undated (1906–1930).

4 NLW, NLWMS21468D, GJ to UT, 28 November 1910. Gwen was hoping Ursula would take Mary's flat in her absence.

5 NLW, NLWMS21468D, GJ to UT, 28 November 1910.

6 KC, CHA/1/369, MCL to DG.

7 NLW, NLW MS 22300 B, GJ to MCL, draft letter, c.1920–30.

8 Ibid.

9 KC, CHA/1/369, MCL to DG.

10 Ibid.

11 Ibid.

12 NLW, NLW MS 22300 B, GJ to MCL, draft letter, c.1920–30.

13 KC, CHA/1/369, MCL to DG.

14 Ibid.

15 Ibid.

16 Ibid.

17 NLW, NLW MS 22782D, IJ to AJ, December 1906.

5. GLUCK

1 GA.

2 Jack Halberstam, *Female Masculinity* (Durham: Duke University Press, 1998), p. 88.

3 I am paraphrasing an explanation provided by Juliet Jacques in her discussion of Claude Cahun in the podcast *Bow Down: Women in Art History*, Frieze, Episode 4. I am grateful to her for clarifying the impossible decision of what pronoun to use.

4 I am grateful to Jack Halberstam for inspiring this reading. 'What of a biological female who presents as butch, passes as male in some circumstances and reads as butch in others, and considers herself not to be a woman but maintains distance from the category "man"?' Halberstam writes in *Female Masculinity* (Durham, NC: Duke University Press, 1998) 'For such a subject, identity might best be described as process with multiple sites for becoming and being.'

5 Gluck to her brother, undated (1918), quoted in Diana Souhami, *Gluck: Her Biography* (London: Quercus Press, 2013), p. 43.

6 Ibid.

7 Francesca Gluckstein to Louis Gluckstein, 8 December 1917, quoted in Souhami, *Gluck*, p. 59.

8 Roland Barthes, *Roland Barthes*, (London: Vintage, 2020) p. 46.

9 Constance Spry, *Flower Decoration*, quoted in Sue Shepheard, *The Surprising Life of Constance Spry* (London: Pan Books, 2011), p. 151.

10 G to her brother, undated (1918), quoted in Souhami, *Gluck*, p. 43.

11 BL, 7861: 'Recent Paintings by Vanessa Bell, with foreword by Virginia Woolf', 4 February to 8 March 1930, p. 26.

12 GA, G to NO, undated (1936).

13 Virginia Woolf, 'Walter Sickert: A Conversation', in *Collected Essays*, Vol. 6 (London: Chatto & Windus, 2000)

14 GA, 'Sketch of an Arrowhead'.

15 Shepheard, *The Surprising Life of Constance Spry*, p. 153.

16 Quoted in Souhami, *Gluck*, p. 167.

17 GA, G to NO, October 1936.

18 GA, G to NO, September 1936.

19 GA, G to NO, October 1936.

20 Ibid.

21 Ibid.

22 Ibid.

23 Ibid.

24 Ibid.

25 GA, G to NO, September 1937.

26 GA, G to NO, October 1936.

27 Ibid.

28 Ibid.

29 Ibid.

30 GA, G letters to NO, 1937.

6. WINIFRED

1 BO: Winifred Gill: Diaries, MS 6241, A.2.

2 VW to RF, September 1911, *Collected Letters*, Vol. 1, p. 477.

3 BO: MS 6241/38, Folder 1, WG to DG.

4 BO: MS 6241/38, Folder 4. WG to Quentin Bell, 15 April 1967.

5 BO: MS 6241/38, Folder 1, WG to DG.

6 BO: MS 6241/38, Folder 4, WG to Quentin Bell, 6 May 1967.

7 BO: MS 6241/38, Folder 4, WG to Quentin Bell, 6 May 1967.

8 BO: MSS 6241/37, Folder 1.

9 BO: MS 6241/37, Folder 2, RF to WG, 3 June 1915.

10 BO: MS 6241/38, Folder 1, WG to DG.

11 BO: Winifred Gill: Diaries, MS 6241, A.2

12 BO: MS 6241/38, Folder 4, WG to Quentin Bell, 15 April 1967.

13 VW, *Diaries*, 7 January 1915, p. 11.

7. VANESSA

1 The critic Keith Roberts, quoted in Grace Brockington, 'A "Lavender Talent", or "The Most Important Woman Painter in Europe"? Reassessing Vanessa Bell', *Art History*, Vol. 36, No. 1, pp. 128–53.

2 Mark Hudson, 'Atmospheric insights into a world of privileged bohemianism', *Daily Telegraph*, 8 February 2017, online: https://www.telegraph.co.uk/art/what-to-see/atmospheric-bohemianism-vanessa-bell-dulwich-picture-gallery/ telegraph review

3 VW to VB, *Collected Letters*, Vol. 2, 27 October 1919, p. 393.

4 Vanessa Bell, *Sketches in Pen And Ink: A Bloomsbury Notebook*, (London: Pimlico, 1997), p. 67.

5 Sara Ahmed, *The Promise of Happiness*, (Durham, NC: Duke University Press, 2010) p. 46.

6 Bell, *Sketches*, p. 99.

7 VW to VD, *Collected Letters*, Vol. 1, 18 June 1905, p. 192.

8 VW to VD, *Collected Letters*, Vol. 1, 16 January 1906, p. 217

9 Bell, *Sketches*, p. 101.

10 Virginia Woolf, *Moments of Being: Unpublished Autobiographical Writings*, (London: Pimlico, 2002) p. 104.

11 KC, CHA/1/59/5/1, VB to JMK, 1914.

12 Virginia Woolf to Katherine Cox, *Collected Letters*, Vol 1, 4 September 1912, p. 6.

13 Frances Spalding, *Vanessa Bell* (London: Tauris Park, 1983), p. 66.

14 TA, TGA 20078/1/44/2, VB to DG, 1910.

15 Woolf, *Moments of Being*, p. 213.

16 VW to VD, *Collected Letters*, Vol. 1, early January 1905, p. 174.

17 KC, CHA/1/59/1/1, VB to Clive Bell, 31 July 1906.

18 VW to VD, *Collected Letters*, Vol. 1, 23 December 1906, p. 271.

19 CT.

20 KC, CHA/1/59/1, VB to Clive Bell, 31 July 1906.

21 VW to MV, *Collected Letters*, Vol. 1, 2 April 1907, p. 290.

22 Bell, *Sketches*, p. 107.

23 VW to MV, *Collected Letters*, Vol. 1, 2 April 1907, p. 291.

24 VW to VD, *Collected Letters*, Vol. 1, 12 April 1907, p. 291.

25 Vanessa recalls her dislike of Rembrandt in *Sketches*, p. 81. From Duncan Grant's correspondence with Mary Constance Lloyd from the early 1900s (KC, CHA/1/369) it seems he had the opposite view.

26 CT.

27 VW to VD, 28 December 1906, *Collected Letters*, p. 272.

28 KC, CHA1/59/4/8, VB to RF, July 1916.

29 For this line of enquiry, I am grateful to Anne Boyer, who asks these same questions of the food in the poetry of Gertrude Stein in *Garments Against Women* (London: Penguin, 2015)

30 Quoted in Tate Gallery label, available online: https://www.tate.org.uk/art/artworks/bell-mrs-st-john-hutchinson-t01768.

31 KC, CHA/1/59/1/2, VB to Clive Bell, *c.* 1910.

32 KC, CHA/1/59/9, VB to Madge Vaughan, 10 March 1920.

33 TA, TGA 20078/1/44/22, VB to DG, 25 March 1914.

34 Shulamith Firestone, *The Dialectics of Sex: The Case for Feminist Revolution*, (New York: Farrar Straus & Giroux, 2003 [1970]).

35 VB to VW, *Selected Letters*.

36 Ibid.

37 TA, TGA 20078/1/44/19, VB to DG, 17 February 1914.

38 Bridget Elliott and Jo-Ann Wallace, *Women Artists and Writers: Modernist (Im)positionings* (London: Routledge, 1994), p. 67.

39 KC, CHA1/59/4/5, VB to RF, 1912.

40 Sarah Knights, *Bloomsbury's Outsider: A Life of David Garnett*, (London: Bloomsbury, 2015) p. 81.

41 Spalding, *Vanessa Bell*, p. 135.

42 KC, CHA1/59/4/7, VB to RF, 2 May 1915.

43 TA, TGA 20078/1/44/75, VB to DG, 22 September 1918.

44 Griselda Pollock, 'Woman as Sign', in *Vision and Difference* (London: Routledge, 2003), p. 169.

45 KC, CHA/1/59/5/8, VB to RF, October 1916 (VBRF209).

46 TA, TGA 20078/1/44/66 and TGA 20078/1/44/67, VB to DG, *c.*1917.

47 Virginia Woolf, *Diaries*, Vol. 1, 16 August 1918, p. 182.

48 Spalding, *Vanessa Bell*, p. 166.

49 VW to VD, *Collected Letters*, Vol. 2, 10 April 1917, p. 147.

50 CT: Angelica Garnett Gift.

51 Ibid.

52 KC, CHA/1/59/1/5, VB to Clive Bell, 28 April 1915.

53 KC, CHA1/59/4/7, VB to RF, 2 July 1915.

54 VB to Saxon Sydney-Turner, *Selected Letters*.

55 Spalding, *Vanessa Bell*, p. 128.

8. GWEN

1 Simon Schama, *The Face of Britain*, (London: Viking, 2015); David Fraser Jenkins, *Gwen John and Augustus John*, (London: Tate Publishing, 2004) p. 11; Robert Melville, 'Wood Nymph', *London Review of Books*, Vol. 4, No. 5, 18 March 1982. I am grateful to Sue Roe's brilliant biography of Gwen John for being the first to challenge these myths.

2 Alison Thomas, *Portraits of Women*, p. 64.

3 Sue Roe, *Gwen John: A Life* (London: Vintage, 2002), p. 16.

4 Quoted in Ceridwen Lloyd-Morgan, *Gwen John Papers at the National Library of Wales*, (Aberystwyth: National Library of Wales, 1996) p. 7.

5 NLW, NLW MS 22798B, Ida Nettleship to Ada Nettleship, September 1898.

6 NLW, NLWMS21468D, GJ to UT, 8 July 1904.

7 Ibid.

8 NLW, NLWMS22155B, GJ to Dorelia McNeill, undated, spring 1906.

9 NLW, NLWMS22293C, GJ, Notes 1908–1930, 30 June 1910.

10 NLW, NLWMS22298A, Sketches, 1920–1930.

11 Vanessa Bell, ed. Regina Marler, *Selected Letters*.

12 NLW, NLWMS22281B, GJ, Exercise Book, 1910–1912.

13 NLW, NLW MS 22300 B, GJ, Draft Letters, 1919–1939.

14 Quoted in Roe, *Gwen John*, p. 56.

15 NLW, NLWMS22281B, GJ, Exercise Book 1910–1912, 30 June 1910.

16 NLW, NLWMS 22283B, GJ, Exercise Book, 1913–1926.

17 NLW, NLWMS22307, IJ to GJ.

18 NLW, NLW MS22308D, MCL to GJ.

19 NLW, NLWMS22311D, UT to GJ.

20 NLW, NLWMS21468D, GJ to UT, c.1904.

21 Ibid.

22 NLW, NLWMS22279B – NLWMS22286B, Exercise Books, 1903–1933.

23 NLW, NLWMS22281B, GJ, Exercise Book, 1910–1912, 18 November 1911.

24 Ibid., 22 June 1910.

25 NLW, NLWMS22281B, GJ, Exercise Book, 1910–1912, 30 June 1910.

26 Ibid., 30 June 1910.

27 NLW, NLWMS22293C, GJ, Gwen John, Notes 1908–1930, 6 January 1910.

28 Ibid.

29 Hope Mirlees, 'Paris', 1919, https://www.bl.uk/collection-items/paris-by-hope-mirrlees

30 NLW, NLWMS22307, IJ to GJ, August 1904.

31 NLW, NLWMS22299A, GJ, Sketches 1920s–1930s.

32 NLW, NLWMS23874C, GJ to Charles McEvoy, undated, c.1906.

33 Rosika Parker, *The Subversive Stitch*, (London: I. B. Tauris, 2012) p. xix.

34 NLW, NLW MS 22292B, GJ, Exercise Book, 1933.

35 NLW, NLWMS22281B, GJ, Exercise Book, 1910–1912, 18 November 1911.

36 NLW, NKWMS22293C, GJ, Notes 1908–1930, February 1919.

37 Virginia Woolf, 'A Sketch of the Past', in *Moments of Being* (London: Pimlico, 2002).

38 NLW, NKWMS22293C, GJ, Notes 1908–1930, 21 September 1911.

39 Ibid., 19 November 1910.

40 NLW, NLWMS22281B, GJ, Exercise Book, 1910–1912, 30 June 1910.

41 Ibid.

42 Ibid.

43 NLW, NLWMS22297B, GJ, Rough Sketches and Notes, 1928–1933, August 1928.

44 Griselda Pollock, 'Modernity and the Spaces of Femininity', in *Vision and Difference* (London: Routledge, 2003) p. 100.

45 NLW, NLWMS22298A, GJ, Sketches, 1920s–1930s.

46 NLW, NKWMS22293C, GJ, Notes 1908–1930, September 1920.

47 Ibid., 9 February 1911.

48 NLW, NLWMS22281B, GJ, Exercise Book 1910–1912, November 1911.

49 NLW, NLW MS 22303C, GJ, Draft letters, c.1908–1938.

50 Ibid.

51 Ibid.

52 Ibid.

53 NLW, NLWMS22293C, GJ, GJ, Notes 1908–1930, February 1911.

54 Quoted in Maria Tamboukou, 'Heterotopic and holey spaces as tents for the nomad: rereading Gwen John's letters' in *Gender, Place and Culture: a journal of feminist geography*, 2012-06-01, Vol.19 (3)275-290.

55 NLW, NLWMS22293C, GJ, Notes 1908–1930, 21 September 1911.

56 NLW, NLWMS22281B, GJ, Exercise Book 1910–1912, July 1910.

57 NLW, NLWMS22293C, GJ, Notes 1908–1930, 12 July 1911.

58 Ibid., 12 April [no year].

59 Ibid., 11 January [no year].

60 NLW, NLWMS22281B, GJ, Exercise Book 1910–1912, 18 November 1911.

61 NLW, NLWMS22293C, GJ, Notes 1908–1930, undated.

62 Catherine Lampert, *Rodin Sculptures and Drawings*, (London: Arts Council of Great Britain, 1986) p. 175.

63 NLW, NLW21468D, GJ to UT, 4 February 1910.

64 Quoted in Roe, *Gwen John*, p. 67.

65 Quoted in Roe, *Gwen John*, p. 99. Interestingly Gwen tells Ursula (proudly) about writing this to Rodin in a letter, 1 June 1908. NLWMS21468D, GJ to UT.

66 NLW, NLWMS22293C, GJ, Notes 1908–1930, 20 December 1911.

67 Ibid.

68 Ibid., 19 December 1911.

69 Ibid., 18 December 1911.

70 Ibid., 15 February 1912.

71 Ibid., 18 December 1911.

72 Ibid., 12 April [no year].

73 Ibid., 30 April 1911.

74 Ibid., 7 March 1912.

75 Ibid., February 1911.

76 Quoted in Roe, *Gwen John*, p. 103.

77 NLW, NLWMS 22285B, GJ, Exercise Book 1920–1930.

78 NLW, NLWMS21468D, GJ to UT, 15 October 1911.

79 Ibid.

80 NLW, NLWMS22293C, GJ, Notes 1908–1930, 19 October 1912.

81 Virginia Woolf, 'Women and Fiction,' in *Selected Essays*, pp. 132–40.

82 BO: MS 6241/63, Folder 9.

83 NLW, NLWMS22293C, GJ, Notes 1908–1930, 11 January [no year].

84 Ibid., 21 April 1921.

85 Ibid., 15 January [1910?].

86 NLW, NLWMS22281B, GJ, Exercise Book 1910–1912, 22 June 1910.

87 NLW, NLWMS22297B, GJ, Rough Sketches and Notes, 1928–1933, 21 May 1929.

88 NLW, NLWMS22293C, GJ, Notes 1908–1930, 22 May 1912.

89 NLW, NLWNS22278A, GJ, Diary 1931–1935, 23 November 1931.

9. NINA

1 All details of her childhood are from Nina Hamnett, *Laughing Torso*, pp. 2–6.

2 Ibid., p. 1.

3 Ibid., p. 35.

4 Ibid., p. 27.

5 In her memoirs, Nina describes taking a flat on '41 Grafton Street, Fitzroy Square' but looking at a map, it seems that off Fitzroy Square there is only a Grafton Way.

6 Hamnett, *Laughing Torso*, p. xx.

7 Ibid., p. 41.

8 Katherine Mansfield, 'Miss Brill', in *Selected Stories*, (Oxford: Oxford World's Classics, 2008) pp. 225–30.

9 Mary Douglas, *Purity and Danger: An Analysis of Concepts of Pollution and Taboo* (London: Routledge, 2002) p. 44.

10 Hamnett, *Laughing Torso*, p. 47.

11 Denise Hooker, *Nina Hamnett: Queen of Bohemia* (London: Constable, 1986), p. 155.

12 Hamnett, *Laughing Torso*, p. 56.

13 Ibid., p. 55.

14 Ibid., p. 69.

15 Ibid., p. 64.

16 Jean Rhys, *Quartet*, (London: Penguin, 2000) p. 15.

17 See Alison Light, *Forever England: Femininity, Literature and Conservatism Between the Wars* (London: Routledge, 1991).

18 See Leslie Jamieson, *The Recovering: Intoxication and its Aftermath*, (London: Granta, 2018) 2018.

19 Virginia Woolf, *Diaries*, Vol. 4, 30 October 1931, p. 51.

20 KC, CHA1/59/1/5, VB to CB, undated, [1906?].

21 Hamnett, *Laughing Torso*, p. 107.

22 Ibid., p. 42.

23 Ibid., p. 40.

24 Denise Hooker, *Queen of Bohemia*, p. 54.

25 Hamnett, *Laughing Torso*, p. 41.

26 The University of Essex, Art and Special Collections, written outlines for the Gaudier-Brzeska Collection.

27 Hamnett, *Laughing Torso*, p. 70.

28 Ibid.

29 Ibid., p. 80.

30 Ibid., p. 82.

31 Ibid.

32 Ibid., p. 43.

33 BO: MS 6241/38, Winifred Gill to Quentin Bell, 15 April 1967.

34 Hamnett, *Laughing Torso*, p. 93.

35 KC, CHA/1/216/3/3, RF to VB, 1917.

36 RF to Nina Hamnett, quoted in Denise Hooker, *Queen of Bohemia*, p. 112.

37 Hamnett, *Laughing Torso*, p. 42.

38 Ibid., p. 82.

39 Virginia Woolf, *Roger Fry*, (London: Penguin, 2003) p. 187.

40 KC, CHA/1/216/3/3, RF to VB, 1917.

41 KC, CHA1/59/4/9, VB to RF, June 1917.

42 KC, CHA1/59/4/10, VB to RF, 12 February 1918.

43 Ibid.

10. HELEN

1 Dr Mary Louisa Gordon to VW, quoted in Martin Ferguson Smith, 'Virginia Woolf and "the Hermaphrodite": A Feminist Fan of Orlando and Critic of Roger Fry', *English Studies*, Vol. 97, No. 3, pp. 277–97, 2016, DOI: 10.1080/0013838X.2015.1121724.

2 Smith, 'Virginia Woolf and "the Hermaphrodite"'.

3 KC, REF 3/61, Helen Fry to Julian Fry, 2 October 1907.

4 KC, REF/4/1/23, Roger Fry's sketchbook.

5 Smith, 'Virginia Woolf and "the Hermaphrodite"'.

6 KC, REF 8/2, Helen Fry, untitled short story (18 pages), 1895–9.

7 Smith, Virginia Woolf and "the Hermaphrodite"'.

8 Ibid.

9 Ibid.

10 Ibid.

Further Reading

INTRODUCTION

Ahmed, Sara, *Queer Phenomenology: Orientations, Objects, Others* (Durham: Duke University Press, 2006)

Birnbaum, Paula J., *Women Artists in Interwar France: Framing Femininities* (London: Routledge, 2011)

Deepwell, Katy, ed., *Women Artists and Modernism* (Manchester: Manchester University Press, 1998)

Elliot, Bridget and Wallace, Jo-Ann, *Women Artists and Writers: Modernist (Im)Positionings* (London: Routledge, 1994)

Freeman, Elizabeth, *Time Binds: Queer Temporalities, Queer Histories* (Durham: Duke University Press, 2010)

Kosofsky Sedgwick, Eve, *Epistemology of the Closet* (Durham, NC: Duke University Press, 1990)

—, *Tendencies* (Durham, NC: Duke University Press, 1993)

—, *Touching Feeling: Affect, Pedagogy, Performativity* (Durham, NC: Duke University Press, 2003)

Meskimmon, Marsha, *We Weren't Modern Enough: Women Artists and the Limits of German Modernism* (Oakland: University of California Press, 1999)

Pollock, Griselda, *Vision and Difference* (London: Routledge, 2003)

Rosner, Victoria, *Modernism and the Architecture of Private Life* (New York: Columbia University Press, 2005)

CARRINGTON

Chisholm, Anne, *Carrington's Letters: Her Art, Her Loves, Her Friendships* (London: Chatto & Windus, 2017)

Gerzina, Gretchen, *Carrington: A Life of Dora Carrington* (London: Random House, 1989)

Hill, Jane, *The Art of Dora Carrington* (London: Herbert Press, 1994)

ETHEL SANDS

Baron, Wendy, *Miss Ethel Sands and her Circle* (London: Owen, 1977)

Castle, Terry, *The Apparitional Lesbian* (New York: Columbia University Press, 1995)

Faderman, Lillian, *Surpassing the Love of Men* (London: Women's Press, 1985)

Love, Heather, *Feeling Backward* (London: Harvard University Press, 2007)

Medd, Jodie, *Lesbian Scandal and the Culture of Modernism* (Cambridge: Cambridge University Press, 2012)

Roche, Hannah, *The Outside Thing: Modernist Lesbian Romance* (New York: Columbia University Press, 2019)

Vicinus, Martha, *Intimate Friends: Women who Loved Women, 1778–1928* (University of Chicago Press, 2004)

Wachman, Gay, *Lesbian Empire: Radical Crosswriting in the Twenties* (New Brunswick: Rutgers University Press, 2001)

GLUCK

de la Haye, Amy and Pel, Martin, eds, *Gluck: Art and Identity* (New Haven: Yale University Press, 2017)

Doan, Laura, *Fashioning Sapphism: The Origins of a Modern English Lesbian Culture* (New York: Columbia University Press, 2001)

Doan, Laura and Garrity, Jane, eds, *Sapphic Modernities: Sexuality, Women and National Culture* (New York: Palgrave Macmillan, 2006)

Halberstam, Jack, *Female Masculinity* (Durham: Duke University Press, 1998)

Shepheard, Sue, *The Surprising Life of Constance Spry* (London: Pan Books, 2011)

Souhami, Diana, *Gluck: Her Biography* (London: Quercus Press, 2013)

VANESSA BELL

Caws, Mary Ann, *Women of Bloomsbury* (London: Routledge, 1990)

Deepwell, Katy, *Women Artists Between the Wars: 'A Fair Field and No Favour'* (Manchester: Manchester University Press, 2010)

Humm, Maggie, *Modernist Women and Visual Cultures: Virginia Woolf, Vanessa Bell, Photography and Cinema* (Brunswick, NJ: Rutgers University Press, 2002)

Marsh, Jan, *Bloomsbury Women: Distinct Figures in Art and Life* (London: Pavilion Books, 1995)

Reed, Christopher, *Bloomsbury Rooms: Modernism, Subculture and Domesticity* (New Haven: Yale University Press, 2004

Spalding, Frances, *Vanessa Bell* (London: Tauris Park, 1983)

Tickner, Lisa, *Modern Life and Modern Subjects: British Art in the Early Twentieth Century* (New Haven: Yale University Press, 2000)

GWEN JOHN

Foster, Alicia, *Gwen John* (London: Harry N. Abrams, 2016)

Mullholland, Terri, *British Boarding Houses in Interwar Women's Literature: Alternative Domestic Spaces* (London: Routledge, 2016)

Olson, Liesl, *Modernism and the Ordinary* (Oxford: Oxford University Press, 2009)

Pease, Allison, M*odernism, Feminism and the Culture of Boredom* (Cambridge: Cambridge University Press, 2012)

Roe, Sue, *Gwen John: A Life* (London: Vintage, 2002)

Thomas, Alison, *Portraits of Women: Gwen John and her Forgotten Contemporaries* (London: Polity Press, 1994)

NINA HAMNETT

Farfan, Penny, *Performing Queer Modernism* (Oxford: Oxford University Press, 2017)

Grosz, Elizabeth, *Volatile Bodies: Towards a Corporeal Feminism* (Sydney: Allen & Unwin, 1994)

Halberstam, Jack, *In a Queer Time and Place: Transgender Bodies, Subcultural Lives* (New York, NYU Press, 2005)

Hooker, Denise, *Nina Hamnett: Queen of Bohemia*
 (London: Constable, 1986)
Light, Alison, *Forever England: Femininity, Literature and Conservatism
 between the Wars* (London: Routledge, 1991)
Perry, Gillian, *Women Artists and the Parisian Avant-Garde: Modernism
 and 'Feminine' Art, 1900 to the late 1920s* (Manchester: Manchester
 University Press, 1995)

Image Credits

INTRODUCTION

Apples, Vanessa Bell, © Estate of Vanessa Bell. All rights reserved, DACS 2021, Image: National Trust

Shopping list, Vanessa Bell, © Estate of Vanessa Bell. All rights reserved, DACS 2021, Image: Charleston Trust

CARRINGTON

Dora Carrington by Lady Ottoline Morrell © National Portrait Gallery, London

Female Figure Lying on Her Back, c.1912, Dora Carrington, Photo © UCL Art Museum, University College London / Bridgeman Images

Female Figure Standing, Dora Carrington, Photo © UCL Art Museum, University College London / Bridgeman Images

Photograph of staff and students at Slade School of Art annual summer picnic, Photo: Tate

Letter from Dora Carrington, Photo: Harry Ransom Humanities Research Center, University of Texas at Austin

Staffordshire Dogs, *c.*1928, Dora Carrington, Photo © Christie's Images / Bridgeman Images

Sketch, Dora Carrington, Photo: Harry Ransom Humanities Research Center, University of Texas at Austin

Mill at Tidmarsh, Dora Carrington, private collection

Kitchen scene, attributed to an anonymous child, © The Courtauld, London (Samuel Courtauld Trust) Photo © The Courtauld

Standing Female Nude, attributed to Dora Carrington, Photo © Courtauld Gallery / The Samuel Courtauld Trust / Bridgeman Images

Mountain Landscape with Bridge, attributed to Dora Carrington, Photo © Courtauld Gallery / The Samuel Courtauld Trust / Bridgeman Images

Cyclamen in a Pot, Dora Carrington, Photo © Christie's Images / Bridgeman Images

Mrs Box, Dora Carrington, Photo: The Higgins Bedford

Tulips in a Staffordshire Jug, Dora Carrington, Photo © Christie's Images / Bridgeman Images

Spanish Boy, the Accordion Player, Dora Carrington, Photo: The Higgins Bedford

Eggs on a Table, Tidmarsh Mill, Dora Carrington, Photo: Courtesy of Liss Llewellyn

Letter from Dora Carrington, Photo: Harry Ransom Humanities Research Center, University of Texas at Austin

Iris Tree on a Horse, Dora Carrington, Photo © Bridgeman Images

EDNA

Sketches by Edna Clarke Hall: Pencil sketch of face. Dried flower attached to page; Pencil sketch of face; Wedding Banquet; Sketch of hands, © Estate of Edna Clarke Hall, Photos: Tate

ETHEL

A Dressing Room, Ethel Sands © Ethel Sands. Presented by Ethel Sands, the artist, 1948. © Ashmolean Museum, University of Oxford

Letter from Ethel Sands to Nan Hudson

The Chintz Couch, Ethel Sands © The estate of Ethel Sands, Photo: Tate

The Open Door, Auppegard, France, Ethel Sands © The estate of Ethel Sands, Photo: Guildhall Art Gallery, City of London

Interior at Portland Place, Ethel Sands © The estate of Ethel Sands, Photo: Guildhall Art Gallery, City of London

Girl Sewing, Auppegard, France, Ethel Sands © The estate of Ethel Sands, Photo: Guildhall Art Gallery, City of London

Nan Hudson Playing Patience at Auppegard, France, Ethel Sands © The estate of Ethel Sands, Photo: Guildhall Art Gallery, City of London

Chateau d'Auppegard, (Nan) Anna Hope Hudson, © The estate of Ethel Sands, Photo: Tate

Interior with Mirror, Ethel Sands © The estate of Ethel Sands, Photo: Guildhall Art Gallery, City of London

Ethel Sands by Lady Ottoline Morrell © National Portrait Gallery, London

Tea With Sickert, Ethel Sands © The estate of Ethel Sands, Photo: Tate

Morning, Ethel Sands © The estate of Ethel Sands

The Dream of St Ursula, Vittore Carpaccio, Photo: Gallerie dell'Accademia © DEA / G. DAGLI ORTI/De Agostini via Getty Images

GLUCK

Gluck Archive, Photos: author's own

The Pine Cone, Gluck, © The Gluck Estate. All rights reserved, DACS 2021

Before the Races, Gluck, © The Gluck Estate. All rights reserved, DACS 2021

Chromatic, 1932, Gluck, © The Gluck Estate. All rights reserved, DACS 2021, Photo: Bridgeman Images

Lilies and Guelder Rose, Gluck, © The Gluck Estate. All rights reserved, DACS 2021, © Manchester Art Gallery / Bridgeman Images

Lillies, Gluck, © The Gluck Estate. All rights reserved, DACS 2021

Still Life, Gluck, © The Gluck Estate. All rights reserved, DACS 2021

Lords and Ladies, Gluck, © The Gluck Estate. All rights reserved, DACS 2021

Bank Holiday, Monday, Gluck © The Gluck Estate. All rights reserved, DACS 2021

Nature Morte, Gluck © The Gluck Estate. All rights reserved, DACS 2021, Photo: Private Collection, Courtesy Piano Nobile, Robert Travers (Works of Art) Ltd.

WINIFRED

Sketch by Winifred Gill, Photo: The Bodleian Museum, University of Oxford

VANESSA

Vanessa Bell, Duncan Grant, © Estate of Duncan Grant. All rights reserved, DACS 2021, Photo: Ulster Museum NMNI

Iceland Poppies, Vanessa Bell, © Estate of Vanessa Bell. All rights reserved, DACS 2021, Photo: Charleston Trust

Sketch of Clive Bell, Vanessa Bell, © Estate of Vanessa Bell. All rights reserved, DACS 2021, Photo: Charleston Trust

Sketch, Vanessa Bell, © Estate of Vanessa Bell. All rights reserved, DACS 2021, Photo: *Charleston Trust*

The Arnolfini Portrait, Jan Van Eyck

Photograph of Vanessa Stephen (Bell) painting *Portrait of Lady Robert Cecil*, 1905 from life, Photo: Tate

The Kitchen at Charleston, Vanessa Bell, © Estate of Vanessa Bell. All rights reserved, DACS 2021, Photo: Charleston Trust

GWEN

Sketchbook, Gwen John

Self Portrait with Letter, Gwen John

Sketch of a Nude Woman, Rodin, Photo: © The Trustees of the
British Museum

The Convalescent, c.1923, Gwen John © Fitzwilliam Museum /
Bridgeman Images

A Lady Reading, Gwen John, Photo: Tate

A Girl Reading at a Window, Gwen John, Photo: MoMA / © 2021.
Photo Scala, Florence

A chain of paper dolls, Winifred Gill © estate of Winifred Gill,
Photo: Bodleian Library, University of Oxford

The Little Interior, c.1926, Gwen John, Photo: Bridgeman Images

Untitled painting of roof of Meudon home, Gwen John,
Photo: Llyfrgell Genedlaethol Cymru/ The National Library
of Wales

NINA

Lady Reading, Wyndham Lewis, Photo: © Christie's Images /
Bridgeman Images

Portrait of a Woman, Nina Hamnett, © Estate of Nina Hamnett,
Photo © Christie's Images / Bridgeman Images

Der Sturm, c.1913, Nina Hamnett, © Estate of Nina Hamnett,
Photo: Bridgeman Images

No. 1 Still Life, c.1913, Nina Hamnett, © Estate of Nina Hamnett,
Photo: Bridgeman Images

Still Life, 1918, Nina Hamnett, © Estate of Nina Hamnett, Photo
© Blackburn Museums and Art Galleries / Bridgeman Images

The Little Tea Party, Walter Richard Sickert, Photo: Tate

Portrait of Nina Hamnett, 1917, Roger Fry © Courtauld Gallery /
Bridgeman Images

HELEN

Lemons, Manet, Photo: Musée d'Orsay / Christophel Fine Art/
Universal Images Group via Getty Images

Acknowledgements

I am immensely grateful to my agent and friend Harriet Moore: without her this book would not exist. Her encouragement, support, patience and wisdom made this process possible. For every fastidious email, word of reassurance and transformative editorial suggestion, I could never thank her enough.

Huge thanks to Michael Fishwick for taking a chance on this book. Lauren Whybrow was the calm, conscientious and compassionate presence I needed to finish the project. Amanda Waters understood the book immediately and implicitly and proved another indispensable guiding force as it took shape. Kate Johnson's editorial acumen was invaluable. Hetty Touquet and Ella Harold made me feel comfortable, excited even, about the potentially terrifying reality of this book having a public life.

Thank you to the librarians, curators and archivists at The Yale Center for British Art, The Charleston Trust, The National Library of Wales, The Tate Archive, The Harry Ransom Centre for the Humanities at The University of Texas Austin, The Bodleian Archives Oxford, The Kings College Cambridge Archive, and The British Library Manuscript Collection. Thank you to Penny and Roy Gluckstein for welcoming me into their home, and allowing me to explore their archive. Funding from The Arts and Humanities Research Council enabled me to write this book. Thank you to the University of Edinburgh and the Edinburgh College of Art

for financial support, and to Patricia Allmer and Carole Jones in particular for their interest in this project. Thank you to the Society of Authors for awarding me the Antonia Fraser Grant, without which the international travel necessary for my research would not have been possible.

Dr. Sandra Mornington at Range High School was my introduction to everything that would subsequently interest me. I am immeasurably grateful to Dr. Sally Bayley for her transformative attention to my work: for every inspired recommendation and clarifying conversation, and for insisting to me that I should write long before I had the confidence to do so. I owe so much to the Women's Studies programme at the University of Oxford, and to the community at Mansfield College: thank you to Dr. Maria Donapetry and Professor Ros Ballaster in particular. Thanks to all the staff at The Charleston Trust; especially Darren Clarke and Alice Purkiss for beginning my education in archival work, and Emily Hill for her later guidance in accessing the collection. Enormous thanks to Jo Lamb, who in doing everything she could to make my time in Lewes happy and stable — and at a time when I was desperately in need of it — lay the ground for my future research and happiness. Thanks to all the staff at The Department of Prints and Drawing at The British Museum: their passion was catching. Thanks to Rob Airey and Cassia Pennington at the Wilhelmina Barns Graham Trust for giving me something new to think about during the final stages of this book. Special thanks to Helen Denerley at the Clashnettie Arts Centre in Strathdon: for the space, light, walks, raucous evenings and Corrie's trust, I feel so fortunate.

From my parents, Debbie and Duncan Birrell, I learnt industriousness and resilience; their boundless, unconditional love and support has meant so much. Raphael's compassion, political commitment and generosity have enhanced my life and shaped this book. Dan, my lifelong champion, spent arguably too much money on natural wine and too much of his time writing elaborate, satirical alternative chapters to this book, knowing as he does precisely what distractions I need when I'm stressed.

I am lucky to have wonderful friends who have made the years writing this book different and better. Anna Quirk's immense kindness and unwavering love have brightened my life since childhood. Sarah Thrift has offered so much time, care, faith, practical assistance and canny advice. Olivia Harvey has been available at all hours for calming rants about obscure celebrities. Thank god for Beatrice Kelly, the first art historian I befriended: her hosting of me in Washington D.C. while this book was percolating helped me in making a proper start, as did her insistence – Kelly family wisdom! – that I need only write a few hours each day. Few friends are so kind they will uncomplainingly attend a long, chaotic Kate Bush tribute act on request: for this and so much more, thanks to the angelic Matthew Rudman. At the Yale Center for British Art I made friends that immediately felt like family: I have no idea what I would have done without Francesca Kaes, Matthew Holman, Mae Lossasso, Hannah Lyons, Rosie Ram, and Emily Burns. The same goes for those I met when I moved to Edinburgh. Emma Henderson's warmth, enlivening dinner parties, and professional pep talks were vital. Alexa Winik and Rosa Campbell, beloved hags and astonishing poets, made me feel like a writer for the first time, and it is impossible to articulate precisely what their attention, intelligence, empathy and affirmation has meant; without them I wouldn't have had the courage to write this book. Imogen Wilson's humour, love, intellectual convictions and emotional generosity have buoyed me up even at a distance; I will never forgive her for moving to New York. Isabel Seligman is the reason why I am writing about art: I am forever grateful for the chance she gave me professionally, and everything I subsequently learnt through her about a discipline that was then still so new to me; I never anticipated she would become such a brilliant friend. This book really began through constant conversation with Zoe Marshall at The Charleston Trust, who remains the best, most rigorous companion for talking about the feminist possibilities of curatorial and archival practices, and the challenges of writing. Gulzaar Barn transformed the way I think about myself and others, and in doing so fundamentally reshaped how I read and write, and

in a book partly about intimacy I felt her electric, singular presence constantly as I wrote. Amber Stevenson's genius thoughts on gender and class have pushed my own thinking further and shaped the thesis of this book; her friendship — so attentive, considerate, giving and present — kept me going more than anything in the day-to-day production of this book. Sing Yun Lee has drawn out the better side of me since we met: she has given me a strength, daring and intellectual companionship I could not now live without. The impulse to write has always been inseparable from a desire to enter into a dialogue with her and her art, and all along this book was written with her reading in mind. Jenny Page has been at the absolute centre of my life for nearly two decades, and I would not be who I am without her; anything I know about ambition, friendship, love, grief, resilience and queerness is because of her. I wasn't sure what this book was when I met Sam Buchan-Watts. I am so thankful for his inexhaustible interest in this project and all that he has done to mould its motive and arc; throughout, it was his optimism that drove the text forward, and so much has rested on his emotional, intellectual and practical support. To all my brilliant friends – thank you.

A Note on the Type

The text of this book is set Adobe Garamond. It is one of several versions of Garamond based on the designs of Claude Garamond. It is thought that Garamond based his font on Bembo, cut in 1495 by Francesco Griffo in collaboration with the Italian printer Aldus Manutius. Garamond types were first used in books printed in Paris around 1532. Many of the present-day versions of this type are based on the *Typi Academiae* of Jean Jannon cut in Sedan in 1615.

Claude Garamond was born in Paris in 1480. He learned how to cut type from his father and by the age of fifteen he was able to fashion steel punches the size of a pica with great precision. At the age of sixty he was commissioned by King Francis I to design a Greek alphabet, and for this he was given the honourable title of royal type founder. He died in 1561.